SOCIAL
WORK
ARTFULLY

SOCIAL WORK ARTFULLY

BEYOND BORDERS AND BOUNDARIES

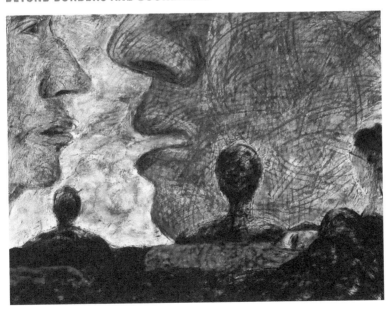

CHRISTINA SINDING AND HAZEL BARNES, EDITORS

WILFRID LAURIER UNIVERSITY PRESS

This book has been published with the help of a grant from the Canadian Federation for the Humanities and Social Sciences, through the Awards to Scholarly Publications Program, using funds provided by the Social Sciences and Humanities Research Council of Canada. Wilfrid Laurier University Press acknowledges the financial support of the Government of Canada through the Canada Book Fund for our publishing activities.

Inspiring Lives.

Library and Archives Canada Cataloguing in Publication

Social work artfully : beyond borders and boundaries / Christina Sinding and Hazel Barnes, editors.

Includes bibliographical references and index.
Issued in print and electronic formats.
ISBN 978-1-77112-122-4 (pbk.).—ISBN 978-1-77112-089-0 (pdf).—
ISBN 978-1-77112-090-6 (epub)

1. Arts and society—Canada. 2. Arts and society—South Africa. 3. Social service—Canada.
4. Social service—South Africa. 5. Social change—Canada. 6. Social change—South Africa.
I. Sinding, Christina, 1967–, author, editor II. Barnes, Hazel, [date], author, editor

NX180.S6S62 2015 700.1'030971 C2014-904389-9
 C2014-904390-2

Cover design by Daiva Villa, Chris Rowat Design. Front-cover image: *Six Figures, One Sleeping,* 2003 (oil on board, 112 cm x 131.5 cm), by contemporary South African artist Louise Hall (www .louisehall.co.za). Text design by Janet Zanette.

This book is printed on FSC® certified paper and is certified Ecologo. It contains post-consumer fibre, is processed chlorine free and is manufactured using biogas energy.

Printed in Canada

Every reasonable effort has been made to acquire permission for copyright material used in this text, and to acknowledge all such indebtedness accurately. Any errors and omissions called to the publisher's attention will be corrected in future printings.

MIX
Paper from
responsible sources
FSC **FSC® C004071**
www.fsc.org

Contents

Art for Transforming Social Relations

Art for Transforming Social Care Practice

Preface

This book began on a bus. Christina was seated near the front, waiting to be shuttled between venues at the 2010 Africa Research Conference in Applied Drama and Theatre. Hazel stepped on board, settled herself, and we began to talk: about Drama for Life (DFL), a post-graduate program in applied drama and theatre at the University of the Witwatersrand in Johannesburg (Hazel chaired Drama for Life's research committee at the time); and about social work education and practice (Christina teaches in the School of Social Work at McMaster University in Hamilton, Canada). We had a lively conversation about points of contact and possibility between our two disciplines and their justice projects.

Later, talking with Munyaradzi Chatikoba (DFL's program manager) and Warren Nebe (director of DFL), Christina learned more about joint teaching initiatives between DFL and the Discipline of Social Work at Witwatersrand. She also met Edwell Kaseke, head of the Discipline of Social Work, and came to know something of the Discipline's social development orientation and its synergy with DFL's focus on critical pedagogy and practice for social change.

We all kept in touch over the next year. A call for workshop grant applications from the Social Sciences and Humanities Research Council of Canada (SSHRC) prompted a more focused set of conversations. In a flurry of emails and Skype exchanges, we hatched a plan for the workshop *Social Work Beyond Borders, Social Work Artfully.* Held in Johannesburg, South Africa, at the University of the Witwatersrand, and funded by SSHRC, the workshop drew together scholars, students, and practitioners of social work and of the arts from McMaster and Witwatersrand. Over three very engaging days, we mapped productive intersections between social (justice) work and the arts; engaged specific examples of arts-informed social work and social change initiatives; and critically interrogated the claims and potential for artful practice to respond to contemporary challenges.

We ended our time together with a conversation about our interest in sharing our experiences and reflections at the intersection of social (justice) work and the arts, in a book. This is that book.

Acknowledgements

Many people's imaginations and labour contributed to making this anthology possible. Donna Baines generously lent her experience with book publishing, and linked us with Wilfrid Laurier University Press. Cathy Paton was a genial

contact point for authors, encouraging and celebrating chapter contributions. Rachel Warren engaged with the daunting task of assembling references for the chapters into coherent form, and maintained remarkable equanimity as the database kept switching up citations.

At WLUP, Ryan Chynces and Lisa Quinn offered energy and wise direction to the early stages of work on the book; Blaire Comacchio was an entirely kind and expert shepherd of the entire process; and Kristen Chew performed such thoughtful, careful copy editing.

Finally our thanks go to the authors who responded so thoughtfully to our suggestions, and whose creative and analytic work has enabled the exchange of ideas represented here.

Introduction

Christina Sinding and Hazel Barnes

The past two decades have witnessed a profound challenge to social work. A growing global convergence between the market and the public sector has meant that private sector values, priorities, and forms of work organization, increasingly, are permeating social and community services. Cost efficiency and other narrowly defined accountabilities have become key "targets" for social workers (Pease, 2007), and quantified, standardized, and evidence-based procedures (with "evidence" tightly circumscribed) are more and more in demand (D. Baines, 2010a). Regulators are pressing for social work education that meets check-box, behaviourally defined competencies (Aronson & Hemingway, 2011). At a time when the challenges we face as people and communities are becoming more layered and complex, our means of responding are becoming more time-bound and reductionist (Postle, 2002). Skilful relationship building, responsiveness to people's stories and social contexts, experiential knowledge, and explicitly value-saturated, open-ended change processes are under considerable pressure (Lundy, 2004).

This anthology has emerged from the recognition that the ways of knowing and acting that many social workers value are currently encountering considerable opposition. It explores, through example, evocation, analysis, and reflection, how engagement with the arts can offer conceptual and pragmatic renewal for social work in the context of enduring relations of domination and subordination and the relatively new relations of neo-liberal globalization. The authors whose work appears in this volume believe that arts-based approaches have the potential to revitalize social (justice) work, and to affirm and invite creative responses to changing and challenging social contexts. Our goal is to make visible a range of ways that art enables social change, by: supporting processes of conscientization, and enabling re-storying of selves and identities; contributing to community and cultural healing, sustainability, and resilience; helping us understand, challenge, and transform social relations; and deepening experiences, images, and practices of care.

In analyzing possibilities for social work at this moment in history, international scholars have encouraged Western social workers to learn from our colleagues in countries in which social welfare is less formally organized and more obviously a site of social contestation. In South Africa, most people rely on non-formal and non-state regulated forms of social protection (Kaseke, 2005). Social development—non-remedial forms of social work intervention

that foreground social connections, and individual and community strengths (L Smith, 2008)—is emphasized, as is locality relevance (Rankopo & Osei-Hwedie, 2011). In South Africa, as well, scholarship about social development, community mobilization, and the arts is informed by the powerful history of their intersection in the liberation struggle.

This book, emerging as it does from a collaboration between scholars in Canada and South Africa, draws on lived knowledge of how art can shape history and alter political and social futures (Hauptfleisch, 2010). Its origins also support the editors' intent to avoid some common concerns about social work's engagement with the arts. Arts-informed practice is often viewed as overly concerned with self-expression at the expense of analysis and a response to social conditions and social relations. However, this book includes examples of arts-informed research, pedagogy, and practice that are fully social, attentive to diverse knowledges and identities, attuned to various forms of personal and communal expression, and cognizant of contemporary economic and political conditions. In more substantive terms, our collaboration also means that the anthology addresses certain themes (colonization, displacement, and forced migration) that appear relatively infrequently in writing about social work and the arts.

The anthology begins with critical accounts of the emergence of social welfare and social work in Canada and South Africa. Writing from the specificity of their national contexts, Donna Baines (Canada) and Edwell Kaseke (South Africa) make clear that social welfare provision has reflected, and often exacerbated, the social hierarchies of specific places and times. Both authors point to the influence of neo-liberalism at this point in history, with its insistence on residual and often means-tested and stigmatizing social welfare programs, service standardization, and restrictions on social workers' autonomy and discretion—changes that exacerbate social divisions, and erode robust collective responses to people's struggles and needs. They point, as well, to fissures and opportunities: to progressive social policies built on enduring and revitalized social solidarities; and to the possibilities of resistant, creative practices, deliberately oriented towards justice.

Christina Sinding and Hazel Barnes take up these themes, describing the promise of the arts and outlining ideas about how the arts can contribute to social change while, at the same time, challenging simplistic assumptions about the innocence or benefit of the arts. This chapter includes a review of the literature on art and social work that is focused on how social workers and social work researchers have taken up the arts in efforts to enable personal and community expression, catalyze empathy and solidarity, and disrupt dominant ways of perceiving and knowing. Practitioners of applied drama activate the participatory and embodied nature of drama to generate both felt

engagement and intellectual reflection on community problems. Ideas salient to both disciplines—the intimate link between personal and social troubles, and personal and social liberation; the significance of stories told and witnessed; the determination to challenge habitual, damaging, and oppressive "scripts"—offer rich possibilities for reciprocal learning and collaboration.

Contributors to this book attend to myriad forms of violence and exclusion—colonization and apartheid, displacement and forced migration, sexual assault, and ableist othering—drawing attention to suffering that is personal and communal, embodied and structural. They are linked by the conviction, variously understood and expressed, that art is a vital and productive means of responding to the troubles they witness and in which we are all implicated. We have grouped the chapters thematically according to what art is understood to "do," and how the authors imagine and experience the effects art has on people, communities, relationships, and ideas.

The first section of the book considers how art is used for conscientization, for re-storying selves and identities. Edmarié Pretorius and Liebe Kellen outline the dominant storyline defining the lives of children who are migrants, a "thin" account of pain and suffering linked with singular and diminishing identities: the orphaned child, the abused child. The theoretically informed arts activities they describe draw forward alternative or subordinate stories—of resilience and resourcefulness, strong relationships, sustaining memories—and then "thicken" these stories, lending them texture and colour, and eroding the power of dominant stories in the children's lives.

Linda Harms Smith and Motlalepule Nathane-Taulela are concerned for the appropriate education of social workers in a post-colonial society. They argue strongly for the importance of a self-reflective critical awareness in social workers who themselves have been marked by the experiences of colonization, and are subject to internalized oppression. In their engagement with Drama for Life (a post-graduate program in applied drama and theatre at the University of the Witwatersrand), they encourage this critical faculty in students and a re-authorizing of personal stories through the use of drama techniques, which encourage analysis of power structures and reflection on one's own relationship to them.

Khayelihle Dominique Gumede's chapter begins with a reflection on the legacy of apartheid in South Africa, and the persistent and profound conflict within the imaginary of South African social identity. He analyzes the Truth and Reconciliation Commission as a social performance, and critiques it as a coercive approach to the telling of trauma in Boalian terms, in that it had a clearly articulated and predetermined social purpose. In response to this critique, he sets out a method of theatre-making aimed at a redressive approach to trauma. The extended ritualized preparation, remembering, and exploration

he undertook with a group of actors eventually created an imaginative space between memory and its interpretation that allowed for a new negotiation of the individual trauma story. It was a space that, Gumede explains, enabled a degree of emotional autonomy from traumatic events; witnessed and further negotiated in performance, it promised new forms of community.

In the next section, art—and in particular, the artful use of narrative— engenders community and cultural healing, sustainability, and resilience. Patti McGillicuddy and Edmarié Pretorius premise their chapter on the idea that hope and practices of social care are critical to the realization of human and social rights, and that trauma and unresolved traumatic injury deeply disrupt hope and our capacities to sustain community. Reflecting on work with survivors of sexual assault, colonial violence, and forced migration, they describe post-structural and anti-colonial approaches to trauma. Without denying fragmentation and loss, they show how carefully chosen metaphors and arts-informed group activities can provide transformative links between inner and outer life, forging stronger, more generous, and more vibrant personal and communal stories.

Through reflections on two theatre-based projects that have a deep concern with the ways in which previously ruptured lives can be re-envisioned, Hazel Barnes draws attention to the engagement of imagination and empathy as fundamental aspects of the capacity to pretend and to place oneself in the shoes of others. The chapter also considers the pull, common in justice-oriented projects, towards "realistic" and often didactic representations of problematic situations. The impulse towards realism and prefigured messages to audiences is compared with the benefits of a crafted aesthetic: primarily, the generation of a deeply felt and cathartic response to performance grounded in social issues.

Randy Jackson, Corena Ryan, Renée Masching, and Wanda Whitebird begin their chapter with a question: "Do you want to hear our side of that story?" The question, drawn from the book *Magic weapons: Aboriginal writers remaking community after residential school*, is both challenge and promise, provocation and gift. In this chapter, the authors offer a sustained reflection on how Indigenous researchers craft and tell "our side of that story." They envision researchers in Indigenous contexts as storytellers deliberately integrating multiple sources of knowledge (oral, dreamtime, written) and linking past, present, and future. They describe a process of weaving traditional knowledge together with research participants' accounts and scholarly literature, and developing artful, composite narratives designed to reverberate into the future: crafted as medicines, sent out as arrows, carrying knowledge for living well.

Artful approaches are also used to understand, challenge, and transform social relations. Kennedy Chinyowa notes that mainstream approaches to

conflict tend to address disputes directly, and call for rational deliberation and problem solving. His chapter makes the case for approaches to conflict infused with the arts. Applied arts approaches to conflict foreground storytelling and experiential education, and—central to the point of the chapter—deliberately activate fictional worlds alongside lived experience. The distancing effect of the art makes the familiar (our usual patterns of knowing and relating) strange, allowing us to subvert and reconstitute "reality." The constraints and obligations of ordinary reality do not disappear, but an opportunity to experiment (in a context in which consequences are minimized) is created. Chinyowa suggests that personal responses to and responsibility for conflict can be explored and new relational possibilities rehearsed through applied drama— an approach oriented not merely to the resolution of particular conflicts, but to a transformation in its social, cultural, and relational structuring.

The right of people labelled "intellectually disabled" to represent themselves and to comment on how they have been represented in public images is the subject of Ann Fudge Schormans' research. Her chapter focuses on how audiences have reacted to both the insights and self-representations of the PhotoChangers, a group of four adults who self-identify as people with intellectual disabilities. As Fudge Schormans notes, the PhotoChangers' work makes entirely visible that people labelled intellectually impaired can understand, reflect on, and respond to photographic images, challenging deeply held assumptions about what people with intellectual disability can and cannot do. Yet the challenge is more than this: we learn in the chapter that an image perceived as quite benign by audience members was understood and represented as thoroughly violent by a member of the PhotoChangers. The realization that the interpretations of people with intellectual disabilities might stand in profound contradiction to the interpretations of able-bodied others deeply unsettled audiences, and shook assumptions about professional knowledge. In this way, the PhotoChangers provoked the kind of critical reflection they and Fudge Schormans intended.

In the final section, authors reflect on artful practices as they deepen experiences, images, and practices of care. Cathy Paton's chapter calls us to focus on the ways social workers "do" relational processes—and on how we might do them differently. Paton's intent is to make visible how techniques drawn from improvisational theatre can generate fresh, critical, embodied understandings of relating, and thus support our much more active and less scripted engagement with other people (particularly service users, research participants, and colleagues). Paton describes how carefully designed improvisation exercises generate a lived experience of often-elusive practice ideas, such as mutual constitution and (the value of) unknowing. Reflecting on conversations that have been prompted by her use of these exercises in workshop settings, Paton

links social workers' heightened sense of their relational gestures—a heightened sense of how we create one another, in moments—to Levinasian ideas about embodied attentiveness, vulnerability, and responsibility for others.

Patti McGillicuddy, Nadine Cross, Gail Mitchell, Nancy Davis Halifax, and Carolyn Plummer engage the specific question of suffering. They describe a project in which social workers and nurses used a range of artistic media to explore what it means or can mean to bear witness to suffering in busy, pressure-filled healthcare contexts. Their exploration was no simple representation of care work, or coping; rather, they were seeking what is elusive and profound about care and suffering in the "in-between"—in the spaces where subjectivities meet, the spaces between words and images, the tight spaces of the nursing station where care workers jostle for charts, equipment, hope. Co-remembrance is a central theme: making art together, group members were released to remember specific moments of being with people who were suffering, and, through storytelling and artmaking, evoked a sense of empathic memory within and across a complex care system, laying foundations for collective action for change.

The chapters in this anthology confirm the range of ways that social relationships can be (re)humanized through the arts. Artful approaches described in this anthology interrupt the images and storylines that narrow practice and distort our relations with others; they also open up new ways of envisioning, representing, and living out our social justice commitments. We learn that in knitting together voice and authorship—self-definition and self-representation—art has a central place in processes of conscientization, and in undoing constraining narratives of self and community. Particularly as a response to the violence and profound losses of colonization, but also as a response to trauma more broadly, artful practices are activated to restore cultural knowledge, bolster community resilience, and support capacities for resistance. In undoing our familiar ways of understanding and relating to "others," art marks pathways to transformed social relations. And, finally, artful approaches offer practitioners new idioms of reflexivity, and new means for evoking and sustaining responsive, hopeful, and justice-oriented practice.

Where we've been and what we are up against: Social welfare and social work in Canada

Donna Baines

Canada—A colonial/post-colonial country

The territory currently known as Canada has deep colonial roots, with post-colonial/on-going colonial relationships shaping the lives of the Indigenous[1] and non-Indigenous peoples who now live here (Freeman, 2011; Galabuzi, 2010; Kulchyski, Angmarlik, McCaskill, & Newhouse, 1999). Though rarely addressed outside of lengthy court battles, Canada occupies land acquired through means that, by current standards of international warfare and occupation, would be seen as illegal and openly aggressive (International Committee of the Red Cross (ICRC), June 8 1977).

Social work theory and practice, just like mainstream society around it, tend to be based in the immediate social concerns encountered at the local level. They have been slow to address the complexities of colonialism, and how it benefits from and is sustained by global political economies. However, it is appropriate that critical social work texts address these themes from the start. Since white contact, Indigenous people have struggled to define their culture separate from and in relation to the mainstream culture and economy. Though increasing numbers of Indigenous people are pursuing higher education, they remain among the poorest groups in Canada, marginalized and exploited in numerous ways (Kulchyski et al., 1999). In order to address racism, impoverishment, and misrepresentation of Indigenous people in Canada, many Indigenous people continue to try to extricate themselves from non-Native social welfare systems and develop their own services, based on principles of self-determination and mutual support, albeit with full government funding (Galabuzi, 2010; Kulchyski et al., 1999; Sinclair, Bala, Lilles, & Blackstock, 2004). Post- and neo-colonial relations are evident within the operation of the Canadian state beyond the situation of Indigenous people, as in the ways that many immigrants and refugees to Canada find themselves at the bottom of the labour market, pushed to the edges of our racially stratified society (Galabuzi, 2006). Similar themes of colonialism are seen in the kinds of exploitive relationships most of the Global North has with (un)developing countries, and our governments' unwillingness to support fair and sustainable development or provide reasonable levels of

humanitarian assistance to countries in the Global South (Gardner, 2007; Reader, 1999).

Many social workers find they barely have enough time to deal with their workloads, let alone reflect critically on world events and larger systems of inequity. However, in order to remove the source of many of the deep-seated difficulties encountered by those using social services, it is important to understand the interconnection of larger systems and everyday problems. This requires both an understanding of the ongoing negative impacts of European colonization in Canada, as well as an analysis of the ways that much of the wealth in the first world was, and is, acquired through the colonization of the Global South and the original theft of land from Indigenous peoples. The disproportionate wealth in industrialized countries and among ruling elites in third-world countries comes from exploiting the labour of working and poor people and the depletion of natural resources worldwide (Nikoloski, 2011). This set of social relations also ensures that the poverty in the Global South continues, and that their economies remain dependent on trade with the Global North, providing disproportionate benefits to the wealthy. At the same time, social workers in the Global North often work with those excluded from the wealth of the society around them. Navarro (2006) reminds us that it is not the entire society in colonized or colonizer societies that reaps the benefits of capitalism; it is various groups of elites, and those able to position themselves well within competitive labour markets.

For social work, these complex social problems highlight the importance of a collective struggle for social justice, and not one limited to a particular country or culture. These problems prompt us, as well, to develop ways to understand colonialism in everyday life, to work across cultures and difference, and to celebrate resistance and the contributions of those on the margins—projects to which a critical, arts-informed approach to social work can contribute.

Social work and social welfare in Canada—Historical roots

The earliest forms of social welfare in Canada were collectively provided by extended families and communities of Indigenous people (D. Baines, 2011; Bourgeault, 1983; Lavell-Harvard, Memee, & Corbiere-Lavell, 2006). As mentioned earlier, many Indigenous people in Canada are currently attempting to extricate themselves from the non-Native social welfare systems that have been imposed on them since Euro-contact, and to develop their own services based on principles of self-determination and mutual support (Freeman, 2011; Galabuzi, 2010; Kulchyski et al., 1999). While Indigenous systems of communal social welfare continued to be the strongest system of social support for a substantial time after the arrival of Europeans, social welfare provision draw-

ing upon the Christian religious models used in the colonial homelands took precedence once significant populations of white settlers learned to sustain themselves in the new lands (Bourgeault, 1983). The Poor Law Amendment Act, passed in England in 1834, was the first occurrence of a European-style, national, and centralized approach to social welfare provision, and ensured that state provision of aid would always be less than the lowest wage (Abramovitz, 1999; Lightman, 2003). Poorhouses or subsistence refuges for the poor, set up by the new laws, framed the poor as being in need of stern incentives to accept paid work, regardless of wages or working conditions. Many argue that suspicion of those in need continues to underlie most welfare state programs today (Abramovitz, 1999; Lundy, 2004).

As in most of Europe, Canada developed a fairly extensive welfare state after the Second World War, and a mixed economy of human services including public, nonprofit, and private. Welfare states developed for a number of reasons, including a consensus between labour, government, and business that government should intervene to prevent a return to the harsh years of the Great Depression (Lightman, 2003). Part of this consensus emerged out of lengthy social justice struggles over how society should distribute wealth and provide care for those in need. In addition to mass mobilizations such as the "On to Ottawa Trek" in the 1930s, this struggle witnessed decades of social justice organizing involving a wide array of social activists, including artists, aimed at challenging, condemning, disrupting, and recreating the ways people thought about social solidarity and our responsibilities to each other as citizens and human beings.

The crowning glory of the Canadian welfare state was made up of a few universal social programs (provided to all, regardless of income) aimed at health, education, and redistribution of income, and a number of targeted programs, such as provisions to improve access to higher education, and services or pensions for elderly people and those with special needs. Yet even at its most robust, the Canadian welfare state was limited and exclusionary. Similar to the UK and US, it was a *liberal* welfare state, in which most social benefits were provided through the workplace and explicitly linked to participation in the paid labour market (Esping-Andersen, 1999; Lightman, 2003). This meant that those most likely to do well in the labour market—that is, white, straight, well-educated men—were also likely to have the best social benefits package, while women, racialized people and new Canadians, Indigenous people, and people with disabilities were pushed to the margins of the social safety net (Hick, 2002; Lightman, 2003).

Most versions of history agree that social work emerged as a profession in the Global North during the aforementioned Victorian era, as groups such as the Charitable Organizations Society attempted to develop "scientific"

ways to distribute charity to the large populations of urban poor generated by industrialization and land closure (Carniol, 1987; Mullaly, 2002). The interventions of these early professionals tended to be self-righteous admonishments to the poor, advising them to avoid sloth and poor work habits, and failed in the process to challenge capitalism's tendency to exploit the poor and sustain the wealthy (Carniol, 1987; Withorn, 1984). This kind of approach continues to be seen today in social programs that exhort single mothers and people with disabilities to find any job in the paid labour market, regardless of wages or working conditions. For those concerned with inequity, this approach fails to address correlations between race, class, gender, ability, sexual orientation, and other axes of oppression that operate to the benefit of an increasingly small global elite, while poverty and social exclusion grow worldwide.

Fortunately, more social-justice-oriented approaches to social work emerged to challenge the early charitable approaches, reflecting the way that social work has always been a pluralist field, encompassing those who aim interventions at the individual; those who attempt to address larger social, political, and economic forces as the source of social problems; and a number of amalgams and variations of these two approaches. In North America, social-justice-based social work organizations, such as the Rank and File Movement, the Settlement House Movement, and the Canadian League for Social Reconstruction, were developed by the 1880s (Hick, 2002; Reynolds, 1963; Withorn, 1984), focusing on the development of community-engaged, egalitarian approaches to social work intervention. Echoing social justice social work practices today, activists such as Berta Reynolds (1946) called upon social work to serve people in need, while simultaneously working to fundamentally reorganize society.

Even at the height of the welfare states in the Global North, social work theory and practice continued to pursue models that affirmed capitalism and its emphasis on individuals as the authors of their own success or failures (models such as psychoanalytic, systems, or the ecological), as well as models that challenged the underlying socio-economic structures that limited wealth and opportunity for many and built power and control for elites (such as structural, Marxist, feminist, and anti-racist models).

Then, as now, the social work sector was a highly gendered and increasingly racialized workforce and group of service users. Though exact data is difficult to locate, most estimates put female labour force participation at around 80 percent, with subsectors such as the nonprofit social services at closer to 85 percent (Saunders, 2004). Employers, particularly in non-government agencies, generally assume that providing care and services for others is just something women do "naturally" as an extension of their roles as mothers, sisters, and daughters, rather than a set of skills and knowledge (C. Baines, Evans, &

Neysmith, 1998; D. Baines, 2006b). This delegitimizes the skills and knowledge required for voluntary sector jobs, making it hard to improve terms of employment or wages and benefits (Aronson & Neysmith, 2006). It also makes it easier to replace full-time, permanent employees with short-term, part-time, contract, and casual employees, or even volunteers, as it is assumed that anyone, or at least any woman, can do the job under any conditions (D. Baines, 2004a).

Though funding cuts and hiring freezes since the early 1980s have reduced the number of social work jobs in the public sector, social work employment in the nonprofit (non-government) sector has grown as governments have privatized services. That non-profit workforce is increasingly racialized. For example, in Canada's most populous province, Ontario, over a third of voluntary sector employees identify as people of colour or as Indigenous (Clutterbuck & Howarth, 2007, p. 19). Though the links between the racialized workforce and the sector are under-researched, Aboriginal workers and workers of colour often find themselves employed by ethno-specific services and programs, which are among the least securely funded and most vulnerable to closure (D. Baines, 2006b; Richmond & Shields, 2004).

By the mid-1980s, the welfare state—which, despite serious problems, provided vital health, social care, and income redistribution programs—began to be dismantled. Canada introduced its first neo-liberal budget at the federal level, and the programs of the welfare state were refocused to support and legitimize the individual, private family, and private market as the solution to all social and individual problems (Lundy, 2004; Teeple, 2000). Social welfare restructuring continues today, largely supporting targeted, residual social programs aimed at providing minimal service to those unable to access private care or workplace-linked benefits.

Neo-liberalism, managerialism, and changing work organization

As the welfare state downsized and shifted service delivery to the nonprofit and private sectors, the organization and content of social work practice changed significantly. As noted above, by the mid-1980s Canada had introduced its first neo-liberal government budgets and had begun to refashion the welfare state to support and extend the private market. Though it takes on different forms in different contexts and is not as monolithic as often presented (Clarke, 2010), neo-liberalism is a global ideology that emphasizes individual responsibility and the private purchase of services, rather than shared social responsibility and public (i.e., government-run and funded) services (Harvey, 2005). New Public Management (NPM), or managerialism, accompanied neo-liberalism,

encouraging social work managers to view their organizations as business units providing decentralized managerial control within a mixed structure of public, non-profit, and for-profit logics (D. Baines, 2004a). In contrast to older models of public sector management, which emphasized the entitlement of citizens to public services, NPM is often referred to as "results-based" or "performance" management. It emphasizes strict control of the process of service delivery and performance of workers, and provides tight prescriptions for social work practice, replacing workers' discretion with pre-allotted amounts and types of interventions in an effort to cut costs and improve efficiency and accountability (D. Baines, 2004b; McDonald, 2006). Management control over the labour process necessarily increases in order to meet efficiency outcomes and targets, resulting in major changes in work organization.

One of the biggest changes in work organization is the standardization of work practices. Under NPM, individual workers are coached in competitive, performance-improving practices aimed at improving efficiency, cutting costs, and meeting outcome measures essential to continued funding. In public sector and larger non-profit agencies, paper- and computer-based standardized forms, record keeping, and assessments have replaced the informal interactions and assessments of the past. In many agencies, routinization has taken place, in part, through the integration of computer packages that increase the pace and volume of work, the gathering of statistics, and the monitoring of worker productivity through computer-based supervision—a system also called E-supervision. Some E-supervision models involve the use of computer packages that remind workers of pre-set time limits for certain parts of the job (e.g., the completion of intake forms and assessments), the order in which these tasks must be completed, and when workers must seek supervisory approval before moving on. Failure to complete the tasks on time is reported electronically to the supervisor.

Findings from studies I have undertaken with front-line social workers show that they chafe at the way the E-packages and paper-based forms removed their capacity for discretionary power and they question whom they were helping:

> There are assessments that need to be done on the computer, but when you look in reality as a social worker, at what you are doing, you say to yourself, "what is this really doing for the client who needs some help right now?" It's more of a management tracking system for govern-ment legislation than any help. It doesn't speak to people's needs and how we are going to get to meet them. (D. Baines, 2004a)

In short, the standardization of social services delivery abstracts the lived-in realities of individuals and communities, replacing multi-service, holistic approaches with narrowly calibrated, cookie-cutter approaches to diverse prob-lems and issues.

Permanent, full-time jobs are increasingly difficult to find and retain in social services, as neo-liberal restructuring of labour markets has encouraged employers to introduce "flexible" forms of work including: "thin" staffing, such as solo shifts; lean shifts (one or two workers per site, sometimes with cellphone access to workers or supervisors at other sites); split shifts (wherein staff work an hour or two in the morning and return in the evening for a few more hours of work); part-time, contract, casual, and other forms of temporary work; and expanded reliance on volunteer work (D. Baines, 2004b; Cunningham, 2008). Precarious forms of work such as these are less likely to have workplace or pension benefits associated with them, representing a further shrinkage of the social safety net of services and benefits.

Unpaid work

The question of whether or not to perform unpaid work is a complex one in the social services. Unpaid work in the form of undocumented and formally unrecognized overtime is something that is both an act of resistance on the part of social workers and a form of exploitation, as social service managers increasingly depend on their staff to undertake extra hours of work to stretch tight agency resources. In studies I have undertaken, social workers reported regularly working through their lunch hours and coffee breaks, staying late, taking work home with them, working on weekends and holidays, and bringing resources to work from home (D. Baines, 2006a). Many social workers also volunteer at their own and other social service agencies, and undertake a myriad of commitments in their communities and with extended family (D. Baines, 2004b), suggesting that social services run on the unpaid work of many, including their own workforce.

A Canadian Association of Schools of Social Work survey (Stephenson, 2002) shows that workers in this predominantly female sector juggle a number of care responsibilities in the home, making the decision to undertake unpaid work more complicated and stressful. Despite this stressed context, my research shows that workers often see unpaid overtime as a form of resistance to narrow, uncaring social agendas both within and outside the workplace. As one senior mental health worker observed, "It's people's right to have this service even if the government seems to have forgotten that." Another social worker argued, "I can't sit in my comfortable home if I know that all hell is breaking loose on one of my cases. I have to at least patch it up to last until the office opens." Many workers reported that they felt they had to work overtime in order to stretch an uncaring system and ease suffering: "People are desperate and need that cheque; they can't wait until tomorrow or the end of the weekend." In each of these examples, unpaid overtime undertaken by social workers made them feel that

they had contributed something to making society "less cruel, which these days is an act of resistance itself" (D. Baines, 2004a). In each of these quotes, there is a visible sense of social solidarity with service users and moral outrage against the larger system. This outrage and willingness to self-exploit for the benefit of others stands in contradiction to the individualism that underlies the neo-liberal, residual welfare state, and is a way that the social workers interviewed felt they saved their integrity and pushed back at destructive social relations.

While some managers worked alongside their staff to resist practices and policies thought to be harmful to service users, most of the managers involved in my studies told me that they knew that workers put in many extra unpaid hours, and that they considered it "just part of a professional job" (D. Baines, 2004a). In an echo of the oppressive idea that women are naturally caring, some claimed that they could not stop the workers from working unpaid hours even if they wanted to, because of the deep altruism of the labour force. Here unpaid overtime takes on the character of exploitation, and managers need to be reminded that their workers' time, skills, and knowledge require respect and fair pay.

However, if overtime is entered into consciously as a form of resistance to agency-level and larger oppressive social relations, it takes on a different character than if it is an unspoken requirement of the job. Though this resistance may be self-exploitation, it *simultaneously* represents a means through which workers can express many of the values and missions excluded from the managerialized workplace. As neo-liberal restructuring produces growing populations of poor and desperate people in need of services (Giroux, 2012; Teeple, 2000), the increasingly insecure social work labour force absorbs the overflow in demand through the elasticity of their labour and their willingness to care, temporarily restabilizing an inherently unstable and unsustainable situation.

Social workers have also turned to unions to resist changes in the workplace collectively (D. Baines, 2010b). Most unions in Canada adopt an approach known as social unionism, wherein unions address themselves to the defence of those in the workplace, as well as those in the larger community (Ross, 2011). These values are consistent with the values that drew most social workers to the field and keep them there. Through collective bargaining, social workers have managed to improve the quality of care provided to service users by lowering caseloads, expanding training opportunities, and retaining skilled staff through improved wages and benefits. In addition, social service workers have used their union locals to mobilize around issues as diverse as challenging deportations and immigration policies, addressing homelessness, opposing homophobia and transphobia, stopping violence against women and children, and building solidarity with a myriad of groups around these and other issues.

Destabilizing managerialism—Anti-oppressive practice and arts-based approaches

In addition to workplace-based resistance, the Canadian Association for Social Work Education (CASWE) has adopted a social-justice-oriented theoretical and practice model known as Anti-Oppressive Practice (AOP), which challenges oppression in its multiple, intersecting forms (Adams, Dominelli, & Payne, 2009; McLaughlin, 2009; Mullaly, 2002). Rather than a single approach, AOP is an integrated model drawing on a number of social-justice-oriented approaches to social work, including feminist, Marxist, critical, postmodernist, Indigenous, post-structuralist, critical constructionist, anti-colonial, and anti-racist perspectives. It attempts to analyze how power works to oppress and marginalize people, as well as how power can be used first to liberate and empower them across a wide range of social settings, relations, environments, and systems, and then to put whatever power and resources we have towards positive change for service users and communities.

At this point in time, however, some academics and practitioners fear that, as AOP has become mainstream, it may be incrementally losing its capacity to contribute meaningfully to social justice (D. Baines, 2011). One way to keep social justice social work practice at the cutting edge of social struggles, and focused on emerging as well as long-standing inequities, is to ask questions such as the following:

- How do we understand and work across multiple and intersecting differences (intersecting and interlocking oppressions; see D. Baines, 2002; Hulko, 2011)?
- In building oppositional analyses and resistance, how do we draw on the voices of marginalized people and their everyday knowledge, as well as practise knowledge, research, and theory?
- How can resistance strategies promote a clear political program of change while remaining open, fluid, and inclusive (that is, embrace both certainty and uncertainty; see Adams et al., 2009; Mullaly, 2007)?
- How do we provide resources to and act in solidarity with exploited groups?
- How do we sustain ourselves and our analysis in alienating and sterile environments (see D. Baines, 2011, p. 11)?

Social justice approaches to social work need to morph and grow as social conditions change. It is not the name of a given approach to social work theory and practice that is important; it is the model's capacity to analyze social justice issues, question injustice, and provide useful ways to intervene and respond.

Arts-based approaches to social work, such as those analyzed in this book, tend to be well aligned with social-justice-oriented social work approaches. Grounded in giving voice to the marginalized and exploited, approaches such as these do not find fertile ground in the climate of managerialism and austerity. They are difficult to quantify and standardize for cost-control purposes, and run counter to ideas of competitive staff performance models and targets (see Clarke, 2004, 2010, on competitive performance). Yet, at the same time, these approaches have the potential to disrupt the standardization of managerialism, introduce new ways to look at issues, and mobilize people's imaginations and resources for social justice.

Like other social justice approaches, arts-based social work questions taken-for-granted assumptions, and provides fresh ways to look at the complexities of oppressions operating within neo-liberal, post-colonial societies. Radical therapy, community and social development, and arts-informed social work have much to offer each other in terms of an analysis of shared threats, pressures, and opportunities, and the spaces they create to generate new ideas and practices. Social workers taking up these approaches struggle to bring immediate relief to those in strife, while simultaneously addressing the larger social relations that benefit from and maintain inequities at a local, national, and international level. Finally, like other social justice approaches, arts-based social work can help people build internal resilience and uncover new ways to work with some of society's most marginalized and exploited populations.

Note

1. A number of terms are used in this chapter to describe Indigenous people. Reflecting the diversity of terms used in the wider world and among the five hundred Indigenous groups in Canada, I use terms such as "Indigenous," "Native," "First Nation," and "Aboriginal" interchangeably. Reflecting the rights of groups to name themselves, Native words will also be used for specific groups of people.

Where we've been and what we are up against: Social welfare and social work in South Africa

Edwell Kaseke

The legacy of colonialism and apartheid

The history of social welfare in South Africa is one that has to be understood within the context of colonialism and apartheid. Colonized by the Dutch and the British, the country's long history of colonialism has influenced the nature of its approach to social welfare (Patel, 2005). As is true in many other countries, one cannot talk about the history of social work without talking about the history of social welfare, and in South Africa, the history of one is intertwined with the other.

Western-style social welfare in South Africa emerged in response to the problem of destitution among Dutch settlers in 1664, when poverty-stricken Dutch settlers began to receive welfare support from the settler government (Nicholas, 2010). Nicholas also notes that the responsibility for providing relief to the poor Dutch settlers was later transferred to the Dutch Reformed Church, and that priority was given to assisting older persons and children. However, the same welfare support was not extended to the African population, as they were considered lesser beings. Patel (2005, p. 66) observes that "The exclusive group consciousness of the Dutch Settlers manifested itself in the expression of racial and social supremacy, and they judged the African people, their customs, and their rich tradition of social organization to be inferior."

The provision of social welfare support to destitute white settlers was influenced by the social philanthropy approach to social welfare, an approach dominant in Europe during that period. Social philanthropy evolved out of religious imperatives, which called upon the faithful, as an expression of their faith, to provide support to the less fortunate members of society. In this vein, Patel (2005) confirms that churches pioneered alms giving to the poor, and voluntary organizations later joined the churches in these philanthropic endeavours. The state recognized the role of the church and voluntary organizations in providing social relief, and focused on creating an environment in which these organizations could operate and thrive. Social philanthropy was provided as a privilege, however, and not as an entitlement, and benefits themselves also were not an entitlement. It was assumed that the absence of the notion of entitlement would encourage individuals to take responsibility for their own welfare and

not to expect "handouts" from society. As acts of charity, social philanthropic endeavours inadvertently made the poor dependent upon the good will of the churches and private voluntary organizations.

The twin processes of urbanization and industrialization became entrenched in South Africa around 1860, following the discovery of minerals, and reinforced the need for social welfare services (Patel, 2005). Urbanization and industrialization made both white and black people dependent upon paid employment for their sustenance, notwithstanding the fact that the economy did not have the capacity to absorb each and every job seeker. Lack of paid employment created income insecurity among the unemployed, which in turn made unemployed white people dependent on charity, given the fact that this was readily available to them. The effects of urbanization and industrialization were manifested through a range of social problems that included poverty, unemployment, divorce, and crime. However, poverty was the most dominant social problem.

The growing impoverishment of white settlers became a major issue of concern for the settler government, which established the Carnegie Commission of Enquiry in 1929 to carry out investigations on what was referred to as "the poor white problem" (Patel, 2005). The fact that some white people were poor was considered embarrassing. The focus on the poor white problem, whilst neglecting the problem of poverty among the indigenous black people, was not surprising given the fact that whites were considered a superior race and it was believed that blacks could be adequately supported through their extended family systems. The implication of this was that poverty among black people was viewed by the state as tolerable and inconsequential.

Black people were left to depend on those extended family systems in order to meet their needs. However, the processes of urbanization and industrialization had the effect of weakening traditional support systems. Potgieter (1998) observes that urbanization and industrialization necessitated the migration of African men from rural to urban areas in order to sell their labour, and this disrupted the family system. Black people who had moved to urban areas and to work at the mines had to organize themselves differently in order to meet their welfare needs, given the fact that they could not rely on traditional support systems or benefit from the formal welfare system. In an attempt to meet their needs and respond to the gaps in welfare support, black people in urban areas formed mutual aid groups to provide reciprocal social support (Patel, 2005). Patel also points to the formation of home groups in the mines which "provided support to workers in times of illness and in meeting burial needs" (2005, p. 79).

The major recommendations that arose from the Carnegie Commission of Enquiry centred on the need to establish a department responsible for social

welfare, and the need to train professional social workers (Nicholas, 2010). Consequently, the first National Department of Social Welfare was established in 1937 (Patel, 2005). As far as social work training was concerned, the first training was provided in 1929 by the Transvaal University College, whilst the first social work program for blacks was offered by the Jan Hofmeyr School of Social Work in 1941 (Nicholas, 2010). Another major recommendation by the Commission focused on addressing the poor white problem through employment creation (Patel, 2005). This had the effect of reducing employment opportunities for black people, as priority was given to the employment of white people.

The election of the National Party to form a government in 1948 marked the beginning of apartheid (a policy of institutionalized racial discrimination) and the creation of eighteen government welfare departments to serve the different racial and ethnic groups in the country (Potgieter, 1998). Social workers were also expected to serve their own ethnic groups.

McKendrick (1989), cited in Potgieter (1998, p. 23), observes that the social welfare system in the 1980s was characterized by four principles: the "segregation of races; the state/private welfare partnerships; the rejection of socialism and the idea of the welfare state; and a move away from a residual and therapeutic focus to a community-based preventative orientation." Racial segregation meant that the white population received superior services and benefits, and the social welfare system was used to promote and perpetuate white privilege. Potgieter further observes that the establishment of eighteen government departments of social welfare only served to create inefficiency and fragment social welfare services. At the same time, the state/private welfare partnerships were based on the understanding that the state could not manage the provision of social welfare services on its own, and needed players outside government to be involved in social welfare provision. The provision of social welfare services was seen as the responsibility of a range of stakeholders. This thinking was in line with the dictates of the liberal ideology that successive governments during this era subscribed to, and which called for limited state involvement in social welfare provision. It was for this reason that the government chose to have a preventive focus, which was an attempt at proactive intervention designed at reducing social problems, particularly poverty. It did not actually address itself to the root causes of social problems; rather, the state was motivated by the intent to discourage "dependency" among the poor. The ultimate aim was to reduce the demand for social welfare.

The end of apartheid

The birth of a democratic society in South Africa in 1994 marked a turning point in the provision of social welfare services. The major preoccupation at

that point was to redesign the social welfare system so that it could address the injustices of the past. The new social welfare system was premised on the need to remove all discriminatory provisions and create a more inclusive social welfare system. This also entailed making social welfare more responsive to the needs of the majority, who had been marginalized previously. In essence, the new system called for a reorientation of social welfare and social work practice.

Efforts to reorient social welfare services culminated in the development of the *White Paper for Social Welfare* in 1997. The *White Paper for Social Welfare* sought to address the imbalances or disparities created by apartheid. According to the Department of Welfare (1997), the disparities had three major dimensions: racial, geographical, and gender-related. The Department of Welfare further notes that black people living in rural areas and black women were particularly marginalized. In view of these disparities, the *White Paper for Social Welfare* identified key priorities, which included the establishment of a single national department responsible for social welfare, establishing a welfare system that was financially sustainable, and rationalizing the delivery of social welfare services (Department of Social Welfare, 1997).

The *White Paper for Social Welfare* was also intended to promote developmental social welfare with a view to achieving the objectives of social development (Department of Social Welfare, 1997). The overall objective of social development is to improve the quality of life through addressing the problems of poverty, inequality, and social exclusion (Midgley, 1995). Social development is based on the realization that economic growth in developing countries has not translated to improvements in the quality of life for the majority of the people. Midgley (1995) calls this "distorted development," which is characterized by the existence of mass poverty alongside shades of affluence. It is for this reason that social development seeks to promote social inclusion, and not only economic growth. To this end, the *White Paper for Social Welfare* is an instrument for promoting social development. Social welfare and social work practice in South Africa is, therefore, informed by the social development model. In this instance, social development is defined as "a process of planned social change designed to promote the well-being of the population as a whole in conjunction with a dynamic process of economic development" (Midgley, 1995, p. 25). The definition by Midgley suggests that social development and economic development reinforce each other. In this way, social development is dependent on the resources generated by economic development, whilst economic development alone cannot guarantee human well-being (Midgley, 1995). In essence, social development rejects the assertion by the modernization school of thought that the benefits of economic growth trickle down to all citizens or residents. Midgley goes on to point out that the trickle-down is a myth, and that this serves to explain why the social development approach

has to be interventionist in nature, as positive social change occurs only if it is caused to happen.

Social development embodies the principle of social solidarity, which informs the social and economic organization of African societies. In South Africa, the principle of social solidarity gives expression to the societal value of *ubuntu*. *Ubuntu* is used to denote that human beings are interdependent (Rautenbach & Chiba, 2010). The pursuit of social development, therefore, reinforces the need for society to put measures in place that can enable individuals, groups, and communities to realize their full potential. The implementation of an elaborate social assistance system in South Africa gives expression to the principle of social solidarity, and demonstrates that solidarity between the poor and those who pay direct taxes that finance the social assistance system. The adoption of the social development model is based on the recognition that poverty is a major threat to human well-being and human security. At the time of the adoption of the *White Paper for Social Welfare*, 35.2 percent of the population was deemed to be poor while 54 percent of children were categorized as poor (Department of Social Welfare, 1997). In 2000, the proportion of the population living on two dollars a day was 34 percent, and the Gini co-efficient (a measure of inequality) was 0.59 (Government of South Africa, 2010). It is also noted that only 60 percent of the population had access to clean water in 1995, which had increased to 85 percent as of 2003 (Government of South Africa, 2010). The improvement can be attributed to the adoption of the developmental approach to social welfare, and the Constitutional imperatives also.

The HIV and AIDS pandemic has also made the social development approach relevant in South Africa. South Africa has the highest number of persons living with HIV/AIDS in the world today. One effect of the HIV and AIDS pandemic in South Africa has been a significant increase in the orphan population, along with the rise of the phenomenon of child- and grandparent-headed households. HIV and AIDS create social exclusion for both those infected and affected. A social development approach demands that interventions should seek to promote social inclusion in society, which would entail promoting the social integration of persons infected and affected by HIV and AIDS.

South Africa's new welfare system is informed by the human rights approach, which acknowledges that everyone in society has a right to an adequate standard of living, and combines socio-economic rights with basic human rights. Put simply, the human rights approach speaks to the notion that everyone has a right to meet his/her basic needs, and the state has an obligation to ensure that this right is realized. In this regard, the *White Paper for Social Welfare* is informed by the country's constitution, which, among other things, provides for the right to have an adequate standard of living. The constitution holds the government accountable to deliver on this right, as illustrated in the

case *Government of South Africa v Grootboom*, whereby the Constitutional Court ruled that a Mrs Grootboom should not have been evicted from where she was living illegally without providing her with alternative accommodation (Olivier, 2004). Olivier further noted that: "This case raises the state's obligations under section 26 of the Constitution, which grants everyone the right of access to adequate housing, and section 28(1)(c), which affords children the right to shelter" (p. 130).

The current framework for social welfare and social work practice in South Africa

It is apparent that the current framework for social welfare in South Africa has been influenced by the *White Paper for Social Welfare*, the South African Constitution, and globalization. The *White Paper for Social Welfare* provided the basis for the orientation of the social welfare, a necessary orientation given South Africa's legacy of apartheid, and its many years of international isolation, which had created an inward-looking economy. The reorientation was meant to change the focus of social welfare and social work from a remedial to a preventive, developmental, protective, and rehabilitative focus (Department of Social Welfare, 1997). The preventive focus is based on the understanding that proactive intervention can prevent social problems or reduce their severity or impact. Furthermore, prevention is cost-effective, unlike the remedial focus, which is reactive and deals with problems that otherwise could have been prevented. Similarly, the developmental function is meant to ensure that assistance is not an end in itself, but a means to an end. In this case, the end should be creating a situation where individuals, groups, and communities are able to solve their own problems or meet their own needs. Finally, the protective and rehabilitative focus speaks to the need to cushion and protect vulnerable groups, and restore their capacity to meet their needs.

The constitution has also been instrumental in shaping the direction and content of social welfare in South Africa. In fact, the *White Paper for Social Welfare* has largely been informed by the constitution. The Bill of Rights in the South African Constitution makes it an imperative to consider access to social welfare services as a basic human right, making the government is thus obliged to provide social welfare services and benefits that serve to assure human well-being. Governmental commitment to the provision of social services is measured by the levels of resources committed to social welfare. In this regard, the government has been doing quite well, as there has always been adequate budgetary support for those social grants meant to cushion the poor and vulnerable groups.

Globalization has also been a major force in shaping South Africa's social welfare system. As was pointed out earlier on, the social welfare system was influenced at the onset of the democratic dispensation by the Reconstruction and Development Programme, which was developmental in outlook and oriented towards meeting the basic needs of the poor. The Reconstruction and Development Programme was soon replaced by the Growth, Employment, and Redistribution (GEAR) macro-economic framework. This macro-economic framework sought to grow the economy by liberalizing it and, in the process, making South Africa an attractive investment destination, and it is apparent that this macro-economic framework drew its inspiration from neo-liberalism. The shift to the Growth, Employment, and Redistribution framework has been a product of the forces of globalization. It has been argued that South Africa could not resist the forces of globalization, and more so because neo-liberalism was fashionable at the time, and still is globally. According to Patel (2005, p. 94), the adoption of GEAR "implied a shifting of responsibility for social welfare from government to individuals, families and the private sector and resulted in the abrogation of state responsibility for meeting needs." This has seen the entrenchment of residual social welfare, which represents the values propagated by neo-liberalism. There are echoes between the apartheid-era residual approach and the current neo-liberalism, as both approaches emphasize minimal state involvement in social welfare provision. These developments suggest that globalization has resulted in the loss of national policy autonomy (Dominelli, 2004). Consequently, the policy-making space continues to shrink, and South Africa is less and less able to realize the promises of the *White Paper* and the socially progressive constitution. Another negative outcome of globalization alluded to by Dominelli (2004) is managerialism, which has had the effect of undermining the professional autonomy of social workers.

It should be noted, however, that, despite its many negative impacts, there are also positive aspects of globalization. These include resource flows from developed nations to support the delivery of social welfare services, which South Africa, like many other developing countries, is benefitting from. Globalization also makes it possible for South Africa to learn from the best practices of other countries. For instance, South Africa is seriously considering converting its means-tested old age grant to a universal pension in response to best practices elsewhere, including within the Southern African Development Community (SADC). Best practices in this regard have to do with the fact that universal pensions do not carry a social stigma, and that they increase the take-up of benefits. Globalization also provides another opportunity for countries to achieve social development by applying global pressures. Membership in the United Nations makes countries open to global influence. For instance, the UN's

Millennium Development Goals have provided a framework for promoting social change, and have galvanized countries into action. It is possible that many countries would not have achieved their current levels of social progress had it not been for the targets set under the Millennium Development Goals.

Conclusion: Challenges and goals

Social work and social welfare in South Africa continue to grapple with the impact of an apartheid system that marginalized the black population for decades, and which saw blacks designated as second-class citizens whose socio-economic rights were not upheld. The existence of widespread poverty amongst the black population is a manifestation of the impact of apartheid. In this regard, the major focus of social welfare and social work in South Africa has been on responding to the problem of poverty. This explains why the greater part of the budget for social welfare is spent on social grants. The objective of the social grants is to reduce or alleviate poverty and to enable the poor who fall in designated groups to meet their basic needs. Yet more substantial responses to poverty and inequality are necessary.

South Africa needs to develop a comprehensive system of social protection that goes beyond income maintenance and encompasses the provision of basic social services, employment creation, and the strengthening of livelihoods of the poor. The problem of poverty requires macro-level interventions to integrate social and economic policies. The ultimate goal of social and economic policies is to improve the quality of life for all, and the social welfare system becomes one of the instruments for achieving this.

The *White Paper for Social Welfare* provides an appropriate framework for addressing poverty and social exclusion in South Africa. However, the problem is in the implementation of the policy, particularly in terms of putting social development into operation from an intervention perspective. All stakeholders need to be clear, from an intervention point of view, about what social development or developmental social welfare entails.

The social development paradigm suggests a focus that addresses structural impediments to the realization of human well-being, and poverty in particular. Poverty cannot be solved through the provision of handouts but through interventions that empower individuals and communities to become self-reliant. Bak (2004) concedes that the government has taken this on board as evidenced by the number of initiatives put in place by both the state and non-state actors to empower communities and individuals.

However, doubt exists as to whether the government has fully embraced the social development paradigm. This doubt is based on the realization that social grants to cushion poor and vulnerable groups are prioritized, rather than social

development. In other words, the government has not been allocating sufficient funds for the implementation of the social development model. In fact, about 90 percent of the welfare budget is allocated for the provision of social grants (Bak, 2004).

South Africa's categorical system of social assistance further compromises efforts to pursue genuine social development. The Government of South Africa has developed an elaborate social assistance system that is the envy of many countries in southern Africa. And yet, that system is targeted at certain categories of the population only, namely primary care givers of children, foster parents, persons with disabilities, and older persons (Kaseke, 2010), and the government provides social grants to these defined population groups only. The categorical nature of social assistance in South Africa means that those who are not part of the defined categories of the population are not able to benefit from the country's social assistance system (Kaseke, 2010). The exclusion of certain groups from social assistance is in keeping with the demands of the neo-liberal ideological framework in general, which calls for the rationing of scarce national resources. This, in turn, necessitates that the social grants be directed to the most vulnerable groups. This also explains why the social grants are means-tested, notwithstanding the fact that means-testing creates stigma and is also a barrier to access.

Globalization is also a major factor influencing the nature and content of social work and welfare in South Africa. South Africa is part of the international community, and is open to international influences that can have both negative and positive impacts. An example of a positive impact is the flow of resources into South Africa from developed countries through bilateral and multilateral agreements. These resource flows augment national resources that can be committed to social welfare. Furthermore, globalization enables South Africa to learn from international best practices thus it has brought opportunities for the country. The negative impacts on the other hand, are reflected in those practice models that have been adopted which have undermined professional autonomy, along with a preoccupation with the rationing of national resources.

Gray (2006) has observed that the shift from the Reconstruction and Development Programme (RDP) to the Growth, Employment and Redistribution Programme (GEAR) had a negative impact on the implementation of developmental social welfare. She argues that the shift resulted in reduced funding to non-state welfare organizations and in the state transferring some of its welfare responsibilities to communities, which are increasingly being expected to assume greater responsibility for welfare. Therefore, the resources needed for effective implementation of developmental social welfare are seriously limited, and the situation gives the impression that the government is abdicating its responsibilities.

Ideological clarity on the part of the government is essential for the successful implementation of the social development approach to social welfare. The pro-capital stance of government has diluted the focus on social development, as too much priority is given to efforts designed to grow the economy. In this era of global competition and neo-liberal consensus, it makes sense, as this is what is now globally fashionable, and South Africa may be reluctant to swim against the tide. However, there is a risk that the pursuit of welfare ideals may be relegated to the periphery. The successful implementation of the social development paradigm depends on there being an effective social protection strategy that can respond to the problems of poverty, inequality, and vulnerability.

The successful implementation of the *White Paper for Social Welfare* also depends on an effective reorientation of social work. A key question for us is: How has social work practice changed as a result of the adoption of developmental social welfare? One would ordinarily expect a shift in terms of approach to interventions or practise models. The reality on the ground, however, is that it is largely still business as usual because social work is still oriented towards a curative and remedial approach. A new language is being used, but this has not translated into different approaches to solving social problems and enhancing human well-being. Thus, there is a lot of rhetoric surrounding the implementation of developmental social welfare paradigm or social development but not a lot of actual change.

Reorientation will enable social workers to have a common understanding and vision of how the social development approach to social welfare can be operationalized. The reorientation of social workers requires their interventions to emphasize the empowerment of individuals and groups to enable autonomous functioning as a long-term objective. Doing so entails building and enhancing the capacity of individuals and groups to be self-reliant, and also by engaging in advocacy, in order to change the alienating conditions in society and to build a better approach to social welfare.

How art works: Hopes, claims, and possibilities for social justice

Christina Sinding and Hazel Barnes

Art, its relevancy to personal and social struggle, and its ability to aid efforts to transform social relations are the focus of this chapter.

The first section draws from a review of the literature on arts-informed social work (Sinding, Paton, & Warren, 2012). Social work practitioners, educators, and researchers often herald the arts as a means to respond to individual and community troubles. We discuss the various ways art is understood to address constraints on expression, failures of empathy, and oppressive patterns of knowing more effectively than "usual" social work.

In the next section, we reflect on the specific contributions and potentialities of applied drama and theatre. We identify a variety of types of applied drama and theatre, locating each in its historical and social context, and offering an assessment of the particular way in which each type affects people and communities.

The final section is a drawing together of insights at the intersection of social work and applied theatre, focusing both on what we learn from one another and areas ripe for collaboration.

How art "works" in arts-informed social work

Arts-informed social work is not a singular thing—far from it. Social workers and social work researchers take up the arts in a variety of ways; we are motivated by disparate interests and have different ideas about where, why, and how art and social work can and should come together. Not surprisingly, though, we are collectively motivated by a conviction that art can make a unique contribution to processes of change, both personal and social. In the literature on art and social work, the use of art carries at least three key promises: it can overcome constraints on expression; enable empathy; and disrupt dominant ways of knowing.

Overcoming constraints on expression

Many discussions of the arts in social work practice have an image in common of a person who holds a jumble of difficult, troublesome perceptions, feelings, or memories inside. Art, in these writings, is presented as a means of enabling

the exteriorization of difficult feelings and thoughts—of allowing troubles to be "released" from inside (DeCarlo & Hockman, 2004). Art is held to be especially useful and productive for people who "have difficulty expressing themselves in words—whether for cognitive, psychological or safety reasons" (McFerran-Skewes, 2005, p. 148).

While many arts-informed social work projects focus on individual expression, the messy problematic stuff on the inside of a person has an echo in collective life: the social relations between us are messy, troubled, and require expression. Again, art is perceived to be useful in part because usual forms of communication are deemed inadequate, or because expression is constrained by them.

An article by Wulff, George, Faul, Frey, and Frey (2010) begins with reflections on how conversations about racism are so often avoided in the academy. An artful approach made a difference, in their experience. During performances of a drama developed by a School of Social Work diversity committee, the authors reported that "we could say the 'unsayable,' that is, we were empowered to speak in the context of our [performance scripts] that (which) we struggled to voice in our routine daily conversations with each other" (2010, p. 119). Linda Harms Smith and Motlalepule Nathane-Taulela (2011), reflecting on the South African context, describe a similar evasion and suppression when discussing apartheid. Their use of art recognizes the unique set of internalized and structural oppressions of class, race, and gender that permeate the post-apartheid and post-colonial context (L. Smith, 2008). Inviting students to create pictorial representations of early memories of powerlessness enables their consciousness of forms of oppression, and how these become internalized. Harms Smith and Nathane-Taulela (2011) suggest that art also offers a way to make the persistence of oppression available for critical reflection in a context where talk about it is routinely discouraged.

In a variation on this theme, some social work researchers take up the arts not because people or communities encounter some difficulty expressing themselves, or because talk about an oppressive dynamic is suppressed, but because the expected or required forms of expression are themselves implicated in oppression. Ann Fudge Schormans (2010), for example, relied on arts-informed approaches in her inquiry with people labelled intellectually disabled because "traditional research(er) insistence upon the written and spoken word can be both limiting and exclusionary."[1]

In other instances, usual forms of communication are inadequate because the operation of oppression is itself so elusive. Izumi Sakamoto and colleagues have explored the very complex dynamics at play in the requirement that newcomers to Canada demonstrate "Canadian experience" (Sakamoto, Chin,

& Young, 2010). The interactional signifiers of Canadian experience are often intangible—potential employers register very subtle gestures and expressions as Canadian (and not). Research interviews typically fail to capture or adequately describe these subtle gestures and expressions, but dramatic techniques can do so.

Social workers turn to the arts, then, in part because they seem to address or resolve limitations or constraints on expression. Art offers an alternative to conventional language or speaking when they are difficult or exclusionary. In situations where oppressive dynamics are hard to identify or where communication about them is discouraged, artful approaches can help us get hold of them, evade habitual defensiveness in talking about them, and make them available for discussion and action.

Enabling empathy

Another set of ideas about how art can be useful in social work concerns the difficulty social workers and students encounter in attempting to forge genuine relationships across social and cultural differences.

Gregory Gross (1999) suggests that classroom activities designed to create opportunities for students to interact with "others" (in this case, lesbians and gay men) are often problematic. While presentations by members of "marginalized groups" have some place in reducing prejudice, "the contrived nature of that medium usually prevents a true encounter with real people living their lives" (p. 142). Drama has more potential to enable such an encounter. When reading and enacting a script, "students can inhabit those relationships from the inside out and the outside in" (p. 143). Inhabiting those relationships, "students can come to appreciate the varying perspectives of various characters ... can establish empathy with the characters in their situation ... can 'know' these people" (p. 143). Ungar (2011), reflecting on the use of the novel as a research tool, makes similar claims and suggests that fiction allows us "to walk a little while in the shoes of another, seeing the complex weave of associations that characters use to make sense of their world" (p. 292). He points in particular to how fictional forms allow researchers to portray a character's inner world in ways that usual research representations do not. Fictional forms enable us, in an usually deep way, to appreciate the texture and complexity of (in this case) the lives of young people navigating child welfare and criminal justice systems.

Goldstein (1998) advocates for the humanities in social work education while elaborating on this theme in more general terms. He cites Posner (1997) on the "empathy-inducing" role of literature, particularly in relation to cultures and sensibilities unlike the reader's own, and points out that a good novel or play does not merely describe, but draws the reader emotionally into events. It is

not merely "learning about" that happens; rather, "we are acquiring experience vicariously by dwelling in the imaginary worlds that literature creates" (Posner, 1997, quoted in Goldstein, 1998, p. 251).

Many scholars point out that social work education must support students not only in relating to "others," but also in understanding themselves and their own attitudes—a goal that Gross (1999), again, suggests can be accomplished through students vicariously experiencing how characters in a drama evolve in their own perspectives, and live with paradoxes (both love and prejudice, for example).

Ideas about empathy and vicarious experience also find their way into discussions about art and citizen engagement, with the claim that storytelling and theatre can draw community members into discussing social policy dilemmas in especially productive ways. Whereas a case study typically prompts debate and problem solving, a storied theatrical production works by immersing audiences in the situation, enabling audience members "feel the position of the person in the play" (Nisker, 2010, p. 88). Audiences commenting on situations they have "lived in" imaginatively offer much more complex and reflective responses than those who have engaged in other citizen engagement processes (Cox, Kazubowski-Houston, & Nisker, 2009). Kennedy Chinyowa's work makes similar arguments in relation to conflict management and transformation (chap. 10, this volume).

Artful representations, then, are means by which we can imaginatively inhabit life worlds beyond our own, and may help us appreciate and empathize with others and their situations. Art engages us in ways that are emotional, sensory, and embodied, as well as cognitive, and seems to have some special capacity to generate complex, nuanced, and empathic understandings that are, potentially, linked to social solidarity.

Interrupting dominant ways of perceiving/knowing

Yet another set of ideas about art's value to social work starts from the premise that our habitual perceptions are harmful or diminishing to ourselves or others. Art, in this discourse, works as a foil to the usual (dominant) images. It has the capacity to interrupt our habits of seeing, and to challenge and alter what and how we know.

Reflecting upon the reluctance of social work students to enter gerontological social work, for example, Fiona Patterson points to "powerful medical, psychiatric, and sometimes stereotype-based theory and research about aging" (2004, p.178). She uses a narrative perspective and the richness of literary works to counter these constructions, and to "reeducate ourselves and inspire students" to work with elderly people "more responsively and creatively" (2004,

p. 178). Discussing international social work placements, Furman, Coyne, and Negi suggest that poetry, in prompting reflection on alternative meanings for events and interactions, can have the effect of "potentially liberating the mind from stereotypical ways of seeing the world" (2008, p. 76).

In their exploration of the use of photography in social work education, Catherine Phillips and Avril Bellinger (2010) note that popular discourses (in this context, racist discourses about asylum seekers) "can literally dominate and inform [students'] practice knowledge" (p. 3), and have set their use of Diane Matar's photographs of politically displaced people living in Britain in the context of this problematic practice knowledge. Deliberate in their choice of these photographs, Phillips and Bellinger have drawn attention to Matar's recognition of asylum seekers as individuals, and the dignity afforded in both the making of the photographs and the images themselves. In the midst of their efforts to make meaning from photographs, viewers are drawn to "situate [them]selves within the social relations embedded in the image" (Phillips & Bellinger, 2010, p. 7). These particular photographs—in the everyday familiarity of the living spaces, and the full biographies they imply—collide with the more widely available images of asylum seekers, effecting a kind of interruption to the "othering" social relations embedded in the dominant images.

Ann Fudge Schormans, for example, relied on arts-informed approaches in her inquiry with people labelled intellectually disabled because "traditional research(er) insistence upon the written and spoken word can be both limiting and exclusionary (2010; see also chap. 11 in this volume). As part of her research, Fudge Schormans invited people labelled intellectually disabled to respond to and offer commentary on public photographic depictions of people with disabilities. Then, working with a digital media consultant, she invited them to change the images, or create new ones. The significance of the PhotoChangers' artful work was in how it offered "a means of interrupting what is known about them" (2010, p. 54; Fudge Schormans, 2011). Through their research and its public presentation, the PhotoChangers effected changes in the "perceptual habits" of non-disabled people.

Bernd Reiter (2009) describes a somewhat similar process in his account of an arts-based social development project in Brazil. Reiter outlines extreme inequalities of wealth in the country as well as profound "misrecognition," in Nancy Fraser's (1998) use of the term, among members of the community.[2] A music school initiated in the poor neighbourhood of Candeal generated benefits for its students like those available in more conventional social and economic development initiatives (e.g., some of the students gained employment as a result of their involvement). The arts program was distinct, however, in its capacity to draw state actors and local middle- and upper-class white Brazilians to poor neighbourhoods multiple times, over extended periods.

Presenting their art—their own representations of identity and situation to an audience—the young people achieved various kinds of recognition. While there was immediate appreciation for their talents, it was more significant, Reiter claims, that, "artistic expression provided a vehicle for inserting the voices of historically marginalized groups into the public realm, thereby challenging cultural hegemony" (p. 157). The middle-and-upper-class cultural hegemony—and along with it the habitual social and political "misrecognition" of the neighbourhood residents—was interrupted.

The literature on art and social work suggests, then, that art may be an especially effective way to break "bad habits": to interrupt patterns of seeing and knowing defined by stereotype and prejudice, to bring us to consciousness about these habits, and to offer the possibility for new ways of knowing and relating.

Ensuring art works towards social justice

The possibility that art has the effects we outlined above—overcoming constraints on expression; enabling a thoughtful empathy; and undoing dominant, oppressive ways of knowing—makes the use of the arts very attractive to many social workers.

Yet we must not, of course, assume that the use of art necessarily links well with justice-oriented social and personal change. Belfiore and Bennett (2007) have reviewed a wide range of texts to identify recurring claims about the social impacts of the arts. The idea that the arts shape people's beliefs and sense of identity, for example, is enduring, and has had a central place in the development of arts and culture in many societies—including in non-democratic, totalitarian, and colonial political systems. Ideas about art's positive effects manifested, in nineteenth-scentury Europe, as a conviction about the "civilizing powers" of the arts, a conviction that was used to "provide a moral justification for the colonial enterprise" (p. 139).

Belfiore and Bennett's (2007) broad historical exploration certainly prods us to abandon any simplistic celebration of the arts, to set aside the notion that there is something inherently or necessarily community-building or justice-leaning about art. Writing in terms more directly relevant to social work, Esther Ignagni and Kathryn Church (2008) reflect on the range of ways art has intersected with disability studies. Art has been taken up in disability studies in ways these authors describe as emancipatory; it has also, in their assessment, been used in ways very congruent with biomedical or rehabilitative framings of disability. They call for a disability studies in which the arts, rather than aiming to reconstitute or transcend "broken" bodies and minds, deliberately "enables diverse ways of sensing, moving through, or otherwise being in and relating to the world"

(Church, 2008, p. 628). Alan Radley (2009) distinguishes between an aesthetics of activism and an aesthetics of witness. In an activist frame, artworks "are aimed at repositioning individuals and groups." The art of compassion (the aesthetics of witness) has a different goal: that of "creating presence, touching the reader or viewer in the flesh" (p. 83) and establishing what Radley calls "co-suffering." The art of activism is shaped by "politics, the testing or the movement of boundaries between groups" (p. 81); the art of witness "is associated with a dissolving of boundaries between individuals" (p. 82).

Reflecting broadly on the aesthetics of witness and specifically on the claim that art cultivates empathy, Megan Boler (1997) suggests that students, reading stories of other lives, are sometimes allowed to experience a "cathartic, innocent … voyeuristic sense of closure" (p. 266); their empathic identification is with another individual, isolated from a broader historical context. She suggests that a reading practice directed to social justice must take seriously questions of context, and of responsibility—it must analyze the obligations that issue from engaging an artful testimony (p. 4). Hazel Barnes (chap. 8, this volume) addresses this issue as well, noting that dramatic techniques can be used to deny easy identification with any particular character and refuse any simple empathy or sense of closure. In a related analysis, Kimberly Emmons (2011) reflects on a current enthusiasm in healthcare disciplines for practitioners to demonstrate "narrative competence." Narrative competence—fostered through reading literature, or reflective writing—is the capacity "to listen to the narratives of the patient, grasp and honor their meanings, and be moved to act on the patient's behalf" (Charon, 2001). Emmons does not deny the value of narrative competence, but she advocates for rhetorical competence as well, in keeping with Boler's attention to the social contexts of individuals' stories. Rhetorical competence cultivates attention to the broad cultural storylines from which we draw our personal narratives, and to the social and political determinants of those storylines. In exploring women's narratives of depression, for example, Emmons (2010) points to how they echo a broader rhetoric about depression, a rhetoric informed and fostered by the pharmaceutical industry. If practitioners are to support clients and patients to resist the diminishing social conventions carried in dominant narratives, they must be equipped to recognize and "read" both personal and social stories. Without rhetorical competence, narrative competence risks a naive and apolitical empathy (Emmons, 2011).

In her writing, Catherine Phillips (2007a) agrees that social workers have a responsibility to envision the lives of people with whom they work. But the significance of arts-based methods "rests not in an increase in empathy, but rather in a more nuanced and memorable way of understanding relations of power" (p. 200). As she goes on to write:

Arts-based methods allow us another way "into our work," into conversations of power and the dialogic relations of social work practice. It is with such detailed imagination that social workers can consider how to place themselves in relation to acts of power. (p. 200)

Here, the arts lend detail and complexity to the images we hold, not of others' lives and circumstances, but rather of how power is enacted in particular circumstances between particular people. And, as Phillips suggests, the point of all this is to engage more effectively with the question of how we position ourselves, what we do and say, and how, in these relations.

The link between the arts and social justice, then, is not straightforward. The cautions and debates we have outlined here highlight the importance of a carefully considered arts-informed social work. They also highlight the value to social work of alliances with movements in the arts that are grounded in social concerns and have arisen from social justice commitments. Applied drama and theatre is such a movement.

Applied drama and theatre: a methodology for change

The reflexive praxis of applied drama and theatre is based first on the embodied and participatory nature of the medium, and second on principles of critical pedagogy and democracy. The term "applied drama and theatre" refers to the use of dramatic strategies and theatrical techniques in the service of social justice and personal change.

The essence of theatre performance is that it plays out, through physical action, problems that arise through human interaction and then places these at a distance, so that they can be viewed more dispassionately and understood more thoroughly (Boal, 1979; Brecht, 1964). Paradoxically, at the same time, theatre performance allows for both the expression of emotion and for the empathetic engagement of audiences in the concerns presented, enlarging our compassion. It is this movement between feeling and thought that makes the application of drama and theatre such a potent tool in trying to understand the human condition. This movement ensures that intellectual analysis has to take the messy human dimension of feeling into account, and that feeling is contextualized through specific social relationships and settings.

When we shift from theatre to drama, further possibilities emerge. Theatre implies an audience who may be involved in the action to a greater or lesser degree, whereas the term "drama" suggests that all participants are engaged in an improvisatory experience. Drama processes allow for the felt engagement of the participants within the experience of the imagined scenario, and also for an intellectual reflection on the issues raised and the possibility

of new understandings. It is the playful engagement with reality through the imagination that is considered to "loosen up" prejudiced or predictable perspectives, and engender new ideas and possibilities for change (Jones, 1996). It is the human capacity to learn through play (Huizinga, 1949), most notable in early childhood (Needles, 1980; Weininger, 1980) but present throughout our lives, which underpins applied drama and theatre praxis. Play allows us to try out behaviours and responses within a safe environment, in which consequences are not actual but can still be learnt from. Play also encourages spontaneity and lateral thinking, allowing a tangential approach to intransigent problems and the possibility of new and unexpected approaches (Winnicott, 1971).

Like play, drama and theatre take place in a "special" space apart from the demands of everyday life. The relationship of the dramatic space to reality is acknowledged, however, with the dramatic space often considered a "mirror" or "reconstruction" of everyday life. The metaphor of the individual as an actor on the stage of life is a common Elizabethan concept, and has been developed through the work of thinkers such as Erving Goffman (1971). It is now readily understood that theatre and drama can be used as a concrete, embodied language through which we can examine human action and also try out alternative ways of being and acting—what Boal calls "a rehearsal for revolution" (1979, p. 122).

Drama and theatre, like any other medium, can be used to reinforce prevailing ideas and inequalities, just as it can be used to question, to experiment with, or find new ways of promoting social justice. The important underlying ethos of applied drama and theatre is one of self-reflexivity, a continual questioning by the practitioner of their own practice in terms of who it benefits. The writings of Paulo Freire (1970a, 2006) and others working within the paradigm of critical pedagogy (hooks, 1994; McLaren, 1998) have strongly influenced the praxis in terms of democratic working structures, in which participants are respected as the source of knowledge of their own circumstances and the agents of their own change, which is facilitated though the dramatic medium. Facilitators of applied drama and theatre are trained in a core set of principles (Barnes, 2011), which ensures that they are at the service of participants through their knowledge of the medium. The issue of power— who holds it, who is disempowered, and how the balance of power affects the possibilities for change—are continual concerns for the facilitator, who will commonly bring these concerns to the attention of participants.

Types of applied drama and theatre: what they aim for and how they work

The development of drama and theatre as a specific tool for application in situations of discord or stress seems to have originated in Vienna in the 1910s, with

the work of Dr J.L. Moreno. Having observed how children play, Moreno used "acting out" or improvisation (spontaneous embodied action and speech) to comment on current events. Over the next two decades, Moreno developed what is now known as **psychodrama** and **sociodrama** (Karp, Homes, & Tauvon, 1998; Moreno, 1947, 1953); the first aimed at the healing of individuals through the enactment of their dis-ease or trauma, and the second aimed at understanding the ways in which groups are formed in society and how they interact or compete. This latter form developed after Moreno moved to America and established contact with different cultural communities living in close proximity in New York. In psychodrama, Moreno based his work closely on the theatre, emphasizing the dramatic space or stage as a *locus nascendi* —"a place to be reborn." His emphasis was on spontaneity as an important tool in a constantly changing world and he believed in the healing potential of catharsis, pushing protagonists towards an emotional release. Participants take on roles, choose group members to play significant others, and present aspects of their lives that they find problematic. These are then analyzed through active techniques such as role reversal, mirroring, doubling, and self-presentation or soliloquy. The watching audience serves to ground individual experience within that of the group through their personal connection to the themes. In sociodrama, Moreno used embodiment as a means to increase understanding of social relationships and to negotiate conflict between groups. Through sociometric exercises, similarities and differences, alliances and alienations, often covertly expressed, can be viewed clearly and openly by the ways in which participants place themselves physically in relation to stimuli and to each other. For example, participants might be asked to organize themselves on a continuum between two opposing statements, such as "I grew up in a social system which was open and equal and accepted the value of all citizens equally and protected the rights of the less able" or "I grew up in a social system which was hierarchical and valued some citizens more than others, and did not protect human rights" (Nebe, 2011). In another exercise, groups might be asked to place themselves in relation to a number of statements, standing close if in agreement or at any degree of distance. An example of a set of statements used in a workshop (Nebe, 2011) includes: "I have witnessed discrimination." "I have remained silent when someone was being 'othered,'" "I have spoken hurtful words to someone," and "I have experienced being othered myself." The arrangements of bodies can then be overtly examined and discussed in terms of their meanings for the particular group. As shown by the statements above such exercises can be used in relation to both personal and social realities.

The next development of applied drama and theatre occurred in Britain during the 1950s (and has been steadily developed since then), when the use of drama as an educational tool was revolutionized through the work of Peter Slade

(1955), Brian Way (1967), and Dorothy Heathcote (1984; Wagner, 1988). Slade based his work on the free play of children, considering it an inherent learning process; Way considered drama as an ideal tool for the development of all aspects of the child—intellectual, emotional, and social; while Heathcote saw that drama provided children with agency and the opportunity to discover for themselves rather than simply "being taught." **Drama in education**, which has become a worldwide methodology for use in the classroom, is a child-centred approach that aims through embodiment to develop intellectual inquiry and emotional maturity. This is done through the participants improvising complex and contentious situations in order to understand them better, and the emphasis is always on discovery rather than on reinforcing previously held beliefs. The role of the teacher/facilitator is to set up a framework through which learning can happen, to ensure engagement in the imagined situation and roles, and to question easy solutions or facile responses, thus deepening thinking. Because participants in drama in education are often dealing with issues about which they feel strongly, analogy is used as a distancing device and a way to bypass an unthinking, prejudiced response. So, for example, improvisations involving participants in roles such as animals or aliens might establish a context of discrimination analogous to a real one. In these familiar-but-unfamiliar settings, students can experience discrimination, unbridled power over others, and a lack of basic rights, for example, in new and provocative ways. Similarly, role is used to protect participants' vulnerability in that it allows one to speak out, in the guise of someone else, feelings that may be too uncomfortable to acknowledge in reality. Role play is a basic tool of this technique, and is used to enable participants to approach situations from different perspectives and to develop empathy for, or at least an understanding of, alternative viewpoints. Another technique used in relation to distancing that encourages the ability to reflect on the intense experience of the drama is "framing." Framing involves planning the particular viewpoint that participants will bring to the drama. This viewpoint can be extremely involving and provide little distance, or it can be aimed at various stages of distancing from the content of the drama; Bowell and Heap (2001) offer the following examples. In a drama on the First World War, one might enrol participants as soldiers in the trenches in France who have no gas masks in order to experience the horror of warfare techniques directly, but this approach would provide no framing and no distancing. On the other hand, one could enrol participants as nursing or ambulance personnel in a field hospital who are understaffed and under-equipped. This provides a particular point of view at a slight remove from the action. Enrolling participants as sculptors asked to create representations of the role of women in the First World War for an exhibition would ensure a very distanced viewpoint. The degree of distancing required depends on the closeness of the participants to the imagined experience and the learning or investigatory aims of the group.

In drama in education, there is no separation of audience and actors and all are simply participants improvising together to create the drama, which has led to its alternative nomenclature of **process drama**. This name implies that the form can and has been applied outside of formal educational situations. At more or less the same time, **theatre in education** became a mode through which actor/teachers and pupils could interact using the language of the stage—the presentation of action that could then be consciously deconstructed for greater understanding (A. Jackson, 2008; O'Toole, 1976), through, for example, allowing audiences to interview characters, or inter-relate with them within the imagined world of the play.

By the 1970s, as previously British colonies became more and more democratized, NGOs, drama practitioners and arts activists created **Theatre for Development** (Banham, Gibbs, Osofisan, & Plastow, 1999; Odhiambo, 2008; Salhi, 1998) with the specific intention of "developing" previously marginalized communities. At first, this process was very much "from the outside in" and "top down," with non-governmental organizations or government bodies deciding what messages needed to be given to communities and presenting them through staged performances. However, Theatre for Development itself has been democratized. Community members engage community problems themselves with the support of facilitators skilled in drama techniques, using theatre as the language of investigation and expression.

This democratization of Theatre for Development owes much to the work of Augusto Boal and his development of the **Theatre of the Oppressed** (1979). Boal's thinking was influenced by the Brazilian educator Paulo Freire (2006) and his criticism of education as a "banking" system, which simply fills heads with knowledge rather than encouraging critical and creative thinking. Freire advocated a far more participatory and egalitarian form of education, where participants could learn together through active engagement with real problems. Boal developed a methodology to do so through embodiment and through involving spectators in the active exploration of possible solutions. In Boalian terms, the spectators become "spect-actors," moving from being passive recipients of oppression to being actively engaged with understanding oppression, and practising possible ways to shift the balance of power. Boal developed several specific techniques, notably image theatre and forum theatre. Image theatre (see Chinyowa, chap. 10, this volume) encourages the non-verbal, visual expression of this oppression and any possible solutions, where bodies become metaphors and invite a creative approach to the analysis of contentious situations. Forum theatre (see Harms Smith & Nathane-Taulela, chap. 5, this volume) allows for the acting out of problematic situations. Audience members are then invited to enter the stage space to try out in action the suitability of any alternative behaviours that may help to change the structures of power.

These activities are facilitated by a "Joker," whose role is to question and disturb preconceived ideas and to push for deeper and more creative thinking. Forum theatre also allows for the practising (rehearsal) of behaviour that challenges oppression, using theatre practice in the interests of personal and social change once again.

A critique of forum theatre has to do with its historic focus on the oppressed group as the agent of change. This critique has been taken up by contemporary experimentation with forum theatre, which has made visible how patterns of oppression can be challenged from multiple vantage points. An example of this experimentation in action happened in a forum theatre about gender relations presented by fourth year Drama for Life students at The University of the Witwatersrand in 2011.

Underlying the HIV/AIDS pandemic in South Africa is a highly paternalistic culture in which women are disempowered, particularly when it comes to refusing sexual advances. This Forum Theatre dealt with the situation of a couple after a dinner out when the young man expected sex in return for the meal; the young woman was not interested in taking the relationship further. This situation was played out first with the woman attempting to refuse and leave and the man not allowing her to. The Joker then replayed the scene, inviting audience members to intervene by acting out ways in which the situation could unfold differently and in keeping with the woman's rights. Various different solutions were offered, almost all of them focusing on the woman's behaviour and suggesting how she, by changing her verbal and body language, could indicate her attitude earlier, question the intentions of the friend prior to the dinner, and prevent the confrontation from escalating. All of these suggestions could be considered a "rehearsal" of alternative behaviour, a rehearsal for a different reality. At the same time, all of these interventions were "domesticating" in Freire's terms, because they directed the woman ("the oppressed") to monitor and change her behaviour. However, the Joker pushed for this realization, and ensured that discussion opened up about the need to work with men in order to change their attitudes and actions, rather than working primarily with women.[3]

Playback Theatre originated in America through the work of Jonathan Fox (1999). In it, a team of trained improvisers elicits stories from the audience and then plays these back to them through a language of metaphor and symbol, using very basic props of drapery and blocks in an improvised and embodied way. The act of playing back affirms the storyteller's tale in front of the audience (the community) as a whole. This action is based on the contention that identity and dignity are confirmed through the witnessing of the audience.

As the healing potential of drama has been recognized more and more, **dramatherapy** (Jennings, 1987, 1992, 1997; Jones, 1996; Landy, 1994; Landy &

Bolton, 1996) has developed as a recognized intervention in closed therapeutic situations. Once again, the primary tool within this methodology is the possibility of moving from close empathetic identification through role playing to a more distanced understanding as spectator. Inappropriate or troubling behaviour patterns can be played out for investigation, and traumatic experiences expressed and witnessed (for further discussion see Gumede, chap. 6, this volume). The relationships established within the therapeutic setting are also considered to be crucial to the healing process.

Among the contested areas here is aesthetics, or rather, the balance between the need for clear communication and the need for the heightened engagement and affect created through incisive artistic control of the medium. As interventions have moved away from message carrying towards dealing with the complexity of the human reaction to tragic issues such as the AIDS pandemic, so the need has arisen for the aesthetic dimension of theatre and drama to be taken into account (Baxter, 2014; Dalrymple, 2014; Durden, 2014; Barnes reflects on this issue more fully in chap. 8, this volume).

Social work and applied drama and theatre: Productive intersections

For many social workers, the most obvious point of intersection between drama and social work is dramatherapy. Yet, as this chapter makes clear, social work and applied drama and theatre have much to learn from one another, and collaboration holds rich possibilities, both conceptual and pragmatic.

From the social work side, we can see how greater engagement could support practitioners and researchers to better understand the multiplicity of arts practices, the range of ways they can be taken up, and the effects they are likely to have on people and groups. Being more alert to the theoretical underpinnings of particular practices can help us be more reflective about our choices. Insights about distance and engagement, for example—their essential interrelationship in change-related drama processes, techniques for achieving and modulating them, why we would emphasize one over the other—support social workers in their awareness about the relationships between the situations we perceive and the significance of particular arts practices. Social work researchers are often intent on engaging audiences more actively. Applied drama and theatre practitioners have thought deeply about audiences (as witnesses, as spectators, as spect-actors, as learning from the Joker's prodding ...) and can prompt us to develop more sophisticated approaches towards knowledge exchange and mobilization.

More broadly, social workers and practitioners of applied drama and theatre face similar challenges. In both disciplines, there is heightened concern about accountability—and accountability manifests in a wide range of ways. At one end is the externally imposed imperative to prove that our work offers "value for money." As Baines and Kaseke discuss (chap. 1 and chap. 2, this volume), such efforts all too often define value exceedingly narrowly, and overlook or erase the complex support for people, the strengthening of relationships, and the insights vital for community resilience that can emerge in social work and applied drama projects. At the other end of the spectrum are our own efforts to achieve the most profound sorts of accountability to the people with whom we work and the communities that matter to us. Dialogue between social work and applied drama can enable us all to deepen the latter, and resist the former. Ethics is a related area of tension and possibility, with both sets of practitioners struggling to evade the more bureaucratic and regulatory versions of ethics, and to support a reflexive, context-sensitive ethical practice rooted in dialogue and negotiation (for discussion, see Barnes [2011] and Sinding, Gray, & Nisker [2008]).

Finally, both applied drama and theatre and social work have a strong focus on problem identification. Practitioners often grow weary and can feel hopeless, particularly in light of the devastating effects of economic globalization on communities and the widespread erosion of commitments to collective welfare. Social workers have long sought ways of sustaining ourselves in work contexts that are emotionally and spiritually draining; our insights in this regard might benefit practitioners of applied drama and theatre. As well, both social work and applied drama practitioners are experimenting with appreciative inquiry. In Appreciative Inquiry, rather than focusing on problems and solutions, we actively seek out the creativity and care that people exercise every day in groups and organizations. Appreciative Inquiry typically results in a set of ideas or images about where we want to be, drawn from stories that make vivid the best we are doing (Hammond, 1998); its emphasis on identifying and developing strengths can have an invigorating impact (Samba, 2013).

Interdisciplinary collaboration is yet another welcome, and potentially sustaining, development. Co-operation with medicine, environmental studies, and economics has affected applied drama and theatre praxis in important and stimulating ways. Similarly, social workers turn to the arts, at least in part, out of a desire to have our conventional ways of doing practice and research productively unsettled, and extended. The collaboration at the heart of this book is an effort towards more artful practice, for both social work and applied drama and theatre: an effort towards generating more approaches, and even greater ingenuity, for enacting social justice.

Notes

1. In South Africa, communication in formal settings (health, education, law) often takes place in English, disadvantaging the many black South Africans for whom English is a second or third language. Art forms, including applied drama, can work to redress this disadvantage.
2. This is misrecognition in Nancy Fraser's (1998) use of the term, as the denial to some people of full partnership in social interaction; a denial of the status of "peer."
3. Dr Kennedy Chinyowa, in his paper "Interrogating spaces of otherness: Towards a post-critical pedagogy for applied drama and theatre," presented at the Drama for Life African Research Conference, Wits University, Braamfontain 2011, has indicated the need to develop forum theatre further in order to reflect the complexity of power dynamics, particularly in intimate relationships in a patriarchal culture. He also indicates the difficulties of combating such oppression when it is defined through the binary terminology of oppressor and oppressed.

Art for Conscientization and Re-Storying Selves

Art and storytelling with migrant children: Developing and thickening alternative storylines

Edmarié Pretorius and Liebe Kellen

The movement of children across borders is a worldwide phenomenon, and the encounters migrant children have in the external world on their way increase their risk of trauma. The International Organization for Migration (2011, p. 11) confirms that "children and youth migrating—whether between or within countries and whether accompanied by their relatives or not—have become a recognized part of today's global and mixed migration flows," and attention has been drawn to the large number of children who are moving internationally because of exposure to economic, social, and political turmoil, as well as to war and displacement (White, 2005). These conditions contribute to an increase in children's vulnerability to stress and trauma during the process of migration and relocation (Berger, 2008). The effects of multiple traumas and unsafe living environments need to be taken into account when working with migrant children, and the risk of re-traumatization is an issue to be considered in the planning and implementation of interventions (DiSunno, Linton, & Bowes, 2011; J. Morgan, 2004; White, 2005). It is important to provide safe spaces, which Brazier (1993) describes as a bounded subjective space that provides containment, as well as the opportunity for exploration and expression, to enable children to deal with their trauma (Kistner, 2007; White, 2005).

Art is a modality that transcends language barriers. It also facilitates the accessing of difficult experiences, the expression of feelings, and the development of children's narratives. According to Van der Kolk (2002), traumatic memories fragment and, consequently, are stored differently from other memories. Because of the involvement of sensory and emotional stimuli in the creative process, Lüsebrink (2004) argues that art plays a valuable role in assisting the access of traumatic memories. Loumeau-May (2012, p. 100) has postulated that "art making enables a victim to represent his or her experience by externalizing it into a concrete form." The act of creating something is empowering, and gives the client a sense of agency through the process of externalization. The relaxing and meditative effects of creative activity contribute to the creation of safe spaces in which to elaborate on the children's stories. Art entails the sensory exploration of materials with varying kinaesthetic qualities. According to Loumeau-May, "clients are imagining, learning, and practising actions that relieve anxiety, improve self-esteem, and enable them to visualize themselves

functioning in the context of transformed lives and worldviews" (p. 103) when participating in art.

Art interventions are informed by various theoretical models and approaches. Narrative therapy is the predominant one used in this chapter. The narrative approach regards life as being multi-storied. The dominant story is the thin one of pain and suffering, which could result in labelling and the development of a negative identity: examples include "the orphaned child," "the abused child," and "the raped child." The development of subordinate storylines draws on children's values, goals, aspirations, knowledge, and skills, and the contribution of important people in the child's life, which contribute additional layers of story and broaden the child's sense of identity (White, 2005).

We begin with an overview of the migrant child, followed by a review of the available legislation and conventions for the protection of migrant children. We outline theoretical frameworks that contribute to the contextualizing of art with migrant children and the thickening of stories, and afterwards provide an account of how art activities are used to facilitate thicker stories in work with migrant children is presented.

Who are migrant children?

The scope of definitions and descriptions of migrant children varies. The purpose of defining migrant children is to ensure that they are included in the child protection agenda globally, regionally, and locally; definitions serve as guidelines in this regard (Hillier, 2007). There are several broad definitions of migrant children that include: children who are forced to migrate and those who move voluntarily; external and internal migrant children; and accompanied and unaccompanied children (Dottridge, 2008; "Global Movement for Children: Children on the Move," n.d.; Save the Children UK, 2009). Some definitions focus primarily on external migrant children in order to highlight the difficulties they encounter, such as xenophobia and documentation (Hillier, 2007; Palmary, 2009). The Global Movement for Children (n.d.) includes trafficked children and child soldiers in its definitions. Dottridge (2008, p. 9) draws attention to migration placing children "at risk (or at an increased risk) of economic or sexual exploitation, abuse, neglect and violence." Within all of these definitions and descriptions, the vulnerability of the children is evident.

The description of migrant children by the Regional Seminar on Children Who Cross Borders in Southern Africa (2009) has particular relevance for South Africa. It encompasses the vulnerability of migrant children who are undocumented, live and work on the street, cross the border with undocumented caregivers, accompany transient caregivers, have been trafficked, and are stateless.

For the purpose of this discussion, migrant children are defined as children who have crossed borders or who are internally displaced; children who have been forced to migrate due to social, economic, and political conditions or war; those who choose to move; accompanied and unaccompanied children; and children living and working on the street (Dottridge, 2008; "Global Movement for Children: Children on the Move"; Save the Children UK, 2009; White, 2005).

When considering migration statistics, the Global Movement for Children organized an October 2010 international conference in Barcelona on the topic of children on the move. During the conference, participant estimations of the number of migrants worldwide were that there were 214 million international migrants and 740 million internal migrants. Youth aged twelve to twenty-five years old from developing countries represented approximately 33 percent of migrants within and from their countries.

Polzer (2010) estimates that there are between 1.6 and two million foreign nationals living in South Africa, including documented and undocumented migrants, and that this accounts for 3 percent to 4 percent of the total population in the country. It has been noted that children are migrating to live, to study, and to work in South Africa. Most internal migrants move to Gauteng Province, and account for 23 percent of the province's growth rate (Polzer, 2010).

Migration is a process. Berger (2008) notes the phases involved are departure, transit, and the resettlement phase, and there are losses associated with each of the phases. The departure phase pertains to the planning, which also entails preparing to leave the people who are part of one's support network, and places that are familiar. The transit phase pertains to the actual relocation from one place to another. For external migrants, this would mean from one country to another, and could include the dangers encountered in crossing borders, as well as time spent in refugee camps. The resettlement phase entails adjusting to a new environment, going to a new school, finding work, finding accommodation, learning a new language, and learning the laws of the new country. Migration clearly has an impact on the child's identity and sense of belonging. Despite the specific rights afforded to children in the South African Constitution, the implementation of those rights does not necessarily extend to migrant children, impeding their adaptation to the new environment. At school, children face the challenge of integrating with their new peers, whose value systems and cultural practices differ from theirs. There is the risk of xenophobia, from service providers as well as from neighbours.

When children migrate, it is guaranteed that a variety of obstacles will be encountered during the process, and Dottridge (2008) has identified several difficulties that migrant children are likely to encounter. These include being seen as outsiders; encountering difficulties in accessing services such as education,

health, protection, and social services; being less likely to have their human rights recognized in comparison with other children; and being perceived as exploitable, because there is less likelihood of someone standing up to defend them.

The impact of war experiences, displacement, being undocumented, xenophobia, fear of arrest, and language barriers was observed by Clacherty (2004) in her work with migrant children. Watters (2008) found that children from developing countries who sought refuge in industrialized countries were not believed and were not given refugee status. Palmary (2009) has highlighted that ensuring the enforcement of migrant children's rights is a major obstacle faced by children and those who work with them.

Reflections on conventions and legislation protecting migrant children

Since the abolishment of apartheid in South Africa in 1994, the South African government has accepted, ratified, and signed many United Nations (UN) conventions crafted frameworks and policies guarding human rights. Subsequent to the signing of numerous conventions, an extensive process of legal reform was initiated by the government of South Africa to ensure that migration management is embedded within a rights-based approach. One of the main conventions signed by South Africa is the Convention of the Rights of the Child (CRC), which states clearly that all children are given equal status, despite nationality, and that the state is expected to take appropriate measures of protection and promotion in terms of children's rights (Dottridge, 2008).

The African Convention on the Rights of the Child (ACRC) draws from the CRC, and stipulates the entitlement of all children to enjoy the rights and freedoms admitted and pledged in the ACRC. Palmary (2009, p. 8) posits that the ACRC offers an imperative framework "for securing the rights of migrant children."

In the Constitution of the Republic of South Africa, the protection of rights is explicitly guaranteed to all children, and no distinction is made between citizens and non-citizens. In every matter concerning a child, the child's best interests are of utmost importance and this guarantee of protection applies to all children in South Africa.

The South African Children's Act, amongst its other aims, sets out principles relating to the care and protection of children, and gives effect to the rights of children as declared in the Constitution. The Act implies that South African citizenship is not a requirement for protection of, and service delivery to, children. A previous minister of social development, Zola Skweyiye, stated in 2008 that "This means that foreign children are offered the same protective measures in terms of this legislation whilst they are in South Africa" (Palmary, 2009, p. 11).

A comprehensive study done by Palmary (2009) identifies additional legislation that affects migrant children. These include the Refugees Act, which is in the process of being amended; the Immigration Act; the Basic Conditions of Employment Act Amended; the South African Social Assistance Act; and the South African Schools Act.

Other significant South African plans and frameworks that affect migrant children are the HIV & AIDS and STI Strategic Plan, the National Framework for Orphans and Other Children made Vulnerable by HIV and AIDS in South Africa, and the National Action Plan on Orphans and Vulnerable Children (OVCs). Finally, the draft Policy Framework and Strategic Plan on the Prevention and Management of Child Abuse, Neglect and Exploitation is a draft document which, if passed, can be tapped into to secure the rights of children.

The key question for our purposes is whether all these frameworks and legislation are, indeed, promoting, protecting, and securing the rights of migrant children. It appears to be challenging to monitor adherence to signed conventions and the implementation of appropriate frameworks and legislation. A research study done by Dottridge (2008) about protection practices in different countries indicated that several governments scattered all over were neither protecting migrant children adequately, nor doing enough to ensure that children could exercise their rights. The Committee on the Rights of the Child (the UN treaty-monitoring body established to monitor the implementation of the CRC) appealed to governments to take appropriate actions to ensure that migrant children's rights are respected, and that these children are provided with more appropriate protection. In 2005, the committee published a General Comment: Treatment of Unaccompanied and Separated Children Outside Their Country of Origin, which endorsed the seriousness of the matter (Dottridge, 2008).

Concerns about South Africa include, first, contradictions in how migrants are dealt under other legislation. Although the Refugees Act is a progressive piece of legislation, very few migrants (families and children) fall under its purview (Palmary, 2009). The majority of migrant children come under the Immigration Act, which is a rather callous act, and one that authorizes anti-immigration activities such as the restriction, detention, and deportation of undocumented migrants. The control of migration is having a serious impact on the rights of children, and is undermining their sense of agency. Findings from a study done by the Forced Migration Study Programme (2007) showed that children had been illegally arrested and kept in cells with adults, and that all of the children who had been deported had been illegally deported by officials from relevant government departments. Second, service providers are confused by the different categories of migrants and their rights, in terms of the services migrants can access. It seems that there are inconsistent practices in medical care settings about the provision of medical services to migrants in these

different categories, and misunderstandings in an educational context about whether children without documents should be enrolled in schools, which has resulted in many schools turning these children away (Palmary, 2009).

Migration appears to be a complex issue, and bears a politicized context. A recent example from South Africa is the proposed move of reception centres from urban to rural areas. This has severe financial implications for migrants, which contributes hugely to the challenges they are already experiencing (Amit, 2012a, 2012b). Despite many sound documented frameworks and legislation, it is evident that governments across the globe, including in South Africa, give priority to anti-immigration measures, rather than protecting and promoting the rights of children within the process. Legally, South Africa operates from a rights-based approach, which lawfully affords migrants the right to work, access to social services like education and health, and free movement within the country. Unfortunately, migrants experience substantial challenges in accessing these rights, and reforming the situation appears to be a slow process.

Theoretical frameworks for engagement with migrant children

When practitioners engage with migrant children, the tendency is often to apply theoretical frameworks that are largely based on diagnostic perspectives developed from Western research in developed countries. While attempting to create "thicker stories" when working with migrant children, practitioners can explore some alternative frameworks that are firmly grounded in a developmental perspective. Tolfree (1996) explains the alternative framework "[as viewing] human beings as having capacities and personal resources to identify issues they need to work on, and to deal with these themselves. By avoiding terms which label people as traumatized or pathological, the [social work practitioner] works with [the children's] strengths rather than their weaknesses" (p. 109). Tolfree's view is also in line with the developmental perspective to social welfare utilized in South Africa, which again is firmly rooted in a rights-based approach that emphasizes social rights, social justice, and the right to dignity for all citizens (Patel, 2005). Indigenous and culture-specific values and principles guide behaviour; therefore, diverse cultural perspectives must be considered when applying theoretical frameworks during engagement with migrant children (Birns, 1999).

For the purposes of this chapter, attachment theory, resilience theory, narrative therapy, and creative art therapy are seen as the most important frameworks in which to contextualize art with migrant children as a means to create "thicker stories." How these frameworks underpin art with migrant children as a means towards creating "thicker stories" is the focus of the rest of this chapter.

Attachment theory

Attachment theory has been perceived in distinct ways by different authors because their theorizing is shaped by their own beliefs, knowledge, and experiences. Bowlby (as cited in Worden, 2002, p. 7), describes attachment theory as being focused on the inclination of human beings to develop strong affectionate bonds with others, and with understanding the intense emotional reactions that occur when there is separation from significant others, or when these bonds are threatened, broken, or lost. Attachments are rooted in a need for security and safety, developed early in life, are usually aimed at a few specific individuals, and are expected to continue throughout the better part of the life cycle. From the research done by Bowlby (1973), it was evident that physiological provision alone is not adequate for optimal development of human babies. For children to thrive, attentiveness and emotional nurturing are required. Bowlby (1977) further argued that attachment behaviour has survival value.

Mary Ainsworth has built on Bowlby's work, and identified three distinct attachment styles in children: securely attached, avoidant attached, and anxious-ambivalent attached (Ainsworth, Blehar, Waters, & Wall, 1978). Ainsworth's research about attachment was continued by Main and Solomon, and they identified a fourth attachment style, which was called disorganized attachment (Main & Solomon, 1990). From research done on the correlation of adult attachment styles with children attachment styles, it was evident that parents or caregivers can transmit attachment trauma to children (Main, Goldwyn, & Hesse, 2002).

Researchers have proposed that interpretations of attachment theory have to consider and respect different cultural perspectives when applying principles in interventions with maltreated children (Marvin, Cooper, Hoffman, & Powell, 2002; A. Slade, 2008). For social work practitioners working with migrant children who are likely to have experienced challenges in different phases of the migration process, awareness of different attachment patterns, and the intensification thereof when these patterns are disrupted is important (Ringel, 2011). However, this assessment has to be viewed in relation to the social and cultural contexts of the migrant child. Furthermore, attachment behaviour's survival value is likely to influence the resilience of migrant children.

Resilience theory

Fostering resilience has become an important focus in practice and education when working with marginalized young people. Despite the complexity of resilience as a construct, resilience is a capacity that all individuals have, and one it appears can be strengthened. Vanistendael (1998, p.6; cited in Morgan, 2000), explains resilience as "the capacity to do well when faced with difficult

circumstances ... [and observes that] this implies the capacities of both resistance and of positive construction." Adding to this, Norman (2002) argues that resilience includes both risk and protective factors. This corresponds with the strength-based perspective in social work, which is grounded in resilience research and leads to the assumption that no matter how disheartened or incapacitated people are, they can discover "strengths" in themselves that they had not been aware of (Benard & Truebridge, 2009).

The conceptual framework on the theory of resilience, developed by Benard and Marshall (1997), is very valuable in understanding resilience theory and its association with attachment theory, creative art therapy, and narrative. The framework has five components: beliefs, conditions of empowerment, programs/services/strategies, personal development outcomes, and societal impacts (education/prevention). These five components, as postulated by Benard and Truebridge (2009, pp. 203–206), and their interrelationships are highlighted below.

Beliefs are the starting point of resilience and determine resilience. Beliefs are the socially constructed judgments and evaluations people make about themselves, others, and the world around them. Therefore, the perceptions and beliefs of significant others or social work practitioners can either positively or negatively affect a person's self-efficacy, perceptions and beliefs of his/her own abilities, and capacity for learning and change. Again, Ungar (2006, cited in Bottrell, 2009, p. 333) highlights that cultural sensitivity is essential when using this theoretical framework. Ungar also argues that the constitution of risk is based in culture-specific values, norms, and conditions (2006, cited in Bottress, 2009, p. 324).

Second, given the person's beliefs, the fostering of resilience within a person is dependent on specific **conditions of empowerment.** The three protective factors required are caring relationships, high expectations, and opportunities for participation. The presence of these three factors creates the most advantageous environment for promoting resilience, as such an environment can shield and mitigate the negative effects of challenging circumstances, and engage the person in finding solutions and opportunities. Felner (cited in Bottrell, 2009) alludes to the transactional-ecological framework that recognizes significant exchange beyond an individual's personal experience or control.

Third, once empowering and supportive environments are created, the focus moves to **programs, services, and/or strategies** that will nurture and sustain the factors that are protective. Research-based strategies that strengthen the conditions of empowerment are meaningful work, mentoring, and artistic expression, as well as services to others. When engaging with migrant children, it might be worthwhile to explore how art can support and maintain the protective factors of these children. Research by Bottrell (2009) has revealed

the importance of the individual-social relationships within a community in building resilience in individuals.

Personal development outcomes are the fourth component of the framework. Walsh (1998, p. 77) stated that "resilience-based therapy inspires people to believe in their own possibilities for regeneration to facilitate healing and growth." When using art as the medium to engage with migrant children, it might be useful to ask what strengths and resilience emerged and developed in the individual children because of the art activities utilized during the process of engaging with them. Ungar (cited in Bottrell, 2009), explains the value of exploring and creating new identities by developing a new powerful self-story that replaces the old story.

Finally, **societal impacts** due to resilience-based practice might be evident. Benard and Truebridge (2009) posit that resilience research supports the premise that social work practitioners who possess an understanding of individual and family resilience can engage in practice. Practitioners can also tap into the process of resilience during interventions and contribute to empowering and strengthening the lives of others. The awareness of strengths in individuals and positive development outcomes might contribute to a reduction in societal risk behaviours (i.e., health risk behaviours) and an increase in high school graduation, employment, sensible parenting, and reliable citizenship.

When engaging with migrant children, it might be valuable to embrace different perspectives. Using a resilience lens when looking at behaviour yields an alternative explanation for the behaviour of these children.

Narrative therapy

Narrative therapy has multiple definitions, and is interpreted by people in many different ways. However, stories are essential to understanding narrative ways of working. The narrative is the nexus of human relationships—it is how we make ourselves known, and how we come to know others (Goldstein, 1992; see also Jackson et al., chap. 9, this volume). Consequently, narrative therapy at times involves "re-authoring" or "re-storying" conversations.

Morgan's (2000, pp. 17–75) description of narrative therapy is foundational to the arguments developed in this chapter. According to Morgan (2000, p. 2), narrative therapy:

> seeks to be a respectful, non-blaming approach to counselling and community work, which centres people as the experts in their own lives. It views problems as separate from people and assumes people have many skills, competencies, beliefs, values, commitments and abilities that will assist them to reduce the influence of problems in their lives.

According to White (2007, p. 9),

> people believe that the problems of their lives are a reflection of their own identity, or the identity of others or a reflection of the identity of their relationships. This sort of understanding shapes their efforts to resolve problems, and unfortunately these efforts invariably have the effect of exacerbating the problems.

Externalizing conversations, or naming the problem, is an initial focus of narrative therapy. Externalizing the conversation is about separating the person from the problem, and is based upon the premise is that the problem is the problem, and the person is not the problem. Although the person owns the problem, the problem does not define the total identity of the person; the person is much more than his/her problem. A particular shift in language is required when externalizing, which is an attitude and orientation in conversation and not merely a technique or skill (A. Morgan, 2000).

Tracing the history of the problem, whereby the problem is named and separated from the person, follows the opening of the conversation. This is when the therapist asks some questions to inquire into the history of the problem in the person's life. **Exploring the effects of the problem** happens early in the conversation to understand, in some detail, the effects that the problem has had on the person's life. This part has to be done carefully and thoroughly to allow for appreciation and clear understanding of the dominant story's impact upon the life of the person.

Deconstruction conversations are another central component of narrative therapy. During narrative therapy, the therapist is interested in discovering, acknowledging, and deconstructing the beliefs, ideas, and practices of the broader culture in which the person lives, and that are feeding into the problem and the problem story. This is often referred to as "situating the problem in context" (A. Morgan, 2000; White, 2007). There are links here with the idea of rhetorical competence, as discussed in Sinding and Barnes (chap. 3, this volume).

During the process, the therapist has to listen carefully for times when the problem has had less or no influence. **Discovering unique outcomes** during the conversation allows for the discovery of new and different stories (A. Morgan, 2000). **Tracing the history and meaning of the unique outcomes and naming an alternative story** happens when the therapist firmly grounds the alternative or subordinate story and places it more in the foreground of people's consciousness. The alternative story is usually anti-problem, and brings forth the skills, abilities, competencies, and commitments of people. White (2007) refers to the focus on unique outcomes as re-authoring conversations, because it provides for an entry point to alternative storylines of people's lives that are hardly visible at the onset of the conversations.

When a new and preferred story begins to emerge, the therapist attempts to assist the person to stay connected to, and embrace, the new and preferred story. **Thickening the alternative story** can be facilitated in different ways, such as remembering conversations, therapeutic documentation, therapeutic letters, rituals and celebrations expanding the conversation, and outsider-witness groups and definitional ceremonies (A. Morgan, 2000; White, 2005, 2007).

Creative Art therapy

The artmaking process can be described as a flexible therapeutic medium that allows the client to take a significant amount of control for determining the course of an engagement session. According to Johnson (2009, p. 115), creative art therapy allows for "the expression of deeply held thoughts and feelings within a trusting therapeutic relationship that can alleviate mental suffering caused by fear, shame and anxiety."

The main aim of art therapy with children is to create a safe environment with art material, the facilitator/therapist, and the child, where the engagement with and between the role players will lead to positive change (Waller, 2006). The fundamental principles of art are described by Waller (2006, pp. 271–272), who explains that visual image making is an important aspect of the human learning process, enabling the child to get in touch with feelings that cannot easily be expressed in words. Art serves as a means of communication between parties involved and can act as a "container" for powerful emotions.

Loumeau-May (2012) describes artmaking as a sensory-based (i.e., it uses visual, kinesthetic, olfactory, and auditory sensations) and psychomotor activity. Because art is a psychomotor activity, Steele and Raider (2001) argue that it permits access to sensory memories. Artmaking allows the child to externalize the experience into a concrete object, which then enables the child to describe the challenge or difficulty encountered. In this way, artmaking is a symbolic and metaphorical re-creation of experience, especially for young children who constantly change an image whilst using it when telling a story.

Kagin and Lüsebrink (1978) and Hinz (2009) conceptualized the therapeutic potential of artmaking on four different levels: kinesthetic/sensory, perceptual/affective, cognitive/symbolic, and creative. Using art in combination with narrative allows for the development of subordinate stories, which in turn creates territories of identity and thickens the preferred or alternative story.

Art and storytelling activities with migrant children

The essence of social work is the facilitation of human relationships in ways to increase and support potential, enhance choice, and contribute to the empowerment of individuals, groups, and communities (Graybeal, 2007). Science

and art in social work are two dimensions of a coherent integrated whole. The artistic dimension of practice should be seen as an opportunity to enhance and expand the scope of the profession and the potential contribution of science.

When working with migrant children, the process of engaging in creative activity gives a sense of mastery over experience and reduces the risk of re-traumatization. Di Sunno, Linton, and Bowes (2011) have noted that engagement with creative art provides a safe space for children to access their memories. In this section, we will show how the use of different art activities, in combination with storytelling, can contribute to thicker stories through looking at work done with migrant children in the inner city of Johannesburg and at a shelter in Ekurhuleni, Gauteng. The shelter in Ekurhuleni provides for the physical and psychosocial needs of children in need of care. Art activities there, however, contribute to subordinate storylines that "provide an alternative territory of identity for children to take recourse to in speaking of their experiences of trauma" (White, 2005, pp. 11–12).

Persona doll

Persona dolls are large, lifelike dolls that were developed initially for anti-bias work (C. Smith, 2006). An identity is established for the doll by giving it a name, a history, and other background information. The doll's lifelike quality and the development of a persona facilitate engagement with children, although the persona doll has been effective in bridging age and race divides (Heath, Brooks, Cleaver, & Ireland, 2009). A persona doll was used during sessions with a ten-year-old Mozambican girl at the shelter in Ekurhuleni. She had been sent to South Africa as a domestic worker, was treated harshly by her employer, and then ran away. Subsequently she was placed at the shelter. She was introduced to the doll and given some of the doll's background information. The doll then asked her questions about herself. The interaction with the doll enabled the girl to tell her story and to add more detail over time. She explained that her mother's friend had offered to take her to South Africa to stay with a family that would send her to school. Instead of going to school, however, she was expected to clean the house, do the laundry, and cook. She was not paid for the work, and was often beaten. She demonstrated her resourcefulness by escaping from the family, which entailed running to a police station for help. She was happy at the shelter, but longed to be reunited with her mother. The girl smiled when she spoke about home, spoke about her parents and siblings, and described memories of happy times she had shared with them. She also spoke about her friends at the shelter and the activities she enjoyed. Her story, facilitated by the persona doll, made the multi-faceted nature of her identity apparent.

Winnicott (1951) identified the role of art as a transitional object. Art is effective in maintaining a connection with the child within and between

sessions, and can therefore be helpful in enabling the child to develop a secure attachment. The persona doll has a powerful presence as a transitional object. This was particularly evident in work with a six-year-old streetwise boy who had been bullying other children and stealing at the shelter. Initially, he was apprehensive about coming for counselling. He hugged the doll at the beginning and at the end of each session, and kept her next to him while he was engaged

Figure 4.1 ❖ Persona doll. *Photo credit: Liebe Kellen*

with other activities. It seemed that behind his tough, streetwise exterior, there was a vulnerable little boy who wanted to be loved. After several sessions, he hugged the social worker as well as the doll. There were a couple of times that he punched the doll when he was angry with the social worker.

The collage

A collage is made by gluing different types of paper, fabric, and other materials onto a flat surface (Solomon, 1989), and the experience of handling the different materials in the process of making the collage can be meditative and relaxing. According to Loumeau-May (2012), the relaxing and meditative qualities of art contribute to the reduction of trauma and stress-related arousal.

Collage was used as an activity with a group of unaccompanied migrant girls who were staying in overcrowded derelict buildings in the inner city of Johannesburg. Most of the girls were from Zimbabwe, while some were from South Africa. All of the girls attended the same inner-city school. The girls' living conditions were unsafe.

The work with the girls came to a sudden halt several weeks later, when social workers were denied access to them. It became evident, subsequently, that most of the girls were involved in survival sex in order to obtain new clothes, toiletries, food, cellphone airtime, and protection. There were concerns about the possibility that the girls were being groomed for sex work.

However, prior to this event, the girls were asked to do a collage about safety. They were reluctant to focus on safety, and the theme that emerged from their collages instead was the importance they placed on looking good. The discussion uncovered feelings and attitudes about second-hand and new clothing. Clothing was perceived as a way of expressing and negotiating identity, and collage helped made this conscious and visible.

Clay sculpturing

There has been a long history of working with clay in Africa, and clay sculpturing is another useful art activity. Clay sculptures "had deep spiritual meanings and spiritual powers" (Solomon, 1989, p. 131), and were used in important rituals and ceremonies. Children enjoy the feel of the clay and work spontaneously with it (Solomon, 1989). The three-dimensional quality of the clay sculptures is conducive to children engaging with their creations. Loumeau-May (2012) argues that "[d]uring creative activity, the artist is continually responding not only to internal images and feelings but also to the impact of embodied imagery as it develops in the artwork in progress" (p. 101).

Clay sculpturing was one of the activities used during a storytelling holiday program at the time of the 2010 soccer World Cup. The children were asked

to make sculptures of important characters in their stories. One girl made a sculpture of someone selling mangoes, which reminded her of the country she had left. A boy dealt with his fears and stress by dancing, and made a sculpture of himself. A child who wanted the power of being a magician made a hat, a wand, and a rabbit. The process of making the sculptures, and the subsequent discussions elicited, detailed information about important people in the children's lives (White, 2005).

Memory work

Morgan (2004) defines memory work as creating safe spaces for containing life stories, and "The Chapters of My Life" exercise could be regarded as a form of memory work. This activity was used in the inner city of Johannesburg, with groups of unaccompanied migrant children who had moved to the shelter in Ekurhuleni. Most of the children were from Zimbabwe, and were engaged in discussions about storybooks and chapters.

The facilitators chose the following chapters: "The early years," "Life at home," "The journey to Johannesburg," "Crossing the border," "Life in the inner city of Johannesburg," and "My life now," and story development entailed both drawing and writing. The children gave accounts about why they came to South Africa; some had been living, working, and begging on the streets of Zimbabwe prior to arrival. Children wrote about fond memories of particular family members or other significant people who played important roles in their lives, and there were poignant accounts of how children had held each other's hands as they crossed the Limpopo River into the country. The children's survival skills and their acknowledgement of important relationships contributed to subordinate story development and multi-storying (White, 2005).

Sock puppets

Astell-Burt (2002) explains puppetry as "an art form that gives a voice and a language to those who perhaps have little voice" (p. 107). Solomon (2005) provides several guidelines for getting to know the puppet and developing its personality, which entail experimenting with how the puppet expresses feelings, giving the puppet a name and a history, finding out about its likes and dislikes, and deciding what kind of voice it has. In a scarcely resourced environment, sock puppets lend themselves to the development of personas and are also simple to make. A relationship with the puppet is formed during the process of making it.

One documented use of sock puppets is when they were used with a group of unaccompanied Zimbabwean boys. The first stage was making the puppets, and the boys were asked to develop a persona for their puppets. They chose names that differed from their own and all except one gave descriptions

of their puppets that were similar to themselves. One of the boys created a fictional character. The boys thought that it would be a good idea to develop a puppet show and to have a few people as an outside witness group to whom they could perform their show (White, 2005). The title they used for their show was "My Journey to Freedom." During the following few weeks, they worked on their scripts, and included some more detail in the scripts each week. The subordinate storylines emerged and stories became thicker in the process of script development (White, 2005). When it came to performing their shows, the boys used their own names for their puppets and told their own stories, along with some additional information in the final telling. The boys described themselves and spoke about their journeys, as well as about life in South Africa.

The Suitcase Group

When working with migrant children, there are many divides (race, age, class, etc). Western therapeutic models are not necessarily part of the migrant children's context; however, storytelling is part of the African culture and context. Glynis Clacherty's engagement with refugee children since early in 2001 confirms the value of the combination of art and storytelling within the African context (2006).

In 2001, Clacherty established the first Suitcase Group in her work with a group of refugee children who were staying in Hillbrow, Johannesburg. The group provided the children with creative ways of dealing with their trauma and their adaptation to their new country. The suitcase provided a powerful metaphor for understanding the children's experiences. The outside of the suitcase depicted the present, and the inside of the suitcase illustrated the past. The children pasted their artwork on the outside and inside of their suitcases. A process of telling and retelling contributed to the thickening of the children's stories. Clacherty and Welvering (2006) observed that, through their storytelling about the artwork, the children also "began to see that their stories were full of knowledge and skill, and that they were not trapped and paralysed" (p. 168).

Sophiatown Community Psychological Services has subsequently taken over the Suitcase Project. Groups are run annually for new migrant children who arrive in Johannesburg (for further elaboration on this project, see McGillicuddy and Pretorius, Chapter 7, this volume). A variety of creative activities have been used to enable the children to work through the trauma of displacement and to adjust to their new environment, and the artwork has been effective in enabling the children to access traumatic memories and to process them (Lüsebrink, 2004). By the end of each year, the children are able to talk freely about their experiences and are better able to integrate into their communities. This is evident from the friendships they are able to develop

outside of the group with South African children at school. Their participation in the Suitcase Group has enabled them to develop alternative territories of identity (White, 2005).

Conclusions

The phenomenon of child migration is a reality often beyond the control of formal interventions. The reasons for migration are diverse and different contexts create different dynamics, making it challenging to define migrant children and their experiences. The challenges migrant children themselves are encountering during the process of migration have an impact upon their identities, and clearly require resilience and courage. Once the children have arrived in their "new country," they have more obstacles to overcome. The gaps in the instruments of protection for migrant children, and the shortcomings in the enforcement of the different conventions, also appear to be problematic for them.

The interventions that might assist migrant children to manage the experiences they encounter are clearly underpinned by theoretical frameworks such as attachment theory, resilience theory, narrative therapy, and creative art therapy. Therapists have to acknowledge, be sensitive to, and respect the fact that the dynamics and principles of prevailing theories and therapies are valued and experienced in distinct ways in non-Western cultures. The contribution of the diverse social context in which children are raised should never be underestimated or refuted. Creative art activities consistent with these theoretical approaches can be practised to facilitate the process of dealing with traumatic experiences, and to reduce re-traumatization. Art activities help to create space in which migrant children can develop alternative territories of identity that contribute to a subordinate storyline, thickening their stories.

The outcome is that migrant children do not see themselves as traumatized only, but become aware of all the other facets they have as people —"there is more to me than trauma," is what they walk away with. Tolfree (1996, p. 113) captures the arts experience as "a special form of interaction and the 'tools' with which people themselves can discover and build on their own and each other's personal resources." Fleshing out the child's emotional experiences with the application of art activities in combination with narrative bolsters the child's sense of who he/she really is, and strengthens the child's resilience and capability to adjust to society.

Art towards critical conscientization and social change during social work and human rights education, in the South African post-apartheid and post-colonial context

Linda Harms Smith and Motlalepule Nathane-Taulela

Art is not a mirror to hold up to society, but a hammer with which to shape it.
—attributed to both Vladimir Mayakovsky and Bertolt Brecht

South African social work practice, with its roots in capitalist, Western paradigms, faces a challenge of appropriateness and relevance in terms of both training and practice. The South African post-apartheid and post-colonial context consists of a unique set of internalized and structural oppressions of class, race, and gender, which produces complex challenges for social work practice as well as social work education.

Achieving structural social change through interventions at macro levels requires concomitant interventions at the psychological level, and thus at the individual level. Internalized oppression, especially in the South African context of colonization and apartheid, remains an important area of focus for social workers and social work educators; any interventions focused on social justice, human rights, and social change necessitate that attention be paid to issues of internalized oppression (Fanon, 1967), as well as ongoing structural realities. This means that processes of critical conscientization are necessary to enable understanding, and to deal with the psychological and structural (psychosocial) nature of racism, inequality, and other forms of oppression. It is possible that aesthetic practices, such as art and drama, may be used as vehicles for people to re-author themselves and find new subjectivities through a process of conscientization and praxis. Social workers, as they intervene in the lives of oppressed peoples and in oppressive structures, also experience various levels of oppression themselves. Therefore, they too need to explore their own experiences of oppression, to self-reflect, and to become critically conscientized and involved in a critically engaged praxis. Their own practice, therefore, needs to account for "psychopolitical validity" (Prilleltensky, 2008).

This chapter explores how both art and drama techniques, in practice, offer useful methodologies for social justice and social change, as well as in the development of social work knowledge. It specifically describes examples of how

drama and art were used as part of a social work curriculum at a South African university, and is a further reflection on work by Smith (2008) regarding critical conscientization processes with social work students at a South African university.

The South African context

South Africa, with its population of approximately 51 million people, faces complex realities of poverty, inequality, and ongoing "race"-based class stratifications. It may be argued that, during apartheid, the struggle for social justice and equality became subsumed by the project of political emancipation. The end of apartheid brought freedom and equality in the ideal, rather than the material, as political emancipation was obtained without concomitant socio-economic emancipation. Statutes and policies have been transformed, but South African society remains largely untransformed. The country is still stratified by race and class, with 40 to 50 percent of its people regarded as poor (May & Meth, 2007). South Africa is among the fifty wealthiest countries, but appears 115th out of 175 in social indicators, has levels of inequality greater than ever before and one of the highest Gini coefficients (measures of inequality) in the world, and has shown a decline in the Human Development Index.

South Africa's shift from the Reconstruction and Development Programme (RDP) to the Growth Economic and Redistribution Programme (GEAR) in 1996 was the African National Congress government's response to pressures from world financial institutions and the so-called "Tutelage" programs required for African states (Bond, 2006). It was global neo-liberal capitalism that dictated the path of social change and macroeconomic policies, with an emphasis on the market as the template for solving problems. Neo-liberal capitalism relies on principles of fiscal policy discipline, cutbacks in state expenditure, trade liberalization, privatization of state enterprises, and security of private property rights (Ferguson, 2008; Sewpaul & Hölscher, 2004; Terreblanche, 2002), and exists in complex entanglement with the post-colonial (i.e., the ongoing effects of colonial exploitation, extraction, and oppression—see Kaseke, chap. 2, this volume). It may even be seen as a continuation of historical colonialism evidenced by global resource consumption and wealth distribution (Polack & Chadha, 2004).

Social work, social justice, and social change

Social work has claimed the project of humanization, social justice, equality, and freedom from oppression to be its leitmotif. The international definition of social work also places an important emphasis on social justice and human rights:

> The social work profession promotes social change, problem solving in human relationships and the empowerment and liberation of people to enhance well-being. Utilizing theories of human behaviour and social systems, social work intervenes at the points where people interact with their environments. Principles of human rights and social justice are fundamental to social work. (International Association of Schools of Social Work, 2001)

However, social work often finds itself in a position of complicity with ongoing oppression, maintenance of the status quo, shoring up of skewed power relations, or acquiescence (Dominelli, 2002; Patel, 2005; Sewpaul & Hölscher, 2004). Theories of social change are fraught with ideological underpinnings and interpellations. Arguments depend on positions around agency and structure, various forms of oppressions, ideologies around social and economic development, and perspectives on disadvantage and social justice. Many of these theories are limited, however, by the conceptual determinations of the current capitalist era of structural relations of production and of power (Mezaros, 2010). In order to radically transform society, change needs to occur on both a structural and personal level; for this reason, a Marxist perspective of radical change is necessary, utilizing change efforts of the socialist-collectivist kind, along with critical and radical social work perspectives (Payne, 2005; Ferguson, 2008; Ferguson and Woordward, 2009). Radical social work includes change efforts that emphasize the empowerment and collective actions of oppressed people to achieve social change, as well as an analysis of society that acknowledges the historical and material nature of power contradictions and hierarchies (Andrews & Reisch, 2002; Bailey & Brake, 1975; Payne, 2005).

In addition to these perspectives and approaches, the context of social work practice in the "two-thirds world"[1] requires an anti-colonialist position:

> The anti-colonial, challenges any form of economic, cultural, political and spiritual dominance. It is about identifying and countering all forms of colonial domination as manifested in everyday practice, including individual and collective social practices, as well as global interactions. (Dei, 2006, p. 5)

Attempts to restore or nurture hope for the achievement of change, consequently, are futile without critical consciousness and a critical analysis of psychopolitical realities. Working towards social change in the Marxist real rather than the Hegelian ideal (Brown, 1995), may be found in empowerment practice and radical social work engaged with such critical analysis and conscientization. A critical analysis and stance in relation to dynamics of power and oppression

as well as ongoing reflexivity, and processes of critical conscientization must be encouraged (Burstow, 1991; Carroll & Minkler, 2000; Freire, 1970b; Ledwith, 2001; Lee, 2001).

For social work students, working with their own internalized oppression and developing critical conscientization in order to facilitate praxis for liberation among their client systems at micro-, meso-, and macro-practice levels, becomes a critical imperative (L. Smith, 2008). The utilization of art and drama techniques offers an effective approach towards such conscientization and, therefore, commitments and skills for social change.

Intra-psychic and political violence of oppression

The intra-psychic violence of colonization (and apartheid) is found in the process of assimilating external socio-historical reality into subjective reality. Fanon (1967) describes the inferiority complex that results from this process "colonization of the mind." According to Fanon, racialized identities and the violence of colonialism are psychopathological in the sense that they are first sociopolitical, and then manifest in the psychological after they have been internalized. Psychological and political liberation are reciprocal. Similarly, for Biko (1978), the liberation of the oppressed person's mind (conscientization) is a prerequisite for political liberation and part of the liberation struggle. In this regard, Biko regarded the most important weapon in the hands of an oppressor to be the mind of the person who is oppressed.

The particularly complex ongoing nature of oppression and racism in the South African context is found in its post-colonial and post-apartheid reality, together with the consequences of neo-liberal capitalist processes. Structures of economic inequality and racist social stratifications make for exceptionally noxious psychosocial relationships within and amongst people. The racist capitalism of the colonial and apartheid eras has meant that power relations along "race" and class lines are particularly extreme today and thought of as being legitimate. "Race" and class hierarchies operate as hegemonic orders, and are "taken for granted, assumed, unproblematic and accorded some degree of legitimacy" (Foster, 2004, p. 562). Racism is linked in a particular way to relations of social, political, and economic domination and marginalization in South African society, and "involves systematically skewed relations of power in all major spheres of social organisation" (Duncan, Stevens, & Bowman, 2004, p. 362). The domination found in these social formations was perpetuated through violence, political exclusion, economic exploitation, cultural control, and fragmentation and division. These processes all have also had an impact on psychological well-being and functioning in South African society (Foster, 2004).

Conscientization and liberation

The effects of structural realities of oppression on the subjective experience of the oppressed are described by Freire as a process of dehumanization. The project of humanization, described by Freire (1970b) as the most important vocation for human beings, is to be found in the process of liberation from oppression. The oppressed must become critically conscientized, and engage in dialogue and praxis by perceiving the reality of their oppression, reflecting on it, and taking action. This process of praxis, therefore, accounts for both the psychological process of conscientization and an external process of taking action in relation to social realities.

Freire maintains that the oppressed, "having internalized the oppressor," face conflict around choices that must be made (1970b, p. 25). These choices relate to speaking out or remaining silenced, remaining in a state of alienation or achieving human solidarity, and taking action or having an illusion of acting through the oppressor. These are the struggles and dilemmas that must be resolved in order to achieve liberation from oppression and from internalized oppression. The reality of oppression must be perceived, and must enlist the oppressed into a struggle for freedom. However, according to Freire (1970b, p. 28), leaving the change at the level of perception, without pursuing critical intervention, will not lead to transformation of objective reality. Reality must be reflected upon, confronted critically, objectified, and acted upon, "making real oppression more oppressive by adding to it the realization of oppression." This then leads to the motivation to make real change in structural realities. Furthermore, according to Freire (1970b, p. 41) liberation must include "critical and liberating dialogue" through reflective participation, which presupposes action.

Various other anti-colonial writers have described such processes of resistance to and liberation from oppression, including Bulhan (1985), who described general stages of resistance to and rebellion against oppression. These consist, first, of the state of capitulation, whereby defensive processes, such as identification with the oppressor, occur, there is assimilation into the dominant culture, and a rejection of one's own group culture. The second stage is that of revitalization, which is described as "resilience and resistance" and an "active repudiation of dominant culture and a defensive romanticism of indigenous cultures" (Foster, 2004, p. 587). The third stage is that of radicalization, which includes an "unambiguous commitment to radical change" (p. 137). Foster (2004) suggests that ideals of emancipation should include not only the structural and macro-level sites, such as political oppression, patriarchy, economic exploitation, cultural imperialism, and ecological destruction, but the more micro-level forms as well, such as sexuality, health, spirituality,

aesthetics, disability, and even the details of psychological states. A requirement for liberation is critical analysis and a "challenge to existing social conditions," which "entails alternative voices from the margins, from the contradictions and gaps of hegemonic discourses" (Foster, 2004, p. 592). Such critical analysis must, however, lead to solidarity and collective action (Foster, 2004; Freire, 1970b).

According to Giroux (1992), the challenge presented by Freire (1970b) and other post-colonial critics offers new theoretical possibilities to address the authority and discourses of those practices that are part of colonialism's legacy—a legacy that either directly constructs or is implicated in social relations that keep privilege and oppression alive as they actively constitute the relations of daily life.

Conscientization and revolutionary aesthetics

Liberation from both structural and internalized oppression through conscientization may be pursued in various ways. The utilization of art and drama can be a powerful tool in such processes of "metamorphosis" and change, and in this regard revolutionary aesthetics is described as "the literature (and art) of protest and social metamorphosis for the re-humanization of the dehumanized in a given social matrix" (Nwagbara, 2011, p. 118). In this way, literature (and art) reflects, represents, and refracts the reality of the world across age and time (Obafemi, 1997, cited by Nwagbara, 2011, p. 114), and the idea that art acts to "refract" social reality leads to an appreciation of how art might "portray and interrogate" (Chukwu-Okoronkwo, 2011, p. 76) the contradictions of class consciousness. Developing critical consciousness requires understanding of how any present moment is the product of its historical antecedents. Such a process offers participants a way to link their current perceptions and views with their history, and the structural realities that shaped them.

Art may, therefore, be used very productively in this process of critical conscientization. Similarly, art can "not only ... expose the norms and hierarchies of the existing social order, but it can give us the conceptual means to invent another, making what had once seemed utterly impossible, entirely realistic" (Hardt & Negri, 2009, p. 179). Participants move from a culture of silence (Freire, 1970b) and a sense of helplessness towards empowerment and the agency to affect their reality. Social change then becomes a possibility. For social work students, such a process is essential in order to make the shift from their own sense of lack of agency towards facilitating broader social change as a possibility and reality.

Material class contradictions may be overcome through art, as it acts as a form of social consciousness. Udenta (as cited in Chukwu-Okoronkwo, 2011, p. 76), who maintains that in such a form (of social consciousness), art "exists

only in the context of the negation of existing contradictory reality of class society, by rising above its impediments, by going beyond its ideology and developing a system qualitatively new that challenges it." Art may then be seen as a tool "in the battle for the extermination of class society in all its manifestations: a realization which can only come through aroused consciousness furthered with action" (Chukwu-Okoronkwo, 2011, p. 76).

The dialectic relationship between the psyche and the political, that of agency and structure, may be synthesized through art, which in turn may be seen as a process of making conscious a "political unconscious." Similarly, Chinweizu (as cited in Nwagbara, 2011, p. 115) maintains that literature (art) is "a matter of orientation, a matter of perceiving social realities and of making those perceptions available in works of art in order to help promote understanding and preservation of, or change in the society's values and norms."

Furthermore, the idea exists that relational aesthetics, and encounters with art, are able to change subjectivities among people by creating ruptures in the mental and social realms (Bourriaud, 2002). Exploring Bourriaud's views about how the experience of art is similar to the shaking up of "sedentary elements," Abbott (2012, p. 87) describes the role of the aesthetic experience as a "rupture and redistribution of subjectivity towards unforeseeable destinations" and an "experimental zone with a crucial relationship to what is outside, unknowable or invisible to it." This role of art, then, may be seen in contrast to the "radical potential of socially engaged art" (2012, p. 88), which makes conscious, as well as challenges, structural norms and hierarchies. Art and aesthetics, therefore, may be seen as having an impact on a structural as well as an agency level, incorporating both the individual intra-psychic as well as the socio-political. Chapters in this volume by Khayelihle Dominique Gumede, Hazel Barnes, and Kennedy Chinyowa offer further insight and reflection about the integrative (personal and structural) affect of the arts.

Use of drama and art as forms of conscientization and work for social change

Drama and art may be used in these ways to achieve critical conscientization, which, when part of praxis as a cycle of reflection and action (Freire, 1970b), may lead to both psychological and structural liberation. Situations of drama and art constructed to stimulate narration, reflection, and participation provide dialogical encounters.

Various fields utilize projection and projective techniques to gather information, stimulate dialogue, facilitate awareness, and achieve change. Freire (1970b) used projective techniques in the strategy of codification to stimulate the identification of, and dialogue around, generative themes. Projection is a

mechanism by which individuals assign subjective perceptions, feelings, and desires onto other people or objects without the inhibition of rational scrutiny (Porr, Mayan, Graffigna, Wall, & Vieira, 2011, p. 32). Projective techniques are useful in the exploration of experiences and internalizations, which contribute to understandings and explanations for social realities, while art and drama provide such opportunities for projective and symbolic visual imagery. Furthermore, given the complex dynamics of how language is implicated in the oppression and domination of cultures, the use of languages other than a culture's mother tongue to explore deep-seated issues around oppression and discrimination becomes problematic. The use of art or symbolic representation to express and describe experiences may be particularly useful for this reason.

Forum theatre in social work and human rights education

The first of the strategies discussed here was used in the collaboration between the Drama for Life program, based at the University of the Witwatersrand School of the Arts, and the Social Work Community Work course in the Department of Social Work at Witwatersrand, which has been run over the past three years. The second area of collaboration is between the Department of Drama and the course Psychosocial Perspectives on Human Rights, which forms part of the International Human Rights Exchange (IHRE) at the same university. Drama for Life is a postgraduate research, training, and development program that explores the interdisciplinary field of applied theatre. Students from social work and IHRE, in their courses on community work and on human rights, are exposed to the work of (among others) Paulo Freire (1970b) and Augusto Boal. They are then offered workshops that use forum theatre techniques to work with students around issues of social justice, conflict, and human rights and social change (see Sinding and Barnes, chap. 3, this volume, for an overview of forum theatre). These workshops have been part of the curricula of these two courses for the past four years.

The workshops have, through experiential learning, offered students powerful experiences of exploring and envisioning change around difficult conflict situations in the areas of oppression, power, conflict, rights, and interpersonal relationships (see Chinyowa, chap. 10, this volume, for a focused discussion about the use of applied arts for managing conflict). Through acting out, participating, and projecting, students are enabled to explore and express what previously may have been "taboo" issues for some (in spite of a professed environment of dialogue and openness in the "classroom"), along with unconscious feelings and reactions. Students who may have been reticent in participating verbally in class, due to power and privilege dynamics, race and class dynamics, or a sense of inferiority, seem to have found the experience liberating—as seen in their active and relaxed participation.

Facilitators from Drama for Life take the students through various participatory processes of reflection and action, constructing and intervening in various scenarios related to oppression, asymmetrical power relations, and injustice. The embodiment of particular positions of asymmetry facilitates the exploration of consciousness of those positions. The challenging and altering of those scenarios and positions is then enabled, demonstrating what Chukwu-Okoronkwo (2011, p. 76) refers to as the "negation of existing contradictory reality of class society, by rising above its impediments, by going beyond its ideology and developing a system qualitatively new that challenges it."

Students reflected on the experience as "uncomfortable," as being "an eye-opener," and as helping them to understand "being in the shoes of the 'Other.'" One of the participants, who had experienced repeated incidents of xenophobia, described the experience as giving him an opportunity for the first time to explain to others how it felt to be the recipient of such xenophobia. Participants also explored and reflected upon the subjectivity associated with "white" and "black" categorizations, and were able to share feelings and thoughts from positions of the self and the "Other."

Generally, the workshops enabled participants to explore and share intensely personal and emotionally charged content through the "safety" of role play and enactment. By giving and receiving feedback regarding various positions, scenarios, and solutions, they were able to develop critical consciousness. Participating in and reflecting on changed outcomes for scenarios of injustice and oppression provides the opportunity for the "social metamorphosis" and "re-humanization" described by Nwagbara (2011).

These workshops expose participants to the use of forum theatre as a tool for transformation, as described in Boal's (1979) Theatre of the Oppressed, and as a methodology to raise consciousness and promote liberation of oppressed groups. The use of community theatre is a valuable tool in social work practice as "the techniques, all based on transitive learning and collective empowerment, are not limited to the stage; educators, political activists, therapists, and social workers devoted to critical thought and action have adapted the work" (Schutzman & Cohen-Cruz, 1994, p. 1). As Chinyowa states (2009, p. 50) regarding the use of forum theatre as a mechanism of socializing or cultural engineering, "alternative realities were created that may leave traces from which future actions can be constructed," although Chinyowa emphasizes the reality that such change is not possible without concomitant structural change.

Art in a "journey of critical conscientization"

The second example, described here in more detail than in the first, uses art as a projective technique that may make the politically unconscious, or the norms

of the existing order, conscious. Structural oppressions and power asymmetries are accepted as normal within the framework of hegemonic discourses around wealth, inequality, and "race." In a South African social work training program, students need the opportunity to explore, interrogate, and uncover their own experiences of oppression so that they, in turn, may work with the levels of intra-psychic and internalized oppression of their client systems. The process facilitates a rupture in the subjectivity of participants, as well as in the collective interactions of the group, described by Bourriaud (2002) as a rupture in the mental and social realm Norms, knowledges that are taken for granted, and hierarchies of the existing social order (Hardt & Negri, 2009) are challenged, and participants are able to resist and reject those norms.

Freire's (1970b) methodologies offer an approach to the process of critical Conscientization, and liberation from such forms of oppression. The utilization of these methodologies of critical pedagogy, together with projective techniques that form the basis for exploring narratives around oppression and racism, generates a powerful process of interaction, conscientization, and recognition of internalized oppression.

Students in such programs are, therefore, invited to participate in a series of "conscientization group" conversations based on the methodology of Paulo Freire (1970b). Through reflection on the drawings that they create, meanings that students ascribe to their experiences of oppression, discrimination, racism, and inequality are discussed and explored. Such a program consists of a series of seven group sessions of approximately two hours each. The bases of these group discussions are the students' experiences of growing up in South Africa, and the discussions are designed to achieve openness, trust, communication, and depth sharing (see also Barnes, chap. 8, this volume). Key elements of the program include: adult education principles; provision of handouts and recommended literature for reading; self-reflection; use of a "talking stick," a traditional cultural symbol of respect and authority in many non-Western cultural contexts (P. O. Walker, 2004); projective art techniques about students' earliest memories of experiences of oppression or racism; in-depth group discussion of drawings; and optional written reflections in a personal journal.

Three such participant drawings are provided here, together with a summary of the narrated content related to the drawing. These were examples of the content of drawings and narrations that formed the basis for the group conversations that followed in each case.

The narrative that accompanied this drawing included the following:

Umm, my grandmother lived in, I think it's in ... somewhere. And umm, whenever we went to visit her I noticed that she worked in this very nice big house and she'd have to like get out of the yard and go

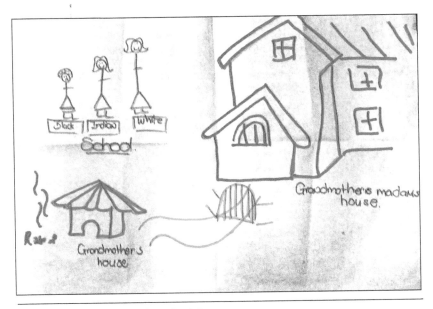

Figure 5.1 ❖ Grandmother's madam's house

to a small little hut outside, which was about, it was quite a distance from the house, not too far, but it, this is where she lived. And she lived a very agrarian life, you know she lived basically the type of life that I would ... people in the rural areas would live. The house next to her had electricity, it had everything. And umm, we visited her a lot, I remember I hated visiting my grandmother because where the taxis dropped us off we had to walk something like an hour to get to her place and I never knew what the house looked like inside because I wasn't allowed in there, but there was a time when my grandmother sneaked me into the kitchen and it was so beautiful, it had ah, a kitchen unit and I, I never understood all those things but it looked very nice. And, that was a, basically my first recollections of the differences between myself and my people and, um, white people.

This participant related how she had accompanied her mother on a shopping excursion to "town" from the "township." This was the first time that she had seen such levels of opulence: clean and neat buildings, and beautiful houses. She had become excited as she had decided that she too would one day have a life like this. Upon returning home she excitedly related the story. Her grandmother had later reprimanded her to refrain from such imaginings, as she had no right to aspire to such things. She then told a story to the children that evening about a man asking God about why there were such differences, and God had told

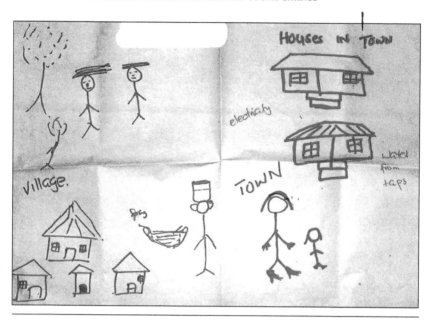

Figure 5.2 ❖ Crossing the divide

him not to question such things because this is how it was supposed to be. The participant had accepted this story and from then on regarded this as the truth.

The narrative that accompanied the third drawing was as follows:

> This is, ok, basically—it's about hair. Ok, this is really hard for me, because I only realize now how much of an impact it still has on my life. Um, this is what black people are sort of perceived to have as hair. The afros and the dreadlocks and the short cut hair. Um, OK, of course there's a lot of options now, you can just shave it off, or grow dreadlocks or whatever, and I think because the whole thing, the oppressed thing, you know everyone tried to have relaxed hair. But I've always had long hair. I remember this one particular point in time, my hair was sort of at my back, and I'd opened it the one day because the night before I think my mom couldn't plait it or something. And the headmaster, at that morning assembly, he told me I needed to cut my hair. He said, the hair is not yours and what have you done, and he was like, those are extensions, that's not your hair, you need to cut it. And this is the sort of hair they wanted us to have. And then this is the other thing, every year my dad did a traditional ceremony for us, to celebrate blessing in his life. And I had to cut my hair off. And also, just how everyone used to want to touch you, my God, you know, they want to touch your hair, they want to touch your skin, why is your skin a shade darker you

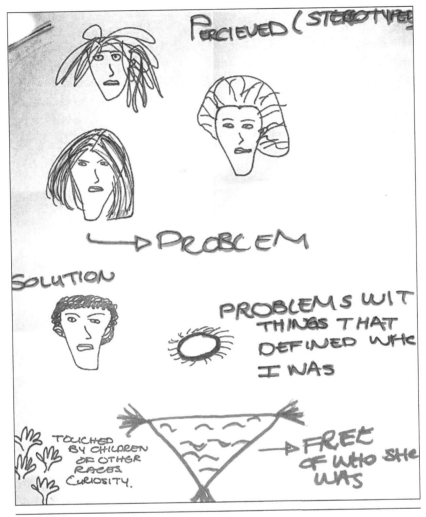

Figure 5.3 ❖ "Black hair"

know, why this why that, oh my gosh I hated that. I hate those memories ... they always told us they want to go to Soweto and take buses and you know, just going to townships and taking buses. I hate that. And that makes you feel like a real alien or this animal that nobody knows and you know, I think up to this day nobody knows why I will grow my hair and cut it. I have issues with my hair, not because I want to have white hair but because you know, it took away such a part of me that I don't think I will ever get that part of me back again. I'm not fighting with anybody, but I still have that fight in my head.

In most cases, dialogue that followed sharing the content of the drawings included discourses around inequality, enforced acceptance of the status quo, failure to challenge violations of dignity, and internalization of oppression and inferiority. Participants were able to uncover shared experiences of oppression and discrimination, anger, racism, and a deep sense of violation and inferiority.

The value of sharing in such a series of group sessions, and the critical conscientization that followed, was linked to the safety of an experience during which such content could be shared, as well as the sense of solidarity which it engendered. For example, one of the participants stated:

> So when you stand against oppression you stand alone and I am very grateful that we had this platform this place of safety where we could just speak our minds and get through things, because maybe after this it goes back to the individual fight, you know you yourself against system against these things that happen around us so it was such a nice experience to have people on your side people to stand by you because it does not happen a lot and I don't know to some people it might be the first and the last time we have people stand by you.

And other participants maintained:

> I think that it is the experiences that people had because I am one those people who used to say like I do not mind, we were born under the situation. Regardless of how oppressed we are, we are going to be like this because we are blacks, so there is nothing that we are going to (be able to) do about it, but now my mind has changed I think that I do have some kind of power—I can do something about this.

> … when I was on my way home I just realized that, you know, there is something going on in my life. You know, I think I needed to give it a bit of time to go through. I didn't realize that I was angry, but through that process that we went through last week, I realized that it came to that I need to deal with what I felt within, ya. Sometimes it redefines the way that you see the world, the way you think. I have learnt from the discussion that we had last week and the way that we shared information—it gave me a new look.

Conclusion

In the South African context and in other such instances of structural social realities where unequal power relations relate to inequality and oppressions of class, "race," and other social categorizations, there is a need for critical conscientization, liberation, and mobilization for social change. The psychosocial

realities of oppression, asymmetrical power relations, and class contradictions of inequality require educational approaches that engage with both these internal and external realities. Social work, as a social justice profession working for social change, needs to utilize innovative strategies for such processes of engagement.

The use of art and drama is a powerful means to facilitate "rupture and redistribution of subjectivity towards unforeseeable destinations" (Abbott, 2012), and from there to achieve critical conscientization and, beyond that, social action. In social work education specifically, and human rights education generally, such methods may facilitate their own processes of critical conscientization as students engage with learning processes which, in some cases, may confront them with their own experiences of oppression and injustice. Developing conscientization, reflection, and promoting possibilities of action around internalized oppression and ongoing structural realities of inequality and disadvantage then equips students for working from critical and radical positions and perspectives.

Note

1. The author concurs with Sewpaul and Holscher (2004, p. 3) who argue that the first world–third world dichotomy is limited in its linear modernist implication, and that the concept "two-thirds world" is preferable as it reflects, numerically, the majority of the world's population who live in poverty and deprivation, and does not imply any hierarchy of superiority and inferiority.

When we are naked: An approach to cathartic experience and emotional autonomy within the post-apartheid South African theatrical landscape

Khayelihle Dominique Gumede

This written account attempts to relate and negotiate an exploration of Practice as Research; one whose core intent has been to redefine and contextualize an approach to cathartic experience and emotional autonomy within the post-apartheid South African theatrical landscape.

Practice as Research, within the context of my exploration, can be defined as a combination of practice-based or led research and qualitative research. Combining what is known as action research (Kumar, 2005), which is a technique based on conducting a practical experiment to posit a particular hypothesis and qualitative research. The qualitative component is derived through a measured and chronicled response of the selected performer participants to this practical experiment (Kumar, 2005). Practice as Research is not just a process of archiving or comparing numbers or situations, however, but a response to the insights, effects, and effectiveness of the practical experiment conducted.

In this case, my research sought to experiment with the notions of catharsis and emotional autonomy and its contextual relevance to the South African situation.

This chapter begins with a conceptual critique, analyzing social performance and gesture within the South African situation through a critical reflection on the Truth and Reconciliation Commission of South Africa (TRC) as a self-confessed framework for "national healing" post-apartheid (Homann, 2009). This critical backdrop provides context for unpacking the correlation between Aristotle's Coercive Model (also known as Aristotle's Coersive System: see Boal, 1979), understood through Augusto Boal's critique as a classical model for catharsis, and the TRC as a social performance attempting to facilitate catharsis. This critique will provide a springboard to enter into a practical exploration that attempts to produce a performance model to address the concerns arising from this critique.

South Africa's collective trauma

There is a deep and vivid trauma within the social psychology of the South African community at large (Homann, 2009), due for the most part to the effects and legacy of the apartheid project and discrimination in South Africa

(Homann, 2009). This trauma seems to be debilitating when coupled with the reality that there has been a lack of transformation post-apartheid within the socio-political and economic spheres of the country. We could easily draw evidence of this from the unemployment statistics, poverty levels, and (re)distribution of wealth within the country. Even the overwhelming amount of violent crime indicates a deeply troubled nation, lashing out against its history (Van Graan, 2006). This violence seems to mimic an attempt to "purge" or, rather, to vent against a collective national trauma seen in most post-colonial African situations. This issue is not just a simple question of an economic or political transition or transformation but, rather, is about the factors motivating our decision-making within these areas as a nation.

Within the matrix of power, we, as South Africans, do not yet understand that social gesture is as powerful, if not more powerful, than economic and political gesture (Alexander, Giesen, & Mast, 2006). It is through our social identity that we "understand" ourselves as a society, and that determines how we will act politically and socio-economically. If we are to induce a meaningful transformation in South Africa, we need to grapple with and unpack our social identity, or lack thereof, as a nation. For "it has been meaning, not action, that has occupied central attention, and deservedly so. To show the importance of meaning, as compared to such traditional sociological ciphers as power, money, and status, it has been necessary to show that meaning is a structure, just as powerful as these others" (Alexander, Giesen, & Mast, 2006, p. 2). Therefore, it is within the complex negotiation of social identity that we may influence meaning.

There is a deep lack of coherence within the social identity of South Africa as a whole. The country suffers from a deeply fractured identity; fractured by the effects of the unresolved national trauma of discrimination and social prejudice.

If we are to accept that a series of unresolved traumas exists, produced by the narrative of segregation and inequality in the country, then it may be possible, and indeed deducible, that these traumas serve as barriers to deep social progression or cohesion in the country. These barriers could be labelled as sources of conflict within the imaginary of the South African social identity, and be loosely separated and categorized for the purposes of this analysis into the internal, the interpersonal, and the socio-political (Homann, 2011). There is an obvious and tenable link between the various levels of conflict. On the internal level are hindrances or barriers between the individual and his or her own imaginary or psychology; on the interpersonal level, there are barriers between individuals; and, on the socio-political level, there are barriers between individuals and the social or political superstructure.

The Truth and Reconciliation Commission as social performance

Many of our collective traumas are captured within the very testimonies of the South African Truth and Reconciliation Commission (TRC) hearings[1] (Homann, 2009). For, it was the aim of the TRC, in the words of the chair of the commission, Archbishop Desmond Tutu, in his opening address, to "unearth the truth about our [South Africa's] dark past, to lay the ghosts of that past so that they will not return to haunt us and that we will thereby contribute to the healing of a traumatized and wounded people, for all of us in South Africa are wounded people" (Homann, 2009).

It would appear that these traumas are inscribed within our imaginaries, our very bodies, and in the landscape we occupy (Homann, 2009). The body carries a social codification. Within the South African context, it carries the particular inscription of the social abuses of apartheid and discrimination, with concentrated attention and differentiation attached to skin colour. Therefore, the black body in particular becomes the site and sight of trauma (Homann, 2009). Even the trauma that is suffered by the broader physical landscape is internalized and expressed through the black body.

We see this dialogue actualized in Lara Foot's *Tshepang* (2005). An arguably seminal play within the post-democratic era, *Tshepang* grapples with the rape of a baby who became known as baby Tshepang. Simon, played by Mncedisi Shabangu, is the main character and narrator within the play. He oscillates between his trauma as an individual and taking on the trauma of the entire town of Louisvaleweg, where the rape occurred. Simon's recollection of the events that lead to the rape of baby Tshepang are reminiscent of a TRC testimonial, even to the point where he re-enacts the mutilation of the baby on a bread loaf with a stick; an act that seems to have been almost directly transmuted from the TRC. A platform is given to Simon to "testify" or tell his story, much like the participants of the TRC, and he begins a tentative retelling much like the "monologues" of Victims and Oppressors. Whether intentionally or not, these TRC testimonies almost always gained an energetic momentum with a palpable dramatic tension, as the teller/re-enactor was forced to either navigate his or her trauma as a victim or reach for a defence as a perpetrator, clutching at an opportunity to preserve the idea of their humanity or dignity (Gobodo-Madikizela, 2003).

Within the TRC, the abuses that were recounted became performative acts, making the TRC a social performance not only on the level of social gesture but also a dramatic performance of enactment and re-enactment of narratives and moments that were often linked to personal traumas (whether as the one responsible for inducing trauma or suffering a trauma). These acts inscribed

themselves into our imaginaries and play themselves out continuously in our daily lives (Homann, 2009). In other words, we as a society have not only taken on the actual traumas that were collectively experienced—we have also taken into our imaginations a myriad of potential traumas. We have done this so deeply that we perform their effects within our lives, imagining and reacting to the potential rape or act of violence we are waiting to have happen to us. Only reiterating, within our personal capacity as individuals, we remain a deeply traumatized society (Homann, 2009).

In many ways, the vocabulary that developed out of the TRC became marred by a rhetorical attempt to make definitive sense of the discrimination we had suffered as a nation. This language was also an attempt to find a means to reconcile ourselves with that "past," or at least talk about it. Instead, it produced a sophisticated and evolved vocabulary that works to shroud, rather than reveal, our social trauma (Homann, 2009). Now we cannot directly speak to our trauma or its effects without being trapped by this evolved jargon, which makes the conversation around the source of these traumas difficult and complex (Homann, 2009), and limited to a vocabulary of associated and intended meanings.

This vocabulary has now become archived through the TRC's transcripts and testimonials (Homann, 2009). In many ways, the TRC unwittingly reduced members of our society down to either victims or perpetrators through its trial-like proceedings, which may be a large contributing force to the level of violent crime within our society. One could understand this violent crime as either an attempt to lash out against a lack of closure or delivery of promises from the TRC, government policy, and other national transformational instruments; or as a response to being reduced to enacting the role of a victim or perpetrator within the matrix of violent behaviour within South Africa in the limiting and, at times, polarizing language of the TRC (Van Graan, 2006).

The social performance that was the Truth and Reconciliation Commission attempted, by its own admission, to purge the country of this deep social evil imprinted by the project of apartheid (Homann, 2009). In light of the current and perpetual state of this ongoing social trauma, we can argue that the TRC has not adequately provided closure on this account.

Links between the TRC and Aristotle's Coercive Model

So why has the TRC not been able to "purge this evil" and provide emotional closure, as it set out to do? The answer may lie in the model.

The TRC is not the first socially orientated "performance" to attempt a social intervention of this nature. In fact, there have been more than thirty such commissions around the world (Enweazer & Basualdo, 2002). It has been

argued that South Africa is unique not just because of the manner in which the Commission was centralized as the official means of redress, but also due to the way in which amnesty became an incentive to testify as a former perpetrator.

Boal (1979) claims that Aristotle's Coercive Model, as he calls it, has been utilized for socio-political control for hundreds of years, asserting that theatre as a mechanism has been central to the agenda of governing institutions since the ancient Greeks (notwithstanding the fact that it has been the life's work of theatre makers such as Brecht and Grotowski to use theatre as an act of political critique and "transgression," shaping the way in which theatre is viewed and utilized within the socio-political realm). Boal (1979) asserts that Aristotle's Coercive System, in different incarnations, has been utilized roughly since 384 BC. This bound the relationship between politics and art (particularly theatre, in this instance) in a complex yet hardly deniable way (1979). This very model can be traced within the TRC, thus raising the question if, in fact, this was not the inherent flaw in the structure of the TRC? A close analysis of Aristotle's model, as Boal understands it, might help us arrive at a conclusion.

Since it was the intention of the TRC to provide closure and purge the nation of the evil of apartheid, the first point must be to analyze how this is said to work through Aristotle's model. Aristotelian catharsis is the purging of "negative" emotional traits or flaws within the spectator (Aristotle, trans. 1961) and is achieved through the tragic hero, established within the tragic narrative. The tragic hero exhibits a character flaw, or *hamartia*, which is responsible for his success and will also be the cause of his downfall (Aristotle, trans. 1961). At the point of his downfall, the character recognizes his error, known as the *anagnorisis*, and the spectator recognizes his own error through the empathetic relationship he or she has built with the character (Aristotle, trans. 1961).

Already this model presents a problem within the South African context. The very idea of a tragic hero has produced the fault line that has induced the language of perpetrators and victims within this context, reducing the complexity of the relationship individuals had with the system of apartheid.

Empathy and identification are, for the most part, assumed by Aristotle to be present; because the narrative recognizes and acknowledges the tragic hero as such, it is assumed that the audience will too. All that is assumed about the tragic hero is that he should have aspirant qualities for the spectator to engage with (Boal, 1979).

Nonetheless, once the hero has identified his own flaw, "the character suffers the consequence of his error, in a violent form, with his own death" (Aristotle, trans. 1961) or a fate worse than death, such as the death of a loved one. Then the spectator, presumably terrified by the catastrophe that has befallen the tragic hero, is purified of his own *hamartia* (Boal, 1979). Fear and pity, then, become the facilitating emotions of the emotional purification process (Aristotle, trans. 1961).

Aristotle's model makes a number of presumptions, for which I would like to take it to task. Within all of the model's calculated permutation, there is no variation that allows the state or society to be the party at fault, while the individual holds the position of moral impunity. This already does not account for apartheid, systematic slavery, and systemic oppression in South Africa. Boal (1979) notes, aptly, that the very emergence of a protagonist "aristocratized" theatre, thereby excluding the majority of the South African population. These are two factors that would have made the TRC model an inappropriate framework with which to deal with the needs of the society the Commission was representing. It seems there was an inherent contradiction in the means by which the TRC attempted to gain the country's "trust" and, therefore, its ultimate credibility from the greater national psyche. Members of the TRC were attempting to address a wrong committed by the previous regime while maintaining a sense of benevolence, and by taking collective responsibility for "healing" the nation, with the Archbishop himself presiding over the Commission. This tone was reminiscent of the fundamental Christian nationalist agenda of the apartheid government, which claiming a paternal interest in the collective "needs" of the people according to their "aptitude" (Van Graan, 2006).

Grotowski (1975), provides a rounded critique of Aristotle's model. Rather than a politically sympathetic act (as is the case in the Aristotelian model), Grotowski believes that theatre-making is, or should be, a "transgressive" act that disavows the production of the myth, rather than perpetuates it (1975), the myth being the socio-normative qualities the hegemonic discourse would have individuals assimilate. The myth perpetuates the idea that there is an inherent good in the hegemony, and that there will be some kind of "reward"(or, at least, the avoidance of "punishment") by keeping these values (Grotowski, 1975). This relates to the complicity which became systemic during apartheid. People had been coerced by the myth so deeply that, in many instances, they became their own police.

If we are to apply Grotowski's ideas to the TRC as a social performance, then a self-aware, socio-political agenda would have needed to be apparent within the commission itself—one that does not claim the role of moral arbiter but, rather, one that grapples with itself and its participants around its meaning and intended meaning. One that is not afraid of its sense of fallibility, but also one that does not fear or cut off the depth and scope of conversations necessary to facilitate healing, let alone the time frames required.

However Aristotle's Coercive System cannot entirely be discounted because of its effectiveness and prevalence over hundreds of years within the socio-theatrical sphere. Yet, because of its lack of appropriateness for the South African context, the system has left those narratives of trauma related within

the TRC still hovering, it seems, unresolved, over the lives of those who testified: the same trauma that ultimately rendered individuals incapacitated by that very trauma.

Developing a model of performance-based redress

In this section, I describe my efforts to devise a model of performance-based redress that is appropriate to the South African context. Since the TRC itself cannot be undone, a means of addressing and redressing the effect of that traumatic event became a priority in our attempts as a theatre company to uncover a new performance model. The need, as I saw it, was to provide an access to emotional autonomy in the face of the fractured emotional identity of the traumatized self. This would allow individuals to negotiate their response to their traumas while recognizing memory as an archive—the very archive that holds not only the composition of an individual's personal identity, but the inscription of social codification (Demaria, 2004). Clinton van der Walt (2001), through his account of "Lacanian conceptions of trauma," furthers the notion that the personal narratives of those traumatized by the "master" discourse of apartheid looked to the TRC to have their traumatic symptoms drained away into symbolic coherence. My intent is to replace the symbolic gesture of the TRC with another instrument of performance-based redress, one that allows the symptoms of trauma to drain more fully.

Doing so can make a traumatic instance become negotiable, rather than solely being an imposition within the imaginary and memory of the individual. In this way, the social implication of such a trauma becomes negotiated within the social psyche of a society. This process is evident in van der Walt's (2001) recognition that Lacan's hysterical discourse is the only structure Lacan elevates to a social discourse. In the face of this realization, I was led to the true genesis of the practical component of my research.

My next step was to break away from this notion of Aristotelian cohesion. However, the notion of bearing witness remained central to my understanding of catharsis. The audience, as Aristotle explains, bears witness to the "tragic hero" who, on behalf of the audience, undergoes a tragic fall. Members of the audience, by feeling pity and shame for the fallen hero, purge themselves of negative emotions. This purging of emotion is believed to induce catharsis for the audience (Aristotle, trans. 1961).

Taking up this notion of the induction of catharsis through purged emotions, I began to experiment through performative means to uncover a method that might also provide catharsis for the audience and performers involved by demonstrating emotional autonomy over particular negative or traumatic events in an attempt to produce a cathartic experience. My intent was

to offer individuals the means to negotiate the traumatic moment, rather than having the moment or its effects remain as an imposition on their lives.

The creative practical investigation

At this point, I began to engage with the practical component of my research. I started by selecting a criteria-specific group of actors and theatre-makers, whom I auditioned through workshops and interviews.[2] I had to explain to each of my cast members/collaborators that their identity and personal experiences as individuals would be interrogated in the process, and that they might need to face potentially sensitive parts of these experiences. Doing so, for me, set up the way in which we would work as a company, and immediately made people aware of what the process required of them beyond technical proficiency as performers.

The early part of the rehearsal process was purely centred on preparing the space to enter into the sensitive work that would be done. By space here, I mean physical, emotional, psychological, creative, conceptual, and even metaphysical space. My first priority was to produce emotional safety. Producing this safe space meant not only that everyone would be allowed to take conceptual and emotional risks, but that the company would have the means to cope with (re)visiting certain moments within their lives (see also Barnes, chap. 8, this volume). I produced this safe space through a ritualized preparation of the physical space, drawing mainly from two very different approaches to entry: Yoshi Oida's (1997) exercises for preparing the actor and Peter Brook's *The Empty Space* (1968). On the one hand, Oida creates a ritualized sanctum to contain the work, while Brook deals with space from a more conceptual place. However, both methods of entry concern themselves with broaching conventional performance modalities to produce a deeply connected and intended "presence of being" in performance.

Yoshi Oida's (1997) exercises, focused around "cleaning" or "cleansing" the space through repetitive physical gesture, seemed to clear the "clutter" of negative self-awareness amongst the ensemble and provided a trusting environment between all the collaborators, including myself—it was one not clouded by the assimilated socio-political barriers that form blockages in the search for identity. This method of preparation also opened a new social contract with the company. They now understood the space that they were deliberately creating with each other, which in turn not only demanded sensitivity but also probed a deliberate and heightened exchange.

This new space of heightened exchange seemed to lead the performers into an exploration of the use of cultural song and dance as an entry into the metaphysical. It seemed to me that, through these elements, we were beginning to broach an "emotional diaspora" imposed on the traumatized imaginary of

ourselves as individuals who have been left floating and dismembered from ourselves (our identity). It seemed undeniably intense, our yearning and longing to understand a part of ourselves that did not yet exist or which we had long ago lost; we were seemingly crying out while, at the same time, uncovering a part of ourselves we had lost touch with. I had to question, though, whether this was not in fact an atavistic reaction: were we going into subconscious safety nets, or were we really forming intelligible and intuitive responses to the fractured makeup of our identity?

A fundamental shift in exploration came when the performers started to view themselves as a conceptual resource, and their personal narratives as an archive for the work. Doing so gave the performers the ability to detach and negotiate an insider-outsider relationship with their own experiences. To achieve this, I drew strongly on the experiences of Marina Abramovic as a case study around viewing the memory and body as archive (Demaria, 2004). Abramovic, in interviews, talks about the body as a "hard drive," and that the social inscriptions aspersed onto it by socio-normative values live on it. She also asserts, though, that the body carries the imprint of the natural daily wear of life, making the process of inscription a combination of elements (Demaria, 2004). Abramovic proposes a method or means of an active negotiation of this process of inscription bringing into the present and both in and onto the "archive" (namely the body). She calls for the production of a deliberate, heightened, and condensed experience, induced through the actions of the performer (Demaria, 2004). Much of Abramovic's life's work has been about creating scenarios where she must actively endure a situation that forces a fuller state of presence out of her, condensing time, and often charging the space, along with other factors within this heightened state of presence. Abromovic argues that we cannot interact with an energy state like this and remain unchanged in such a space (Demaria, 2004). She does not attempt to place a parameter on what this change might be, because that would be too prescriptive and narrow an interpretation.

Abramovic's guidance produced a powerful performative entry to the work at hand, helping us to advance our negotiation of the socio-normative imprint of discrimination and the legacy of apartheid. Her approach intersects with the way in which Grotowski speaks about the heightened exchange of performance. Grotowski argues that the ensemble of actors is met by an ensemble of audience members that has, in their own way, undergone their own preparation of entry into a performance. Once the two ensembles meet, a communion is established where there is a heightened metaphysical exchange (Grotowski, 1975).

For this reason, we had to build a co-dependent cast ensemble that would interface with the ensemble of audience members. For this development, I relied on adaptations of John Wright's exercise entitled "Taking the space." This exercise made the performers more aware of each other in a holistic

manner (i.e., of the dimensions of each other's bodies, the energy emanating from bodies, taking in each other's energy levels, seeing "with new eyes," and learning to negotiate themselves in relation to each other). This produced a level of sensitivity in the most positive sense. The exercise became an enabler, giving the ensemble safety while plunging deeper and deeper into conceptual, physical, and emotional risks. This was also a means of empowerment. As the title of the exercise suggests, it gave the ensemble the ability to take ownership of the space. This was also an important definitive point within the process.

I was extremely deliberate and careful around when I broached specific areas within the ensemble space—issues such as physical touch, emotional outreach, and negotiation. For instance, I used a number of imaginative exercises to break an individual's social buffers, attempting to facilitate a conversation with my cast and their "inner selves." This was most telling in exercises that required cast members to have a conversation or interact with their (perception of their) "younger" selves. This, for me, was the area in which each individual was safeguarding from the ensemble early on within the process.

However after breaking through this safeguarding, the cast seemed more emotionally empowered, which allowed them to take more emotional risks and work more deeply in this area. They drew on the "ensemble presence" that was continuously "bearing witness," and therefore affirming each personal narrative within the collective. After preparing the space and ensemble for the work, I started providing different triggers for the cast to explore aspects of their personal narratives and identities, and gave tasks, such as writing a personal eulogy. This made individuals confront themselves (or, rather, their perceived notion of themselves) in a very present and surprisingly brave way. Even though some of the eulogies were lighthearted, they contained a sense of authenticity and vulnerability—a "truth," if you like—that was unhampered or inhibited by preconditions or judgments. The personal eulogy would, in fact, be the central image upon which one of the actors, Khothatso, would build his performance journey.

Khothatso's performance of his eulogy was one of the most compelling moments of the final staging of the work. In it, he is placed in a dark chasm behind the main stage between the door leading into the greenroom and the stage's right wing. The scene is lit only by candlelight. He is naked in a zinc bathtub, and the candlelight dances on parts of his bare skin. He begins by carefully washing his body as he starts to deliver the monologue; as the dramatic moment builds, so does his action. By the climax he is vigorously scrubbing as if he is trying to wash the "black," the gay, the anger, and the shame off of himself.

We also used various character observation exercises in the rehearsal room and around the city as a method to analyze perception through behaviour. I asked the cast to bring pictures that related to the targeted conversations we were having. This helped enhance the texture and inform the aesthetic we were building.

My research by this stage had shifted from a socio-political question to a question around identity, with socio-political, cultural, and intellectual complications, considerations, and implications. The foundation for socio-political, cultural, economic, and intellectual challenges beyond the superficial conversation is formed in such a deeply invested exploration of identity and "meaning making."

I then tasked the cast to start documenting specific moments from their personal lives or from the lives of people within their environment (focusing on family and close personal connections), ranging from their happiest to most dehumanizing memories. I also asked the cast to observe and document the social rituals they are exposed to, which could range from actions as mundane as daily grooming routines to cultural ceremonies they have been exposed to. I did this in an attempt to find various containers for the work while also providing interplay between the ritual of performance and social ritual and gesture, which formed part of the critical framework of the project. Many of the elements and layers that individuals were interrogating were at odds with one another; sometimes in interesting ways, and at other times in ways that presented as negative personal contradiction within their lives. In many instances, the conflict was between a prioritization of religious or cultural beliefs. These conflicts forced us to delve into issues such as religious and cultural perceptions of sexual identity, gender and race as performance, heavily entrenched patriarchal sentiments, and gender-based discrimination. The work seemed to exhibit the multiple shades of social factors at odds within the multicultural context(s) of South Africa.

Many of the traumatic incidents and how they were located in the minds of the individuals within the cast related to the socio-political status quo in slightly oblique ways, while others were entirely hinged on it. The work dealt with a range of traumas and/or barriers: physical, sexual, emotional, and psychological abuses; poverty-induced sickness; disease management; and exposure to violent death. However, what was telling was the manner in which trauma was managed by the vast majority of the group or, more aptly, not managed. For instance, the sheer proximity of many of the traumatic incidents (the sites of trauma) influenced how individuals processed their response to it. In some instances, this proximity even worked to re-traumatize individuals—being forced to share a room with one's abuser because of economic conditions, for example, or having to reuse the sheets on which a rape occurred.

Once the cast had discovered what they wanted to confront and explore within their personal narratives, or what they believed caused the largest barrier or personal trauma, we began to test and create the framework of how each story or issue would be interrogated. We imagined the real or "raw" instant as the site against which a creative response would be moulded and crafted.

This is where I believe the interest of my proposed model lies. The process I have described created an "imaginative space" between the "memory" or instance and its negotiation within performance—that space into which the symptoms drain, as van der Walt (2001) put it. The entire process, I believe, led to our understanding and unpacking of this notion of imaginative space. This place between the real instance and its interpretation allows the individuals to negotiate their relationship with the event or instance, rather than allowing it to stay as a traumatic imposition onto the individual's memory. It is in this negotiated "imaginative space" where, I believe, emotional negotiation and eventual emotional autonomy takes place.

This was the very feeling that Mam' Nomonde Calatha spoke about when she recalled the wail of agony that consumed her during her TRC testimony as she recounted the murder of her husband. Sibongile Khumalo's taken over her outcry and turned it into an improvised aria in the opera *Rewind: A Cantata for Voice, Tape and Testimony* by Phillip Miller (2006), and Mam' Nomonde claims now that the moment hovers over the entire auditorium. She then goes on to say that she does not know why, but every time she watches a performance of this opera she leaves feeling lighter (Mam' Nomonde Calatha, personal communication, November 2011). I believe she is able to do so because Sibongile Khumalo extends the "real or raw" of the expression of her trauma, and brings it into an imaginative space in which Khumalo can negotiate; one where she is able to express against, bear witness to, converse with, and ultimately produce a lament, with Mam' Momonde and the entire auditorium bearing witness to the moment all the while.

Now, the next challenge was to find a manner in which each cast member could uncover a means to transpose the moment they were confronting into a creative release.

We also sourced lighter, more joyful moments within the personal narratives of the cast to break up and nuance the emotional texture and reflection of the lived experiences. It became integral to the research to explore the weight of moments that were not steeped in trauma, and that carried deeply positive imprints for individuals. These moments felt important to our efforts to recompose and uncover various aspects of psycho-social identities. Arriving at this conclusion is a significant ideological assertion, intent on producing a more three-dimensional view of the identity of the previously oppressed. There is much post-apartheid thinking that only recognizes non-white identity as a depressive static image. Jacob Dlamini (2009) refutes the notion that suffering was the sole preoccupation of blackness during systematic discrimination. He aptly notes that people lived full lives under apartheid; they loved, married, and even took holidays.

The process also made me readjust my perception of the conditions under which catharsis and emotional autonomy are possible. Initially, I thought

this was something that could or would only see itself out in performance. It became very apparent to me, however, that by bearing witness to each others' narratives within the intensive rehearsal mode, each individual within the process was significantly altered. The public performance went a step further in this negotiation. Actor Raezeen Wentworth described the effect of the presence of an audience as being held emotionally accountable by the audience; it was a new social contract, this time with the audience, outside of the private contract shared by the cast.

Staging the performance

The first challenge that needed to be confronted within the performance of *When we are naked* was the site for performance. I chose to perform in the Wits Main Theatre, and my intention was to transform the space and use it in a way that moves beyond the conventional reading of the proscenium arch stage space. This was to suit and support the nature of the work and to destabilize the audience's expectations, allowing our performance model experimentation to become overtly apparent and present. The Wits Main Theatre also afforded me the opportunity to craft a physical journey, which became a physicalization of the nature of the emotional journey for the ensemble. I had wanted to work within the known connotation of the theatre space to easily draw on the idea of ceremonious presentation, much like the mould of the TRC itself. Working in the theatre also allowed us to operate within the established world of theatre signs and symbols, making it easier to draw on and problematize established processes of ascribing semiotic meaning. By doing this we could directly enter into the language of trope, cultural myth, and stereotype. The performance started outside of the physical building of the theatre, in the theatre's loading bay, and was followed by a ritualized preparation to enter the theatre.

The first moment we see of the performance is in the loading bay of the theatre. There are ten bodies dressed in black under a harsh florescent light. They begin to breathe in sequence and the breathing builds, taking over more and more of their bodies until all ten are bouncing off their heels in a ritualized grunt. This action breaks into a series of childhood games that are played all over South Africa, accompanied by songs in various indigenous languages, and even in Portuguese. The ensemble work their way towards the back door of the theatre, where each cast member performs a symbolic gesture before crossing the "threshold" into the theatre. Once on the other side, the performers begin a verbal rhythm in tandem with a repetitive gesture of ritual, hands flicking open all the way above their heads and coming back down to the centre to connect. The ritual invites the audience to enter, and worked to heighten the audiences' awareness both of crossing the "threshold" and of their preparation to enter and receive the work. In some ways, the ritual represents a granted rite of passage;

it also raised tensions around whether certain audience members felt they had earned the right to enter or, in fact, have transgressed through entry.

The treatment of the space was extremely sparse and physically bare. This created a naked and, at times, hard feeling in the literal space of the theatre. That nakedness served this version of the piece very well, reiterating the exposed and fragile quality of the ensemble's negotiation of personal identity. There was no formal set per se, just props such as zinc tubs, candles, and ropes. The cast was dressed all in black to avoid the specificity certain types of clothing holds. This also highlighted the quality of exposed flesh at certain points in the performance and complete nudity in one instance. We also avoided conventional lighting from the front-of-house position or general rig. We placed lights in strategic positions and, at times, chose a lack of light as an aesthetic and as an atmospheric tone. The sparse lighting seemed to make certain parts of the performance even more ephemeral: fleeting in the active moment of performance, and something one can't quite reach out to.

After a conversation with a few of the audience members who witnessed the work, it became clear that many felt as though there had been an exchange during the performance that they were left with. Some described it as a kind of "heaviness," as if they took something from the cast. This was interesting as we were actively searching for a quality that would leave the audience altered.

However, there is a great deal of scope for the audience to be more active participants beyond just walking within this mode of performance, especially at points such as the ritual of entry into the space. This realization also led me to consider crafting an emotional "de-rolling" (a dramatic technique used particularly in Drama Therapy to detach from a particular emotional state that may have been explore through a dramatic exercise or an emotional re/enactment) or debriefing experience: that is, a moment of release for the audience. That moment of release might have been achieved by affording the audience an opportunity to perceive their experiences, through writing at pre-placed writing stations within the performance space, or by encouraging more physical interaction in the performance.

Responses to the work

I was curious as to how the work had been experienced. In a conversation with one of my respondents, the woman described the work as a multi-dimensional perception that was an hour of visible therapy for the cast. This observation was an important stepping stone towards understanding what had been uncovered through this work.

She challenged me to look further into what sorts of metaphor I can offer cast members to further facilitate their emotional transposition into the

performance. She also commented on the presence of an "otherness" from time to time, which was exciting to experience; those were moments where the cast came out of themselves and seemed to exhibit another "spirit." The use of this word, "otherness," also made me curious about the level of self-awareness the work placed onto the audience. The respondent said that the use of breath in the work also resonated deeply with her and spoke to the area in which the research is centred. She felt that the breath work captured the traumatized state well, and yet she also felt something like absolute relief in moments of deep exhale. There were two physical sequences encompassing breath work that bookended the performance.

The ensemble moments seemed to keep the performers deeply in contact with one another, she added. These moments seemed to have the greatest transcendent quality. Another respondent commented on the working method adopted during the process, and felt it was apparent within the crafting of the performance. The conventional role of the director was brought into question, and a new strength emerged within the working methodology, premising a truly collaborative outlook. This is an interesting observation within the South African theatre-making context, considering the link to the tradition of workshopping and devising work in partnership.

One of the respondents noted that this was the beginning of an entirely unique model of working within this exploration. It transports the perceivably immovable (namely trauma and biographical narrative) into the imaginary—a process of uncovering and negotiating the composition of "being." There might be the beginning of a hypothesis within this work that would allow us to find the means to relocate our thinking around identity, and work towards a more coherent understanding of ourselves as South Africans. The road ahead is long and the shadow hovering over it still deep. The task ahead is to continue to unearth, painstakingly, a deeply resonant echo that guides us closer and closer as a national ensemble to enter into healing.

Conclusion

A great deal of experimentation is necessary to refine and to move ahead on this proposed working method. However, it seems this process in some way has worked to penetrate the narrative of personal trauma within the lives of those who have engaged with this project. This does though remain a tentative step towards understanding our scars as a nation and as individuals. The real triumph would be to place ourselves permanently in a position of control over this narrative. Achieving this goal requires re-crafting, redefining, re-exploring, and refining the expanse of the "imaginative space" so that it can become a

repository for our outcry as a nation in the hope that we can somehow emerge "feeling lighter" from it all. And maybe light enough to grapple with and define ourselves as the nation we dreamed of one day becoming during the darkest days of our continued struggle for liberation.

Acknowledgements

Thank you to the wonderful and generous souls that gave of themselves during this process. I dedicate this work to all those who still live traumatized by the legacy of oppression in South Africa and to my wonderful and brave cast. I am now and will remain eternally grateful and indebted to you.

Notes

1. South Africa's Truth and Reconciliation Commission is understood as a national commission convened in attempt to investigate and ascertain the truth around criminal activities committed during the apartheid era (Homann, 2009). The commission offered an application of amnesty to perpetrators on the condition of full disclosure of their participation in crimes during apartheid and "sincere" remorse for their actions (Homann, 2009).
2. The cast was Lurdes Liace, Raezeen Wentworth, Bulelwa Ndaba, Andisiwe Mpinda, Tshepiso Shikwambane, Khothatso Mogwera, Nyaniso Dzedze, Merriam Leeuw, Lerato Matholodi, and Kholosa Gcali.

Art for Community and Cultural Healing, Sustainability, and Resilience

Excavating and representing community-embedded trauma and resilience: Suitcases, car trips and the architecture of hope

Patti McGillicuddy and Edmarié Pretorius

Embedded, community-informed narrative and arts-based group work has links to non-remedial forms of social work intervention that foreground social connections, as well as individual and community strengths (see Kaseke, chap. 2, this volume). These forms of group engagement also build rich deep stories of lived experience. Much of this type of work in South Africa is focused on the challenge of coming to terms with catastrophic disease and societal trauma, which often manifest in displacement and disconnection from community, self, and the possibility of hope. The right to hope and the right to social care are human rights that background many social rights, the realization of which are profoundly affected by exposure to, and the effects and lack of, traumatic injury resolution. In the context of the work described here, touching on these rights and the reasons why they are so very difficult to realize would require what Makunga Akinyela outlines as post-colonial or anti-colonial therapy approaches that intentionally work to decolonize the lives of persons and cultures traumatized by such colonialization (Akinyela, 2002).

Trauma-informed processes can act as a catalyst, a comfort, a therapeutic intervention, a powerful picture (whether played or drawn or imagined), and a shared pathway to community change. Intentional, responsive, and well-honed use of the arts as a social activation and education strategy has been well documented by South African academics and activists (see Sinding and Barnes, chap. 3, and Chinyowa, chap. 10, this volume). This approach allows for the "doing" of qualitative research by excavating meaning, exploring actors' stories, and building shared or linked narratives to create visceral engaged experiences that build knowledge. Attention to such processes is an essential component of the weaving social, psychological, and political stories that have both therapeutic and social resonance.[1] This de-structuralizing of therapy and knowledge use, and the accompanying and interwoven concept of decolonizing, are elucidated by Akinyela (2002, p. 37) as follows:

> There is much to be gained from thinking through the relationship between post-colonial and poststructural therapies. Just as the post-structuralist writers and therapists are determined to separate from the normative judgments of dominant western culture, so too are we

post-colonial therapists, but from a different position, with a different history and a different trajectory. The work of poststructuralist therapists (White 2001) seeks to question the professional knowledges of the helping disciplines and instead to honour, acknowledge and build upon the healing knowledges of those who seek counselling. Their emphasis on metaphors of story and narrative is resonating with many different communities. (Wingard and Lester 2000)

The post-colonial approach is further clarified by Akinyela, as he reflects on the idea of "peoples at various stages of relationship with the colonial condition" realizing, that in the lived experience of many, generating one's own cultural metaphors and "pockets of freedom" or liberated territories is challenging (Akinyela, 2002, p. 40).

Contextualizing "personal" trauma in communal life

The intentional use of a post-structuralist, arts-based, trauma-informed approach in collaborative practice and care in communities means we are working as social workers in partnership with professions that bring their own bodies of practice—artists, creative arts therapists, directors, actors, musicians, comedians, community developers, poets, psychologists, nurses, and occupational therapists, to name a few. Violence, inequity, and community disintegration are communal and individual concerns—they are relational in nature, impact, and outcome. Attending to these injuries in a fulsome manner, then, requires a collaborative, accessible, non-deliberative narrative response that elevates voice and movement. It requires a lateral way in to find and excavate territories of identity (White, 2005) in which complex experiences bide.

This delicate revelation of complexity is illustrated in the work of Rebecca Campbell (2001), who, when she began her qualitative study of researchers researching rape, was compelled by the realization that the associates she had employed to interview and record women's stories of being raped were vicariously experiencing trauma. In hearing the stories of the research interviewers—the intentional and intent witnesses—she identified two important themes that had not clearly emerged from the original research data. First, that which is often viewed as an individual interpersonal act of violence is also experienced as a communal act of violence, a communal injury that breaks the relational social contract and results in fracture, mourning, and dislocation. Second, being in the presence of the narrators (the women interviewed about being raped) resulted in a vicarious understanding of the profound emotional nature and repercussions of rape, and the fragility and necessity of hope and resilience (Campbell, 2001). These affirmations of the depth and breadth of injury indicate that, even when

trying to excavate this reality, the tendency, and one might argue intent, is to use academic, rational, and interpretive language, which dulls emotional realities and thus minimizes damage, maximizes alienation, and denies access to territories of freedom.

These realities have been recognized in social justice movements and forays into community reconciliation between governments and Aboriginal communities, and, in South Africa, between governments and the Truth and Reconciliation work. All of these processes, to some degree, acknowledge the layered narratives of personal and community injury, as well as the colonization of experience, and all are in need of a revisit as the ability and opportunity to speak and to be heard unfolds (for a revisiting of the Truth and Reconciliation Commission in South Africa, see Gumede, chap. 6, this volume). This unfolding can be facilitated by arts-based group work with collaborative social workers who can develop the skills and vision to work with this interface.

In the last decade or so, we have moved from seeing *trauma work* as the work of specialized mental health professions in specialized clinics to speaking of *trauma-informed practice* (J. B. Moore, 2011; Saakvitne & Pearlman, 1996). This shift has opened up the territory of colony, body, and spirit by recognizing the fact that trauma and its related effects are part of human experience within and across all aspects of life. Trauma has an impact on our survival, our rights to successful inclusion in the enterprise of living, and our ability to form and grow communities. This recognition has resulted in new and renewed partnerships in care between social, psychological, and political sciences, the arts, artists, philosophy, and the humanities.

Trauma-informed group practice with women dealing with sexual assault: Trips and stories

The Sexual Assault Care Centre Counselling Team at Women's College Hospital in Toronto, Canada, has for many years developed and facilitated support and therapy groups for survivors of recent sexual assault. The use of the arts was embedded in these groups through co-creation and facilitation by social workers, creative arts therapists, nurses, and occupational therapists.

It is essential to note that there are three critical factors that must be addressed before engaging in any trauma-related or informed therapeutic work (Herman, 1995; Kaminer & Eagle, 2010). First, it is essential to create a sense of psychological and emotional safety; second, the trauma has to be processed and integrated; and, third, re-engagement with the community at large has to be faciliated. Without the establishment of safety, the successful introduction of the other two aspects is essentially impossible. These aspects must be in place

in any group, no matter the therapeutic approach, and must be consistently incorporated by facilitators at all stages and phases of the group process.

In this particular group, with this ground work in place, a specific creative narrative therapy approach resulted in a shared group activity and shared narrative model that guided participants through the story of a post-assault, storytelling car trip. The group met once a week, over an eight-week period. This "road trip" was co-facilitated for co-travellers who charted territory in story, in art, and in a map of the journey (shared and individual) as they moved to and through emotions, and challenges both personal and social (Cologna, John, & Johnson, 2011).

The concepts of territories of identity (White, 2005), of dominant and forbidden discourses, and a deepening therapeutic understanding of the need for social connection and the reduction of shame, influenced this emerging model. The model was also informed and shaped by the facilitators' lived experience as counsellors, and their own awareness of the effects of prolonged exposure to the stories counsellors hear and the emotions they witness in providing individual therapy and legal advocacy, and working at family/community interfaces. Often stories were about inequity, racism, sexism, ableism, homophobia, poverty, and social class. The counselling staff (social work and art therapy) wanted to shape a group opportunity and experience that could bring all of these stories to the wisdom of the group while incorporating an anti-oppression, feminist lens throughout (Cologna et al., 2011). An important component of this approach is the establishment of a non-expert facilitative positioning, which forefronts curiosity, respect, self-reflection, collaboration, and the emerging development of embedded ways of knowing.

The participants' road trip starts with the invitation to join and be in a shared space, and to make an intentional choice to be part of something that may bring communal resonance, emotional intensity, and opportunities for hope (Cologna et al., 2011). Group membership is voluntary, and members are usually in individual therapy and have had at least six to twelve months to begin to deal with the effects of traumatic events. Individuals who have suffered recent or past assault and abuse are included. The women are representative of those in the large multicultural city of Toronto in terms of culture, race, immigrant/refugee status, Aboriginal/First Nations origin, sex/gender orientation, age, ability, health, and social class.

The stages of group development and of the emotional, social, and political journey are embedded in the travelling challenges participants face along the way. There are opportunities to name the hills, valleys, swamps, caves on the trip—to draw them individually and together, to tell and hear stories about what happened, what happened because this happened, what is happening now, what might happen—and to share fears, losses, hopes, and strategies while the car drives along, stops, and starts as the group members dictate. The stages of

trauma (acute, pseudo-adjustment, and (re)integration; see Herman, 1995) are also addressed in the sequencing of the sites and experiences on the journey. Members have the opportunity to write and tell stories, work with art supplies and collage, and participate in a joint mural of the journey while also working on individual pieces that they may or may not share.

The car drive and ride allows for choosing roles, stopping and starting, exploring, and understanding in a way that helps these complex stories to merge. This approach is essential when the nature of harm has involved a lack of consent, forced bodily intrusion, disrespect, and compounded acts of injury— being forced to be "in place." The evidence of survival, when one does physically do so, can seem a self-betrayal of consent. This is not about consent, of course, but about the territory of the soul, body, and mind being indefensible in very particular and very political ways, and which require careful externalization to renew or establish territory. As the facilitators describe:

> Employing the art helped thicken and deepen their alternate stories even further [than was possible with a narrative and non-structural approach alone] creating tangible scaffolding for this process. By using the overarching metaphor of the Road Trip, and richly illustrating this metaphor through creativity, our aim was also to create a sense of fun and play, even while navigating some rough terrain. (Cologna et al., 2011, p. 33)

Engaged therapeutic participation that supports the experience of being together (reducing shame, building trust, hearing and speaking, creating art) and feeling empathy without feeling flooded by very difficult stories requires expert facilitation and the will of the group to drive. Moving through court appearances, custody hearings, separations, nightmares, job losses—*the worst things, the best things*—allows the complexities of lived experience and layered identities to be in the room for the teller and the listeners. The process allows the communal nature and the deeply emotional injury to be felt—in packing for the trip, filling up at the Self-Care Station, driving through Myth Town, navigating Flashback Lane, spending the Mourning in the City of Grief and Loss, visiting the Geyser of Anger, and finishing with Finding Our Way and the End of the Road trip—everyone gets to prepare, drive, draw, witness, and tell stories, and everyone gets to ride (Cologna et al., 2011, p. 33). Shared agreements about road safety and rules of the road were supported through a GPS system, whereby any member could help the group navigate the road or group process; this system was adapted from Mueller's concept of "angels with attitude," who are able to reflect and guide through respectful co-operation and mutual trust (Mueller, 2005, p. 111). Thus, "there was supported congruence between the process, content and journey of the group which allowed for further deepening of stories, art and experience" (Cologna et al., 2011, p. 38).

For example, the Geyser of Anger visit began with *letting off steam* and included women making clay pieces, as well as incorporating a significant piece of music that resonated with the group and then became part of the journey. The women's relationships with anger were complex and ambivalent, given the nature of the violence itself, previous social censure, and identities impacted by colonialism, oppression, and stigma. Some spoke of cracks in their clay pieces as representing this dilemma, after which alternate stories and images of strength and voice began to emerge. One woman made a mask and spoke of her motivation to make contributions to social change (Cologna et al., 2011).

This group format has proven to be an adaptable and robust way for women who have been assaulted to work together to make meaning that can be internalized without harm; to build and rebuild identities, territories, and plans for survival; and to grow—self-respect and empathy.

Often, narrative arts-based approaches like the car trip provide meaningful metaphors and images of inner and outer life, the telling and witnessing of alternate stories about that which is hidden or lost, the revelation of stories about finding strength and creating protection, stories of resilience, and of moving to hope while recognizing and respecting the parallel realities of fragmentation.

A brief arts-based narrative group (workshop) approach: Shields and Stories

The following is an example of a brief group approach that can act as a catalyst for reflection and change. At the University of Toronto, the Counselling and Learning Skills Service (CALSS) staff (social work, psychology, and creative arts therapy, including the chapter author Patti McGillicuddy), in collaboration with First Nations House (FNH) staff (counsellors, elders, community leaders), developed and offered day-long workshops entitled Shields and Stories. The workshop was offered as an opportunity to speak of stories of trauma using an arts-formed, narrative, anti-colonial approach—and this shield-making activity in particular. Groups of eight to twelve included members who ranged in age from 19-year-old students to community elders 80 years old or older. An elder was present to co-facilitate and participate, and to conduct a beginning and ending ceremony and blessing. Facilitators provided stiff cardboard, mixed media, paints, cloth, and magazines for collage, and group members fashioned a shield in the design of their choice. After checking with each member as to their hopes and (perhaps) fears about the group and the day, the morning was spent creating and layering the shields using the materials and sharing stories. The outer shield was about identities one showed to the world or had imposed by the world, and the inner side of the shield was about identities and stories that

were not usually shared and, perhaps, were hidden. The shields were shown and stories shared about the meaning of the shape, colours, pictures, and symbols.

After this sharing and after lunch, members sat with their shields and told a story they had chosen about themselves and their experience dealing with trauma—often, older people spoke of their time in residential schools or as indentured workers in rural communities, and younger students talked about trying to adjust to life in a large city, loneliness, fear, and dealing with stigma. The shield was part of the story as the teller moved around the shield, front and back, integrating what was seen with what was not seen, and then talking about strength and resilience. Empathy between members was strong, and often expressed with tears, hands on knees, and verbal appreciations. The stories were teachings, as the elder reflected, and wove the stories together.

This workshop format, offered from an anti-colonial, narrative arts-based collaborative framework, is very transferable to other groups at FNH and at CALSS, and can act both as an entry point to further therapy and artistic expression and as a touchstone for those dealing with trauma. The focus is on building people's strengths and providing "a special form of interaction and the 'tools' with which people can discover and build on their own and other's personal resource" (Tolfree, 1996, p. 113). The creation of narratives or "storying" is an imperative part of human existence, culture, and survival. Somers (2008, p. 63) captures this idea brilliantly as sustenance, when he says, "story acts as a placenta that connects our inner world to the world outside, the medium through which our thoughts, feelings and knowledge of the outer and the inner pass."

Trauma-informed group practice with migrant children: Suitcases and finding place

Trauma-informed practice in migrant communities can involve the use of a reflective intentional and reflexive arts-based approach to building comfort and voice. This practice uses creative, interactive modalities, which are sensitive to developmental stages and allow time for engagement and integrated use of imagery and metaphor.

Given the misfortunes associated with war, displacement, disease, famine, and economic and political instability in many countries worldwide, children are most vulnerable to being deprived and exposed to trauma. As a result, children and youth, whether accompanied or unaccompanied by relatives, have become part of migration globally. South Africa is a promising destination for migrants in Africa because it is considered to be the economic hub of the region. In 2009, the crisis in Zimbabwe deepened as political instability and

violence grew, schools closed, and a cholera epidemic raged, and the influx of unaccompanied children in South Africa reached proportions that resembled a humanitarian emergency. In 2011, the International Organization for Migration (IOM) reported that worldwide IOM offices had assisted approximately twenty thousand unaccompanied migrant children between 2006 and 2009. Of that twenty thousand, approximately seven thousand received assistance in Zimbabwe at the Beitbridge border crossing (International Organization for Migration, 2011). It is challenging to estimate the numbers of migrants (including children), as most are not registered at border crossings, instead entering South Africa in unofficial ways. Families are often exposed to exploitation by the so-called "facilitators" who pretend to assist them in crossing the borders, but who confiscate their belongings and money instead; attacks by wild animals; and in the case of South Africa, are in danger of drowning when crossing the Limpopo River. Those who do arrive most likely have unsafe lives ahead of them, despite the legislative responsibility of the South African government to offer foreign children protective measures similar to those offered any South African child (for further discussion, see Pretorius and Kellen, chap. 4, this volume).

Studies within public and private schools in South Africa (Ensink, Robertson, Zissis, & Leger, 1997; Peltzer, 1999; Seedat, Nyamai, Njenga, Vythilingum, & Stein, 2004; Shields, Nadasen, & Pierce, 2008; Ward, Flisher, Zissis, Muller, & Lombard, 2001; Ward, Martin, Theron, & Distiller, 2007) comment on the fact that, by adolescence, approximately half the population of all children in South Africa might have been either a victim of or a witness to trauma (Kaminer & Eagle, 2010). Thus, trauma-informed education is essential for all children, and migrant children in particular are unlikely to enter trauma-free environments. Despite the ability of children to apply a range of coping strategies when confronted with difficult situations, Kaminer and Eagle (2010, p. 122) claim that "the fact that aspects of their bodies, minds, and brains are not fully developed means that they are often particularly vulnerable to trauma." When working in the field of children and trauma, developmental differences in trauma presentation are apparent. It is useful to consider the various stages of development in the life cycle when planning service delivery in this field (Eth & Pynoos, 1985), as well as providing for emotional and psychological safety, processing, and integration and (re) engagement (Herman, 1995).

Despite the creation of an emotionally safe environment, migrant children often hesitate to disclose experiences. The reluctance might be attributed to denial and/or suppression because of concerns about retribution and the high risk of reliving the trauma. Therefore, the approach has to be alternative, developmental, and iterative. When giving voice to the trauma experienced, White (2005, p. 11) argues that it should not contribute to the "reinforcement

of the negative conclusion they hold about their identity and about their lives." If trauma is prolonged, compounded, and/or complex, the challenge of not unintentionally reinforcing or of breaking down established ways of resilience is accelerated (Herman, 1995; Saakvitne & Pearlman, 1996).

The challenge is to establish a context in which migrant children will feel safe enough to build comfort and give a voice to their experiences without being re-traumatized, so that opportunities can be created to allow children to find what White (2005) calls alternative "territories of identity." White asserts that he "consistently found that when children have territories of identity available to them ... they engage in powerful expressions of their trauma and its consequences ... which provide an antidote to the sense of shame, hopelessness, desolation, and futility that is invariably reinforced in the context of re-traumatization" (White, 2005, p. 12).

The challenge for social workers and other service providers is to find alternative approaches that actively acknowledge the children's responses to trauma. It is important to understand what particular children hold precious and what gives value to their lives. Their responses may reveal knowledge about survival, resilience, and skills in the "preservation of life in life-threatening contexts, finding support in hostile environments, establishing domains of safety in unsafe places, finding connection and a sense of affiliation with others in settings that are isolating and healing from the consequences of trauma under conditions that are unfavourable to this ..." (White, 2005, p. 12). The knowledge and skills applied by children when in traumatic situations are usually not independently constructed, but are significantly formed by familial, community, and cultural ethos. Partnerships with parents, other adults, and children who have been exposed to trauma, help to form a culture of voice or silence, punishment or hope. When these responses to trauma are acknowledged for what they are, possibilities to find alternative territories of identity are opened up. Children are not merely victims of their circumstances, as they have the power to make contributions to their own healing and recovery from a place of safety.

The work done with refugees by Tolfree (1996) supports the views of White (2005) and provides a cornerstone for this alternative approach that is firmly based in a developmental perspective. It does so by aligning with the values, principles, and lexicon of the strengths perspective, which emphasizes resilience and right to thrive (Saleebey, 2009). This is an alternate narrative to the stereotype of refugee children as helpless, passive, and traumatized. The case study described here was informed by Tolfree's approach in working with refugee children.

In 2001, Glynis Clacherty started the Suitcase Project as a psychosocial "support through art" project with refugee children in Hillbrow, Johannesburg, South Africa. Hillbrow is a high-density populated area that contains relatively

inexpensive high-rise apartment blocks, many of which are neglected and have no municipal services. The area is characterized by crime, illegal drug trading, violence, and poverty. Many of the apartments are overcrowded, with three-roomed apartments sometimes occupied by up to fifteen people. The children who participated in the project lived in two large neighbouring apartments, which the Jesuit Refugee Service used to use as an informal "shelter" for unaccompanied minors. These children had been met by one of the facilitators during a research study on xenophobia, which highlighted their need for psychosocial support. This is an excellent example, as with the work of Campbell (2001), of the reflective and responsive link between social science research and social work practice. It was decided to meet with the children informally once every second month (Clacherty, 2004; Clacherty & Welvering, 2006), and the suitcase group and project began.

At its inception, the group included eleven boys and nine girls, ranging from six to eighteen years of age, with the majority being between eleven and sixteen years old. One of the female members was a mother and brought her infant with her. The countries they had travelled from included Angola, Burundi, Democratic Republic of the Congo (about half of the children were from DRC), Ethiopia, and Rwanda, as well as South Africa. The children were initially uncomfortable and ambivalent, and often denied their identity as refugees, resisted any kind of feeling expression games, and clearly articulated that they were not prepared to tell the stories about their past difficulties (Clacherty, 2004). The facilitators and children were joined by an art teacher who used an open-ended mixed media approach, introducing opportunities for the children to engage in many different kinds of materials and techniques. The facilitators decided to use used suitcases purchased from second-hand shops to facilitate the process. As Clacherty (2004, p. 5) explains, "A suitcase is about a journey; all the children had taken journeys. A suitcase also has a face that is opened to everyone to see and a hidden space inside that we can choose to expose or not." Welvering (2006, p. 157) says that the therapeutic intentionality of the use of suitcases "was most deliberate.... these objects inherently signified many of the issues surrounding the lives of these children." The suitcases also allow for the type of metaphor and meaning associated with the shields and car trips described earlier in this chapter.

The group met weekly on a Saturday morning for twenty-four weeks at an accessible local school. The process incorporated both artmaking and storytelling. Clacherty (2004, p. 5) reflects that "the children needed to tell their stories, but they needed an approach that would allow them gently and over a period of time to reclaim and integrate their memories and restore their identities." Children had the opportunity to tell their stories to one of the facilitators, who sat under a tree in the school's courtyard whilst the other was

facilitating the artmaking process. There was always a choice to tell or not to tell, details were not probed for, and it was accepted when a child wanted to stop the storytelling (Clacherty, 2004). Once trust was established, a variety of stories were told. Some took about six months and others over a year before they felt comfortable enough to tell stories.

The suitcases created an opportunity for the inner and outer worlds of these children to connect and to bridge through the work of "storying" and "art-making" individually and in a group. Welvering (2006, p. 158) confirms that the suitcases were "powerful, personal representations of the individuals who made them ... [because] their own personal histories were invalid within the South African context." From the perspective of trauma theory in community practice, this process allowed for safe parallel play and an opportunity to be "in place" with self and others, rather than displaced or on the move.

The context in which the suitcases were used was carefully considered. Children chose the suitcase they wanted to work with. A "window activity" format was initially used to guide the children. They decided what they wanted to show in each window, and drew a small picture in the window. Thus, the starting point was a portion of the outer shell of the suitcase. Children were asked to represent their present lives as **the story of my life now**—on the outside of the suitcase. It was believed that starting with the children's lives in the here and now was emotionally less threatening for them. For about four weeks, children used mixed media—drawing, painting, wax resist, and printing—to make images that told the stories. These images were pasted on and further decorated with tactile materials like beads, string, cardboard, and mosaic chips.

Clacherty (2004) tells the particular story of a fifteen-year-old boy who was very depressed when he joined the group. He was restless and spent most of the first half of the first workshop wandering around irritating the other children. He chose the only suitcase with no handle. When asked what he was going to put on his suitcase, the answer was "I don't know." The facilitator said, "Maybe you should look at your suitcase and think about why you chose that one; maybe it will give you some ideas." The boy then spent the rest of that group printing many copies with the words "My life is like a suitcase without a handle." During the next group, the boy drew a boy's face with tears and subsequently explained why he felt his life was like a suitcase without a handle. He had found a powerful metaphor and the ability to externalize the conversation (A. Morgan, 2000) about his trauma. A subordinate storyline developed, creating a first layer in the process to proceed with his life in a different way.

For the following eight weeks, children used the same materials to create images of **the story of my life in the past**. Emphasis was on where they came from and the memories (good and bad) associated with the past. These were placed inside the suitcase, creating some distance between the child and the

memory, because the memory stayed in the suitcase and could be closed, kept, not disturbed, ready for alteration, observed, and be added to. The work of art was always the starting point of the story telling and "this created some measure of emotional distance" (Clacherty, 2004, p. 13), comfort, and predictability by allowing metaphors and images to sit beside, to comfort, to deepen, to change, and to represent. This "being beside" allows for a sense of companionship as well as a sense of parallel realities—a both/and experience, rather than a dichotomized experience, creating opportunities for resilience and the building of alternate stories, an architecture of hope.

One of the children mentioned, "When we draw, you don't just draw. We draw how we feel at the time. We express our feelings in the pictures." Another stated, "When we talk about our mothers who had passed away it makes us sad. We need the time to be right to talk about those things. There are certain stories to be told and some not to be told." These reflections allow facilitators to ask questions that are likely to trace the history of the challenge experienced, explore the effects of the challenge, deconstruct the challenge, and by listening carefully, become aware of when the challenge had less or no influence (A. Morgan, 2000).

Once they were satisfied with the outside and inside of their suitcases, the children made sets of small journals in which they would draw particular issues that they felt troubled them. They also constructed objects from clay, paper mâché, and wire. Welvering (2006, p. 158) notes that

> the individual suitcases became significant ... as metaphors for their identities ... as powerful representations of ownership—ownership of identity, ownership of physical space, ownership of [and a home for] something special and treasured- something they could take with them wherever they went; that they could manipulate and change and "grow"; a concrete place where they could leave a sign or trace of them-selves; their own private place where they had the power to make a difference.

At this point in the process, a weekend retreat was held that focused on traumatic memories for which the suitcases formed the core of the work. Experienced counselors and a psychologist trained to work in a more conventional way with trauma (with the intention of creating an opportunity for the children to unpack traumatic memories should they be ready to do so) facilitated the process. White (2005) notes that children are often reluctant, as are adults, to speak about their traumatic experiences because disclosure might result in retribution, and the risk of reliving the trauma and being re-traumatized is too high if it is not guaranteed to be done in a psychologically and emotionally safe way. One of the children mentioned, "It didn't help me.

She (the psychologist) just wanted me to cry about it. I got bored so I did and then she (the psychologist) felt better." Another child lamented, "When we told them something they forced their way to ask about things we didn't want to say."

In contrast, the children reflected on what the Saturday workshops offered, and one commented, "You don't get pressurized here to do something. It is fun." The children were doubtful about any intervention that appeared to be therapeutic or healing. The importance of trust and choice cannot be underestimated in working with refugee children. At the same time, this opportunity did illustrate to the children that there was a genuine interest in hearing about the trauma, and that the opportunity to do so would be provided. This pause to focus on the trauma more directly was not entirely successful, perhaps in part because new facilitators were introduced late in the group life, and in part because this change in approach was not necessary to the process already in place—a process that successfully led to the next difficult stories about their journeys to Johannesburg.

The story of my journey to Johannesburg was told over the next six weeks. To portray their journeys, children made large, hand-made creations by building a collage with drawn images and magazine images. While they worked, with each image carefully considered, children had time to think about and reflect upon what were probably their most painful, fearful, and traumatic stories.

A child who had survived the Rwandan genocide carefully cut out many pictures of shoes and sandals. When telling his story, he explained, "These shoes remind me of walking and walking and that I survived that walking, I was only ten years old but I survived the walking." The images of shoes and sandals became part of the subordinate storyline layering and deepening the story. The ability to do this layering often gives children energy, a springboard from which to choose action and proceed as survivors. The development of subordinate storylines creates opportunities to restore a sense of personal agency and to build authentic resilience (White, 2005).

The final six weeks were focused on looking to the future: **Where am I going to take my suitcase?** By tracing around one others' bodies, members of the group made large drawings of themselves with their suitcases in their hands. They answered questions about where they were going with their suitcases by layering images in the body maps and reflecting on these. This activity assisted the children in moving from the past to the future, and many of them started making specific plans for the following year. The older group members became particularly mindful about their emerging, near futures and made tangible plans. Two boys over eighteen years old, one in Grade 9 and the other in Grade 10, were worried about the quality of education they were currently receiving, with one reflecting, "I know I am not going to achieve my dreams if I stay in that school. Even the principal said to me I should find somewhere else." They took

responsibility, gathered information, and moved to a local technical college where they were able to achieve their goals.

Another participant who, for many sessions, did not want to do any art but stayed connected by helping with other tasks, asked the facilitator after a workshop to bring her a big piece of paper the next week, because "I have a very big story to do next week."

During the next four workshops, secluded from other participants at a corner table but within the physical presence of the facilitator (who did her own artwork at the other end of the table), the girl worked intensely and without interruption on a collage. She then volunteered to tell her story. After telling the story, the collage got another layer of tissue paper. As Clacherty (2004, p. 13) commented, "this layer looked at what she had with her then to help her survive and what she had now to help her with her bad memories." She was then able to move on and started to make future plans, indicating she was going to set up a small business selling clothes on the street with her foster mother.

In conclusion, it is important to remember that these children have resilience beyond expectation and that they are not victims at this point, but survivors. The children's artwork was exhibited twice to raise awareness about the lives of refugee children. During and after the second exhibition particularly, the children from the group had a very positive opportunity to integrate with outsiders: with community. They freely opened their suitcases and shared the contents of the suitcases with a group of academics from a local university who visited the exhibition (Clacherty, 2004; Clacherty & Welvering, 2006). This, again, thickened their lived experience and their stories without re-traumatizing them (A. Morgan, 2000; White, 2005), and brought them to community as members of the community.

The project also became part of the public domain when it was profiled in local newspapers and when the book *The suitcase stories: Refugee children reclaim their identities* was published in 2006. The children were proud of their roots and where they had come from, and this publication enhanced their self-worth, self-empathy, and sense of relationship to self and others. Throughout, the children were in control and had power over their lives: "[t]hey were involved in setting up the exhibitions ... and used their power too, informing a photographer from the *Sunday Times* [a local newspaper] that he could not photograph their faces" (Clacherty & Welvering, 2006, p. 173). The significance of such claims for control over self-representation is discussed in Fudge Schormans (chap. 11, this volume).

The group process was intentional in explicitly fostering two levels of social interactions. The first was to create an environment in which trust relationships with the facilitators could develop, as many of the children had experiences of

grief due to the loss of significant people in their lives, or had been let down by adult service providers who promised, but did not deliver. Facilitators attended the meetings as agreed upon, and were very careful not to make promises on which they could not deliver, demonstrating consistency, and the children began to reciprocate. Secondly, the children were encouraged to support and care for each other. It was evident that "the group became almost an alternative family for most of the children" (Clacherty & Welvering, 2006, p. 176). The building of relationships within their immediate community was also promoted through the process, with the older boys becoming involved in a local church that ran children's holiday workshops in the community, and through the bringing of the project to communities. In this project, the combination of artmaking with narrative allowed the children to create "thicker" and alternative stories in which they were more than "just a refugee."

The Suitcase Project, as with The Car Trip and the Shields and Stories work, illustrates that when excavating and co-representing community trauma, a group approach that is rooted in respect, resilience theory, and arts-based narrative methodologies can be very effective and life-affirming.

A word on trauma-informed care and the caregivers

Secondary or vicarious trauma and compassion fatigue (Figley, 1995; Saakvitne & Pearlman, 1996) are concepts that have evolved in the past two decades, as social workers and others engage in work that is centred on being with people who are traumatized, and witnessing and being in traumatic situations. The act of "being with" has very particular repercussions regarding a reduced sense of efficacy and opportunity for resolution. Programs using the arts and humanities approach have evolved for care givers, healthcare workers, social workers, and researchers and educators as well (Campbell, 2001; McGillicuddy et al., 2011), all of whom employ narrative arts-based approaches to reduce vicarious trauma, foster meaning and hope, and enhance the capacity for emotional support in collaborative teams. For example, J. Bronwen Moore, an occupational therapist and visual artist, has written and illustrated a comic in graphic text entitled *Superheroes: Healthcare workers walking the walk* (2011) that includes the results of her research interviews with healthcare workers and chapters with titles such as "Supertherapist Battles Burnout!" She comments, in her comic book persona, "after all, arts-based research is all about trying to make a real-world difference" (J. B. Moore, 2011, p. 40).

The use of arts as healing in and of themselves, from comic to classical, and as part of human expression and the human condition, can strengthen our sometimes weary relational bridge of empathy. Such narrative community and

self-care can include the reading of poetry, plays, and novels in reading groups (Polkinghorne, 2001). Ronna Bloom reflects on this work and our relationship with self and other in her poem entitled "Just This":

Just This

A friend says she thinks we're not wired
for this much intimacy, for knowing so much
about so many lives. Last week I joined her
in the group she runs, all the women survivors
of violence: one-off randomness and deliberate
consistent relentless assault. She is gentle in the room
almost whispers and this is what she offers:
a space for them to speak or not, to cry or not,
to leave or not, to listen. It sounds cliché but the space
for pain is underrated.
A voice in me was crying: this is what I always wanted
my family to be, just this: a room and five people in it,
and enough quietness to hold all the shrieking
or all the fear or all the desire or all the love,
a room with people in it.
Ronna Bloom (*Personal Effects*, Pedlar Press, 2000)

A room with people in it, the right to be part of life and to come and go from community with confidence, to comfort and be comforted—this is very much part of the care needed when one is excavating trauma and building resilience.

Discussion and Conclusion

The tolerance for story and image, for being present in a room, the right to peace and belonging to create and move through pathways, is so much part of *social work*. Perhaps this breaking down or disassembling of what is "primary" and what is "secondary" is part of an emerging recognition, a shared discourse, fuelled by joint experience and joint creation, of the nature of harm—and of hope. Not the dichotomized co-opting, dulling, or disenfranchising of experience; rather, a deepened sense of what is communal and what can be valued and planned for. Art, then, forms part of the human learning process and allows people to get in touch with feelings that are challenging to express in words. It is a medium for communication that contains and evokes powerful emotions. As Waller (2006, p. 272) notes in working with children, "the process of art making [in a group setting] and the interaction amongst members ... can assist in the acquisition of social skills and lead to behavioural change." This is the territory of social work, social labour, and of the creative soul.

These stories of group work are about the right to moving and being still, having a place to speak from, and persons to speak with. Harm to community and community resilience can tend to be disguised or interpreted within individual, family, group therapeutic interactions that do not acknowledge shared experience, histories, and inherited culture. Individual acts of violence can be based in and result in community injury, and the profound emotional nature of these acts are often diluted by psychological interpretation (Campbell, 2001).

This displacement of trauma does not allow for the acknowledgement or emergence of resilience, and can serve to invert and disorder the lives of those affected (Pearlman & Saakvitne, 1995).

The architecture of hope takes many forms—as a journey, a car trip, many pairs of sandals, a suitcase handle, a folded note, the faith of the counsellor, the vision of the anti-colonist, the strength of the storyteller. Trauma is usually acknowledged by the state only in terms of individual effect or damage, or perhaps heroism. It is the unacknowledged, as it exists within and across both intimate and political realms, which requires creative voices and synergies to form within and across communities. This excavation and illustration is often the work of artists, therapists, educators, healthcare workers, community care workers, and social workers. There is a great deal of opportunity and hope here as we bring these discourses, skills, and tools together with our client co-travellers, our colleagues, and our communities.

Acknowledgements

The authors wish to thank:

- Glynis Clacherty, a well-respected researcher who specializes in participatory work with children. During the past fifteen years, she has worked with children from different provinces in South Africa and other African countries on issues such as migration, violence against children, poverty, HIV, and AIDs.
- Ronna Bloom, a poet, teacher, and psychotherapist, as well as the Poet in Community at the University of Toronto and at Mount Sinai Hospital, Toronto, Canada. She has published six books of poetry, the most recent of which is *Cloudy with a fire in the basement* (Pedlar Press, 2012).
- Marilyn McCallum, a psychotherapist and creative arts therapist in Toronto, Canada, who, when working at the University of Toronto, co-created and co-facilitated with the Counselling Service and First Nations House staff, the Swords and Shields workshops.

- Lillian McGregor, from Whitefish River Birch Island, former Elder-in-Residence, University of Toronto, who was pivotal to the work at FNH.

Note

1. See McGillicuddy, Johnson, Jensen, Fitch, & Jacobs, 2011; Saakvitne & Pearlman, 1996; Barnes, chap. 8, Pretorius and Kellen, chap. 4, Jackson, Ryan, Masching, & Whitebird, chap. 9, and Gumede, chap.6, this volume.

Performing understanding: Investigating and expressing difference and trauma

Hazel Barnes

Theatre has traditionally been a way for humans to explore and express their understanding of themselves, their interactions with each other, and with the environment. Finding an appropriate metaphoric expression—an evocative way of naming experience—is one of the ways in which humans come to terms with the fears and confusions of being in the world (Jones, 1996; see also McGillicuddy and Pretorius, chap. 7, this volume). Theatre does this in such a way that the aesthetic of the form is of equal, if not more, weight than the content, and audiences are invited to respond unobtrusively. Applied drama and theatre, on the other hand, intentionally sets out to engage with social and human problems through the unique role-playing abilities of humans, which ensures their active participation in the solving of problems. Chapters in this volume by Chinyowa (chap. 10) and by Harms Smith and Nathane-Taulela (chap. 5) also draw on these features of applied drama and theatre.

The focus in such cases is on the process of discovery rather than the end product, but in many interventions both the exploration of the issues causing unease and their presentation through the aesthetic form of theatre are considered important. This chapter examines two different examples of interventions undertaken in the years immediately after the establishment of democracy in South Africa, during which participants engaged with drama and theatre as a means of investigating and expressing both difference and trauma in order to gain insight and understanding and, possibly, new ways of being and inter-relating.

The first intervention, which resulted in the production *Inhlanzi ishelwe amanzi—As fish out of water,* occurred in response to problems of difference experienced amongst students at the then-University of Natal.[1] The particular challenge of the late 1990s in South African universities was one of transformation from being predominantly white or black institutions to ones that encompassed and facilitated diversity. My interest was in what part theatre and drama could play in opening up dialogue and understanding between students of different cultures who had almost no knowledge of each other's lives and life circumstances, due to "separate development."[2] The second intervention was a response to evidence of trauma among adolescents and young adults from the local townships of Pietermaritzburg. One consequence of the oppressive violence of the Nationalist apartheid government was a

struggle for power in the 1980s between the ethnic Zulu grouping, known as Inkatha, and supporters of the more inclusive United Democratic Front and the African National Congress. This struggle for power was aided by government forces bent on exacerbating what was known as "black on black" violence. This violence was evident in the major cities and particularly in Johannesburg, where migrant workers were thrown together through the availability of work. Pietermaritzburg in the heart of KwaZulu-Natal, the territorial home of the Zulu nation, experienced its own escalation of violence culminating in the "Seven Day War" in the surrounding townships, which killed and displaced hundreds of people (Mazel, 2010; Merrett, 2010). As a result of this violence and the increase in crime that occurred during the 1990s, many South Africans experience ongoing trauma and persistent stress response. My interest here was to work with the Programme for Survivors of Violence in an attempt to use drama and theatre as a healing medium.[3] For another example of drama and theatre in healing, see Gumede (chap. 6, this volume).

Inhlanzi ishelwe amanzi—As fish out of water

In 1994—the year in which the first democratic election was held in South Africa—our learning spaces presented us with a microcosm of the effects of apartheid on young South Africans, particularly in terms of the silencing of educationally under-prepared black students having to learn in a second or third language and an increasing sense of alienation amongst white students. As might be expected, the prejudices of the past still existed despite a willingness to meet as equals and a welcoming of recent political changes. The forced separation of apartheid had resulted in cultural polarization, exacerbated by fear and ignorance of the "other."

Drama carries particular possibilities in a context like this one. The experience of drama demands group co-operation, the courage to reveal oneself and make use of one's personal experience, and the energy to empathise with others. It demands a democratic setting and individual responsibility; it requires and makes possible justice-oriented teaching and learning, as articulated by bell hooks: "Making the classroom a democratic setting where everyone feels a responsibility to contribute is a central goal of transformative pedagogy" (1994, p. 39). Through facilitation that emphasizes dialogue and problematization (Freire, 1970b), this medium has the potential to create a greater depth of understanding, tolerance, and compassion.

The social changes brought about by the election of a democratic government challenged us as drama academics to find different ways of engaging students in creating meaningful contemporary theatre, in thinking about the nature of performance in Africa, and in using drama as a development tool. A number of

innovative projects were carried out, amongst which was a devised performance undertaken with the Walk and Squawk Performance Project, a two-woman company (Erika Block and Hilary Ramsden) based in Ann Arbour, Michigan and in London, Britain. They were invited for a three-month residency at the University of Natal, during which they were to train a group of students in Physical Theatre and to facilitate a performance based on the themes of culture, geography, and identity.

I intend to focus on two aspects[4] of the process of workshopping this performance: namely, methods for raising racial and cultural issues, and the appropriateness of the Physical Theatre form for multicultural expression.

Raising issues of race and culture

How does a facilitator raise racial and cultural issues with a cast involved in improvisatory work in a way that leads to multicultural understanding and mutual respect? And, especially, how is this done in a context of profound racial and cultural injustice?

An important preliminary is to establish a dialogic relationship amongst all involved that is inclusive and democratic, and through which trust and respect can be built. Creating the special safe space of the rehearsal floor, which includes confidentially and openness, is another. This was done through establishing ground rules of mutual respect and equality. As with Boal (1979),[5] the first emphasis was on working with the body. This included building group cohesion through physical exercises,[6] which required a sensitivity towards and awareness of others, and of oneself in relation to others. It was interesting to see how quickly the group bonded through close physical co-operation before any sharing of feelings or experience was attempted. The energy engendered by this vigorous physical involvement created a lively, playful atmosphere. These exercises provided an ideal space for individual creativity to be shared and modified by the group, and were basically inclusive—everyone contributed. The emphasis on playfulness released the participants' energy, allowed them the freedom to make mistakes, and encouraged inventiveness.

As the group moved to towards discussion and sharing of experience, listening became an important part of the interaction—doing so carefully, giving the speaker one's full attention—and also allowing silence, refraining from easy answers, and thus acknowledging the existence and pain of injustice.

Specific techniques were used to engender material for the performance. One of these was brainstorming around specific themes. Verbal and written brainstorming alternated with exploratory improvisations, during which specific themes raised were embodied. Through careful observation of embodied representation and through questioning interpretations of embodiment,

students were encouraged to analyze critically the themes expressed. The facilitators asked students to consider the problems and struggles made visible, and also those hidden, by each representation. They also pushed for the specificity of sensual and felt responses, as well as for raising the investigations to a metaphoric level. Another technique used was word association: students were given words such as "home," "culture," "geography," "identity," "tradition," "language," "western," "South Africa," "myth," "land," "taboo," "gender," "race," and "money," and asked to respond. Improvisation, incorporating the physical use of the body and voice in combination with the intellect and imagination, was the basic workshopping tool and was used as a holistic form of exploring issues and generating material. For example, in response to being asked to improvise around the word "tradition," various traditions from different cultures were performed—a Hindu student performed a meditation exercise; African students performed traditional songs and dances, preparing for a ritual, and the throwing and reading of a diviner's bones; white students performed their sense of lacking tradition ("culture is something other people have")—and, at the same time, attitudes towards tradition became apparent. Some students expressed the comfort found in tradition, while others realized a sense of constriction and limitation. During the rehearsal period, students showed an increase in physicalization, in contrast to their initial reliance on language, as the chief medium of expression. In fact, non-verbal expression proved to be much more effective as a demonstrative language, and justified the emphasis on the use of this form.

Students were also given writing exercises. The first requested them to relate an experience of frustration—an incident in which a strong personal wish had been thwarted.[7] The reading out of these stories deepened the level of personal knowledge of one another within the group. It also aroused a depth of feeling that frightened some, and time was taken to discuss this response in detail. The facilitators emphasized both the humanizing effect of the "act of knowing" (Freire, 1970a) and the importance of understanding personal experience within a socio-political context. On the inner, psychological level, they pointed out that the acknowledgment of vulnerability leads to strength and that strength also can be found in community. As one facilitator said, "We are building a community right here, we are creating community and connection which is important because it is so rare and so needed by people" (Ramsden, facilitator). On the outer socio-political level, they stressed context and the creation of form: "We give people tools so that they can take raw emotion and turn it into art. Form gives context and perspective, explores how your story connects with the others' context and perspective" (Block, facilitator). The level of trust amongst the students was high, but they were unsure about developing their individual stories for a public audience and so the students were further

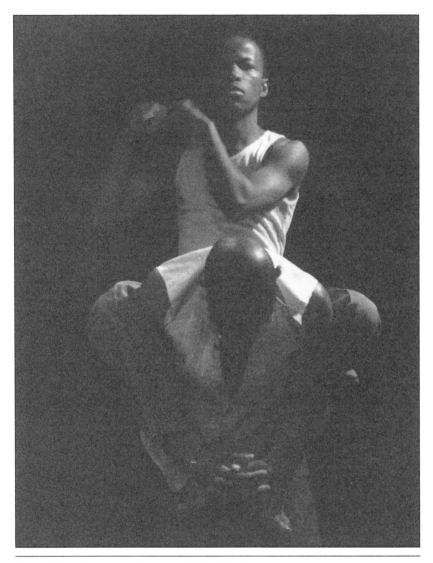

Figure 8.1 ❖ Canoeing. *Courtesy of Erika Block*

protected, if they wished, by not necessarily having to work with or perform their own story.

To create an awareness of context, the students were then asked to think in as much specific detail as possible around the incident described: what they were wearing, the weather, a political event, what smells were there, and so on. They were asked to choose one of these and write ten sentences of minute detail about this focus. The students were then asked to observe each other and note

what natural, spontaneous gestures were used in the telling of these details. These gestures were discussed after each telling, and the students were asked to choose three or four to weave into the performance of their stories. These gestures were then explored through physical exercises—they were mimed in detail, exaggerated to involve the whole body, and reduced to a minute size. The order and pace of the gestures was varied. The students then were asked to summarize their stories in three or four sentences, which were supposed to convey the essence of the experience. Sentences and gestures were then put together, and the possibilities for image and counterpoint explored. For example, contrasting stories might be performed in relation to each other, creating a composite, layered representation of different attitudes, or, similar experiences might be placed together to form emphasis or to create humour. Through this technique, the facilitators allowed the participants to explore painful experiences but provided them with a means of relating the personal not only to the variety of experience within the group, but also to the wider world in terms of the context of that experience.

The experience of living in a post-colonial society emphasizes the need to understand that one's personal experience and cultural traditions are not universal, but culture- and context-specific. The mindset of apartheid implied that any values or ways of being other than those of the colonists must be inferior. Seeing one's own experiences in juxtaposition to those of other cultures (which was denied during apartheid) develops perspective. Thus, context (the specific circumstances shaping an experience) was also stressed as an important element in the understanding of culture and in communicating experiences to an audience.

Another writing exercise involved a stream of consciousness exercise in which the students were given particularly emotive subject matter that had arisen during discussion and improvisation. The subjects were carefully chosen and given to the particular students for whom they were troublesome. Topics included "white guilt," "education," "love and marriage," "rural versus urban," "the generation gap," and "skin colour." The reading out of the writing that resulted from this exercise provided an intimate sharing of experience, and led to a number of admissions of prejudice, which had arisen out of painful personal experiences of violence and discrimination. This exercise was a watershed in terms of the level of honesty that the cast had reached, and proved the level of personal acceptance amongst them. They had reached the stage where they could acknowledge and apologize for their class and racial prejudice, and trust that they would be understood and accepted. This more painful aspect of the work needs to be seen in relation to the atmosphere of enjoyment that pervaded the rehearsals, and the satisfaction that the students experienced in learning about each other and forming important friendships.

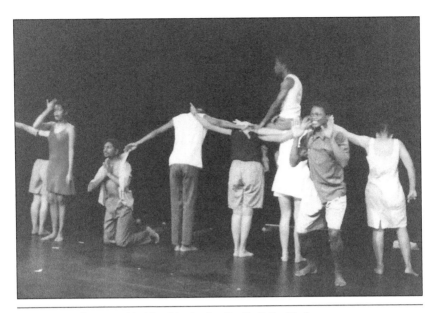

Figure 8.2 ❖ "I went with this white guy." *Credit: Erika Block*

Appropriate form for multicultural expression

In considering the relationship of form to content in the expression of cultural diversity, it became apparent during the *Inhlanzi* residency that Physical Theatre has an appropriate eclecticism.

The fact that the words in the script were all their own, and that those words could be spoken in the language that the actor felt most comfortable with, resulted in meaning being immediate and personal for the performer. The problem of making meaning clear to a multilingual audience was overcome in three ways. When it was felt to be necessary, a second student would give a simultaneous translation; in other words, the text was devised so that content was spoken in two different languages as an integral part of the scene. Second, the theme of the content of such a speech was clearly established beforehand, and intelligent guesses could be made about the content from context and from the action, although the action was never a simple illustration of the meaning of the text. Third, Physical Theatre uses visual imagery through the grouping of bodies, which enhances and enriches understanding.

A formal device that audiences found controversial was the use of overlapping speech and simultaneous staging. At times, two or more performers would give their opinion, or story, at the same time, inviting the listeners either to hear one opinion or to move their concentration from one to another, thereby

gaining an impression of various points of view. An example of this device came in the section on "white guilt," during which three performers spoke. One performer presented her pain as a white South African, tormented by her sense of her culture's responsibility for apartheid. The second, also a white student, gave a cool, intellectually reasoned argument about why she as a young South African could not be held responsible for the actions of her forefathers. The third speaker was an African-American exchange student who spoke of her anger at the imposition of slavery, and her complete lack of sympathy for, or interest in, white guilt. In the opinion of some audience members, this form provided a fascinating analogy of post-colonial thinking in an efficient and engaging manner. Predictably, some were frustrated by the inability to hear every word. We can speculate that this frustration emerged in part from the audience members' difficulty in being able to discern—and more importantly, being able to identify with—a particular view. In Brechtian terms, audiences were denied catharsis, subjected to a distancing device that encouraged them to think of the social and political implications of the action onstage rather than simply to empathize with the characters presented.

In fact, through careful timing, the performers could ensure that the main drift of these speeches was apparent and, in my opinion, the multiplicity of

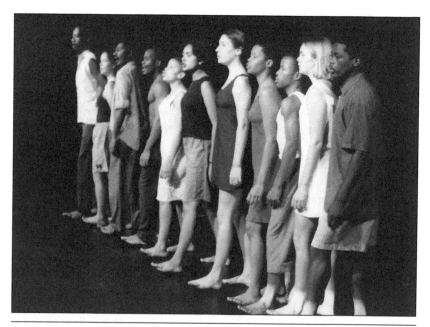

Figure 8.3 ❖ The cast of *Inhlanzi ishelwe amanzi—As fish out of water.*　　*Credit: Erika Block*

viewpoints enriched the theatrical effectiveness. Similar responses occurred to simultaneous staging when two completely different scenes were presented at the same time.[8]

The facilitators were concerned that language not be allowed to become the principal element of form. Focus was also placed on movement, action, grouping, and visual imagery, and on sound and sound imagery as well as on the effects of stage lighting. Doing so presented the audience with a collage of ideas and themes, intricately interwoven and layered. This complexity of form allowed *Inhlanzi* to include and reflect the complexity of experience and response that had emerged as the students explored this material. Not only could diverse attitudes be presented quickly and enhanced through juxtaposition, but the form also allowed for the creation of atmosphere and place, which the facilitators considered an important aspect in the evocation of culture. It also ensured that humour and irony could easily find a place in commentary on the main action. The various elements were woven together as legitimate conveyers of experience, and no single one became dominant. The emphasis on the body in physical movement and grouping meant that the performers themselves gained a metaphorical presence onstage as skin colours mingled and separated, and as bodies supported and opposed each other, and transformed image and meaning—a deeply moving experience for audiences who daily face the challenges of living in post-apartheid South Africa.

The Programme for Survivors of Violence

The Programme for Survivors of Violence was set up in 1992 in response to escalating violence in communities around Durban and Pietermaritzburg,[9] and in recognition of the ways in which violence tends to perpetuate itself. Once exposed to violence, the fear and anger it arouses becomes a trigger for a violent or hate-filled reaction. The PSV's programs intervene in this "cycle of violence" (Botcharova & Johnston, 1998) to find ways of supporting people exposed to violence, and ways of addressing some of the underlying causes of violence through community development. Most of the youth who belong to groups run by the Programme have dropped out of school and are unemployed, and it is essential to develop their sense of self-worth and to equip them with life and work skills.

Dain Peters, the Midlands co-ordinator for the KwaZulu-Natal Programme for Survivors of Violence, has sought to extend the work of this organization into the area of community arts. His vision is innovative in that it expands trauma work beyond an individual focus to include the communal and socio-political, and at the same time it expands community artwork beyond skills development to include an overtly personal and communal healing aspect. It

also expands community development to include both capacity building and income generation through a career development component.

The basis for our exploring the use of art with survivors of violence arose out of the thinking of several key theorists. Herman (1992) emphasizes the importance of recovering lost memories through correctly sequencing the details of the trauma story. Van der Kolk (1984) puts forward the hypothesis that working through a trauma is only successful therapeutically if affect can be engaged, and also that it is only by fully understanding the trauma that an affective link can be re-established between pre- and post-traumatic relationships and events. White and Epston (1990) focus on the importance of storytelling as a crucial component of community building and, together, these writers suggest several important features of trauma-related work. For instance, it seems that recovering the details of trauma quietens their intrusion through flashbacks, promoting healing. Trauma also alienates people from others, leading to the sufferer to feel alone in the struggle for survival. Telling the story of trauma helps to return individuals to their community; being heard, especially by those who understand or have experienced similar events, can lead to a sense of normalization or universalization (Yalom, 1970). The systemic model supports the importance of interventions that consider the interplay of many levels: individual, communal, societal, and global. Telling the story in a way that makes trauma's effects apparent at many different levels can function to bring about personal healing, community building through the sharing of stories, and even institutional social change by revealing the need for legislative action (see also McGillicuddy & Pretorius, chap. 7, this volume).

A pilot project was set up between the KwaZulu-Natal Programme for Survivors of Violence and Drama Studies at the university in September 2000, in order to explore the healing potential of the creative arts. This project included training in basic arts skills in music and drama, the accessing of personal and community stories, the symbolizing and crafting of these stories into artworks, and exploring income generating prospects within communities using skills learned. The project culminated in a public performance, and included a community development task as follow-up. Since then, two similar ten-day workshops have been run. This has allowed us to refine and develop the workshop further, and to become increasingly involved in necessary follow-up development work.

Each ten-day workshop was evaluated immediately afterwards by the facilitators in terms of its effectiveness in personal development, the learning of arts skills, and the creating of a performance. In both workshops, there was evidence of personal growth in the handling of disputes and in the group's ability to interact effectively (see also Chinyowa, chap. 10, this volume). Basic skills were learnt and were evident in the performances, which were considered

effective by the audiences who viewed them. Most of the participants voiced a feeling of pleasure and pride in this achievement and felt that they had succeeded in doing something they had not previously believed themselves capable of. However, in choosing to use the arts as a primary medium of intervention, we did notice certain areas of unease and tension. This was evident primarily in attitudes towards reality and fiction.[10]

The tension between reality and fiction

Dramatic or pretend play in children has long been recognized as a means of exploring possibilities, of testing out ideas and behaviour, and of learning to symbolize. It also enables children to move between the worlds of fantasy and of reality, using the one to reflect on the other, and thereby finding expression for their feelings and obtaining mastery in development (Needles, 1980; P. Slade, 1954; Weininger, 1980). The permeable boundary between reality and fiction is what makes art a useful therapeutic tool: we can pretend to be things we are not and this process can have many levels of truth and fiction (Gersie, 1992; Gersie & King, 1990). Yet, within this group, we noticed a commitment to "reality" that seemed to limit—or raise questions about—the potential for creating art.

Character and imagination: The symbolic representation of individual human experience through the taking on of a "character" seemed unclear to the participants. This came out in terms of incessant questions to visiting performers regarding how they chose an appropriate individual to play a character (i.e., how did they match the real individual with the fictional individual?). Their questions implied that the actor needed to be someone whose experiences and feelings were very close if not identical to the character's. Later when a participant had played an energetic and convincing *tsotsi* (petty criminal), he announced to the audience in the post-performance discussion that they shouldn't come to him if their cars were stolen; similarly, a participant who created and played an HIV-positive character made sure to tell the audience that she herself was not infected.

The ability to pretend and play is well documented in developmental literature as a core process of instruction, soothing, working-through, and empathy development (P. Slade, 1954; Weininger, 1980). In these youth, all of whom are from difficult family situations and are survivors of violence, the ability to pretend seems to be handled in particular ways.

On an interpersonal level, we wondered to what extent the absence of community and familial traditions around imagination had impinged on the participants' ability to be creative and to imagine. It is well known that a lack of personal and social security results in a need for definite and clear parameters,

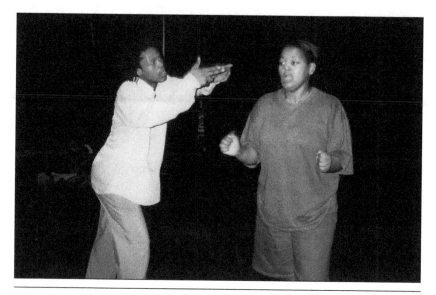

Figure 8.4 ❖ Hijack. *Credit: Hazel Barnes*

and that moral complexity becomes threatening. Amongst the fatalities of apartheid and urbanization are communities, which are fragmenting; and with that fragmentation comes the loss of traditions of social education and integration, rites of passage, oral traditions, and social norms. Television is the predominant cultural medium experienced, exacerbating the loss of ritual and symbolic representation in its relentless presentation of received images.

On an intra-personal level, there are a number of considerations that could influence the ability and inclination to imagine. In some psychological frameworks, the tensions between reality/fiction, inside/outside, and self/other are all indications of ego-strength in the individual. Pervasive early and ongoing trauma has an effect on the ability to concentrate and to control arousal, and on the deep integration of the ego. In the experience of violence, the trauma response can include flashbacks and uncomfortable nightmares. For this reason, the survivor of violence might experience the imagination as being inherently threatening, external, unbidden, and beyond control in a hostile and threatening way. The ongoing experience of such a sabotaging imagination would seem to shape an individual's response to fantasy. In many forms of healing, ranging from mainstream psychoanalysis to alternative therapies and rituals, it seems as if the activation of the imagination is, in itself, healing. Freud regarded the ability to free-associate without censorship to be central to the psychoanalytic relationship and its healing potential, and Grainger (1990, p. 130) defines the imagination as "the raw material of transformed reality." Imaginative processes

lead to learning and change (re-enactment, modelling, mastery), as well as to restraint in the form of sublimation through acceptable artistic expression.

In the literature on creativity (Bellak, Hurvich, & Gediman, 1973; Kris, 1952) it is argued that creativity requires a form of cognitive processing that needs a healthy ego in order to return unharmed. Although survivors of violence are well practised in their use of dissociation (an imaginative device), it would be useful to explore how, and to what extent, creativity, fantasy, and imagination were considered or experienced as threatening or nurturing for survivors of violence. Is the loosening of association in creativity potentially threatening for individuals who have suffered from violence, and who have had limited benevolent experiences of imagination? If we believe that imaginative processes lead to learning and change, the challenge is to develop imaginative processes that accord well with participants' histories and orientations to imagination.

Realism vs. crafted form: This tension between the facilitators and the participants' different orientations to fiction was also evident in making decisions about the appropriate form through which ideas and experiences should be communicated to an audience. Both participant groups displayed a tendency to present literal truth and to resist the shaping of narrative into a more symbolic or crafted form. It is conceivable, although a little overstated, that survivors of violence in their vigilance need to be very attentive to the real and not distract themselves with the unreal. This might particularly be the case with the communities represented by our participants, who have had to endure continuous trauma, rather than isolated traumatic experiences that can be dealt with in some removed safe space. These communities have very little space that is inherently safe for the opening-up process that healing requires, resulting in the persistence of trauma and profound challenges to recovery. Responses to trauma accumulate, evoking deep changes, amongst which are heightened vigilance and, perhaps, a bias for the literal.

This desire for literalness does not seem to be primarily rooted in culture, as indigenous ritual and storytelling forms freely employ symbolization, exaggeration, and formal verbal and physical presentation (Larlham, 1985). Township Musicals[11] also are inherently non-realistic in their presentation of stereotypical and exaggerated characters and in the use of song and dance. Protest Theatre also, while making use of personal testimony of injustice, very often places these within a metaphorical context: images of the hungry earth consuming her children, the heavy chain of slavery that imprisons the mine workers; the drought of colonization that must be broken by the blood of the liberation struggle.[12] Sitas (1986), however, comments on literalness as one of the elements of Worker Theatre created with trade union members in the 1980s.[13]

The imperative to communicate important facts and social conditions would appear to predominate in this situation as well. In this case also, the performers had limited exposure to performance training: the choice of realism may be because of a lack of experience with alternative forms (and the dominance of television realism) and an unfamiliarity with the process of structuring and layering an artistic artifact. Another factor noted by Sitas (1986) that is relevant to the performances created in our workshops is the device of a personal monologue to communicate inner pain. An example from the workshop might help to make the point clearer.

HIV/AIDS was a theme within the performances created in both workshops, although it was a subsidiary one in the first group's performance. With the first group, the facilitators influenced the group to present this theme through the image of an AIDS spider, who lured the unwary into her web and devoured them.

The actress concerned used lengths of string to reach out to a prostitute and bind her. She in turn ensnared a client in the same manner, and the sequence ended with the triumphant spider hovering over them both. This sequence was performed to a musical score created by the rest of the cast using body sounds predominantly. The movement was dance-like and exaggerated. No language was used. The three actors concerned had varying degrees of difficulty with this sequence and never really seemed to understand the importance the facilitators assigned to using the body and facial expression to communicate the implied

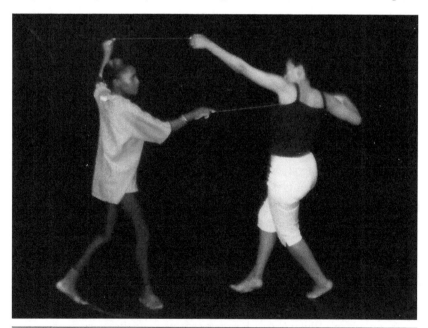

Figure 8.5 ❖ The AIDS spider. *Credit: Hazel Barnes*

terror and struggle. They seemed merely to walk through the actions, rather than to perform them with commitment and intensity.

With the second group, the main theme of the performance was the need to treat HIV/AIDS sufferers with compassion. The facilitators deliberately refrained from imposing artistic decisions and the group chose to present the climactic moment, when the protagonist discovers and communicates her illness, through a personal monologue directly addressed to the audience. This type of monologue is common in Township Musicals, where the protagonist almost always presents a monologue, sometimes sung, expressing suffering (see Sitas, 1986, p. 96, for a similar device in Worker Theatre) and is similar in feeling and style to a torch song. The sense of heightened emotion and the direct connection with the audience appear to be important factors in ensuring that searing experiences are heard and understood. The metaphorical presentation of the same theme, on the other hand, seemed to be considered confusing or entertaining, and therefore lacked the impact that the group required.

Sitas writes of the "clash of moral orders" (1986, p. 97) in relation to the difficulties of presenting learning plays to workers. He points out that interesting theatre is made from the contradictions within human nature that make for flawed characters and an ambivalence of moral judgment. In presenting the moral high ground as being present with only one group of people, the workers, the plays become simplistic. In our case, the intent to communicate an abhorrence of abuse and crime very directly led to the creation of mono-dimensional characters and a rather simplistic analysis of motivation and power relations.

Many writers on trauma and recovery point out the importance for survivors of their story being heard by an appropriate listener (see Jackson, Ryan, Masching, & Whitebird, chap. 9, this volume, on researchers preparing themselves as listeners and witnesses). Herman (1992) uses the word "testimony" to describe this process. The legal and religious connotations of this word certainly do suggest a need for literal truth telling. Again, we were unsure to what extent both these groups were drawing on cultural or political traditions that prioritize the literal. Or, alternatively, we might understand that they needed to go through a process of direct truth telling before their experiences could be transformed into a symbolic presentation.

A likely additional cause of this need for literal presentation is the deprivation of symbolic play in childhood, and therefore of the development of the imagination,[14] experienced as a result of the dislocation of apartheid and the imposition of Bantu education. Such a finding supports the movement towards arts therapies in this country. Many practitioners claim that the imagination is an important tool in creating distance from trauma, and also in envisioning a future.[15] It is this future that the Programme for Survivors of Violence is most

concerned about. Developing skills and abilities is one aspect of such work; developing the ability to imagine a positive future and the self-empowerment to realize it is another. The experience of these workshops challenges facilitators to find new methods with which to engage with participants reluctant to work with the imagination in established ways.

Conclusion

The creation of *Inhlanzi ishelwe amanzi—As fish out of water* provided the students involved with the opportunity to examine their lives and cultural conditioning consciously. The process, used by facilitators Block and Ramsden, enabled the participants to create a theatre piece that spoke authentically of their joys and fears, and which used a form of expression that affirmed and enhanced the students' own creativity. The production provided them with the space to articulate issues of crucial importance to them in coming to terms with the recent and considerable changes in social relationships in South Africa.

Inhlanzi also had a considerable effect on audiences. Some people felt defensive about the issues raised, and uncomfortable at the expression of deeply held feelings about race, such as anger over slavery and guilt over racial or gender injustice.[16] Others were filled with wonder and delight at the visible proof of intercultural harmony evident in the performance—a diverse group creating a moving and authentic expression of their own experience and understanding of being in Africa.[17] The form aroused equally disparate feelings, outlined earlier, although the predominant response was that the complexity with which the elements of form were interwoven and layered was not only intriguing and informative, but also more truly representative of post-colonial diversity. It also allowed space for the creation of an inclusive cultural expression that respects the multiplicity of cultural forms available in South Africa.

The most profound effects of the production have been on the students involved. Quite obviously, the students developed in terms of performance skills, in terms of self-confidence and personal efficacy, and in terms of their understanding of the rich diversity of cultural heritage in South Africa. More profoundly, they experienced those cultures not only intellectually but through direct exposure to the lives of others, and to the ways in which culture influences attitudes and values. They came to understand the extent to which a hierarchical approach to culture, inherited from the past, has deprived and dehumanized us all, and has limited our understanding and appreciation of diversity. Their sense of who they are and the degree to which they are products of their cultures, and their understanding of their personal agency for creating change, are more clearly defined. And, most importantly, they experienced the potentialities and realities of cultural diversity. They succeeded in questioning

and analyzing their experiences, and they succeeded in overcoming alienation and accepting difference, in sharing feelings and aspirations, and in creating a cultural expression of this together. What they achieved in this microcosm gives them the self-confidence and the courage to believe in the possibility of a truly culturally equitable future.

The work carried out for the Programme for Survivors of Violence can be viewed in terms of Herman's three stages of recovery (1992): namely, establishing safety, reconstructing the trauma story, and restoring the connection between survivors and their community. The structure of the workshops, the supply of accommodation and meals, the inclusion of physiological and mental techniques to control arousal, and the frequent sessions to express feelings and responses and to plan the details of the performance were all techniques that established and maintained safety. The workshops took a tangential, rather than direct, approach to the reconstruction of the trauma story, viewing it as a communal, social story instead of focusing mainly on the personal and specific. This seems appropriate for group work and in response to violence, which has predominantly social and political roots. Sessions on violence, both informational and exploratory, and exercises tapping into personal experiences all covered this stage. Learning expressive skills in music and drama and the crafting of the groups' stories into performances straddled both the second and third stages of recovery, in that a medium of communication is needed that allows the performers to express, and the hearers to connect empathetically with, their concerns. By finding a way of expressing experiences and stories important to the group and to their communities, the groups created an artifact that they could take back to their communities, and through which they could reflect common concerns. Because these young people were unemployed, and very often lacked formal education, it was particularly important for them to develop skills that enabled them to function effectively in their communities. The income generation activities of the Community Arts Project were, therefore, not "tacked on," but were integral to the recovery of trauma survivors.

There is still the issue of sustainability.[18] The experience of working with the groups has taught us the degree to which follow-up support and ongoing supervision are required if the work undertaken is to achieve its long-term aims. In order to be able to perform their stories, the groups need to learn planning, publicity, and administrative and bookkeeping skills. Learning how to negotiate with hierarchical power structures, such as management boards, community policing forums, and community development committees in order to obtain access to venues and permission to perform, is also necessary. In order for the stated aim of career development and the third stage of recovery to be realized, further specialized training will be necessary.

Art has the potential to encapsulate experience and to make it accessible to others. For the makers, it exercises our need to transform raw feeling and experience into a satisfying pattern and shape. It invites the audience to create personal meaning through relating what is seen and heard to their own understandings. Performance, because it is created in the presence of the audience, has the ability, like ritual, to remind us of our communal existence and values, and our connections to each other. In both these interventions, the experience of creating and performing has challenged the participants' original perceptions of themselves and shown them the possibility for change and growth.

Notes

1. In 2004, The University of Natal amalgamated with the University of Westville and the Edgewood Teachers Training College to become the University of KwaZulu-Natal. This amalgamation was a continuation of the transformation of universities in South Africa during the process of democratization.

2. Apartheid imposed a separation of races in all institutions. Separate development was supposedly separate but equal, but in reality most resources went to white institutions. The result was the impoverishment of what is known as "Bantu Education."

3. The research methodology for both interventions was largely qualitative, using participant observation and in-depth facilitator reflection, and the entire process was recorded. Throughout all workshops and in the follow-up, group attitudes and responses to the work were constantly interrogated as a form of participant research and evaluation. Audience response was interrogated through post-performance discussion and questionnaires.

4. More complete reports of this project have previously been published as Barnes (1999) and Barnes (2000).

5. See Boal (1979), and particularly the chapters "Knowing the body" (126–130) and "Making the body expressive" (130–131).

6. A favourite exercise, known as "Transforming Gestures," involves the group standing in a circle. A volunteer is given the task of creating a repetitive gesture. This gesture is repeated by the whole group until everyone has mastered the gesture and the individual nature of its creation has turned into an expression of group unity. When this is felt (not discussed) by the group to have happened, the person to the left of the gesture's originator modifies or transforms the gesture slightly and the group follows along. This pattern progresses around the circle until all individuals have had a chance to initiate a gesture for the group to use. The intention is that the gesture must be only slightly modified, thus demanding attention to what has already been created but allowing for individual variation. Vocal sound is added as a variable in the next round. Exercises of this nature encourage the ability of participants to take leadership when required, but also to follow exactly and become an integral member of a unified group. They also warm up both the body and voice in a repetitive, unified fashion similar to that used to build unity through ritual.

7. Stories varied from small hurts, such as not being allowed to go and see the snow or stay overnight with a friend, to the heart-rending: a black child who had the opportunity to attend a more resourced school but could not afford the uniform and fees; a child who was taken from his mother at four years of age because his father was an alcoholic.

8. An example of this was in a scene in a hairdressing salon, during which a discussion about a choice of hair colour metaphorically explored racial attitudes while being juxtaposed with a monologue about the cooking of eggs, this performer's favourite memory of home.

9. The ordinary person's experience of violence in South Africa is alarming. Crime statistics indicate that for every 100,000 people there are 10.8 murders, 14.5 attempted murders, 29.5

rapes, 156.4 serious assaults, and 168.8 residential burglaries (crime statistics released on 1 June 2001 by the Minister of Safety and Security, Steve Tshwete). These statistics inform us of the extent to which violence is prevalent; a glance at any newspaper indicates how it occurs in the normal processes of walking, waiting for a taxi, and sitting relaxing at home. No longer is violence in South Africa associated predominantly with political action: it is now part of everyday life, on the street and in the home. Consequently, the number of citizens traumatized by violence is immense.

10. Various other tensions were noted, which will not be dealt with here. They are included in more complete reports of this project, which have been published as H. Barnes & D. Peters (2002a; 2002b).

11. This applies both to their origins in the work of Gibson Kente and in the development of the form by such artists as MbongeniNgema.

12. See, respectively, plays by MaisheMaponya, *The hungry earth*; Matsemela Manaka, *Egoli: City of gold*; and Matsemela Manaka, *Pula*.

13. I am indebted to my colleague Dr. Veronica Baxter for drawing my attention to these parallels.

14. "When the inner eye is closed we lose the capacity to generate dreams, ideas and visions; our ability to imagine begins to atrophy" (Gersie & King, 1990, p. 23). Gersie also compares traditional storytelling (which stimulates the imagination through encouraging the creation of images) with the main form of recreation experienced by South African youth, namely television, which merely presents us with prescribed images.

15. "In the act of imagining we create a separation between our current, actual situation and one that we imagine as an alternative. The space, which is thus created, enables us to reflect upon our actual situation; to shed light upon it. As long as we are identified with an experience we cannot see it nor can we illuminate it.... Using the imagination to create space is effective because of its multi-dimensional and multi-functional qualities.... The multi-functional aspect of imagination helps to resolve, reconcile, energize, stimulate and encourage" (Gersie & King, 1990, p. 36).

16. An Indian male audience member, in response to the monologue on arranged marriages, vigorously denied that Indian women were still subject to their parents' and culture's wishes in this manner. His comment brought a chorus of objection from the Indian women present, who felt that this monologue exactly expressed their feelings of anger and rebellion.

17. A local white academic commented that he was extremely moved by the sight of the group performing harmoniously together, that for him this was an expression of hope not only for this campus (there had been tension earlier in the year when black students rioted because of inadequate funding for disadvantaged students, which helped to polarize racial attitudes) but for the future possibility of a united nation.

18. The nature of performance is itself problematic in terms of sustainability. While performance provides an intense therapeutic experience in the way in which it arouses and exercises the emotions, it is extremely difficult to package and sell because it relies on the ability of the performer to be present and to recreate the artistry at each performance. This is more difficult when the content communicated is painful. Two similar storytelling projects were reported in our local papers during the time of this project, both of which appeared to be less fraught with problems of sustainability because they involved the creation of artifacts, which can be separated from their creators. One involved the making of "memory cloths," an embroidered panel depicting the story of the embroiderer's life (many of these reflect the extent to which violence is a significant part of their experience), which were collected and sold. The artists received R100 for their first memory cloth and the opportunity to sell more on consignment (*The Natal Witness*, March 22, 2001). The other involved township women in the taking of photographs that depicted their daily lives, and were then exhibited at the Grahamstown Festival and in London (*The Natal Witness*, May 18, 2001).

Towards an Indigenous narrative inquiry: The importance of composite, artful representations

Randy Jackson, Corena Debassige,
Renée Masching, and Wanda Whitebird

Do you want to hear our side of that story? (Johnston, 2007)

When pondering how to use Indigenous knowledges to think across unsettling difficulties when working within the rigid tenets of Western social science, we were inspired by Thomas King's Canadian Broadcasting Corporation (CBC) Massey Hall Lecture Series, *The truth about stories: A Native narrative* (2003). In these lectures, King provides us with sage advice that bolsters how we pivot our understanding of ways narrative inquiry can be reimagined through Indigenous knowledges. King does this by offering the following: "The truth about stories is that that's all we are" (2003, p. 2). Although stories can help us better understand the world, they can also uncomfortably govern our lives. In fact, they are both miraculous and troublesome. You see, we divide the world up with stories, and sometimes the only differences we can find in something are the stories we are told by others or ones we quietly whisper to ourselves. King also describes himself as a "hopeful pessimist," and he writes "knowing that none of the stories [he tells will] change the world. But [he writes] in the hope that they [will]" (2003, p. 92). It is a position where a promise is offered; as he says when he quotes Okri (1997, p. 46), "If we change the stories we live by, quite possibly we change our lives."

Today's Indigenous peoples are learning ways to "restory" the world by grounding our resistance to contemporary and historical conditions through our knowledge of traditional stories and teachings. Tedlock (2011) points out that this resistance is accomplished in ways that implicate the "Other," and is tethered to, and flourishes in, space that encourages use of one's double consciousness. Our use of the idea of double consciousness refers to two worlds—the shared space in research occupied by competing world views. It is space occupied by privileging neither a Western nor an Indigenous perspective; rather, the two perspectives create and are connected to a third space that draws on both world views in an artful expression located within narrative inquiry. We find the concept of double consciousness similar to principles of "two-eyed seeing" advocated by Indigenous scholars. Here we are urged to use both eyes

to locate the strengths of each perspective and to use them together in blended ways to illuminate aspects of the social world that are of interest (Hatcher & Bartlett, 2010; Iwama, Marshall, Marshall, & Bartlett, 2009). Tedlock, herself Indigenous, says that double consciousness is a reminder that she "should walk in balance along the edges of these worlds. 'There is beauty and strength in being both: a double calling, a double love'" (2011, p. 337).

Tedlock (2011) discusses double consciousness in the context of preformed ethnographies that are expressed through memoir and creative non-fiction. In the case of narrative approaches to social inquiry, however, double consciousness carefully and cautiously urges the use of the aesthetic of oral storytelling in synergistic, musical, and poetic ways, bridging critique with written forms (Gilbert, 2006; King, 2003). Denzin and Lincoln argue "that everything is always already performative. The performative, in addition, is always pedagogical, and the pedagogical is always political" (2008, p. xi). It is an approach that reminds and challenges us to continue *dibaadadaan*—an Anishinaabe word meaning to tell stories—for if we stop, we'll soon discover that "neglect is as powerful an agent as war and fire" (King, 2003, p. 98).

This chapter focuses on the use of narrative inquiry filtered through an Indigenous knowledges perspective. Our primary goal is to use conventional narrative inquiry as a springboard, weave Indigenous knowledges within and around, and work towards having composite narratives as a useful research tool to ground Indigenous participants' voices into a single literary, oral, and artfully representative *dibaajimowin*—an Anishinaabe word referring to "teachings, ordinary stories, personal stories, histories" (Simpson, 2011, p. 50). Our use of a composite approach to narrative is meant to push us past critiques (i.e., a critical perspective) focused solely on the negative consequences of colonialism, paternalism, and imperialism. Rather, we wish to move into a space that actively envisions and fruitfully grounds the artful practice of Indigenous epistemologies and ontologies through *dibaajimowin*. Composite narratives, for us, are meant to be interactive and attentive to the audience (King, 2003; Tafoya, 2000), maintain oral tradition (Kovach, 2009), and draw on ancient Indigenous tribal wisdom through traditional stories (Tafoya, 2000, 2009). In our particular practice, we also set composite narratives in context by connecting them to critiques of contemporary health theory (Murray, 2002). Such an approach, as Anderson (2011) and Borrows (2010) argue, supports, sustains, and grows Indigenous knowledges (Wilson, 2008). The composite that we are encouraging, like other forms of storytelling and narrative imagination, is as Simpson argues, "at [its] core decolonizing, because it is a process of remembering, visioning and creating a just reality where Nishnnabeg (meaning "the people") live as both *Nishnnabeg* and *peoples*" (2011, p. 33; italics in original). Such stories are powerful for they embody our relationship with our ecologies. When we voice these stories, we

locate ourselves within them: we establish ourselves and our ecologies as inseparable in ways that can't be severed by colonialism (McLeod, 2007).

Before we begin, however, there is a caveat. We, the authors, were reminded as we wrote this chapter that coming to know Indigenous knowledges and finding useful applications for it is always a journey. With Indigenous knowledges as our opening, we began first with personal experience. It is a position that required each of us to "go to the centre of [one's] self to find [our] own belonging" (Kovach, 2009, p. 49). It is highly personal work in the sense that it is unique to the individual, and as a result, it doesn't "lend itself to a check-box, universal approach" (Kovach, 2009, p. 50). As Indigenous peoples who live, work, and contribute to our communities, our approach has ultimately been shaped by our own "intertribal experience" (Anishinaabe, Delaware/Cayuga/Irish, Cree, and Mi'kmaq) and by our professional lives as support workers, researchers, and Elder. Our approach is also constrained by the "semantics of the English language," and it represents, as we see it, simply "one view of reality, a perspective that needs to be evaluated in the contexts of other stories by other members of the community" (Brant Castellano, 2000, p. 32). As such, our writing about composite narrative in Indigenous contexts is not meant to be taken as prescriptive, but is presented here as one approach—among many others—that we feel is useful for understanding the complexities of stories shared by Indigenous peoples.

In this chapter, we are especially intent upon developing a means of understanding the complexities of stories shared by Indigenous people who live with HIV and AIDS as they explain to themselves (and to us) the roots of their depression, how they experience depression, and ways in which they respond.

Research that centres Indigenous knowledges

Although a lengthy description of the essential features of Indigenous knowledges is beyond the scope of this chapter, we must understand the essential elements of Indigenous knowledges before we can centre it in a composite narrative. Considered by many to be a relational perspective (Barton, 2004; Crofoot Graham, 2002), the ways in which Indigenous knowledges is used in research contexts is varied, owing to the diversity among Indigenous peoples. Kincheloe and Steinberg describe Indigenous knowledges as:

> a lived-world form of reason that informs and sustains people who make their homes in a local area. [Indigenous peoples] construct ways of being and seeing in relation to their physical surroundings. Such knowledges involve insight into plant and animal life, cultural dynamics, and historical information used to provide acumen in dealing with the challenges of contemporary existence. (2008, p. 136)

In addition to these key features, Brant Castellano (2000) notes that the use and development of new Indigenous knowledges almost always involves the interpretative involvement of healers and Elders. Indigenous knowledges are thought first to be personal, always correct, oral, experiential, holistic, and conveyed in narrative and metaphorical language. For knowledge to have social validity in ways that support the participatory involvement of communities in research, it is "validated through collective analysis and consensus building" (Brant Castellano, 2000, p. 26; see also Battiste & Youngblood Henderson, 2000).

Moving towards centring Indigenous knowledges in ways that speak to participants in research—in ways that Western ontology often avoids (Kirmayer, Brass, & Valaskakis, 2009)—Anderson, in her study of life stages of Aboriginal women drawn from interviews with Elders, writes about how "allegorical stories underpinned the narratives and events of their own lives" (Anderson, 2011, p. 19; see also Tafoya, 2000, 2009). It is in both space and place—rather than time—where allegory assists Indigenous people to non-intrusively derive meaning, to add to their personal body of tribal wisdom, refract memories of older and ancient times, and where this can be interpreted in light of shifting experience and context (McLeod, 2007). In other words, Indigenous knowledges offer "maps of meaning [...] located at the centre of a community's identity" (Kirmayer, Brass, & Valaskakis, 2009, p. 442). Using Indigenous knowledges can also provide opportunities—in shared cross-cultural spaces and places— for mutual participation (King, 2003; Kirmayer et al., 2009). They potentially shift the research landscape to support Indigenous identity and consciousness, and enable cultural meaning to move further to the surface in ways that can be understood by a variety of readers, irrespective of their cultural identities.

This approach is premised on deep listening, quietness, and stillness, so that we are better able to hear the reverberations from the past in contemporary contexts (the significance of deep listening, and on space and place rather than time, is also highlighted in McGillicuddy and Pretorius, chap. 7, this volume). This listening draws on principles of "spiritual history" that simply urge "us to try to engage the narratives through the lens of those who originally experienced it" (McLeod, 2007, p. 17). It also suggests that we incorporate these ancient ways of deriving understanding about contemporary experiences of illness by acknowledging "their relations to a world in which nonhuman persons play an active role in the lives and fate of human beings, either through their visible actions or in an invisible spirit realm" (Kirmayer et al., 2009, p. 442). Inquiry into the illness experience is best approached with attention to the notion of *all my relations*, for it recognizes that Indigenous knowledges continues to operate in Indigenous lives because it has been "ongoing, and [has been] sustained through relationships, respect, and responsibility" (McLeod, 2007, p. 18). Accessing meaning and interpretation through Indigenous knowledges

premised on composite narrative means "participating in a ritual [and] seeking spiritual wisdom" that is "not subsumed by material or psychological levels of explanation" (Kirmayer et al., 2009, p. 443).

Research as Ceremony

Benham (2007) and Wilson (2008) both previously outlined that doing research—or, in our case, narrative inquiry—in Indigenous contexts means one must address the thorny issue of how best to retain the sacred and the spiritual aspects of ceremony. We acknowledge that the single most important feature of an Indigenous centred, decolonizing methodological approach rests in "the *process* of doing [... where such is] as important as what is *produced* at the end" (Anderson, 2011, p. 15, italics in original; see also Cochran et al., 2008; Brant Castellano, 2000). To achieve this we understand, as Brant Castellano (2000, p. 29) writes, that "all of the senses, coupled with openness to intuitive or spiritual insights, are required in order to plumb the depths of Aboriginal knowledge."

In the project we describe here, we focused effort from the outset on becoming spiritually ready to receive knowledge, and moved towards an approach that openheartedly (Simpson, 2011) incorporated ceremony (Wilson, 2008) into the design of the project. This means that we acted in ways in which the doing of research respected "the core values, beliefs, and healing practices of the Indigenous community [...] throughout the research process" (Lavellée, 2009, p. 23). Lavellée also offered specific directions towards enacting these commitments: working collaboratively with Elders as equal partners who provided stories of traditional knowledge and assisted with interpretation through that lens (see also Anderson, 2011; Baskin, 2005; Brant Castellano, 2000; Kovach, 2009); incorporating or mirroring Indigenous ceremony (e.g., focus groups were modelled on the basis of a sharing circle format; see also Baskin, 2005; Lavellée, 2009; Poff, 2006); offering tobacco to participants as a gift that symbolized the "Creator" was present and witnessing the exchange (Kovach, 2009); and as far as was possible, using Indigenous symbols to elicit stories from informants about their understandings of Indigenous knowledges (Lavellée, 2009).

However, Shahjahan (2010) documented how the usual approaches to curriculum development often do not capture the key features of the personal work scholars engage in towards embedding spirituality in their own lives prior to engaging in their social justice work. The same is also likely true of our research endeavours. Nonetheless, as we understand research practice through an Indigenous lens, conducting research involves adopting a process focused wholly on aspects of "personal work that must be done by the researcher in conjunction with [their] own world (both inner and outer)" (Kovach, 2009, p. 50). From an

Anishinaabe standpoint, it directs one to seek out Elders, centre the holistic nature of knowledge, and participate in activities such as ceremony and prayer as means to access inward knowledge. As Kovach noted, "[We] need[ed] to open ourselves to those teachings and then give ourselves time to integrate them so that we can be of use to our community" (2009, p. 50). This process of becoming ready to hear stories in Anishinaabe contexts is referred to as *debwewin*—meaning "to know with one's heart"—so that the connection contemporary stories have with ancient and wise ways of knowing the world is more clearly understood (Simpson, 2011). It is a process that sustains and honours *n'ginaajiwimi*—our essence is beautiful (Peltier, Jackson, & Nowgesic, 2012)—and works to incorporate this notion in context with difficulties and challenges faced by Indigenous people in contemporary settings. Further, as Kirmayer, Brass, and Valaskakis (2009) write, spirituality becomes an interpretative strategy meant to further our understanding beyond biological, or even psychological understanding towards a deeper appreciation of ways in which spiritual meaning is assigned by participants to their experience. It is a process that "recognizes that the meanings conveyed by myth are not only personal but also concern larger webs of connection that draw in culture, history, the social world, and the environment" (Kirmayer et al., 2009, p. 443).

Our research as ceremony: Method

We first sought to ground our reflections about narrative inquiry in an Indigenous context. Adopting a community-based research strategy, in collaboration with partner agencies (2-Spirited People of the 1st Nations, the Canadian Aboriginal AIDS Network, and the Ontario Aboriginal HIV/AIDS Strategy) who provided recruitment assistance, Indigenous people living with HIV or AIDS were invited in September and October of 2012 to participate in one of three focus groups. The focus group with men had six participants, the one with women had six participants, and the one for transgender people had three participants. Of the fifteen participants, twelve self-identified as First Nations and three declared Métis status. Three women self-identified as transgender, five as heterosexual, and one as bisexual. All the men asserted their two-spirit identities. The majority of participants reported they had been living as HIV-positive for between seven and twenty-two years. One participant stated they had tested positive for HIV in the past two years.

Modelled on the basis of an Aboriginal sharing circle (Baskin, 2005; Lavellée, 2009; Poff, 2006; Rothe, Ozegovic, & Carroll, 2009), following a brief presentation focused on Indigenous knowledges (i.e., creation story), focus group participants were asked a broad series of questions about their individual understanding of Indigenous knowledges, how they use Indigenous knowledges

in their lives, and how Indigenous knowledges might best be used in research. The use of a sharing circle as inspiration was meant to reflect the central importance of oral tradition and storytelling for Indigenous people (Poff, 2006; Rothe et al., 2009). This format structured the gathering of stories about Indigenous knowledges by providing a cultural signal to participants that the consultation was premised on egalitarian, supportive, non-confrontational values meant to solicit collective identification of problems and solutions (Rothe et al., 2009). The sharing circle was moderated by a fully disclosed, HIV-positive Indigenous person and an Elder in an effort to gain trust and to reduce any potential power imbalance. The central goal in adopting this approach was to create a "mutually respectful, win-win relationship with the research population—a relationship in which people are pleased to participate in research and the community at large regards the research as constructive" (Poff, 2006, p. 28). Research plans were vetted through community representatives prior to submission and approval by McMaster University's Research Ethics Board.

All stories gathered during the focus groups were audio recorded and transcribed verbatim. Later, consistent with recommendations offered by Onwuegbuzie, Dickison, Leech, and Zoran (2009) for analyzing focus group data, we used constant comparison to weave their stories together. Following processes similar to those developed by Strauss and Glazer (1990), Onwuegbuzie et al. (2009) described three stages of analysis. Open-coding was employed in the first stage, which refers to "the part of analysis that pertains specifically to the naming or categorizing of phenomena through close examination of data" (Strauss & Glazer, 1990, p. 62). In this first step, we grouped smaller units of our data that expressed similar properties and assigned a code (e.g., talk with Elders, stories). In the second stage of coding—axial coding—we grouped the codes "back together in new ways *by making connections between a category and its subcategories*" (Strauss & Glazer, 1990, p. 97; italics in original). So, for example, we grouped "talk with Elders" and "stories" under the broader category of "sources of Indigenous knowledge." In the final stage, selective coding, a theme was developed to highlight the content of each group. Selective coding is the process of "selecting the core category, relating it to other categories, validating those relationships, and filling in categories that need further refinement and development" (Strauss & Glazer, 1990, p. 116). Here, our core category became "knowledge from stories," and validity was established by linking our codes and categories with direct quotes that spoke about the continuing importance of Indigenous knowledges in our participants' lives. As the paper was finalized, we again sought out focus group participants, who wished to remain involved, for a member-checking process structured to assess the validity of what was written and to further ensure the trustworthiness of the findings.

Knowledge from stories: Findings

Our conversations with the focus group participants powerfully demonstrate ways the participants feel disconnected from their Indigenous knowledges. Many participants highlighted how Indigenous knowledges were important to them. However, accessing and respectfully using Indigenous knowledges was problematic. Several participants commented how they continue to hear that Indigenous knowledges are worthless or without value—and not something learned. Others spoke of how they felt personally unworthy to apply their knowledge by participating in ceremony because of active personal substance use. Still others shared how little they knew, or how they were disconnected from or stripped of their knowledge because of difficult childhoods. Participants discussed these difficulties as being connected to a history of colonialism that included experiences of racism, protocols about active substance use in relation to ceremonial participation, and constrained access to traditional people from whom they could learn Indigenous knowledges.

> For the longest time, actually, I wouldn't even admit I was Native. When I was in [name of community] where the majority of people were Native—cause where I grew up in [home community] they would call me squaw. So yeah, I'm like, yeah, I'm Indian [laughter] from [name of community]. I tried to get involved. But for the longest time there were things I didn't understand [about how to use our knowledges]. Then I'd feel embarrassed about it so I, but with you [i.e., the Elder facilitating the focus group], I don't feel embarrassed. I feel like I can ask you. 'Cause before, I would wonder what we were saying. (Elizabeth, interview)

> I just moved and have wanted to smudge my new home. But I can't 'cause I use drugs and alcohol. Mind you, I don't do that like I use to [i.e., use drugs and alcohol], but I still do. Still, you aren't supposed to smudge for 48 hours (after your last drink). So I don't smudge. (Lisa, interview)

> So, yeah, right, Indigenous knowledge to me is making sense of colonialism. [...] And, well, um, my Indigenous knowledge is what's kept me alive. It's where [crying] the hope comes from in a hopeless world. And the metaphor of the water for me [pause] is the tears and the feeling like I'm drowning in assimilation and [in] the [...] consequences of those stupid fucking policies. (Brad, interview)

As authors of this chapter, we approached our work as Anderson (2011) did, believing that, despite challenges, "vestiges of [...] traditional knowledge [...] were still operational" (p. 5). The stories that many participants shared as

each focus group progressed revealed the variety of ways in which Indigenous knowledges continue to shape our participants' lives. Participants shared how they work to instill Indigenous knowledges in their children, how they were engaged in processes to recover their Indigenous knowledges, or how they might—despite continuing challenges brought into their lives by colonial intrusion—continue to honour the gifts they received through stories shared by *nookosiag's teachings* (those of their grandmothers). For many, Indigenous knowledges are a touchstone and something they experience as they make sense of their lives. Participants shared the following comments in recognition that Indigenous knowledges has always been a part of who they are as Indigenous peoples:

> It's what I do with my kids. I pass along our grandfather teachings. I wasn't taught, well basically, I was taught the seven sacred teaching like honesty, humility, courage, respect, you know, it's something I try to instill in my kids. (Samantha, interview)

> It's hard to kill the Native spirit and the knowledge that is inside of us. So, for me it was a[n] [un]conscious kind of learning thing. It got me through that childhood I had. But what I think—it was that Native spirit and that innate knowledge—that came forth once I needed it. When I was finally exposed to my Native culture, and once I became aware that I was Native, I started to practise my Native culture. It felt so comfortable and right. It was amazing and empowering as well. I can't explain how, 'cause it was like I was reconnected to something I was separated from. (Russell, interview)

> I talked with a lady who is an Elder here—and we talked about—she's the typical grandmother kind of person, you know? I can't remember her name but she was just wonderful. When we did the smudge, she made me turn around or something like that, but I didn't ask her why. And then I kinda felt something … and I thought, I guess I'm someone special. (Lisa, interview)

> I woke up to my native spirituality six weeks after I was diagnosed—I went to a sweat lodge. At some level my Indigenous knowledge [was] awoken for me on that day and I've been able to use that for healing, or start to deal with it. (Brad, interview)

In the focus groups, we also asked participants to reflect on the value of Indigenous knowledges in research. From the perspective of participants, research practice does not always adhere to Indigenous knowledges in ways that mirror learning styles in Indigenous communities. One participant shared the following:

> You know, what I'm most thankful for is when I'm learning about my Aboriginal [heritage]. You know, I always participate in those white men studies but when I come across something like this [focus group/ project] I find it much more important to me. You learn things you didn't know. (Rhonda, interview)

We contend that in order to make research more relevant for Indigenous people, approaches to research need to centre and embed Indigenous knowledges mindfully throughout their processes. Several participants, for example, felt that research in its current form offered little opportunity for learning. This has unintended consequences, such as shutting people out, or degrading Indigenous people by making them feel worthless or without value. Several participants shared the following:

> I would love to go to a conference where I could understand what they are saying. They say come—be with us—but I feel like I have to [have a better education] to at least understand what the hell's going on. I don't want to know about statistics, this and that, and those endless five-letter words—I don't understand that and I don't want to understand that—I go because I want to know the knowledge but if they want to talk in another language it defeats the purpose. (Albert, interview)

> It makes me feel stupid—that I need to have all this education—and I went to this conference and asked them to tone it down a bit ... just don't talk down [to us]. (Russell, interview)

Towards this end, one participant talked about the need to retain and to bring back the ways in which Indigenous people learn—through *dibaajimowin,* through talking/sharing circles, through other Indigenous teaching practices such as interactions with Elders—as necessary towards creating research that is understandable and meaningful to them. As one participant shared:

> But it's time to retain all that stuff, like the stories. You know, I have to hear things a hundred times before, you know, before I'm able to share it. But it would be nice to be able to tell a story like that, something from being Aboriginal, so that it doesn't get lost cause it's already really kind of lost for me. (Elizabeth, interview)

For many—as powerfully demonstrated in the quote below—Indigenous knowledges can assist people to move on, to heal, and to understand the negative impacts of colonialism. Perhaps our responsibility as scholars working collaboratively with Indigenous people is both to heal from the effects of colonization through our research, and to bring out aspects of Indigenous knowledges that assist people with their own healing, as was powerfully captured by one participant:

And I've been beat up, fucked over, lied to, cheated, fucking betrayed, and there's been a level of anger in me that [I] don't know what to do with. But my teachings are teaching me what to do with it. And they are teaching—and I'm seeing the more that it gets out of me—the clearer I get. So, yeah, right, Indigenous knowledge to me is making sense of colonialism. (Brad, interview)

The themes described above, which were drawn from excerpts of our dialogue with participants, suggests the use of Indigenous knowledges in research as an important consideration. Focused on stories, storytelling, and narrative inquiry, our project provides a more culturally grounded research process for Indigenous peoples. It presents a research approach that, potentially, could be more relevant and meaningful to Indigenous communities concerned with HIV/AIDS. Next, we offer a discussion of composite as an Indigenous aesthetic, why it's important to adapt this approach for an Indigenous context, and present our Indigenous composite narrative approach.

Composite narrative as Indigenous aesthetic

The magic of narrative inquiry when it embeds and centres Indigenous knowledges, like the literature King (2003) writes about, "is not in the themes of the stories—identity, isolation, loss, ceremony, community, maturation, home—it is the way meaning is refracted by cosmology, the way understanding is shaped by cultural paradigms" (p. 122). As we considered story as an artful composite representation—one that weaves into as well as challenges principles of narrative inquiry—and as we considered the importance of Indigenous knowledges, the following questions became our guideposts. How can *dibaajimowinan* (stories) from multiple and diverse participants interact with one another, merge, and braid into a single *dibaajimowin* (story)? In what ways do composite narratives, in artful ways, reflect the sacredness of stories and the diversity in which Indigenous participants' cultural identities are lived? We contend that narrative research, when mindfully centred through Indigenous knowledges, can assist with the creation of a composite *dibaajimowin* that is both written voice and an aesthetic pursuit (Blaeser, 1999; Gilbert, 2006). In addition, and bridging this approach with other mutually compatible social scientific discourses, our use of a composite is intended to mirror an Indigenous understanding of story. Inherent in this approach is the "researcher-as-storyteller" reflexively connecting the past (using traditional stories) with the present (set in the literature specific to the phenomena and in stories shared by participants), with an eye to the future (to imagine and awaken Indigenous realities). Like other critical approaches in social science, composite narratives can act as mediators that trigger positive social transformation by resisting colonial practices. As Blaeser (1999) states:

Through speaking, hearing, and retelling, we affirm our relationship with our nations, our tribal communities, our family networks. We begin to understand our position in the long history of our people. Indeed, we become the stories we tell, don't we? We become the people and places of our past because our identity is created, our perspective formed, of their telling. (p. 54)

Using Indigenous knowledges and how people understand and use this knowledge in the contemporary world, stories from research participants are blended, woven, and tied together to form a single wedded account in ways that describe and enhance not only our understanding (Collins & Barker, 2009) of Indigenous knowledges, but also the challenges and triumphs that Indigenous people living with HIV and AIDS encounter in everyday life. Composite narrative offers "a chance to use the traditional art of storytelling to teach and to heal" (Nerburn, 2009, p. xv; see also Blaeser, 1999). They are opportunities "to share the stories [that] help rebuild the narratives by which the Native people were understood" (Nerburn, 2009, p. xvi). It is an approach that is respectful of the fact that "people learn by story, because stories lodge deep in the heart" (2009, p. xvi), and it is a perspective widely shared among Indigenous scholars.

Framed by critical race scholarship as one of several possible counter-stories (Solórzano & Yosso, 2002), a composite approach to narrative inquiry is a literary pursuit (Coulter, 2009), a synthesized account (Arrington, 2004) meant to highlight some of the more representative ways participants organize personal stories, make sense of, and provide meaning in their lives (Borrows, 2010; Collins & Barker, 2009). This unifying approach—meant to add further texture and richness—is woven with the "reflective understandings of the researcher in the telling of a composite narrative" (Wertz, Nosek, McNiesh, & Marlow, 2011, p. 5896). Embedded within a cyclical process of development, they are often times "conceived of and written in layers," and "stretch back" (Borrows, 2010, p. ix) across time to the stories shared by Elders and wise ones in Indigenous communities. As McLeod wrote, "Old voices echo; the ancient poetic memory of our ancestors finds [a] home in our individual lives and allows us to reshape our experience so that we can interpret the world we find ourselves in" (McLeod, 2007, p. 11; see also Anderson, 2011; Borrows, 2010; Simpson, 2011). From an Anishinaabe perspective, Simpson (2011) offers us additional perspective. Referred to as *biskaabiiyang*—a verb meaning to look back—this process provides an approach to return to ourselves in ways that allow researchers to evaluate the impacts of colonization. It opens space in research to incorporate aspects of Indigenous culture (e.g., philosophies, stories) that were lost to colonial practices. In other words, *biskaabiiyang* is about decolonizing the mind prior to research, and learning new ways of incorporating Indigenous knowledges into research. As Simpson writes:

The foundations of Biskaabiiyang approaches to research are derived from the principles of *anishnaabe-inaadiwiwin* ([...] ways of being). These principles are *gaa-izhi-zhawendaagoziyang*: that which was [given] to us in a loving way (by the spirits). They have developed over generations and have resulted in a wealth of *aadizookaan* (traditional legends, ceremonies); *dibaajimowin* (teachings, ordinary stories, personal stories, histories) and *anishnaabe izhitwaawin* ([...] culture, teachings, customs, history). Through Biskaabiiyang methodology, [...] research goes back to the principles of anishnaabe-inaadiziwin in order to decolonize or reclaim anishnaabe-gikendaasowin. (Geniusz, 2009, as cited in 2011, p. 50)

In this way, the product of a composite narrative is simultaneously "current," in the sense that it is grounded in a contemporary context; at the same time, it "predates" itself by drawing on ancient Anishinabek knowledge to develop an understanding (Borrows, 2010, p. ix). Indigenous scholars also work with community stakeholders, using participatory research approaches, to create composite narratives. The composite narrative advocated here, rather than an original approach, has existed in the social science literature for the past decade, where researchers from a variety of disciplines have drawn upon it to explore a variety of issues. Composite narratives have previously been used to explore Anishinabek legal traditions (Borrows, 2010), Indigenous self-determination in the context of homelessness for an urban-based population in Canada (R. Walker, 2005), and stories of Anishinaabek women's lifecycles (Anderson, 2011). As these sources used composite narrative approaches, stories are woven to add depth, and to acknowledge the multiple layers of stories and the multiple sources of knowledge—oral, dreamtime, and written.

Composite narratives: A method for weaving stories

They are all we have, you see,

all we have to fight off illness and death.

You don't have anything if you don't have stories. (Silko, 2006)

For many Indigenous peoples, stories work as if they are like medicine. Stories in Indigenous communities possess pedagogical value, and are reflexive devices that allow listeners to imagine new possibilities through Indigenous world views (Peacock, 2013). They provide a lens through which colonialism is challenged, and as Simpson suggests, a means of

envision[ing] our way out of cognitive imperialism, where we can create models and mirrors where none existed, and where we can experience

the spaces of freedom and justice. Storytelling becomes a space where we can escape the gaze and the cage of the Empire, even if it is just for a few minutes." (2011, pp. 33–34)

Reverberating with collective tribal memory handed down by Elders, stories are meant, with each subsequent telling, to assist Indigenous peoples in making sense of experience, giving meaning, and explaining both the known and the unknown aspects of the social world. In this way, stories can be viewed as embodying a living spirit that offers wisdom in dealing with the contemporary challenges of life (Peacock, 2013). Stories are meant to deepen our understanding of who we are as cultural and social beings by affirming our tribal identities. They allow us to experience the similarities between ourselves and others in ways that focus attention on priority issues that may not be addressed in the literature (Banks-Wallace, 2002). Composite narratives include characters, and draw on the direct quotes of participants to support dialogue and discussion. They are intended to do this in ways that frame the key issues as originally identified by community through Indigenous knowledges. The focus of composite approaches in narrative inquiry is intended to shift "the analytic gaze away from excessive attention to structural elements [within narratives] and towards the capacities of stories (i.e., inform, teach, and to learn from)" (Garroutee & Westcott, 2013, p. 64).

What follows is our method for writing a composite narrative. The goal here is to explicate the ways our approach is grounded in Indigenous oral tradition and world views. This process includes several overlapping categories that include (1) narrative elements that inform a composite narrative, (2) living with and getting to know the stories of participants, (3) movement from individual stories to braided account, and (4) writing the composite narrative.

Elements of our composite narrative

Our approach to the development of a composite narrative used several disparate elements to weave into a single story. Our primary data source narratively explored the experiences and responses to depression by Indigenous people living with HIV/AIDS across seventy-two in-depth interviews. In analyzing these stories we used an adapted narrative inquiry framework to reveal the importance of relationships, connection, the intergenerational continuity of knowledge, use of ceremonial practices in responding to depression, and cultural insights that participants drew to make sense of and find meaning in depression (Cain et al., 2013; Cain et al., 2011; R. Jackson et al., 2008). Focusing on these key areas, a composite narrative can assist with decolonization. In Cree communities, for example, McLeod writes, "narrative memory is an ongoing attempt to find solutions to the problems we face today, such as breakdown of

families, loss of language and general loss of respect for ourselves and others" (2007, p. 91). Stories of oral history are Indigenous knowledges in action that offer culturally grounded acumen in ways that inspire change for the better (Anderson, 2011).

Supplementing our growing understanding of experiences and responses to depression among our participants, we also reviewed the literature in this area. We searched the social science literature (e.g., sociology, social work, psychology, anthropology) for research reports highlighting experiences and responses to depression among Indigenous people living with HIV. However, we found the literature generally lacking. As a consequence, we expanded our review to include the broader areas of depression and Indigenous peoples. In conducting this search, our goal was not only to explore ways of piecing our cultures back together, but it was also about learning to work our composite narrative as if this story were medicines (Anderson, 2011). We also separately searched through the humanities literatures (e.g., critical literary studies) to explore the writings of scholars who work with Indigenous stories. Our goal here, consistent with an approach described by Banks-Wallace (2002), was to define the boundaries of what we mean in using a composite narrative as an Indigenous story. Findings from these separate reviews were folded into our composite narrative.

We also drew upon traditional stories that focused on mental health in Indigenous communities. These stories came from our own oral knowledge of our cultures, were shared with us by the Elder who is represented on the project, and last, gathered from the literature. Here, as Ong (1982), writes, "Originality in oral cultures […] consists not in the introduction of new materials but in fitting the traditional materials effectively into each individual, unique situation" (cited in Ballenger, 1997, p. 793). Ballenger (1997) also notes ways in which this oral history blends the past and present to influence the future. Our exploration of the experiences of and responses to depression among Indigenous people living with HIV/AIDS represented an opportune time to be informed by these oral histories in our developing understanding of depression among Indigenous people living with HIV/AIDS. Traditional stories informed our developing interpretation, and in turn, refracted one way in which Indigenous knowledges were reconstituted in our composite narrative. Our use of a composite narrative approach reflects several important precepts of Indigenous knowledges—that the world is alive, dynamic, and relational. Thus, exploring experiences and responses to depression among Indigenous people living with HIV through traditional stories was necessary and appropriate in our contemporary context.

Finally, we also wove our own reflexive understanding with participants' accounts of experiencing and responding to depression in the context of HIV/AIDS. When composite narratives include the author's reflexive self, the reader is provided, potentially, with a "felt-sense" (Wertz et al., 2011) of participants'

experience with depression in the context of HIV illness. Favret-Saada (1980) writes: "To understand the meaning of this discourse [...] there is no other solution but to practice it oneself, to become one's own informant, to penetrate one's own amnesia, and to try and make explicit what one finds unstateable in oneself" (cited in Tedlock, 2011, p. 334). This approach rested on the principle that we embed our own stories of experiencing in ways that we felt personally deep down in our cores. Composite narratives potentially provide "a rich double portrait" (Tedlock, 2011, p. 335), one that makes explicit our own experiential knowledge of listening to participants' stories (see also McGillicuddy and Pretorius, chap. 7, this volume). It is an approach that links to broader social and political issues, assumes that the primary audience is larger than academic audiences, and that locates the reflexive gaze of the scholar as protagonist, as s/he critically links theory with vivid descriptions of participants' lived experience (R. Gray, 2003).

Living with the participants' stories

A composite narrative is a single braided story meant to mirror the lives and social world of participants. It is not simply a retelling, but represents the interpretative work undertaken by a researcher. It draws on the social scientific literature of interest (e.g., depression among those living with HIV), embeds participants' understanding of the phenomena, and draws upon the reflexive understanding of the researcher. It rests on the principle that "the author is the active part of the story, a person so enthralled by hearing his own voice and listening to others telling the tale that he cannot remove himself from the narrative" (Tedlock, 2011, p. 332). In this way, a composite narrative

> connects with universal human qualities so that the reader can relate personally to the themes; is a story that readers can imagine in a personal way; attempts to contribute new understanding about the phenomenon; and is not exhaustive, but allows the topic to be seen more clearly. It aims to illuminate, to allow the reader to have an increased sense of contact with the phenomenon without fully possessing it. (Wertz et al., 2011, p. 5884)

The development of a composite narrative, in our case, is buttressed against the content of seventy-two interviews with Aboriginal peoples living with HIV/AIDS in Canada (Cain et al., 2013; Cain et al., 2011; R. Jackson et al., 2008). In our context, interviews were treated as narratives (Chase, 2008), where participants' stories about their experiences with and responses to depression were represented as "a distinct form of discourse. Narrative inquiry is retrospective meaning-making—the shaping and ordering of past experience" (Chase, 2008, p. 64). And, like other forms of scholarly work, it is the basis

upon which also to understand "the narrator's point of view, including why the narrative is worth telling in the first place" (Chase, 2008, p. 65).

A first step in the development of a composite narrative involves reading and rereading each of the in-depth interview transcripts. In reading each of the interviews, in an approach consistent with Gray (2003) and Gray and Sinding (2002), we highlighted various key issues that were particularly revealing about experiences of and responses to depression among Indigenous people living with HIV/AIDS. After reflecting on each of these key issues identified across different interviews, we focused on particular themes (e.g., finding out HIV status, experiencing depression, the benefits of blending ceremony with contemporary approaches when responding to depression), and provided these a central place in our composite narrative. Our approach in identifying these issues was to reflect on the ways experiences and responses to depression connected with and could be understood through Indigenous knowledges (Barton, 2004, 2008). These judgments about how best to handle the data are influenced by the actual content of the interviews. Decisions made along the way were carefully recorded using Atlas.ti (a qualitative research data software program) and reported in ways transparent to readers.

As we became more and more familiar with the narrative landscape of our own project's data, we increasingly noticed, as did Anderson, that "the process of collecting oral history was much more an exercise in learning how story medicines can work, and [of] gradually finding [our] place in [this] work" (2011, p. 15). Consistent with approaches to narrative inquiry as well as principles of Indigenous knowledges, the development of understanding during this phase avoids imposing one's world view on another. Rather, we learn "to both live in and write about other cultural settings [and we worked to create a] space [that could] accommodate multiple individuals with various cultural and ethnic identities who interact and in so doing change while maintaining certain of their unique qualities" (Tedlock, 2011, p. 333). As an analytic approach to understanding participants' lives, this is consistent with Indigenous approaches, where we generate understanding through critical reflection and examination (McLeod, 2007; Simpson, 2011), and where this is woven together with participants' stories and into the "experience for both storyteller and the audience" (Simpson, 2011, p. 104).

From participants' accounts to the braided story: Life story approaches

Our research questions weave with the life story approach. In narrative inquiry, the life story approach refers to "the study of how individuals move through 'crises' that accompany each distinct phase of the human life cycle" from birth to older adulthood (Baddeley & Singer, 2007, p. 177). These pivotal moments of

crisis are felt to transform the subjective meaning of an experience profoundly, in ways that shape identity. Our study was focused on soliciting our HIV-positive Indigenous participants' descriptions of experiences and responses to depression. As a life course approach does, the mental health literature also defines several crisis points that span a life lived with HIV/AIDS. These key points include: knowledge of HIV status; disclosing one's HIV status to others; confronting HIV stigma and responding to discrimination, stress, and the role of social support; and the impact of comorbid mental health challenges on quality of life (Walkup & Crystal, 2010). Through in-depth interviews, we were concerned with how participants understood the roots of their depression (e.g., if it was connected to HIV or not, or the result of a foster/adoption experience), how they experienced depression (e.g., the shock of an HIV diagnosis), and the ways they responded (e.g., substance use, Western mental health interventions, use of ceremony). Originating in psychology, life course approaches in narrative inquiry generally share a focus on the autobiographical, attention to the socio-cultural factors that shape identity, adopt a life span perspective, and are open to multi-method ways of exploring the stories of participants in research contexts (Baddeley & Singer, 2007). In other words, the life course approach offers a way of organizing and understanding critical moments over the course of living with HIV from participants who confront feelings of depression.

How, then, is life course narrative research conducted? What are the key steps in conducting life course research? In using this approach, researchers often draw on open-ended interviews to elicit participants' stories. These interviews are transcribed verbatim, and individual transcripts are read and reread. As researchers develop an understanding of a participant story, they also identify key quotes that offer "compelling texts" that illuminate the general patterns of the story (Riessman, 1993, p. 27). These quotes are incorporated into written summaries for each of the participants' stories in the study. In preparing these summaries, researchers attend to differences in sequence and the influence of a story's plot. Stories are the sequence of "the raw, temporally sequenced, or causal narrative of a life" that are ordered to reflect "the expected arrangement" according to social convention (Riessman, 1993, p. 30). An event occurs, for example, that propels an individual to seek out a HIV test. Upon diagnosis, this leads to decisions about treatment, how to best handle disclosure, and how to deal with the emotional stress of illness, and so on. The plot, on the other hand, "emerges from the unexpected twists in the narrative that draw attention to differences from the conventional story" (Riessman, 1993, p. 30). Sequences with attention to plot demonstrate ways in which meaning shifts, and identity is reframed. Examples that potentially mix up this expected sequencing include plots or stories about how depression is not the result of HIV, how Indigenous

experiences of HIV and depression is both similar and different to other cultural groups, or how social support is best when it is grounded in ceremony. As summaries—including identification of relevant theoretical issues and key substantive themes—are prepared, these are used by the researcher to draw "a comparison across a series of first-person accounts" (Riessman, 1993, p. 30). This comparison focuses on

> locating turning points that signal a break between the ideal or real, the cultural script and the counter-narrative. The investigator searches for similarities and differences among the sample in discursive strategies—how a story is told in the broadest sense. (Riessman, 1993, p. 30)

Focused on the comparison, evidence for a researcher's interpretation is grounded in the direct quotes identified earlier.

From participants' accounts to the braided story: Indigenizing life story approaches

The life course approach in narrative inquiry offers, potentially, a useful framework for working with Indigenous peoples' stories of experiencing and responding to depression in the context of HIV/AIDS. In using life story as our narrative approach, we framed our encounter with this method in ways that embedded our emerging understanding of Indigenous cultures, world views, stories, and storytelling. Our goal in shifting the gaze—where life course remained a useful framework for organizing our own interpretations—was to develop a composite narrative that illuminated the world views of our Indigenous participants through their stories. That is, "rather than offering a chronicle of events, Indigenous oral history typically works to confirm identity and remind the listeners of the social and moral code of their society" (Anderson, 2011, p. 18). In other words, the idea of truth value is about who Indigenous peoples are, rather than a focus on the truths about what happened. This approach is widely acknowledged in the literature. The goal is not to see how a story is set apart, but rather, the purpose of a story is so that individuals can "find themselves in their people, to discover this shared reality" (Ballenger, 1997, p. 796).

The shift in our attentive gaze begged us to approach our participants' stories with a different mindset than offered by a life course approach. First, in our composite narrative we pivoted our attention, not to the "compelling texts," but rather, we searched each of the transcripts for evidence of the ways in which participants framed their stories in ways that reflect their cultural identities. This focus was not about the facts or events over an individual's HIV life course story. Rather, as Anderson states, it was about reflecting on how participants were "coming to grips with the personal meanings of broadly

shared knowledge and converting those meaning to social ends" (2011, p. 19) (Barnes and Gumede also consider how individuals engage their cultures and traditions in shaping artful social projects; see chap. 6 and chap. 8, this volume). Like the life course approach in narrative inquiry, we too searched through our participants' interviews for captivating quotes. However, our approach was focused on the ways participants' words and phrases, "work[ed] like arrows," acting as piercing missives sent out to "make you live right" (Cruikshank, 1999, quoted in Anderson, 2011, p. 19). These arrows acted as a symbol for the dissemination of knowledge in ways that connect the past with the present and remind listeners of the value of wise old teachings. As Noori states, "In its tip are stories, epiphanies, and glimpses of eternity, passed from one generation to the next. These intergenerational ways of understanding are complex, interconnected, and reflected in both Anishinaabe texts of long ago and text being written today" (2013, p. 35).

It was also an approach that begged us to ask different kinds of questions about participants' stories as we scrutinized our interview texts. We envisioned the stories shared by our participants as part of the broader Indigenous world. That is, we envisioned they would provide us with vivid descriptions about the Indigenous world views of our HIV-positive participants, as told through their stories of experiences with, and responses to, depression. Stories have the function of helping us to make sense of the world and our place in it. Stories help us shape our consciousness, and as a result, they help us shape our choices. In other words, as Garroutte and Westcott write, "[Stories] engender 'ways of being in the world' that attend to specific possibilities" (2013, p. 73). So, rather than focusing on events or facts within our participants' stories, our approach is one in which we listened for how participants were using cultural knowledge as strategies for improving their lives (Anderson, 2011). Similar to a life course approach, our reflection on each individual story is also recorded as a summary. Following advice offered by Banks-Wallace (2002), who drew on Indigenous literature to frame her research encounter in African tribal communities, our approach—rather than focusing on sequence and plot—also asked specific questions about participant's stories, including: "(a) What is the point of the story? (b) How does this story foster healing, nurturing, or communion? (c) What other purpose or function does this story serve in this context? And (d) what key words and/or phrases are used to tell the story?" (Banks-Wallace, 2002, p. 416). These questions guided the development of participant summaries that incorporate each of the compelling quotes that were identified in reading and rereading each of the individual transcripts. These first person accounts, as in life course approaches to narrative inquiry, are then compared against other participant stories, with attention to how stories are told. From this, a single composite narrative emerges in ways grounded in our participants' stories.

Writing the composite narrative

Through reading and re-reading, and as our knowledge of participants' accounts living with HIV and depression grew, we became more and more interested in the ways in which individual stories might weave with one another in ways that reflect cultural identity. Reflecting Indigenous oral tradition as it did, we discovered that our composite narrative best shared space with principles of creative non-fiction. In this non-standard way of academic writing, our approach mirrored new approaches in the social sciences that were focused on the development of innovative ways of presenting and sharing research findings (R. Gray, 2003). Although writing from a narrative ethnography perspective, Tedlock writes,

> Creative non-fiction [...] is factually accurate, and written with attention to literary style: However, the story is polyphonic with author's voice and those of other people woven together. In creative non-fiction, the story is told using scenes rather than exposition, and [...] the author-as-character is either the central figure or the central consciousness, or both. (Tedlock, 2011, p. 336)

In this way, the composite narrative focused our attention to a relatively new way of representing research findings. For us, there were three reasons driving the development of our composite narrative approach. The first reason was that in weaving several or more participant stories with one another, we felt we were further protecting the identities of participants by disguising identifying details (R. Gray, 2003). Second, our intent was to celebrate Indigenous identity by developing an interpretative understanding grounded in their Indigenous world views. Contributing to the struggle to decolonize, we were especially interested in how a composite narrative might refract Indigenous knowledges in the stories of our participants. In this, despite the negative consequences of colonization, we held steadfast to the notions that elements of Indigenous knowledges continue to influences the lives of Indigenous peoples (Anderson, 2011). And last, we hoped that our approach might honour Indigenous ways of sharing and learning that occurs through story. In other words, we recognized that our approach to "reporting inevitably shape[s] knowledge" (R. Gray, 2003, p. 178). It was thus our hope to return research findings in ways that made dissemination more congruent with Indigenous cultural heritage; that is, we wished to avoid further colonization with our written composite interpretation of participants' stories.

Creative non-fiction also privileges narrative techniques in the sense that their purpose is to inform, describe and explain, provide arguments, and cite appropriate sources (Tedlock, 2011). The difference between traditional scholarly approaches to the dissemination of findings and creative non-fiction approaches

to narrative inquiry is that one is embedded in the literary tradition. Used by what Gray and Sinding (2002) call "performance science," this approach maintains a profound connection with the data and its original meaning. As Gray states, "accounts should provide abundant concrete detail, so that they express a sense of the everydayness of lived reality" (R. Gray, 2003, p. 183). Creative non-fiction, considered a new form of narrative, has "characters, action, and shifting points of view. They follow a story-like narrative arc with a beginning, middle, and end, as well as high and low points of dramatic development including moments of tension and revelation. They also have an emotional arc consisting of inner conflict that meshes with the narrative arc" (Tedlock, 2011, p. 335) in ways that make this world visible to the reader. Our composite narrative drew on the direct quotes and stories of our participants in ways that mirrored our comparative understanding of the data. Our composite narrative reveals Indigenous identity by exploring the many complex challenges faced by Indigenous people who also live with HIV and depression.

Our hope in using principles of creative non-fiction was to present our findings narratively in ways that made them more visible and meaningful to our participants. We did this by refracting Indigenous knowledges through our interpretation and then writing about it in a woven, braided, and blended way as a composite narrative in ways that tied it to traditional stories. Drawing on methods of creative non-fiction (Forché & Gerard, 2001; Gutkind, 1997), with the writer assuming a reflexive role (Cook-Lynn, 2008), we discovered that it was possible to "use oral tradition and storytelling while [...] simultaneously engag[ing] with the contemporary reality of a dominant white world" (Schorcht, 2003, p. 7). Stories that draw on creative non-fiction principles value accuracy in their writing (i.e., faithful representation). Creative fiction does not typically use real-life places or events to impact reader audiences; "[creative] nonfiction, conversely, must not only ring true, it must be true" (Gutkind, 1997). The hope here—using the findings of the narrative approach described above—was "to emphasize that there is not a single [HIV and depression] story, but rather a multiplicity of experiences" (R. Gray, 2003, p. 183) in ways that highlight not only the common experiences but also the enigmas (Benham, 2007; King, 2003). Although we can say such approaches promote "alternative ways of speaking, reading, writing in ... inquiry [called] critical storytelling" (Dunlop, 1999, p. 3), in the end, "The ultimate test of the validity of knowledge is whether it enhances the capacity of people to live well" and these "new formulations of old wisdom can best be tested in the crucible of everyday life" (Brant Castellano, 2000, p. 33).

Parting thoughts

What's important are the stories [we've] heard along the way.

And the stories [we've] told.

Stories we make up to try to set the world straight. (King, 2003, p. 60)

This chapter has focused principally on the use of Indigenous knowledges in ways that not only challenge but support the use of narrative inquiry, so as to better understand experiences and responses to depression among Aboriginal people living with HIV and AIDS. It advocates a position that experiences with illness, such as HIV and AIDS, are best understood from the cultural perspectives of those who originally experienced it (McLeod, 2007), and thus, best expressed using their cultural practices of storytelling. One way to achieve this was to merge participants' stories into a single story—a story that incorporates and challenges existing theories of health while using traditional stories in ways that draw forth the cultural meaning. The composite narrative approach discussed above is an Indigenous, critical, and decolonizing approach that suggests transformation and healing is possible in ways that support Indigenous identity in the context of research (Anderson, 2011; Simpson, 2011). As the quote above suggests, our approach embraces the notion advocated by King (2003): if we challenge (or change) the ways in which Western research constructs stories about Aboriginal people living with HIV and AIDS in Canada, perhaps we also shape our understanding about ways culture, knowledge and identity are important to experience of illness.

However we might have opened space for use of an indigenized narrative inquiry, we also understand that this space is problematic in ways that may also engender criticism. Perhaps Indigenous peoples—the primary audiences for which we write—may find our approach not nearly Indigenous enough. Our non-Indigenous audiences might find we've pushed Indigenous too far. Perhaps, as well, Western narrative researchers may criticize our approach as too literary, or literary theorists may find us "too bound by research convention" (Coulter, 2009, p. 608). Whatever the challenge, in thinking through ways in which narrative might be indigenized, perhaps we've only affirmed the notion that working with Indigenous knowledges is thorny, knotty, and fraught with challenges that make its application within narrative inquiry not easily resolved. Whatever the eventual criticism, and recognizing this is a journey about learning the ways and uses of Indigenous knowledges in research contexts, we are buoyed by the notion that such approaches are "foundational for the construction of an anticolonial, egalitarian social science" (Canella & Mauelito, 2008, p. 56).

Acknowledgements

We wish to honour the wisdom generously shared by participants in our focus groups. Work on this chapter was supported by an Ontario HIV Treatment Network Aboriginal Pre-Doctoral Fellowship Award. We also wish to thank the reviewers of this article for providing constructive feedback.

Art for Transforming Social Relations

Emerging paradigms for managing conflicts through applied arts

Kennedy C. Chinyowa

This chapter is an exploration of the interface between conflict management and applied arts, two fields that are often perceived as separate entities. To do so, I adopt Shank and Schirch's idea of applied arts as an expressive medium for communicating social change (2008). While admitting that the "arts" defy easy categorization, Shank and Schirch explain that the notion embraces a wide variety of art forms, such as visual arts, literary arts, movement arts, and performing arts. The focus of the chapter will be, specifically, on applied drama as a category of the performing arts, and will place an emphasis on theoretical explorations of a few paradigms that emerged from workshop interventions carried out by the Acting Against Conflict project among students at the University of Witwatersrand (also known as Wits University) in Johannesburg, South Africa, between 2010 and 2012. Shank and Schirch (2008) have emphasized the methodological imperative of finding alternative paradigms for dealing with strategies of handling conflicts and the possibilities of managing and resolving them. To do this, I have adopted Chambers' definition of paradigm as "a pattern of ideas (or concepts), values, methods and behaviour which fit together and are mutually reinforcing" (1995, p. 42). In particular, the chapter examines those paradigms that emerged from the project's interventions, which seem to demonstrate the efficacy of applied drama as a conflict mediation strategy. For instance, I will examine how applied drama enables participants to understand how conflicts escalate, how the escalating conflicts can be handled (or managed), and the transformational learning possibilities arising from the interface between applied arts and conflict management.

Interface between drama and conflict management

The term "conflict" can easily lend itself to jargon if not properly contextualized. Here, "conflict" will be viewed as an opposition or clash of ideas, values, interests, and actions that result in a struggle over rights, power, status, and resources (Augsburger, 1992; O'Toole, Burton, & Plunkett, 2005). By itself, conflict can be a constructive force for change when it offers people an opportunity to respond to challenges, to search for alternatives, and explore new ways of being, and so may have positive connotations, such as unity in diversity, mutual

disagreement, and peaceful co-existence. When conflict degenerates into a destructive force, it creates misunderstanding, disagreement, dispute, incompatibility, hostility, crisis, violence, and even war. That degeneration seems to occur when conflict assumes the mantle of binary opposites such as self and other, us and them, centre and margin, superior and inferior, right and wrong. This binary dimension of conflict, when personal, group, or community interests become entrenched, manifests when individuals fail to accept or recognize the needs and interests of the other.

From their research experience in the DRACON International Project, O'Toole, Burton, and Plunkett (2005, p. 23) have argued that drama is about "the clashes and conflicts of personality, of values, of attitudes, of emotions, of interests both internal and environmental, of philosophy and ideology, of ethics and morals." By playing with models of human conflict, drama confronts the contours of human behaviour and relationships so that differences can be addressed. O'Toole et al. also find close parallels between drama and conflict mediation through the use of similar terminology, such as protagonist and antagonist, facilitation and mediation, tension and escalation, simulation and role play, participation and negotiation, climax and crisis, and denouement and resolution, to name a few. However, one cannot ignore the divergences between drama and conflict management such as the real (or "as is") and the fictional (or "as if"), empathy and distance (often experienced in drama only), experiential engagement, and "third party" involvement. The linking thread that runs through all these convergences and divergences appears to be the idea of dialogue. The examination of paradigms in this chapter is a way to show how applied drama acts as a creative approach to understanding and managing conflicts through dialogue and interaction.

The reasons for using creative approaches in exploring and understanding conflict lies in art's apparent transcendence over the limitations associated with conventional conflict management strategies. According to Schirch (2005), mainstream peace-building approaches tend to deal with conflicts directly, linearly, and rationally. More often than not, such approaches create adversarial spaces that place conflicting parties in opposition to each other across the negotiating table. Proponents of art-based, peace-building strategies argue that the arts have been used for centuries to communicate human experience in ways that have nurtured peace, rather than violence (Shank & Schirch, 2008). For applied drama in particular, Bagshaw et al. (2005) point out that drama education offers an alternative space for understanding, and for handling and resolving conflicts through experiential learning. Through enactment or role play, the medium of drama serves as a means of processing problematic human experiences by engaging patterns of thought, feeling, and behaviour that are

affecting the conflicting parties. Arthur (2007) further notes that the arts can transcend the limitations imposed by ordinary reality. In his own words, Arthur asserts that:

> while only a simple concept, the telling of one's story is a crucial step towards healing, both as a victim and as a perpetrator. Stories need to be shared, and giving a voice to those involved in conflict is a crucial way to heal the wounds and achieve a lasting peace. (2007, p. 2)

The creative imagination can unleash the thought processes necessary for brainstorming new ideas, feelings, and possible courses of action. By using metaphor, analogy, and symbol, imagination makes it possible to come up with ideas on how to deal with situations of conflict without the need for censorship or judgment. As a core function of play, imagination also engages with fantasy, humour, and enjoyment to transcend the internal and external barriers that often inhibit the creative problem solving of conflicts. Gruber (2000, p. 356) has noted that exposure to diverse experiences, preference for the novel, receptivity to metaphor and analogy, the capacity to make remote associations, independence of judgment, and the ability to play with ideas are some of the factors that characterize creative problem solving through drama and conflict management strategies.

Conflict Escalation Paradigm

In order to enable students to understand the nature of conflict, the Acing Against Conflict Project developed an integrated model that would help to bridge different applied drama modes such as process drama, image theatre and forum theatre (see Sinding and Barnes, chap. 3, this volume) with Friedrich Glasl's Conflict Escalation Model (1999). According to Bruce Burton (2006), the limitations inherent in theatre techniques, like forum theatre, lie in the overriding tendency of both the facilitators and participants to solve the oppression of the protagonist at the expense of exploring the oppression in depth. To compensate, theatre practitioners have been compelled to find ways of integrating forum theatre with other forms of interactive theatre. The result has been the creation of an enhanced form of forum theatre that allows participants to explore more complex and problematic issues. To give its integrated theatre workshops a structure that can effectively engage with conflict management, the Acting Against Conflict project facilitators adapted Glasl's Conflict Escalation Model (1999). The advantage of this adapted model lies in how it enables participants to explore conflict through different escalating stages, as in Table 10.1.

Table 10.1 ❖ Glasl's Conflict Escalation Model

Stage	Description
1. Latent	When the conditions for conflict present themselves as potential tensions or clashes over rights, interests, power, and authority. Such tensions have not yet reached a point of crisis but are still hidden from the protagonists.
2. Emerging	When the conditions for conflict begin to move towards a point of crisis, as those affected become partially aware of the growing tensions.
3. Manifest	When the conditions for conflict come out in the open. The growing tensions over rights, interests, power, and authority explode to a point of crisis and become visible to the protagonists and bystanders.
4. De-escalation	When action is taken to defuse the escalating conflict in order to prevent, manage, and possibly resolve it. It is often the task of third parties from outside the conflict, or bystanders, to intervene or mediate in the conflict.

The Conflict Escalation Model falls into the category of what Winslade and Monk (2000) describe as "narrative mediation." Rather than approach conflicts on the basis of objective reality, Winslade and Monk also assert that people live their lives according to stories, not inner drives or personal interests. In order to enable people to overcome divisive conflicts, it is more productive to work with the stories in which the conflicts are embedded (Price, 2007). This calls for the inclusion of more intangible goals, such as an improved understanding of conflicts and of what makes people better human beings. As a function of narrative mediation, therefore, applied drama provides an aesthetic space for participants to understand the nature of conflicts. By knowing the different conflict escalation stages, participants come to learn how they can relate to each other, the power relations informing their relationships, and the need to improve on those relationships.

Conflict Management Paradigm

There are as many conflict handling styles as there are different ways by which people resolve their differences. The ultimate goal is for affected parties to arrive at mutually satisfying solutions that minimize the cost of the conflicts. As Bagshaw et al. (2005) have argued, more creative strategies for handling conflicts are needed if all people involved in conflict situations are considered to have an equal right to exist and a right to their own point of view. To this end, the intention to satisfy one's own interests or to be assertive needs to be counterbalanced by the need to satisfy the interests of the other, or to be cooperative.

Table 10.2 ❖ Conflict Handling Styles

Type of Style	Description
Avoidance or Withdrawal	When one party stops or postpones a conflict until another time. Avoidance also involves withdrawing from a threatening situation or diverting attention. People who avoid or withdraw from conflict situations are often unassertive, uncooperative, and indifferent to dispute or disagreement.
Accommodation	When one neglects his/her own interests or concerns to satisfy the concerns of others. Accommodation involves giving in to the other party, even when one would have preferred not to, by making no big deal out of a conflict situation, or yielding to the other party's point of view. People who accommodate may either want to maintain positive relationships or lack the power to assert their own interests.
Compromise	When one chooses to pursue a moderate course of action by seeking mutually acceptable solutions. Compromise involves partial satisfaction of the interests of the conflicting parties, a kind of "meeting halfway" or making reciprocal concessions. People who compromise are moderately assertive and cooperative, tending to accept or smooth over differences.
Collaboration or Cooperation	When one asserts his or her own interests or concerns while also listening to the other party's views. Cooperation involves negotiating with the other party to find solutions that are satisfying for both parties. People who collaborate are often able to recognize differences of opinion and seek to learn from each other's views in order to come up with mutual solutions.
Competition or Aggression	When one becomes self-assertive, unwilling to compromise or cooperate, and wants to pursue their own interests at the expense of the other party. Competition or aggression involves the exercise of power and authority in order to win at all costs. People who use competing or forcing styles tend to look at conflict situations in terms of a right–wrong and win–lose approach.

Along with enabling students to understand the nature of conflict, the Acting Against Conflict Project applied the integrated theatre approach in its workshop interventions in order to encourage students to explore different possibilities of handling conflicts. The team of project facilitators chose to use Boal's image theatre to create an aesthetic space for students to experiment with various conflict handling styles based on Moore's Conflict Management Model (1996), as shown in Table 10.2.

Workshops

For the purpose of illustrating both Glasl's Conflict Escalation Model (1999) and Moore's Conflict Management Model (1996), I will describe here the general process of adapting image theatre in workshop settings. Augusto Boal, the

prominent Brazilian theatre director and practitioner, regards image theatre as a means of creating images, pictures, or sculptures out of participants' lives, feelings, and experiences in order to articulate their oppressions and explore alternatives for liberation (1992). In his own words, Boal explains that image theatre seeks:

> first, to discover what oppressions we are suffering (through the Real Image); second, to create a space in which to rehearse ways and means of fighting against those oppressions (through the Transitional Image); third, to extrapolate that into real life so that we can become free—which means we can become subject(s) not object(s) of our relationships with others (through the Ideal Image). (1996, p. 47)

Following in the footsteps of his fellow Brazilian and mentor, Paulo Freire (1970b), Boal (1996) argues that oppression exists when dialogue becomes monologue. Dialogue is reduced to monologue when one race, gender, class, or other group wants to dominate the other. Image theatre workshops are meant to enable participants to practise conflict handling styles by showing "the way things are" (the Real Image), "the way things should be" (the Ideal Image), and "the means of dealing with such things" (the Transitional Image) (Boal, 1996).

The Real Image: Workshops typically start with a series of games and exercises intended to introduce the problem of conflict in different kinds of relationships between people of different social groups. The facilitator instructs participants to create still images that represent specific conflicts. Such images are created according to the participants' own personal experiences or observations of conflict. These might involve situations in which one party is frightened by another's actions, or offended by them. Participants take turns to complete the image according to how each perceives the reality of the conflict. While the first stage involves the sculpting of static images of reality, the second stage often deals with dynamized transitional images that enable participants to discover the processes required for change.

Following Glasl's (1999) Conflict Escalation Model, it is usually possible for participants to discern a trend in which each party to the conflict is unaware of the underlying or latent tensions in the relationships until they become polarized. It is when the parties are aware of the brewing tensions that the conflicts come out into the open. When the aggrieved party decides to confront the offender, the conflicts escalate to the manifest stage. Thus, the conflict escalation model not only enables participants to understand the dynamics of conflict but also to find ways of dealing with conflicts before they escalate.

The Transitional and Ideal Images: Apart from creating the real images, workshop groups are also instructed to mould ideal images simultaneously. Groups commonly present ideal images of reconciliation, happiness, and celebration between the conflicting parties. The relationships are apparently free of oppression after the parties have negotiated with each other. At this point, the participants are instructed to show how the parties in conflict were able to move from the problem (the Real Image) to the solution (the Ideal Image). In other words, participants are expected to suggest how they would work out the Transitional Image. The means of arriving at the transitional image reflect the participants' understanding of how to handle conflict situations. Through interventions similar to simultaneous dramaturgy and spect-acting techniques in Boal's (1979) forum theatre, participants are able to formulate their own conflict handling strategies.

Conflict Transformation Paradigm

Understanding conflict management processes through the medium of applied drama cannot be separated from recent developments in the field of narrative mediation. Price (2007) has argued that countries in transition, such as South Africa, face the ongoing challenge of how to restore peace and justice, create socio-economic equality, and promote a culture of human rights. Price also believes that the potential of conflict mediation in transforming the fabric of South African society lies in the ability to instil social relationships that are based on equality, dignity, and respect. Since the experience of conflict itself is shaped by social relationships, any attempt to restore justice and equality needs to be cognisant of the relational dimension of conflict. In particular, the stories that people share about their experiences provide the structure for thinking, perceiving, and imagining conflict as if it were a distanced object exerting an influence on them. Likewise, Eriksson (2009) has argued that applied drama employs distancing to make the familiar strange and to allow a reflective "stepping back" that will enhance a more critical examination of events and situations. Even though distancing creates the awareness that the event is happening at one remove from the real, the power of such distancing lies in its capacity to arrest attention while providing protection, involvement, empathy, and detachment (on the significance of distancing in critical pedagogies, see also Sinding and Barnes, chap. 3, this volume).

What is conflict transformation from an applied drama perspective? How does it affect or effect change in understanding and managing conflictual relationships? Johannes Botes (2003) asserts that the term "conflict transformation" refers to the process of inducing change in relationships

between parties through improving mutual understanding. Processes like these often move through certain transitional phases and structures to bring about change in understanding, and even to mitigate or solve protracted conflicts. Botes (2003) further elaborates that conflict transformation not only represents identifying and removing the sources and causes of the situation that created the conflict, but also necessitates change in the attitudes and relationships between parties. Unlike the term "conflict resolution," which carries the connotation of "ending" or "resolving" a given crisis (Lederach, 1995), conflict transformation appears to be more concerned with the deeper structural, cultural, and relational aspects of conflict.

In applied drama practice, conflict transformation occurs through what Eriksson (2009, p. 45) has described as "distancing effects." These refer to the poetic strategies that help to mediate the seemingly disparate worlds of fiction and reality such as freedom, paradox, make-believe, and metaxis (elaborated below). Madison (2010, p. 2) has argued that, by applying performance based paradigms to acts of activism, we enter a poetics of understanding and an embodied system of knowledge concerning how activism can be constituted through dimensions of imagination and creativity. Poetic strategies act as the means and space for subverting and reconstituting reality during the conflict transformation process.

For instance, acts of activism involve the experience of freedom described by Sutton-Smith as "playfulness" (1997, p. 148). The mood of enjoyment has the capacity to disrupt expectations that people might have had. It involves the fun of transcending one's limitations and arousing feelings of laughter, mirth, and relaxation while simultaneously inverting accepted procedures and hierarchies. The intense absorption provoked by the activity of freedom wields the power to move participants to other states of being. During the process of enjoyment, participants are distanced from familiarity as they enter a different order of existence that offers them a sense of being liberated from the constraints and obligations of ordinary reality. Freedom provides them with an opportunity to experiment, and to generate new symbolic worlds in which the consequences of their actions are minimized. As a distancing mechanism, therefore, freedom enables participants to feel more secure when exploring sensitive conflicts.

Closely linked to freedom is make-believe, which can be regarded as a major distancing mechanism through which conflict transformation can happen. Make-believe lies at the heart of the marvellous and fantastic happenings responsible for transforming ordinary reality into fictional worlds. As Bretherton (1984) points out, human beings constantly create mental variants on the situations they face in life. Either consciously or unconsciously, they manufacture their subjunctive "as if" or "what if" worlds to represent potential

insights into how they want to organize and categorize their perceptions of the world. This subjunctive capacity, which involves participants stepping outside of this world into another, has also been described as "frame slippage" (Goffman, 1974). Participants are made to distance their "selves" in order to find themselves again. In other words, "make-believe" compels them to suspend their disbelief in order to attain the state of "make-belief." One could safely say that it is the "make-belief" dimension of "make-believe" that leads to conflict transformation. As Cohen-Cruz (2006) points out, narratives are rooted in the capacity of experience to place even the least powerful individuals in subject rather than object positions. The very act of telling one's story is a move towards agency, power, and authority. When personal stories are enacted, they no longer belong to the original teller but become the object of identification and projection for others. Even though they may begin as individual stories of conflict, they acquire a symbolic character by becoming matters of public concern. Boal (1995) put it in a nutshell when he concluded that the theatre is a domain of the first person plural.

Paradox is yet another discursive frame that operates through the mechanism of "role distancing" (Eriksson, 2009, p. 36). The feeling of relaxation experienced in drama happens as both a serious and not serious activity. Such paradox acts on the principle that, in order to be a successful player, one must be able to communicate information that simultaneously defines one as a player subject by being oneself, and as a player object in another context. Schwartzman (1978) offers the example of a girl named Linda who needs to communicate to other players that she is both Linda and not Linda at the same time. She can enter into and exit from the paradoxical frame of the role as both the self and the other. The paradox lies in the mental juggling, in being able to manipulate seemingly irreconcilable opposites, thereby creating a situation in which the action is both real and not real at the same time. The self is reduced in importance as attention is focused on the matter at hand.

In terms of conflict transformation, paradox provides participants with protection by making them feel safe from the "real" consequences of their actions, attitudes, and behaviour. The distancing of roles acts as a means of detouring feelings and finding meaning in situations which, by their immediacy and sensitivity, could have inhibited objective exploration. Conflict by itself often creates undesirable reactions among participants who need to be protected from the material causing the emotional disturbance. The paradox lies in making participants look not at their own attitudes but at other people whose roles they will have adopted. In the process, they will be exploring their own personal responses to conflict. Perhaps Vygotsky's notion of "dual affect," in which the player can be able to "simultaneously weep as a patient and revel

as a player" (1976, p. 549), sums up the transformative experience of having empathy with the role while also reflecting on the self. As O'Connor points out, in the gap between the performer self and the audience self, between the fictional world and the real, "resides endless opportunities for reflection about who and what we are as human beings" (P. O'Connor, 2003, p. 43).

The notion of metaxis has close parallels with paradox. Both suggest the existence of an interplay between the fictional and the real world which leads to participants' awareness. In O'Toole's view, the fictional context of the drama allows the real context to be momentarily suspended, yet such reality remains very present as the power of the drama continues to resonate between the two contexts, which is the metaxis (1992, p. 234). There is a simultaneous existence of two apparently disparate worlds, with transformational learning taking place as the fictional world overlaps or collides with lived experience. Bolton asserts that "where the edges between reality and fiction become blurred ... the emotion felt is first order, that is, unmediated by abstraction or knowledge of pretence" (1984, p. 109). In other words, metaxis creates the concrete awareness that goes beyond imagined reality. If the metaxic experience is extended to the conflict transformation paradigm, it creates a complementary relationship between what participants bring to the workshop—such as their cultural background, values, attitudes, and beliefs—with what happens in the make-believe world of the drama, as both contexts begin to operate on each other. Boal (1995) aptly concludes that the "image of reality" (fiction) can be translated into the "reality of the image" (reality) during the process of "rehearsing for the revolution" (transformation).

Mitchell (2002) alludes to a growing shift from a conflict resolution to a conflict transformation paradigm within the field of conflict management and peacebuilding. This shift is being enhanced by another parallel shift towards narrative mediation, due to its capacity to engage not only with the social dynamics of conflict, but also to transform the adverse human relationships affecting parties in conflict. Similarly, the distancing effects employed in applied drama enable participants to act as experts with the capacity to work through the conflicts in their lives with minimum third-party involvement. The incorporation of a counter-story in place of the existing conflict story helps to create new understandings and relationships. If the ultimate goal of mediation is to bring parties closer to the possibility of resolving their conflicts (Price, 2007), then an approach that enables parties to engage with each other and reflect on the changes taking place in their relationships has the potential to produce more lasting results.

Conclusion

The efficacy of applied drama as a medium for understanding, managing, and transforming conflicts can be compared to Bullough's analogy of a fog at sea (1957). Bullough notes that if such a fog was observed aboard a ship, the experience may cause acute unpleasantness because of the fear and anxiety created by the scary sounds and signals. But the experience can also be a source of intense enjoyment if one's attention is directed from the fear towards the pleasurable qualities of the phenomenon. In other words, if the fear is turned into a pleasurable experience, it will be possible to distance the terrifying anxieties and absorb the beauty of the sensations and changes brought by the fog. Bullough concludes that the sum total of what we are as human beings, we owe to experiences made mainly through the medium of sensory impressions. Bullough's fog analogy can be compared to the paradigms that have emerged from the links between applied drama and conflict management examined in this chapter.

By integrating Glasl's Conflict Escalation Model (1999) with applied drama techniques, it was possible for Acting Against Conflict workshop participants to embody their experiences of social conflicts. The conflict escalation paradigm shows how applied drama can act as an alternative medium for understanding and mediating conflict. Participants are made to transcend the barriers that often inhibit them from confronting sensitive issues affecting their relationships. They experience a change in understanding the escalating nature of conflicts, and the causal factors behind the escalation of such conflicts.

Similarly, the application of Moore's Conflict Management Model (1996) demonstrated how applied drama acts as a creative problem-solving and non-violent approach to handling conflicts. As Deutsch and Coleman (2000) have argued, the failure to achieve peace is, in essence, a failure of the imagination. Humanity spends a huge amount of energy and resources on violent means of solving conflicts that could be directed towards creative and non-violent ways of waging peace. Indeed, conflict can be transformed, and peace can be attained, by a concerted willingness to turn conflict-saturated stories into counter-stories imbued with more conducive conflict handling styles, such as compromise, accommodation, and collaboration, rather than competition, aggression, and violence.

By creating and activating images of their reality, applied drama participants can relate such images to the reality of their own lives. Boal (1979) asserts that if the "oppressed" can perform an action rather than the artist in their place, the performance of that action in theatrical fiction will enable them to activate themselves to perform it in real life. The implications of Boal's assertion to the

transformation of conflicts cannot be overemphasized. Applied drama provides an embodied yet distanced way of processing experiences of conflicts that could have been too sensitive for the affected parties. As Bagshaw et al. (2005) have concluded, the integration of applied drama with conflict management strategies enables participants to understand and explore conflicts as a means to managing and overcoming them.

Corroding the comforts of social work knowing: Persons with intellectual disabilities claim the right of inspection over public photographic images

Ann Fudge Schormans

It concerns legitimacy, one's entitlement to look, to arrange or hold within one's gaze, to take in a view, or to "take" a photograph—hence it concerns the title, droit de regards. *(Derrida, 1998, p. 2)*

Coming to see is irreversible and once we have seen something we can never not see it again. (Cixous, 2001, p. 11)

In his text *The Right of Inspection* (1998), Jacques Derrida works with a collection of photographs by Marie-Françoise Plissart to trouble assumptions about our right to look at visual representations of the Other. Derrida questions "one's entitlement to look, to arrange or hold within one's gaze, to take in a view, or to 'take' a photograph"—a right that he understands as the "right of inspection" (1998, p. 2). Photographs have the power to influence how and what we come to know about this Other (Derrida & Stiegler, 2002) and, consequently, how we treat them. When we view a photographic image, we tell ourselves stories about that image—we "take" a photograph. But whose story is being told? And whose stories, and what stories, are not told, are forbidden? It is the meaning(s) gleaned, the "stories" told (and not told)—to ourselves and to others—when we "look" and "take in" visual representations of the Other, that matter. Derrida's destabilization of the photographic image is not an analytical process so much as an opening up of the image for innumerable (but not an infinite) number of possibilities (1998). In so doing, he disrupts that which we think we see, that which we think we know, troubling the simplistic way we might approach our relationship to photographic images and, by extension, to the Other in the image.

Extending this argument, Judith Butler speaks to those practices of visual representation that engage with the fundamental question of the humanity and the de-humanization of particular lives (2004). Dominant claims to legitimacy determine whose faces and bodies may/may not be seen, how they may be seen, and who is allowed to comment. Like Derrida (1998), she also seeks to trouble the boundaries of visual representation, to disrupt accepted notions of what can and cannot appear in public spaces, and to address how—and why—this must

be done. For Butler, "certain faces [marginalized and excluded faces] must be admitted into public view, must be seen and heard for some keener sense of the value of life, all life, to take hold" (2004, p. xviii). I would argue, further, that these marginalized and excluded faces must be admitted on their own terms.

If we consider Butler's and Derrida's questions within the context of visual representations of "intellectual disability," we find that persons identified as having intellectual impairments have long been denied the right and opportunity for self-representation, or the right to even comment upon how they have been represented by others (Fudge Schormans, 2006; Hevey, 1997; Phillips, 2001). The "right of inspection" over intellectual disability imagery is understood, implicitly, to belong to "able" others. In the case of public photographic imagery, we are left with a preponderance of violently reductive and stereotypic visual representations of intellectually disabled persons that reduce intellectual disability to tragedy, burden, disaster, and lack. These visual representations create for persons so labelled a collective iconic identity that, in denying the heterogeneity within this community, subsumes all within a single pejorative category (see Pretorius and Kellen, chap. 4, this volume, for similar points about dominant storylines regarding migrant children). This visual imaging and imagining of intellectual disability both reflects and shapes disabling discourse about labelled persons, and has important consequences for their lives (Carlson, 2001; Clare, 2001).

Derrida's emphasis on *who* has (or should have) the right of inspection over visual representation of the Other is also provocative because of what I perceive to be its link to social work, and to social work's history of "inspection," in all its arrogant forms and with all its multifarious consequences. A review of the history of social work with persons with intellectual impairment reveals that this inspection can be understood to be, in the main, a violent exercise, albeit one couched in terms of benevolent expertise. The social hygiene movement, eugenics, mass institutionalization, forced sterilization, and persistent practices of educational and community segregation come immediately to mind (Oliver & Sapey, 2006; Simmons, 1982; Wenocur & Reisch, 2001). Social work knowledge of intellectual disability remains tethered to a medicalized, deficit-based understanding of impairment as a "problem" needing to be fixed, remediated, or eliminated; the task for practice being to do for and take care of "unable" persons with intellectual impairments (Gilson & DePoy, 2002; Grant & Cadell, 2009; Oliver & Sapey, 2006). Attending carefully to these historical and contemporary practices, to tenacious assumptions about the (in)ability of persons labelled intellectually impaired, and the resultant emphases on the "necessity" of social work expertise in practice for and (less often) with them, I am also concerned about the responsibility associated with social work "inspection," and the necessity of disrupting harmful and disabling social work knowledge of and for this group.

Catherine Phillips argues that arts-based methods "allow us another way 'into our work,' into conversations of power and the dialogic relations of social work practice" (2010, p. 200). In this chapter, drawing on work completed by a group of adults with intellectual disabilities in an inclusive arts-informed research project,[1] I braid concerns over the right of inspection, disability imagery, social work practice, and the use of the arts in social work research to attend to two interrelated questions: "What happens when persons with intellectual impairments claim the right of inspection over public photographic imagery of persons so labelled?" and "How might they use photography to disrupt and extend social work knowledge about intellectual disability?"

The PhotoChangers and the "What's Wrong with This Picture?" project

Donna, Sam, Robin, and Bob—four adults who self-identify as persons with intellectual disabilities[2]—agreed to join me in a project to explore how public photographic images represent, mis- or dys-represent persons with intellectual impairments. The project sought to look at how labelled persons would interpret and respond to visual imaginings and imaginings of people with intellectual disabilities. It also explored how labelled persons can use this same medium— photography—to trouble dominant images, and create new ones, as a means of disrupting what is known about them. The process was intended to enable *self*-representation. It was also intended to illuminate the challenges and conse- quences of representational practices and, through the inclusion of the perspec- tives of persons with intellectual disabilities, to further the conversations about their place in these practices and debates (Butler, 2004; Newbury, 1996).

The project's design reflected participatory and inclusive research ideologies and arts-informed research methodologies, both of which have been increasingly recognized as facilitating more active and meaningful participation in research for persons with intellectual impairment. These methodologies quarrel with and lay waste to ableist claims about the inability of persons with intellectual disabilities to participate in research and knowledge-making (Bigby & Frawley, 2010; Gilbert, 2004; Goodley & Moore, 2000; Knox, Mok, & Parmenter, 2000). In this project, group members were given significant control over the research process, and the methods used afforded multiple and creative means by which they could express their insights and critiques. Over time, Sam, Donna, Robin, and Bob came to identify themselves as a group—the PhotoChangers—that included myself and a digital media specialist assisting us with the technical aspects of the work. "Ann's research" soon evolved to "our work," and, as the project progressed, it was named the "What's Wrong with This Picture" project.

Bob, Donna, Sam, Robin, and I met one to three times per week for three months. To each meeting, I would bring a collection of public photographic

images I had gathered from the most typical forums for photographic images of disability: newspapers, charity advertising, service agencies' corporate materials, medical journals and magazines, social documentary, and photographic art (Evans, 1999; Garland Thomson, 2001; Hevey, 1997). Robin, Donna, Sam, and Bob would select the image(s) to be worked on that day—individually and/or collectively.

The first step was for the PhotoChangers members to critically engage with the images. As this was a new task for them, I initially asked them questions about what they saw in the images; what they did or did not like about the images; and the different stories they read within them. I also asked them to consider how they felt non-disabled viewers would interpret these images—what the images would "tell" these viewers about intellectual disability and persons so labelled—and to address the implications of these interpretations to their lives. In short order, they began to initiate and lead these discussions themselves.

The next task was for the PhotoChangers to realize visually their critiques of each of the images they had chosen to work with. Transforming the images with the aid of Photoshop (with support from Ann and the digital media specialist); taking new photographs that they themselves directed; and juxtaposing original, transformed, and new images, they used photography to articulate different stories: counter-narratives that belied the "truths" inscribed in the originals. The images were then exhibited to three different audiences at a series of community exhibits that they themselves curated. The audiences varied in terms of their knowledge and experience of intellectual disability and the intimacy of their relationships with persons so labelled:

1) other persons identifying as having an intellectual disability;
2) individuals who, by their own admission, knew little if anything about intellectual disability and had never known someone identified as such; and
3) individuals who had personal or professional relationships with labelled persons.

The majority of participants in this third audience were professionals working in clinical and community-based services.

In the sections that follow, I reflect on the responses of this third audience to the PhotoChangers' work in particular. First, however, let me share with you Donna's engagement with one image as a means of setting the stage for the discussion of professionals' responses.

What Donna saw

The photographer of the image Donna worked with was Diane Arbus. (Unable to obtain permission to publicly reproduce the image, we describe it here.) Pho-

tographed in black and white, without any caption or text, the image is included in the book *Untitled* (1995), a posthumously published collection of Arbus' work. The images in the book were taken at institutions for people with intellectual disabilities in the northeastern United States between 1969 and 1971. It is an image of four women—whose ages seem to range broadly—standing side-by-each on a grass lawn directly in front of a large tree. Other leafy trees—that let in only limited light—can be seen in the background, as can a building of some sort. All four women are wearing dresses and shoes—two have on white bobby socks. Over their clothes, they are wearing what look to be identical white paper costumes: ruffled dresses, each with a bow at the neck; paper crowns with a star pasted squarely in the middle; matching stars adhered to the tops of their shoes; and masks covering their eyes and noses (three white, one black). Each women holds aloft a paper-covered wand, also with a large star affixed to the top. The two women on the left are holding hands. All four have their faces turned towards the camera. One woman is clearly smiling; the masks covering the faces of the other three women make their expressions harder to discern.

The first time Donna saw this image she immediately and forcefully closed the book and pushed it away. It was many weeks before she was able to look at it again. At this meeting, with the image positioned at a safe distance, Donna begins with this comment:

> I don't want to look at this picture! It's scary. It looks like a cult picture—they're all covered up, only their eyes are cut out of the mask. It's like the KKK [Ku Klux Klan][3] who insult people and argue and fight! They're violent people!

Her fear audible, Donna speaks at great length about the KKK, telling the rest of us about a documentary on the KKK she had watched many years ago, late one night on television. She has a vivid recollection of this watching, remembering content, colour, and sound. This documentary and other images she has seen have convinced her that the KKK is "evil." In a distressed voice, she references the "white sheets" that cover and hide KKK members' bodies, the hoods that mask their eyes. She spends a long time describing in detail the violence perpetrated by the KKK, the derision and intimidation they inflict, and her struggles to understand their hatred and prejudice. Throughout, she makes plain her fear and abhorrence of this group.

Donna then lets us know that the staging of the women in this image makes them far too similar to the KKK for her comfort. Consequently, the image frightens her—as much now as when she first viewed it. She is deeply disturbed by the association, referencing the white, flowing dresses and the masks the women wear. Covered so completely by the costumes, the women are no more visible than KKK members are in their robes and hoods. Little in the image is

exempt from comparison. The wands the women hold aloft remind Donna of the torches brandished by KKK members as they travel in the night, a contrast achieved in this image by the pairing of the women's white costumes with the darkness produced by the black and white photography. This association has the consequence of constructing these women with intellectual disabilities (and, by extension, *all* people with intellectual disabilities) as the embodiment of evil, a frightening other to be avoided at all costs, as a group who deserves condemnation by non-disabled others judging them. This is the story she believes the image tells non-disabled viewers.

The image speaks immediately to Donna's (and the other group members') personal experiences of being perceived by non-disabled others as scary, threatening, and as someone to be shunned; responses that they understand to be a consequence of their having intellectual impairment. Donna, Sam, Bob, and Robin all believe that many non-disabled people hate them, and hate all people with intellectual disabilities: the way they are treated makes this clear to them. The image thus evokes an understanding of the disabled self that is lamented, to be resisted, and even to be feared.

Donna herself has a background of persistent poverty, social isolation, and rejection by her family. She is acutely aware of being the only member of her large family with an intellectual disability. For Donna, intellectual disability— and by this she means non-disabled understandings of and responses to intellectual impairment and people so labelled—has directly and almost singularly caused all of her troubles. Viewing the Arbus image with her history, it is perhaps not surprising that she rails against the demonization of people with intellectual disabilities that she perceives as having been inscribed in the image. She understands the image to be a violent one: falsely characterizing labelled persons as threatening and frightening, it not only perpetuates this perception (with significant consequences to so-labelled persons), it also violates her own belief that she is kind and good person. With much emotion, she declares: "People without disabilities should look at this picture and think about being in this position! How would they feel to be dressed liked this and called names?" What follows are tears, sadness, and anger, and her insistence that non-disabled people need to understand what it means to be feared and hated to the extent that she believes people with intellectual impairments are.

Asking Donna how she might like to transform the image to put forth her understanding of it, she first asks us to change everything: remove the masks, the costumes, the stars on the shoes, and the wands. She wants the women to be dressed in "normal clothes"—"this would look better, I would feel better if it was changed like this!" What is critical is to remove all references to the KKK— to remove, that is, all of the markers that construct people with intellectual impairment as scary. Admitting to Donna that this is likely far beyond the

capacity of Photoshop, I ask if she has any other thoughts as to how she might express the association with the KKK that she reads in the image. Wishing to assist Donna, the digital media specialist searches for and finds images of the KKK on the Internet. Working with these images in another meeting, she arrives at her transformation of the original image.

In Donna's transformation, a second image (also in black and white) of a large group of Ku Klux Klansmen standing or moving around on a grassy field has been pasted atop the Arbus image, centred over the bodies of the two women in the middle so that, at first, it looks as if they are holding it. Nothing else has been altered in the original image. What can be seen in the KKK image is that each of the Klansmen is wearing the long white gown and hooded cape of the KKK. Planted in the ground is a large burning cross—in the image, this is standing just right of the centre. Several of the Klansmen are brandishing smaller burning crosses.

Unable to remove the signifiers of evil (the masks, dresses, and wands), Donna chooses instead to exaggerate the association as a means of making plain what is to her the image's explicit and pathologizing message. The darkness of the original works in her favour. The masked women in the image are staged in such a way as to appear to be holding the image of the KKK, and to be simultaneously staring back at the camera/viewer in a sombre and solemn way (despite the smiles). For Donna, the transformed image is intended as an address by herself and by the disabled Others in the image to the non-disabled viewers. Implicating the non-disabled viewer in the hurtful treatment of labelled persons, she (and, she supposes, the women in the image) want viewers to know that she/they are well aware of how they are perceived; they "know" what non-disabled people think of them; and she/they understand these images as expressions of non-disabled prejudice and hate. She/they also want to make the point that this type of thinking about intellectual impairment and people so labelled is wrong. Further, with this transformation, she/they are demanding empathy from these viewers. She/they wants these viewers to put themselves (or be put by others) in this position. In this way, non-disabled viewers would come to appreciate how it feels to be so actively discriminated against.

What the audience saw

There were three exhibits in total. Ten people[4] attended the exhibit for family, friends, and professionals: two were friends of persons with intellectual disabilities, and eight were professionals (two of whom were also parents of adult children with intellectual disabilities). To begin, the audience members spent approximately 45 minutes walking around the room, looking at the work. The PhotoChangers had made the decision to mount their transformations on large

sheets of white foam board suspended from the ceiling. Each foam board also contained selected comments drawn from their critical engagement with the original images. Juxtaposing the two sets of images, the originals were laid on tables immediately below the transformations, allowing people the opportunity to look closely at both, and to read any captions or text accompanying the originals. Audience members had been given small notebooks to record comments, questions, or notes, and most used these. As they quietly made their way around the room, Sam, Donna, Robin, Bob, and I milled about, lingering in the background, coming forward only to answer any questions audience members asked.

Following each viewing, we gathered everyone into a circle for a discussion. The PhotoChangers and I, prior to all the exhibits, had scripted a process for this step of the event, sharing responsibility for its conduct. But this time things did not work out as planned. In blunt contrast to the other two exhibits, the audience members actively resisted our attempts to engage them in conversation. Instead of the lively and flowing, open and critical engagement enjoyed in the other exhibits, we were met with defensiveness and silence—averted and downcast eyes, closed-off body language, and the offering of only brief and reluctantly given responses. Quickly becoming self-conscious and discomfited, Robin, Bob, Sam, and Donna were silenced as well.

Puzzling later over what had transpired, we felt unable to determine the reasons for the audience's response. Did it stem from the work itself? Was it the presence of the PhotoChangers? Or being directly addressed by them? Was it all of these things? Or was it something else? With the PhotoChangers's permission, I reached out to individual audience members, requesting one-on-one meetings to talk about what had happened. Five people (all professionals) were agreeable and, over the course of the next few weeks, I was able to explore with them their understandings of what lay behind their silence and of what had triggered their defensiveness.

Seeing but resisting threatening knowledge: Two professionals really struggled with the PhotoChangers's interpretation of the images because they themselves "don't see people with disabilities as disabled." This response seems to reflect an ideology of normalization—an ideology that works to minimize the perceived differences between people with and without intellectual impairment by "fine tuning the deviant person to make her or him more 'normal' in his or her 'normal' immediate environment; the good health of the community has uncritically been taken as a given" (Trent, 1994, p. 275). From this perspective, intellectual impairment remains something to be fixed, to be changed—labelled persons acquire value only when they can "pass," or are perceived to be "normal." These two professionals appeared to take this stance, regarding

persons with impairment as being the "same" as those without. Not only was this their expressed belief, but they appeared unable (or unwilling) for much of the interview to acknowledge that it was not a universally shared one, and attributed this same world view to both persons with intellectual impairment and non-disabled others. Their unwillingness to move beyond their own frame of reference, and their faith in the "rightness" of it, seemed to necessitate their stubborn resistance to seeing or hearing—or giving credence to—the messages being conveyed by the PhotoChangers. Probing further, these responses appeared to me to be, somehow, rooted in their self-identification as "advocates," which, in this instance, worked to distance them from the PhotoChangers, and from people with intellectual disabilities. It obstructed any recognition that Robin, Bob, Donna, and Sam—and people with intellectual impairment as a group—might have different experiences of the world than the professionals themselves do in their advocacy relationships with labelled persons. Especially challenging and strongly resisted was the PhotoChangers' assertion that the images many non-disabled others (including professionals) hold of people with intellectual impairment are typically negative and harmful. For these two professionals, the disconnect between the PhotoChangers' view and how they perceive themselves to regard labelled persons was just too uncomfortable.

These two audience members regarded the original images as being neutral—neither dangerous nor hurtful. Two other professional audience members had made similar comments at the exhibit itself. Some admitted even to liking certain images that the PhotoChangers were opposed to—expressing an aesthetic appreciation of the imaging, and an uncritical acceptance that the purpose of an image (e.g., fundraising) justified any harm that might accrue. For these four professionals, the PhotoChangers' critique was received defensively, as a threat to their own opinions. In a similar vein, a small number of professionals did not regard all of the issues raised by the PhotoChangers in their work to be quite as significant or concerning as the PhotoChangers did. When, in the exhibit, group members gently challenged what they perceived to be a "sugar-coating" of the issues, these professionals were again put on the defensive.

Silenced by seeing: Privately, the other three professionals I met with reported being very moved by the work and proffered their sense that it was an important means of moving towards change. All of this made the silence that we experienced at this exhibit, and their complicity in it, that much more surprising. The explanations given by these audience members share a number of commonalities and also some unique features.

Despite their practice experience in helping professions, each of these three individuals was uncertain as to how to overcome their own or others' silence, awkwardly admitting to not even knowing how to begin. Taken aback

by their own silence, and that of the other audience members, and struggling to understand these responses, two professionals articulated their worry that, in the face of the silence, they would be imposing their thoughts should they be the only ones sharing. Both were keenly aware that some audience members were openly defensive and/or not always in agreement with the emotions, experiences, and opinions being expressed by the PhotoChangers. As such, their response was explained as a desire not to offend or antagonize. Another professional raised the possibility that "maybe people were too concerned about being politically correct." She also felt that everyone who had observed the work was made uncomfortable by it and it was this that silenced them but, because no one was speaking, she did not feel comfortable or free to speak. As she stated, "the atmosphere didn't encourage dialogue."

The work caught these three individuals by surprise. Each independently questioned whether their self-identification as a "professional" working with people with intellectual impairments was the source of the silence. After all, as professionals, they were "supposed to 'know' about disability!" And, prior to the exhibit, they firmly believed that they did know. What they saw at the exhibit, however, was so unexpected that this professional confidence was shaken.

For one professional, the further a transformed image moved beyond the realm of what was familiar (and comfortable) for her—a professional and clinical understanding of intellectual disability—the less likely she was to comment upon it. This was especially true when the changes were provocative and reflective of strong feelings and opinions held by the PhotoChangers. Donna's transformation of the Arbus image, her association of this imaging of labelled persons with the KKK, proved especially unsettling. This professional's first response to the original image had been a positive one and she was upset at having failed to see in the image that which was so troubling to Donna. Embarrassed, and not wishing to compromise her position as a knowledgeable professional, she did not speak up.

Working through her experience of the exhibit, this professional then arrived at another, perhaps more troubling, explanation related to her having "come into the exhibit with her 'professional' hat on." She attested to theorizing and practising with persons with intellectual impairment from a "positive, strengths-based, empowerment, and independence perspective." She wondered if she had not also looked at the images—both the original and counter images—from this same perspective. She concluded that, due to her professional obligation and desire to "support" people with impairment, she did not always say what she felt because she wanted to "empower" the PhotoChangers, to not "contradict or question or challenge them," and to "respect their ideas instead of questioning them" or "offending" them. Her silence really came down to "not wanting to hurt their feelings." She began to wonder if professionals, trained

to be supportive, were inadvertently "blocked from engaging with people with intellectual disabilities in a critical dialogue."

These comments raise important questions both for individual practitioners and for social work educators. The PhotoChangers have, in numerous presentations of their work, inspired many audience members to engage in critical dialogue with people with intellectual disabilities—dialogue that has felt open, frank, and respectful. At the same time, in this interview and elsewhere, professional audience members spoke instead of "not wanting to impose their thoughts," "not wanting to offend or antagonize," "not wanting to hurt their feelings." These comments express an underlying disbelief in the PhotoChangers' ability (and that of all people with intellectual impairment) to manage critical engagement emotionally. Certainly Donna, Sam, Robin, and Bob expressed deep sadness and anger over the course of this project: the work of facing and responding to powerful disabling discourses of intellectual disability was oftentimes emotionally difficult. Yet, for the professional audience members to assume that the PhotoChangers' feelings require protecting in this context denies the persistent ableist assault on their feelings, identities, and abilities that Donna so vividly identified in her response to the Arbus image. To avoid critical engagement with the PhotoChangers about their work is to enact exactly the sort of paternalism and infantilizing that is the source of so much of their distress, and their critique.

The force of the work itself, as a disruptive expression of the knowledge and experience of persons identified as intellectually impaired, was the primary explanation given by two other professionals for their silence. Admitting to being powerfully moved by the work and their conversations with the PhotoChangers as they viewed it, each admitted to feeling overwhelmed.

"Floored" by the nature of the PhotoChangers' interpretations, one professional spoke of how some of the interpretations "almost frightened" her in the sense of the worry they created for her over what the PhotoChangers (and other labelled persons) live with each day. The work likewise led her to wonder "how much harm is being done to people with intellectual disabilities by these [original] images," and to become alarmed that "no one is giving it any thought." Pointing out how, for some time now, "the professional focus is on pushing for accessibility," she worried that, in determining accessibility to be the priority, professionals had significantly "underestimated the magnitude of the barrier of stigmatization evident in the images": professionals, experts, non-disabled others, and even she herself, "take too much for granted about the world."

It was the unexpected nature of the work, the complexity and depth of the critique, that was most disruptive for this professional. She disclosed being "stunned and disappointed with my own surprise" at the PhotoChangers'

engagement with public photographic imagery. In light of her own professional experience and relationships with labelled persons, she was "embarrassed" and "humbled" at having been so surprised. Much of this response was derived from what she articulated as her own knowledge and experience of the many ways in which persons with intellectual impairment are "short-changed" by non-disabled others, and by the ways their knowledge and abilities are so rarely recognized. Not only did she not "know" intellectual disability to the degree she thought she had, she felt she should have "known better." Forced to confront the strength of her own unconscious assumptions regarding persons with intellectual disabilities as knowers; by the revelation she, too, had short-changed them; she discovered that "[I] didn't know as much as I thought I did" about intellectual disability and people living with intellectual impairment, *and* about herself. It was a lesson to her that, as a professional, "you can never be smug about what you think you know."

These same sentiments emerged from my conversation with another professional. However, in addition to the messages articulated by the PhotoChangers' critique and transformation of the original images, yet another professional walked away from the exhibit with knowledge about the importance to Sam, Bob, Robin, and Donna of being positioned in the way they had been in this project, and the effects it had on them as individuals—the pride they took in their work, their strong sense of accomplishment and satisfaction at (finally!) being heard. While appreciating this aspect of the project, it also deeply unsettled her confidence in her usual ways of working. When she went to work the following day, she discovered she "didn't know how to practice."

This professional found herself re-evaluating her role in the lives of clients with intellectual disabilities and doubting her own approach to practice with them. In an encounter with a client later that day, she deliberately attempted to alter her approach to a significant degree, endeavoring to be "less controlling," "trying to *really* listen," and being especially conscious to be "*really* respectful" and "natural"—as opposed to worrying about always acting in a "professional" manner. She was at pains to actively empower the client in ways she hoped would be meaningful "*to the client!*" She reported finding this to be "freeing" and "very comfortable" for herself. And it was her belief that the client was "pleasantly surprised" and quite receptive to this change.

Corroding the comforts of social work knowing

Newbury argues that the value of photography for disabled people lies in the way it affords a potentially powerful means by which to explore and reconstruct societal understanding of "disability" in both cultural and educational contexts (1996). Rendering new and multiple meanings of disability, the possibility is

created for the viewer to "see" disability differently (Kratz, 2002). Re-imaging and re-imagining "intellectual disability," the methodological approach used by Donna, Robin, Bob, and Sam in the "What's Wrong with This Picture?" project opened up an opportunity for social workers and other helping professionals to come to see disability differently, to rethink that which they thought they knew. And, despite their silence at this event, it became clear that this had happened.

The PhotoChangers' inspection, their critical readings of public photographic imagery of people identified as intellectually impaired, expressed in and through their visual transformations, speak immediately to the violence that has been/is being done to labelled people, and which is represented in and through the original images. They highlight what, for Sam, Bob, Robin, and Donna, are the untruths of the image and the dangers that accrue from such. Donna's work unveils the enormity of the violence depicted in and effected by the Arbus image. Looking at the transformed image, the viewer's eye is powerfully pulled towards the same markers of violence that so strongly repelled her. To a great degree, the power of her transformation of the image is its effectiveness in making "real" (or "more real") "matters that the privileged and the merely safe might prefer to ignore" (Sontag, 2003, p. 7). In this case, it is the violence, the subjugation, and the consequences to people with intellectual impairments of the unquestioned assumptions reflected in and perpetuated by visual imaging.

Yet the transformed image's power also derives from the way in which Donna lays blame and places responsibility for this violence squarely with non-disabled others—with the producers of such imagery certainly, but also with non-disabled viewers who accept what has been inscribed in these images without question. This includes social workers and other professionals working with and for them. Throughout the course of the project, Donna and the other group members returned again and again to what they understand to be the role of professionals in the "bad" things that have happened to them. There is little question that Donna's work with the Arbus image, like so much of the PhotoChangers' work, made the professionals who viewed it uncomfortable. In implicating non-disabled others—making plain their participation in the ongoing oppression of labelled persons—she seems to make it less easy for professionals to believe they are somehow exempt; somehow absolved from this responsibility (Garland Thomson, 2001). Defying the professionals' expectations as to what will be (or should be) contained within and by visual representations of intellectual disability, I would argue that Donna's transformation of the Arbus image, and the PhotoChangers' other transformations, reflect the impossible: that contrary to long-held and tenacious beliefs—contrary to common social work knowledge—people labelled intellectually impaired *can* understand public photographic images; *can* think about them; *can* respond; and might

very well have a very specific reaction to them—one that actively contradicts and opposes that of the non-disabled professional helper. In fact, the force of these new images derives primarily from their very clear and active opposition and resistance, from the challenge they pose to the assumed "rightness" of non-disabled professional knowledge of people with intellectual disabilities. The transformed images are a surprise, and, to some, an affront.

The strength of Donna's transformation of the Arbus image is in the fusing of the expected with the unexpected, the familiar with the unfamiliar (Clare, 2009; Garland Thomson, 2009). It is this juxtaposition that served as the source of disquietude for the professionals viewing it. Through the forceful overlaying of the Arbus photograph with an image of the KKK, Donna contests assumptions about people with intellectual disabilities while also dramatically undoing the typical non-disabled reading of the original image as readily decipherable (Baer, 2002). This re-imaging makes obvious the extent to which non-disabled viewers, including professionals, may not know as much as they think they do. "Corroding the comforts" (Baer, 2002, p. 129) of professional knowledge of intellectual disability, it is a move that, I believe, worked to deeply discomfort the non-disabled social work viewer. In so doing, it provokes in the social work viewer the kind of critical self-reflection that the PhotoChangers meant it to do.

What the PhotoChangers accomplish in their critical readings and transformations is to multiply and capture—to make their own—the meanings of the image (Derrida, 1998). In claiming the right of inspection, they claim not only their long-denied right to look at images, but also the right to critique and change images, thereby claiming, too, their position as viewer, commentator, and knower. Their counter images, their retellings of the original images disrupt both the stories told by the originals and notions of legitimacy—of who should (and indeed *can*) speak for persons with intellectual disabilities. They shake professional expertise. For the non-disabled professional viewer, in coming to see the PhotoChangers' interpretations of the images, it becomes harder, if not impossible, to go back to the ways in which they saw the images before; difficult to go back to how they saw and understood labelled persons before; difficult, as one professional noted, to "know how to practise." These images are not neutral, not innocent, and not without consequences (Butler, 2004; Evans, 1999; Sontag, 2003). Nor can labelled persons any longer be assumed to be un-able, un-knowing: they are something other than once was thought.[5] The non-disabled viewer's eye, forced to see the un-seen and thus far un-seeable, is thus directed towards political awareness (Garland Thomson, 2009). Another surprise, then, is the revelation that people with intellectual disabilities *are* a threat, but *not* for the reasons heretofore believed (e.g.,

contagion, unpredictability, uncontrolled lust, irrational aggression). They now pose a threat because, in articulating the situation (Martin & Spence, 2003), their work begins to shatter professional illusions of professional knowledge, expertise, and power.

Notes

1. The project under discussion was conducted by the author towards the completion of her Ph.D. in Social Work.

2. Bob, Donna, Sam, and Robin insist on my using their first names whenever I tell others of the work they completed in this project: this is their work and they want it recognized as such. Upon completion of the project, as a group we identified different forums and means by which to share it. The PhotoChangers members have presented their work (with and without me) at many conferences and in a number of social work classes. They have given me permission to make presentations without them and to write for academic publication. In addition, Bob, Donna, Sam, and Robin identify as self-advocates and choose, in their lives, to use People First language. I come to the work from a critical disability studies lens that regards "disability" both as an embodied experience and an experience of oppression, and which foregrounds the disabling effects of societal responses to persons with impairments (Frazee, Gilmour, & Mykitiuk, 2006). In this chapter I use a mix of these languages.

3. The Ku Klux Klan is a white supremacist organization with a long history in the United States. Wearing long white robes, hats, and masks to hide their identity, they use violence and intimidation against their declared enemies: those who are not white Americans and those who do not share their social and political views.

4. In this audience were professionals from social work, occupational therapy, education, and mental health. They worked in both clinical and community-based service systems. Consequent to the small size of the group, all will be referred to as "professionals" to reduce the risk of identification.

5. The potential for artful (self) representations to disrupt relations between presenters and audience members—and, thus, to shift social relations between "othered" and dominant groups—is discussed in more general terms in Sinding and Barnes (chap. 3, this volume).

Art for Transforming Social Care Practice

Bringing relating to the forefront: Using the art of improvisation to perceive relational processes actively in social work

Cathy Paton

Improvisational techniques can help us shift the way that we understand and engage with relational processes in social work. Relational dynamics are particularly salient in social work as a discipline where relational work is pivotal. Improvising involves creating **in the moment with others**, and engaging with this apparently simple premise encourages us to focus on particular features of social work: its largely unscripted nature, and the way it is co-created. These features of social work are especially important at this moment in history, when standardized work practices are increasingly expected (see Baines, chap. 1, this volume).

Improvisational techniques can provide an experience that allows us to make active the relational gestures that have become and/or are commonly considered as social work techniques. The art form presents us with the challenge of using active relational gestures to bring us into the moment with people and with ourselves. Such departures from the cognitive and the preplanned have the potential to shift understandings, and in doing so, shift the ways in which we relate to one another. In addition, this movement in understanding and relating highlights the significance of reflexivity within social work relationships.

In the following chapter, I examine two cases in which social workers (students, practitioners, and academics) have drawn on insights from improvisational theatre to make visible/address specific relational dynamics and/or to shift understandings of specific relational dynamics. In each case, I begin with a description of the improv exercises the group engaged in, and provide specific aspects of how the exercises are set up to make them rich for generating reflection on relationships in ways that are congruent with social work intentions and values. I discuss how the components of each exercise are designed to highlight or evoke certain aspects of relating. In terms of relational dynamics, I focus on openness and attentiveness, mutual constitution and unknowing, and vulnerability. I draw from the participants' experiences of the exercises in order to illuminate how this alternative form of engagement can contribute to critical changes within processes of relating in social work. I explore the ways in which improvisational techniques can take on active and impactful meanings that allow us another way into the relational dimensions of our work (Phillips, 2007b).

Case One—The Social Work Classroom

In April of 2011, I was a guest lecturer in a course that was part of the social work MA program at Ryerson University in Toronto, Canada. The following is a description of two of the exercises that I facilitated in the classroom, followed by the responses of the students to those exercises.

The "yes, move" exercise

The basic premise of this activity is that you need a "yes" in order to move forward. The participants form a circle, so that everyone can see everyone else's face/front of body. One person (A) begins by pointing to someone in the circle (B). B must say yes before A can move towards her or him and take her or his place in the circle. As soon as B says yes, B needs to point to another person in the circle (C). Before A reaches B's spot, B needs to receive a yes from C so that B can move to C's spot.

The "yes" exercise is intended to make non-judgment visible. In the exercise, the "yes" is used as a vehicle for active acceptance. In improv, to "yes" does not always mean saying a verbal "yes." Improvisers use "yes" as a verb; the idea is to "yes" the reality that is created, the improvisers onstage (including yourself), and their and your ideas. To "yes" the people and ideas allows for the creation of a world within which the improvisers can "play": that is, to create identities, relationships, locations, and motivations. This does not necessarily mean saying "yes" to a character's behaviour. For example, as an improviser, I might say, "No. You can't have your money back." In doing so, I am saying "no" to a character's behaviour or request, yet I am saying "yes" to what has been created—yes, I have your money, yes, you've asked for it back, yes, my character wants to refuse your request. The role of the "yes" is to evoke non-judgment as it calls for actively endorsing, and agreeing to participate in, the reality that is being created. It also involves suspending or evading the all-too-common voices in our heads that might question, hesitate, or judge the ideas that come forward as "not good enough." Playing with the "yes" in the exercise—getting used to it; making it accessible, intentional, and attached to physicality—evokes an awareness of the potential of non-judgment.

Components of the "yes, move" exercise

The circle: This exercise happens in a circle where everyone's body and attention is turned towards/open to everyone in the circle. The purpose of this is to elicit engagement in the exercise at all times—including when participants are not moving or speaking. Everyone is involved in the relationship by being there

(of course, *how* they are there is up to them). Since they do not know when they will be pointed at or be called upon, they are active in themselves in anticipation. What does it mean to stand in a circle—not taking prescribed turns, and being available/open to being called? This is not to place a judgment on either "taking prescribed turns" or being open to being called. Rather, it draws attention to /allows for/makes visible the state of being available to be called upon at any time—a state of openness and attentiveness.

Eye contact: Participants are instructed to make eye contact with the person whose spot they wish to walk towards. The eye contact is intended to highlight [the impact of] nonverbal communication, and intentional nonverbal communication specifically. What does it feel like to make eye contact with your colleagues? What does it feel like to communicate with such clear intent? What do you notice about yourself when you are in a nonverbal relationship with your colleagues (through eye contact)? The use of eye contact is meant to evoke awareness of self and reflexivity in the experience, and of bringing self to the forefront/making the self visible, through the experience of a physical relational gesture, such as eye contact.

Verbal "yes": Needing to give and receive the verbal "yes," as this exercise requires, provides the experience of asking for, giving, and receiving permission and/or acceptance. A sense of mutuality is made visible in this process because, just as participants are instructed to be intentional and to make eye contact, they are also relying on (and thus, vulnerable to) the other participants to pay attention, to recognize their request (to receive them), and to give them the "yes" (permission, acceptance …). The giving and receiving process also intends to draw attention to a sense of vulnerability as we are asking for the "yes," for permission to physically move; we are exposed in that moment to the possibility of being denied, and in that, also stopping the flow of the exercise.

Physical movement across the circle: The physical movement in this exercise is intended to make visible the process of creating and being a part of fluidity (movement, change, give, take …) in relating. The flow that is created as people are continuously moving across the circle gives a visceral experience of the attention, the asking, the receiving, the hesitation—all of the components of the exercise. There is a felt emphasis on how our relational gestures change, stop, slow, or speed up the flow. The movement that is enabled by the "yes" happens both between individuals and as a group, in relationship.

Responses, reactions, and reflections on the "yes, move" exercise

Upon reflection, this group of students put the "yes move" exercise into the context of saying yes to service users—to not judging the service users with whom they work. In the context of the exercise, the students understood non-judgment in terms of relational possibilities that potentially arise when acceptance and support of both the people they are working with and themselves, are unconditional. An important piece of this was that they did not feel they needed to judge behaviour as helpful or healthy, but rather to accept that the behaviour is happening in the moment—"yes."

Another aspect of this experience was about being able to acknowledge their own ideas. The students reflected upon the challenge of saying "yes" to their own responses, and explored the idea of what it felt like to say "yes" to their own ideas—giving these ideas room to exist in their mind and body by acknowledging their presence, allowing these ideas to circulate through themselves, and to impact them in mind and body: "yes" the ideas are here; "yes" I have a thought/sense/feeling/reaction to this. The students considered what it would look like to do this with the people with whom we are in relation—and, specifically, those with whom we work in the social worker/service user context.

In giving and receiving the "yes," students found that they felt vulnerable—that they felt anxiety in giving, as they were then open to being denied/receiving a "no." They also experienced feelings of relief and joy in receiving acknowledgement and hearing the "yes."

Making intentional eye contact had an impact on students. This relational gesture evoked feelings of connection with their colleagues; feelings that for some students, they hadn't considered, explored, or experienced before. The relational flow created within the circle made students conscious of their own gestures, and they noticed themselves within the movement of the circle. For example, the students discussed noticing their own feelings of hesitation, uncertainty, certainty, and connection.

Relational processes evoked by the "yes, move" exercise: Openness and attentiveness

One of the relational processes that was experienced in the "yes, move" exercise is an openness to the unknown. Frost and Yarrow (1989) address this process as it relates to attentiveness:

> Accepting and staying with the state of not knowing "who" or "what" is quite a precise step towards activating a degree of present awareness,

which is ready to sense and respond to a more coherent and extensive range of sensation, intuition and expression. (p. 146)

The state to which Frost and Yarrow refer, this state of not knowing, can enable other ways of thinking and seeing the world; "interrupting what is known to make space for new knowledge and alternative ways of knowing and being and being with ..." (Fudge Schormans, 2011, p. 22). Making this way of "accepting and staying with" visible as an alternative way of being and being with, is an impactful way of pursuing different ways of coming to understand one another. Part of this process involves an awareness of that which is happening within a moment; to feel/sense/experience relating, and that which is developing between yourself and others. The students' responses demonstrated a sense of being aware of their own developing relationships and of their reactions to the relational processes involved in that development.

Simon (2003), in his discussion of the philosophy of Emmanual Levinas, highlights the presence and responsibility that is crucial to relating. Levinas argues that we are called to a responsibility for one another that requires an "embodied attentiveness" (quoted in Simon, 2003, p. 51). He refers to this state, the combination of responsibility and attentiveness, as a sensibility. This sensibility holds the importance, relevance, and life orientation for Levinas that brings him to connect it to Kavannah—a Hebraic term that refers to the "attentiveness, attunement, and intentionality" (cited in Simon, 2003, p. 50) that one needs in order to engage in prayer. This is a space of active peace, in which one is prepared to be immersed in what is in the moment and, consequently, to be actively present to one another.

The kind of attentiveness that Levinas addresses is a sensibility that is comfortable with uncertainty (Fudge Schormans, 2011). It is important to clarify, specifically in the context of social work, that the premise of uncertainty and unknowing is not that we begin relating with a clean slate. According to Blom (2009), social workers have a general knowledge about people and the value of their contexts—the ways in which they understand and navigate through the world. Frost and Yarrow also address the concept of the relationship between our contexts and uncertainty, stating that in being attentive in improv, we are "naked but not defenseless ... armed with wit, agility, mobility, inventiveness" (1989, p. 152). The improvisational techniques in the exercises prompt us to shift more fully and consistently into a place of unknowing, and/or to engage with a sensibility of unknowing where context continues to be paramount.

Frost and Yarrow (1989) speak to the awareness that can accompany giving and receiving, as in the "yes" exercise. "*Disponibilité* is a condition of responsiveness, but it isn't passive reception. It implies *giving* as much as receiving. Reciprocal giving between two or more *disponible* creators ... opens

up a truly new form of artistic creativity" (p. 155). Frost and Yarrow address the interrelated aspects of the kind of relating that improvisation makes visible: the attentiveness in reception, where one is ready to receive and thus ripe with uncertainty. It is also where one is ready to give, where one is calling on their own context; the place from which they are giving.

"Improvising scenes" exercise

In this exercise, two students volunteered to go to the front of the room. The rest of the group suggested a location within which the scene would take place (in this case, a laundromat), and the two volunteer performers proceeded to improvise a scene.

Components of the "improvising scenes" exercise

Going "onstage" with nothing: The volunteers were not given roles to play. The initial intention with this exercise was to engage the students with a sense of unknowing and vulnerability. The students did not know who they would be, or whom they would be interacting with, once their scene started. If the students had been given characters to play, the scenes would have been centred on expectations and assumptions. The improvised scenic work required the students to create one another onstage, which was intended to make visible the relational process of mutual constitution.

Side coaching: The students in the class were not experienced improvisers. The purpose of the exercise was to elicit certain relational processes, and mutual constitution specifically. The intention was not for the students to create an entertaining scene for the sake of entertainment or art or for the purpose of training actors (which improvisation is often used for/ performed as). In order to highlight the relational processes in the scenes, I coached the students from the sidelines. It was not important for them to "know how to improvise well"— people improvise for a living and work to develop skills to do this successfully, as with other art forms—and I was not encouraging them in this way. It *was* important, however, for the students to experience beginning from a place of unknowing, developing a relationship, and creating one another's identities together. The side coaching was intended to help the scene to continue happening, while the students were able to "remain in the scene" without worrying about getting the process right, or that they did not have the skills that it takes to be an entertaining improviser.

Responses, reactions, and reflections on the "improvising scenes" exercise

The students who created the scene reflected upon the ways in which mutual constitution became apparent and vivid to them throughout their experience. They discussed their experiences of constructing reality—defining what reality is in the moment as opposed to having this defined elsewhere. Working with another person to create a scene made visible the impact of the other's contribution to the reality of their situation and relationship. Students witnessing the scene and the exercise discussed getting to know the self in communication with others and in relation to others. The students experienced themselves, as well as their own reflection of themselves, in relationship. The experience of being open to the self—allowing the thoughts and feelings that one is experiencing to exist with minimal resistance, while at the same time being open to the other and what they are offering—became both visible and visceral in meaning. While openness was a concept that the students were familiar with from being in social work classrooms, the improv experience evoked an urgency for openness.

One of the students addressed the concept of performing and her experience of being in a scene, creating and being created, and becoming more aware of how she performs in accordance with certain "rules of performance." She referred to the example of gendered rules of performance. The student further reflected that the rules are otherwise possibly taken for granted or invisible, referring to them as "rules we do not know we are following." She reflected on the idea that we are created, within and by these rules, both by ourselves and by the person with whom we are relating. She suggested that in the context of social work, the concept of creating one another in improv could be helpful in identifying and critically considering rules of performance that can be harmful (when left unaddressed).

Case 2—The Social Work Workshop

In November of 2011, I participated in the "Social Work without Borders; Social Working Artfully" conference in Johannesburg, South Africa. The following is a description of the main exercise that I facilitated with a group of social workers, academics, and theatre students there, followed by their responses to this exercise.

The drawing exercise

The premise of this exercise is that the group works together to create a picture—line by line, person by person. The picture is always changing, and the

group must make room for the ideas of others. This is a silent exercise. The group is divided into about four groups of five people each. Each group has one marker and a large sheet of paper on an easel. The instructions that I give are minimal—draw ONLY one line/mark at a time, and the final drawing should appear drawn by one hand. The group stands back about two metres from the paper and makes a semicircle facing the paper. I come around and make one single mark on the paper, and then stand by the paper with the marker in my hand until someone in the group (A) takes it from me. "A" will proceed to make another mark on the paper, and once again steps away from the paper with the marker in hand and stands until someone else continues the activity. The process continues until the group feels that their picture is complete.

The drawing exercise is, once again, used with the intention of highlighting or evoking certain relational processes. The participants' experience and their reflection (which are sometimes one and the same: i.e., they experienced themselves reflecting upon their actions) hold meaning. The drawing exercise is process driven. The goal of creating *something* is present, but it is clear that how it happens is what is predominant. The exercise highlights uncertainty and unknowing, as no one knows what will be created or how it will happen. We know there will be a drawing made with a marker, but we do not know how this will happen. The instructions do not indicate what it is that is supposed to be drawn. This means that the element of the unknown is prominent (this is the intention). If, for example, each group were given an animal to draw, the exercise might still elicit reflection on judgment, collaboration, and control. However, uncertainty would not be paramount as it is in the current exercise.

The exercise is also set up to encourage reflexivity: it encourages us to feel and look at what we are doing without a sense of competition or an emphasis on productivity. What is happening in the process of the drawing exercise, right then in those moments, is all that there is. It is important to note that within this exercise the goal is not to build or create something "at all costs"—it is set up so that we see, sense, feel, and are made aware of, those with whom we are working.

Components of the drawing exercise

No talking: One of the instructions in the exercise is that there is to be no talking. This instruction is given with the intention of avoiding verbal judgments. The silence is also intended to make visible our habitual reliance on verbal communication (through the lack of its use).

Wait for someone to take the marker: The concept of vulnerability is intended to be made visible with this component of the exercise. Participants have to stand with what they have created until someone else takes the attention: takes the marker and makes a mark. The experience of waiting for someone to take

the marker is meant to make visible—to allow us to see/sense/feel the weight/ presence/complexity of that moment—the moment after we put something out from us, when we add our thought, idea, or contribution. The waiting allows us to reflect upon this moment and encourages awareness of this moment for ourselves. What do we notice about ourselves? How do we feel about it?

Only one mark at a time: Having to make one mark at a time is meant to induce the process of making room for the ideas of others. It is intended to point to how it feels to do this kind of sharing and to point to the experience of creating together and/or "having to" create together. I consider "creating together" to be a relational gesture because, as we relate to one another, we are creating a relationship together. Creating together can also be synonymous to collaboration, which is another relational process.

The technique of making one mark at a time is also used to ensure that people take turns and, in doing so, give up some control and/or have the concept of having control or personal power made visible.

The common insecurity, complaint, or discomfort of "I can't draw," is meant to be minimized by asking participants to make one mark at a time. Making one line at a time does not allow people to demonstrate their "artistic abilities" in a traditional sense. This is intended instead to take that worry and/ or judgment of not being a "good" drawer out of the exercise.

Made by one hand: In an attempt to bring people onto the same page and bring their attention to what it is to collaborate, participants are instructed to make their picture look like it has been drawn by just one person. Once again, the aim is to emphasize creating together. If we did not have the goal of making something appear to have been created by one hand, we could end up with everyone trying to "make their mark" individually. There is no functionality of the drawing—it does not need to "say anything" or "be the best." There is, however, the goal of communicating some version of group cohesion through the drawing.

Responses, reactions, and reflections on the drawing exercise

Many of the participants found that they noticed themselves—that in the silence of the exercise, they could hear, quite loudly, their own frustration, resistance, and relief within the exercise. Frustration often came out of making a mark and having an assumption about what would follow. For example, the inner dialogue might be "There. I've made the second ear. This is clearly a cat we're creating," shortly followed by "What are you doing!?! That is supposed to be a cat! Not a solar system!" Feeling themselves becoming frustrated and observing this frustration was sometimes a point of surprise. Before the exercise, many participants assumed that flexibility was something that they could easily access. Their

frustration caused them to reflect upon their collaboration skills and/or habits within the context of social work, such as working with research participants to create a research project or writing an article with a group of academics.

In needing to avoid talking, people reflected on the ways that non-verbal commenting happens—how people stand, how they pass the marker, who they pass it to, if they wait to take the marker, laughter, silence, and facial expressions. People reflected upon the ways that they often rely on verbal communication while disregarding their own nonverbal comments.

One of the participants questioned *why* the exercise needed to be silent. This question was raised before we did the exercise, and I found it difficult to answer because of the importance of each of the intentional components of the exercise. For example, if I had said we could not talk so that we do not judge one another, people may have then been thinking about judgment. Although I did want to evoke the visibility of certain relational processes, I did not want to "intellectualize" the activity and/or coerce people into thinking about, rather than feeling, these relational processes. It is difficult to articulate this, especially to those who are skeptical of arts-based practices, but the insights involved in these exercises are meant to unfold as it goes along. If described beforehand, the method would be altered. I did not want to give people the instruction to think about judgment; rather, I intended to create a situation that evokes reflections on judgment (among other possibilities) through the techniques (in this case, the technique of not talking).

In reflecting on the experience of waiting with the marker in hand, vulnerability was something that the participants were met with. Standing with the marker after they had contributed caused some to second-guess their mark, and to feel insecure about the gaze of the rest of their group as they faced them in wait. Participants reflected upon the ways that they do not usually experience their own vulnerability. This was considered in the context of social work research, where participants are waiting for your response after they have added their own contribution. Waiting for the marker to be taken elicited an experience of vulnerability.

Some participants reflected upon their impulse and/or need to "save" people within the context of one of their group members waiting with the marker; they felt the need to take the marker from them, but also felt stuck because they were unsure of what to add to the creation. These tensions evoked some critical reflection about helping, and also about judgment. The reflections did not include judging whether this impulse was wrong or right but, rather, that this impulse happened, and how it was experienced. This part of the exercise made the participant's need or desire to "save" and/or help visible to them. Participants felt that this reflexivity was a valuable piece of the exercise.

Further reflection centred on the ways in which allying happened within the process of adding only one mark at a time. People reported "joining forces" when they recognized that they were on the same page as one another in terms of ideas about the picture. Sometimes allying happened from a proactive space, taking the drawing somewhere (i.e., the theme of the drawing, the objects in the drawing) and sometimes from a reactive space, stopping the drawing from going somewhere. This created a sense of the presence of power within the relational dynamics of the groups, and caused participants to reflect critically upon their own roles in collaborative efforts in social work.

The instruction that the drawings appear to be made by one hand created a sense of urgency and focus for some people. The weight of this particular instruction was felt as something that needed focus for some—it caused some stress and/or direction. It heightened the awareness of the actions of others. For other participants, though, different aspects of the drawing process (like shapes, genres, practicality) took over for them and the "one hand" direction faded into the background.

In reacting to the uncertainty that flows throughout this exercise, people found themselves trying to make sense and/or meaning out of what appeared on the paper. Some participants observed that there was a point in the exercise when they found themselves feeling a need to make rational sense, where the picture could not remain in the abstract. In this moment there was a shift from a feeling that the creation was happening, to a feeling that the creation needed to *be something*. Participants further reflected on this experience, explaining that part of this need (to make meaning and/or sense out of the image) is caused by a desire to get closer to being and/or working with their fellow group members. For example, it is easier to be on the same page when it is clear that we are drawing an elephant than if we are drawing something that does not apparently represent anything in the "real world."

Relational processes evoked by the drawing exercise: Mutual constitution and Unknowing

Fudge Schormans discusses the ways in which being open to uncertainty forces us to think and work differently in social work (2011). Frost and Yarrow address this same idea in the context of improvisation, when they state "the attention is focused on the precise moment when things take shape. As well as being the most exciting moment, this is also the most risky ..." (1989, p. 2). In the "Improvising Scenes" exercise, the moment when things "took shape" was the moment when something began onstage. This happened as soon as the students/performers entered the scene. Through their eye contact, their body language, the way they moved into the space, and then possibly (but not necessarily) through

the ways in which they spoke to one another and what they said—in all of this, they were creating one another. This is "the most risky" because it is the most unknown.

Levinas calls us to "admit that the first fact of your existence is not being in itself (of yourself) or for yourself but being for the other" (as cited in Simon, 2003, p. 56). If the "first fact of ... existence ... is being for the other"—what a beautiful thought. This does not mean that our labour or our care is "at the disposal" of (more powerful) others. It also does not mean that we do not "take care of" ourselves. It does mean that, in being in relation to others, we have a caretaking role: all of us. While engaging in improv, this role becomes visible—we shift how we understand being in relation to others because we can see that as we move through the moments together, we create the context together, and we constantly, visibly impact one another. As in the "yes" exercise, we experience how our hesitation, tone of voice, or eye contact shifts the way the circle moves—the way each of us relates and the ways in which we relate as a whole. The activity develops a rhythm and/or we develop a rhythm throughout the activity that allows us to physically experience "being for the other."

Social workers are implicated in processes of constitution that are significantly consequential for people's lives. In social work interactions, service users "become" deserving or unworthy, normal or deviant, while professionals are constituted as experts or supporters, authorities or allies: "we construct one another through our practices" (Phillips & Bellinger, 2010, p. 14). If we are more cognizant of constructing one another in interaction, we can, at least in theory, be more alert and self-reflexive about the process.

Relating to one another involves constituting each other within moments. This process is not something we do by choice; rather, it is the daily, generally unconscious construction we go through as people, in relationship, in interaction with others, living in society. It is through mutual constitution that we construct our power, experience our vulnerability, and come into relationship with notions of self (Butler, 2004; Jordan, 2008). Butler contends that we are "in each other's hands, at each other's mercy" (2001, p. 39). This perspective counters the idea that who we are is predetermined, a fixed feature of personality or consequence of upbringing and social circumstance; instead, it highlights the social and interactional processes that make and remake us. In this intimate and inherent human process, we are impelled to consider what it is to be responsible for one another (Levinas, 2001). While most discussions of mutual constitution remain at a relative abstract level, the improvisational techniques in the exercises provide insight into what it is like to create one another in a literal and visceral sense. We are called to recognize fully that we

do create one another. A deeper awareness of this might generate much-needed patience for one another, particularly in social work relationships.

Improv can help to show the weight of the existence of those around us and to make visible the "illusion of the separate self." Spolin (1999) suggests, that within moments of spontaneity and intuition, we find ourselves in a space of creation and community. Spolin further argues that a strong focus on the individual does not get one very far in improvisation, and that there is a call to grow through spontaneity to the point where we are even more obviously joined with others.

Conclusion

Improv is an art form with unique salience to social work. Improvisation engages with aspects of being in relationships that are valued within social work but are often assumed, and thus made invisible. These relational processes are especially disregarded and neglected within current social work practices because of neo-liberal emphases on efficiency and productivity that dominate the field (see chapters by Baines and by Kaseke, chap. 1 and chap. 2, this volume).

The embodied and visceral experience of improv call upon us to reflect on aspects of *how* we are with people and with ourselves. Participants in the two workshops reflected upon the relational gestures that were made visible through the use of improvisational techniques, and specifically on openness and attentiveness, mutual constitution and unknowing. Drawing attention to these relational processes opens the door for understanding them differently, and so calls us to critical reflection.

The real-time, in-the-moment, unscripted, creation that characterizes the art of improvisational theatre can evoke a visceral apprehension of prominent relational dynamics that prompts us to shift, more fully and consistently, into a place of unknowing, active acceptance, and wakeful attentiveness.

Making meaning of our experiences of bearing witness to suffering: Employing A/R/Tography to surface co-remembrance and (dwelling) place

Patti McGillicuddy, Nadine Cross, Gail Mitchell,
Nancy Davis Halifax, and Carolyn Plummer

Action research, connection, and social practice

A/R/Tography is an arts-based method, a form of action research that involves working with communities of practice who share a commitment to search for meaning in everyday phenomena (Irwin & de Cosson, 2004; Irwin & Springgay, 2008). The method attends to the relational process of creating and interpreting meaning that resides in the in-between of language, images, materials, situations, and stories. In this case, a group of researchers/educators and artists gathered to explore the question: What is the emergent meaning of bearing witness to suffering in healthcare? Suffering is an ever-present reality in healthcare work, in nursing, and in social work. A/R/Tography as an inquiry method, and as a social practice allowed us to surface multiple meanings of suffering, which built and enhanced connection between us and social action in our setting.

Action research using A/R/Tography creates situations that expand understanding, meaning, and knowledge through guided inquiry (Irwin & Springgay, 2008). Irwin & Cosson (2004) embrace the notion that action research is contextual, personal, participatory, and relational. Springgay, Irwin, Leggo, and Gouzouasis (2007) engage the borderland where thought, action, inquiry, art, teaching, and learning continuously intermingle in the living and creation of life. The A/R/Tography method guides researchers towards attending to the in-between of image and language in order to create critical concepts or meanings that emerge in the process of engagement and invention. "Concepts surface in intersubjective locations through which close analysis renders new understandings and meanings" (Irwin & Springgay, 2008, p. 115). Six renderings or concepts guide the process of engagement and inquiry in the A/R/Tography method (Irwin & Springgay, 2008; Springgay, Irwin, Leggo, & Gouzouasis, 2007). These are contiguity, living inquiry, metaphor/metonymy, openings, reverberations, and excess.[1] Each rendering is an invitation to engage the process of inquiry in a particular way. The rendering *contiguity*, for example, directs attention to the ideas that lie next to each other or that exist in each other's presence. In our group, for instance, we asked: What is surfaced because

our experiences of *bearing witness to the suffering* are lived alongside one other? In other words, how does it matter that, as healthcare providers, we work closely together, often side by side around a patient's bed, or in the confined spaces of nursing care station—how does this shape our experience of bearing witness to suffering? Our capacity to bear witness? What meanings of suffering and witness emerge in the (tight) spaces in between us?

Our exploration with A/R/Tography began with a story from Estés (1992) about La Loba, an old woman who collects the bones of wolves to preserve what is disappearing or threatened in the world and sings over them. In the story, wild women come from a call and a cry to join La Loba as she sings until the earth shakes and a new free expressive life form is created. This introductory story provided an anchor for initial discussions. It offered a symbolic account of how people live out their commitment to protect what we value, and of the personal and social transformation that follows. It invited other new and favourite stories to the room.

Figure 13.1 ❧ Research in action. *Photograph courtesy of Gail J. Mitchell*

In response to these stories, we each made art on wooden canvases; these were reworked throughout the sessions, with the six renderings guiding the process of artmaking and reflective discussion. A shared canvas was also placed in the room, and all participants contributed to it as they wished. The development of concepts, related to set renderings and the deepening of themes through use of narrative, is illustrated in the following sections of the chapter.

The surfacing and the resonance of social meaning and social change are particularly relevant to social work and nursing practices, which work *in relationship* to self, others, and communities. The mutual care experience, and the role of co-remembrance as a relational link between carers and with patients, was highlighted in our work to demonstrate the importance of addressing the ineffable "in-between" aspects of care. The congruence between the process of inquiry and emergent understandings provided opportunities through dialogue, and artwork provided opportunities for rich, layered, inter-professional research. This congruence enhanced dialogue, opportunities for exploring social change, and relevant conversations about what matters, particularly in nursing work and social work, when bearing witness to suffering.

Mutual care of one another and relational care of our clients/patients and families requires the courage of the witness. From a nurse's perspective, Arman refers to the work of "validating nuances of witnessing as a caring act" (2007, p. 84). The existential position of being a witness requires the caregiver to be courageous because of its transformative prospect, but may utterly enrich both parties' inner life of shared meaning. This ordinary day-to-day experience, this bone-deep exposure to grief and loss, and the need to recognize our existential positioning, is described by Catherine Phillips in relation to her social work in emergency departments as follows:

> In social work practice … it is not as if there is loss or there is none, grief or no grief—these acts are carried with us all the time. They are not present or absent, but rather we weave them into our practice in complex ways … It is clear that loss and grief in traditional academic form are situated outside the framing of the incorporeal body, every-day life, and the profundity of social relations. (Phillips, 2007b, p. 461)

The edge walking, the courage to move to meaning, the holding of space, body, mind, and heart, are all essential parts of the enterprise of witnessing. This makes the relational A/R/Tography method a particularly relevant one when it is applied within an institutionalized healthcare setting, where efficiencies and accelerating patient flow are often primary drivers that mask or dis-appear the patient, family, and staff experiences (see Baines, chap. 1, this volume).

Also of note here is the contribution of this methodology to the discourse and practice of social action research in the applied social sciences, as well as

the applied arts, in many countries, including South Africa and Canada. Social workers, artists, social organizers, healthcare activists, educators, and academics have employed social organization and engagement strategies to involve people (often who are marginalized or disenfranchised) in co-creating research and art that speaks to their realities, and surfaces meaning that can have social and political influence and resonance. Many of the authors included in this anthology, and the many that were part of the dynamic process which inspired it, are innovative leaders, allies, and facilitators in this work. As Kemmis reflects, regarding educational action research,

> critical or emancipatory action research is always connected to social action … the connection between social research and social action is not resolved simply by changing to a different set of sponsors … nor will it be achieved solely by improving research methods. It is achieved by doing different research, frequently with different purposes and substance and methodologies, with different people, in the service of different interests. (Kemmis, 1993)

The vicarious, relational, reflective, and creative approach to knowledge-making employed in A/R/Tography work provides a choice point, process, and outcome that can be, in and of itself and in its application, critical and emancipatory action research.

Use of A/R/Tography as the method of inquiry: What we did, what happened

In this particular inquiry, we found ourselves answering the following questions in the affirmative: Is bearing witness to suffering "an experience of the impossible," "an event that shatters our horizon of expectation," or a place "to go where we cannot go" (Caputo, 2011, p. 45)? Caputo's questions offered a way into our experiences of bearing witness to suffering from the perspectives of healthcare workers who are courageously seeing what is woven into our practice, and confirmed the need for this non-deliberative approach. As colleagues, we gathered over a period of six three-hour sessions to speak, feel, and create, individually and together, and to co-remember stories of a human phenomenon common to healthcare. In each session, the methodological research task enjoined dialogue and writing with individual visual artwork composition.

Jeff Malpas, in reflecting on human suffering, states that:

> while suffering might threaten the integrity of the self, the recognition of suffering is also recognition of the being of others, and opens up the possibility of a felt relation with others (which is true compassion).

Suffering may be singular, but compassion, with which it is conjoined, is always double. (2012, p. 9)

The space created for our A/R/Tography sessions were carved out of our frenetic schedules and our physical space within a large, urban, acute care hospital with intent—to shape a place for pause, for reflection, and for room to tell stories, listen, and shape the unshapeable. Finding a metaphor, story, or image with which to start is often helpful, and it is important that this image be resonant enough for all participating to find a connection, rather than a restriction. The process we engaged is evoked by one of the participants:

Please let the wolf feel us here holding the suffering in the space ... Watch us—looking for ways to hide hope in a place where it will not be discovered, destroyed or carelessly tossed across the room ... only the wolf can do this ... sometimes only the memory can meet the memory ... everything else, anything else we can think of, create, try ... will destroy the hope ... the co-remembering space is full of possibility.

The opportunity opened us to the lived experiences, which speak to the original impetus and importance of this endeavor, as another participant offers:

I think you were talking earlier about trying to keep a lid on it, on the suffering that was going on in that Unit, but what we notice is the trickle ... trickle down, because everybody was covered in the trickling: the staff that were in the room, the staff that weren't in the room and the patients and the organization. It was just like you couldn't get away, like lava—hot lava that was. ... People were trying to keep it contained, but for twelve years, fourteen years the lava has been flowing. That really speaks to me about that experience. ... There was sacredness to it and I also felt that was also something that needed to be held on to is the sacredness that went along with that. That's what the blue vessel is for. I intentionally left the top of it sort of jagged or not a straight edge, just because nothing is straightforward about it.

This particular reflection illustrates this inquiry process's ability to bring colour, texture, and metaphor to the understanding of complex realities.

Explication of conceptual themes

Resonant, repeating, and layered themes emerged through the A/R/Tography sessions and the subsequent rendering processes. Here, we will explore the meaning of themes of co-remembrance, breath, and place (dwelling), as they were explicated and threaded through our words and art. We shared this work with a larger circle of care providers and academics to confirm resonance, query with renderings, and deepen our understanding.

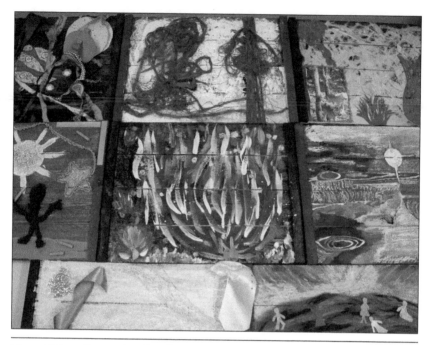

Figure 13.2 ❖ Composite of work in progress. *Photograph courtesy of Gail J. Mitchell*

Co-remembrance: Our interpretation considers our identification of co-remembrance and commemoration with others, as expressed through our artwork and ideas. Co-remembrance emerged within the context of bearing witness to suffering, as we co-participated in making artworks that revived the body and place memory as a commemoration of those who are and were suffering. Understanding co-remembrance may make explicit the irreducible temporal character of bearing witness, and how engaging in artmaking is transformative, releasing us to remember and to co-create memories that can sustain, teach, and comfort us further. The memory of *being with* persons who were suffering, and in some stories, with other witnesses or sufferers in a particular place and time, has in itself an aspect of co-existence or co-remembrance. This sense was deepened and reinforced by the A/R/Tography group process itself.

Casey (2000) reminds us that co-remembering is not exclusively mentalistic, representational, or recollective, but that concrete places retain the past in a way that can be reanimated in our remembering through place memory that is remembering *with and in* the lived body. He states that "body and place memory conspire with co-participating others in ritualized scenes of co-remembering" (2000, p. 216). Through body, place, and co-participating, "we witness the

othering of the mind into something other than itself. Remembering is in effect a progressive voyage into the othering of memory" (2000, p. xi). By taking our formed and reformed bones outside the room; in being outside the room—whether the artmaking room, the counselling room, or the hospital ward room—we are inviting and affirming body, space, and co-remembrance.

Co-remembrance of bearing witness to suffering draws the world together and knits the bones together; without co-remembrance, it would not be what it is or as it is. Again, Casey reminds us that remembering is intensified by the imposition of a text and the setting of social ritual, both of which come to use or light only in the presence of others. And so it was with our group, and those whom we were remembering. As one group member remembered and illustrated,

> When I came back to work, that room was empty that she was in. I walked in, and it was a night shift, I went into that room and I felt a presence in that room. It was very strong and it really struck me. I thought ... It almost filled my body. I think it was not just her, but all the patients, all the remnants, all the bones that were in that room over the years. This represents her, perhaps her soul or her spirit or her essence. Those bones are all going to be like this ... this bright colour when I start to honour them and I always honoured her. That's why I think she's yellow, but like in this brighter colour.

Another story told was about working in a long-term-care facility and having a long-term relationship with a man and his family:

> This was a man who had late stage dementia and Alzheimer's disease, but he, unlike others, he had a very overt ... it was very obvious that there was part of him that knew that something wasn't quite right. He was struggling to get back to clear thought and he knew there was something wrong with him. It was obvious and we all witnessed it all of the time. That was a struggle.

> [Did he ever get beyond that?]

> For a very short period of time before he died. It was only because he had physical things happen to him that caused deterioration that was very quick. I think he broke a hip and then had to go for surgery. That was ... you can just imagine what that would have done to him. He was never the same after that, but still occasionally would call out ... He didn't last long after that ...

Co-remembering is also about the elasticity of time and space, and of running into things that, at one time, were yours and mine and now

are ours as well—things that are waiting in the cracks to be lifted up again. Co-remembrance, to reference our artwork, draws life through time like soft embroidery thread, like shadows of white on white, gashes of sound, breath faltering, curled bodies, sutures straining and moist, children in the corners watching for a space to move into. This layering of space and time evokes the possibility of community, and a sense of empathic memory, within and across complex systems. As one participant explained:

> It helps to know you are there doing what you do as the suffering meets and converses, as those who suffer look for comfort from and with us, as others in other rooms do the same. The co-remembering piece is still bigger than this—it is about the fact that—if this ever happened, if you ever said that, if a family and their loved one *ever* felt that then I can remember, and feel and find/create meaning in places where the suffering needs a guide, a witness, a bone-carrier ... a rendition, a rendering of a rendition ... this can be repeated and in the repeating there is life that keeps the embroidered thread, broken or unbroken—summoning a chance to be colourful, touched, part of something, spatial, blown around.

The ineffable and the in-between are places where the suffering sits and reaches for us, as well as where comfort and knowledge are possible to find in the often distracted, intense rush of illness care.

Place (Dwelling): The theme of *place* can include the possibility of an actual-dwelling, some place to come from and go back to (Luce-Kapler, 2007): a place, a dwelling in the in-betweenness of the stories that give meaning to the many sufferings remembered. A place where, as one participant noted:

> There is a knock on the door when you open it and turn in that direction you meet anguish, unspeakable suffering. Sometimes small and tight, sometimes grand and loud and intensely searing—and yet we go back, return to the door, the place and the stories.

Often it is precisely our job to do so—it is part of the work, meeting and bringing meaning to the healing and suffering rooms we are in together. This is social work and nursing work. In this place, this dwelling, are images of beds, piled high with the bones of the sufferers, invisible bones that, as a participant said, "rattle each time the beds move." And those bearing witness always attend to the bones, and "we remember with the bones, the bones of others, our bones of our bodies." We cannot walk by the place, the dwelling, but must enter, go back. We know so much about what it is like; we recognize others who know. Within our metaphorical place, "we hold each other afloat, soothe, comfort," and bear witness to each other's suffering.

We remember a mother comforting her dying son, curled around him in his hospital bed as the nurse in the room tells us about being in place with them. The image translates, migrates into the work of other members of the group, into our lives together. This image, in the art piece, is covered by the participant with colourful threads of breath, protected—threads held in hands and hearts. At times, we, the witnesses, feel displaced, feeling like we have no place to call home. Is it at the abyss where we have no sense of belonging?

For the research group, the *in-between* place is a space to breathe, to remember, to co-remember. The notion of "in-between" is a dwelling of human inter-subjectivity, in which we find meaning of the life world. A participant reflects on this process:

> The in-between space is about doing this here and now as I write and you read—it is the same as the group in that I am in retrieved, rescued, immediate space—moulded by need and want and remembered connection brought to life by the action of my writing, my listening, my thoughts—I am creating it, re-forming it, knowing this is possible, and more …

These linked places, the remembered room, the in-betweens; the art room began to speak of spiritual dimensions. One member of the group reflected that there was so much to the work about staying, leaving, moving between—the space opens as you say—"Remember the night when you were there alone and the family came in?… And they said enough" or thank you or please help us or we were so disappointed or the pain is too much. We say to one another, Can you bear to hear this, can you bear it?"

How does the process of art open up a dwelling where the experience of bearing witness to suffering is uncovered more explicitly? We could understand dwelling as how place is experienced/staying-in-place. Dwelling became a place of listening to stories, to each other, about our art, our words, our ideas. In dwelling we are hospitable, perhaps spiritual, and making a home for each other as we co-remember. The truths of such inter-subjectivity are understood in the embodied dwelling of bearing witness.

Dwelling place and co-remembrance: The A/R/Tography method, and the subsequent inquiry shaped by the specific renderings, moved themes to inter-relate and deepen. The work in the room mirrored the care needed to share memory in place. A participant reflected on the process as a whole:

> What it is to hold other people's memories and those little bits of memory that come to you in the room? The contemplative silence and the sound of the art making—where we are honouring what is rising up.

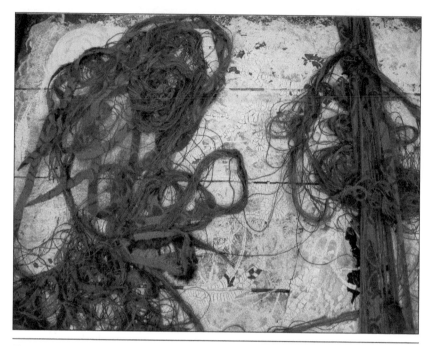

Figure 13.3 ❖ Thread, breath, complexity. *Photograph courtesy of Gail J. Mitchell*

> Co-remembrance with oneself, in the room and together—all are important—as the process of finding meaning from session to session emerged in part from the picking up and reforming of memories from previous sessions as well as the memories from my experience of witnessing suffering. I remember coming in [to the next session] and not recalling right way how I had come to create [the artwork]. The process of taking the time to look back and reflect on my prior thoughts also contributed to making meaning.

Remembering through artwork, we used and reused, individually and collectively, embroidery thread as a connector, texture, and metaphor for breath. One can visualize the threading-in images of a mother with a dying teenage child as it acted as a thick but porous overlay, protecting and exposing this image of suffering.

Collective memory and commemoration is often juxtaposed with powerful collective acts of the forgetting or traumatizing of memory and of rememberers—again, this is a beyond-mind phenomenon. Places where forgetting becomes the cultural norm are deadening places to work, heal, or die. So how are we able to extend, make anew a dwelling in the hospital that is open to the poignancy and plenitude of bearing witness to the suffering around

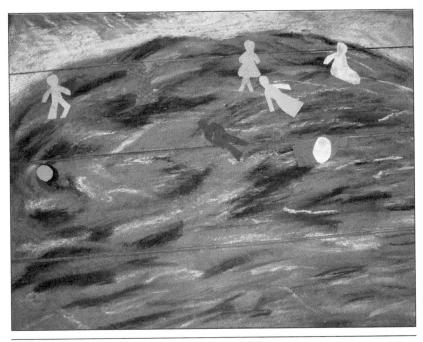

Figure 13.4 ❖ Layered lives, memories, and places. *Photograph courtesy of Gail J. Mitchell*

us (Casey, 2000)? How could "these places, spread out everywhere, yield up and orient new spaces" (2000, p. 331)?

Breathing and breath; that which sits with: The thread of our work was breath. Breath caused us to be placed, to remember deeply and jointly. We spoke about the physicality of being breathless, holding breath, and being aware of our breath and that of others. In writing this chapter, Nadine Cross and Patti McGillicuddy worked further with the emerging words as follows:

> Please let there be a way that we can have this—breath between
> breath, space between space, remembrances feeding remembrances,
> relationships where we know and don't know where we are going, as
> memory gives us clues to step on.
> Breath
> Breathe
> Breathing—held, gasped,
> ventilated, laboured,
> hoped for, comforted by, listened for.
> We remember—to breathe

as if our last.
We wait between breathes.
We come out of the fire of breathing
as one,
In remembrance of many.

As breathing and breath became a conscious and essential part of our work, our connection, and our understanding—these ideas also arose, as a new being, a new creature from the experience of dwelling and co-remembrance—a challenge to forgetting and deadening meaning. The opportunity to come back to this in the group, and to choose to do and do breath work together, deepened the reflection:

> We got into talking about breathing of course. I was thinking about that earlier in terms of the whole life and death piece around suffering and this jagged breathing one hears and the stopping and starting of breath and being with people at the end of life, that kind of being held to their breath in some way, their chest going up and down ... feelings about that and also my own breathing. When I stop breathing, I feel skewered to my chair, skewered to the spot in some way; how that relates to suffering.

The opportunity to breathe in place opened up other witnessing stories, stories of being *in relationship*:

> Sometimes that's when you have to remind yourself to breathe, when your eyes meet because that's when I think about those, one in particular moment with a man, with a man who had a laryngectomy, so he could no longer speak. He was ... it was a night shift, I was looking after him and he was just having a terrible night. He couldn't sleep, he was just very restless and he couldn't ... it had been a few days since his surgery, they were getting ready to send him home and this was his new life and people were treating him as though, well, this is your new normal; you're normal now go home, whatever deal with whatever you have to deal with. He was overwhelmed by the loss of his voice and knowing he would never have it back again. I went in there at one point in the night and he just looked at me and then he put his finger to his head as if he was holding a gun—and I just couldn't breathe in that moment, I stopped breathing. You guys are talking about remembering to breathe, takes me right back to that moment, that moment.

Breathing within the in-between places, creating a dwelling for memory which transcends dichotomies is described in Jan Zwicky's (2008) poem:

– but that's
the light; and shade
is other.
　　Other,
then. Which is after all
a kind of absence, neither a
breathing out or breathing in, top
of the swing.
　　Some place
where we are no one but ourselves
　　and in that moment of transition
　　give off light. (p. 58)

Breath as theme, as memory, and as necessity for life became the conduit and the lifeline for unburying or un-concealing that which was lived in place. Perhaps this is the place *where we are no one but ourselves* or where there is no death of memory. A place which allows for breath and movement to community and to a compassionate vision of a preferred future, which bell hooks (2008) speaks of in her return to her childhood home:

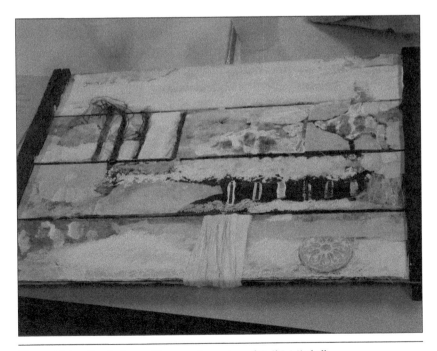

Figure 13.5 ❖ Rendering.　*Photograph courtesy of Gail J. Mitchell*

We are born and have our being in a place of memory. We chart our lives by everything we remember from the mundane moment to the majestic. We know ourselves through the art and act of remembering. Memories offer a world where there is no death, where we are sustained by rituals of regard and recollection.... I pay tribute to the past as a resource that can serve as a foundation for us to revision and renew our commitment to the present, to making a world where all people can live fully and well, where everyone can belong. (p. 5)

Conclusion: Listening, witnessing, and making meaning together

Being at the top of the swing together in order to research meaning is a very unusual and intentional experience, which allowed us to come to, and come back to, the lived reality of work in healthcare. The process of artmaking and rendering brought stories and bones to the surface, allowing participants to breathe meaning again and again into the job of suffering and of witnessing suffering. And so we could *come out of the fire of breathing* to uncover and convey the essential importance of creating and holding in place openings, stories, art, and borderlands in healthcare dwelling places. In coming back to this experience, we were able to talk and plan for change in our system in a newly informed and energized way: looking for shared community space in our crowded buildings, lobbying for opportunities to remember together, renewing our appreciation for the emotional, physical, intellectual, and spiritual nature of the labour in healthcare, understanding the urgency of moving equity initiatives forward, honouring the experience of patients and families.

A/R/Ttography, then, can be of service as an inquiry method and as a social practice allowing for the surfacing of meanings, which can build social connection and social action, enhancing it in and through practice. In this context, perhaps, suffering is more than one chosen theme, question, or focus of a particular inquiry by a particular group of practitioners, but is one of the essentials that we must reference and work from when building the scaffolding of hope and transforming social systems. In this regard, Malpas poses our challenge:

The challenge then, and it is a challenge whose answer will always remain difficult and perhaps even obscure, is to find ways in which the machinery of contemporary life, a machinery that seems itself to include human suffering as part of its very mechanism, can be redirected, refigured, redesigned so as to enable the human to reappear

within it, to enable a properly humane politics, to enable a politics in which suffering is not accepted, but constantly and steadfastly refused. (2012, p. 13)

The found and co-created rituals of knowing are, as bell hooks (2008, pp. 228–230) reminds us, the rituals of regard that sustain communities of care as we witness, mitigate, and if necessary, refuse suffering. To get to, to be in *some place where we are no one but ourselves* is both a goal and a requirement for social change and presence.

Note

1. The rendering *living inquiry* reflects the commitment to interrogate and celebrate meanings and to engage in acts of inquiry that embody theoretical, practical, and artful ways of creating. *Metaphor and metonymy* contribute to dialogue and helps make sense of emerging meaning and of themes that are shifting and appearing as understanding changes. This is an essential stage of the process. The layered nature of our work often brings us to the in-between place of being allowing an entrance through the ruptures/openings. *Openings* are the possibilities that surface when people attend to what is seen and what is not seen. Openings can create ruptures that fuel conversations about differences and possibilities. The rendering *reverberation* reflects the movement, the energy that takes the group to deeper meanings as understandings emerge from the images and texts. These dynamic movements are often found in the co-creating process of coming back, returning to work, moving to contribute to a shared canvas, finding music, and dance. *Excess* is the final rendering. Excess is a call to transform through the process of recognizing what is not acceptable or understandable. Excess may be the horrendous or magnificent, be deeply troubling or be uplifting. Excess is also that which does not yet have a name—excess represents aspects of our lives that are still pure possibility.

Bibliography

Abbott, A. D. R. (2012). Radical reso-
nances: Art, self-organised cultural
activity and the production of
postcapitalist subjectivity; or, de-
ferred self-inquiry of a precarious
artworker, 2008–2011. Unpublished
doctoral dissertation, University of
Leeds.

Abramovitz, M. (1999). *Regulating the
lives of women: Social welfare policy
from colonial times to the present*
(Rev. ed.). Cambridge, MA: South
End Press.

Adams, R., Dominelli, L., & Payne, M.
(2009). *Practicing social work in a
complex world*. Basingstoke, Eng-
land: Palgrave Macmillan.

Ainsworth, M., Blehar, M., Waters, E.,
& Wall, S. (1978). *Patterns of at-
tachment: A psychological study of
the strange situation*. Hillsdale, NJ:
Erlbaum.

Akinyela, M. (2002). De-colonizing
our lives: Divining a post-colonial
theory. *International Journal of
Narrative Therapy and Community
Work, 2*, 32–43.

Alexander, J. C., Giesen, B., & Mast,
J. L. (2006). *Social performance:
Symbolic action, cultural pragmatics,
and ritual*. Cambridge, England:
Cambridge University Press.

Amit, R. (2012a). *Breaking the law,
breaking the bank: The cost of home
affairs' illegal detention practices*. Jo-
hannesburg, South Africa: African
Centre for Migration and Society.

Amit, R. (2012b). *NO WAY IN: Barriers
to access, services, and administra-
tive justice in South Africa's refugee
reception offices*. Johannesburg,
South Africa: African Centre for
Migration and Society.

Anderson, K. (2011). *Life stories and Na-
tive women: Memory, teachings, and
story medicine*. Winnipeg: Univer-
sity of Manitoba Press.

Andrews, J., & Reisch, M. (2002). The
radical voices of social workers.
*Journal of Progessive Human Ser-
vices, 13*(1), 5–30.

Arbus, D. (1995). *Untitled*. New York:
Aperture.

Aristotle. (1961). *The Poetics of Aristotle*
(S. H. Butcher, Trans.). New York:
Macmillan.

Arman, M. (2007). Bearing witness: An
existential position in caring. *Con-
temporary Nurse, 27*(1), 84–93.

Aronson, J., & Hemingway, D. (2011).
"Competence" in neoliberal times:
Defining the future of social work.
*Canadian Social Work Review,
28*(2), 281–286.

Aronson, J., & Neysmith, S. (2006).
Obscuring the costs of home care:
Restructuring at work. *Work, Em-
ployment and Society, 20*(1), 27–45.

Arrington, M. (2004). To heal or not to
heal: On prostate cancer, physician-
patient communication, and sexu-
ality. *Journal of Loss and Trauma:
International Perspectives on Stress
& Coping, 9*(2), 159–166.

Arthur, P. (2007). *The role of civil society
in the promotion of non-violent
conflict resolution*. Paper presented
at the Global Majority Organisa-
tions' International Conference on
Promoting Peace through Dialogue.

Astell-Burt, C. (2002). *I am the story:
The art of puppetry in education and
therapy*. London: Souvenir Press.

Augsburger, D. W. (1992). *Conflict
mediation across cultures: Pathways*

and patterns. Louisville, KY: Westminster John Knox Press.

Baddeley, J., & Singer, J. A. (2007). Charting the life story's path: Narrative identity across the life span. In J. Clandinin (Ed.), *Handbook of narrative identity: Mapping a methodology* (pp. 177–202). Thousand Oaks, CA: Sage.

Baer, U. (2002). Spectral evidence: *The photography of trauma*. Cambridge, MA: MIT Press.

Bagshaw, D. M., Friberg, M., Lepp, H., Lofgren, B., Malm, B., & Rigby, K. (2005). Bridging the fields of drama and conflict management: Empowering students to handle conflicts through school-based programmes. Horst Löfgren and Birgitte Malm (Eds.), *The DRACON International Handbook* (pp. 45–122). Barseback, Sweden: Malmo University Press.

Bailey, R., & Brake, M. (1975). Introduction: Social work in the welfare state. In R. Bailey & M. Brake (Eds.), *Radical social work* (pp. 1–12). London: Edward Arnold.

Baines, C., Evans, P. M., & Neysmith, S. M. (1998). *Women's caring: Feminist perspectives on social welfare*. Oxford: Oxford University Press.

Baines, D. (2002). Radical Social Work: Race, Class, and Gender. *Race, Class and Gender, 9*(1), 145–167.

Baines, D. (2004a). Caring for nothing: Work organization and unwaged labour in social services. *Work, Employment & Society, 18*(2), 267–295.

Baines, D. (2004b). Seven kinds of work—only one paid: Raced, gendered and restructured work in social services. *Atlantis: Critical Studies in Gender, Culture & Social Justice, 28*(2), 19–28.

Baines, D. (2006a). "Staying with people who slap us around": Gender juggling and violence in paid (and unpaid) care work. *Gender, Work and Organization, 13*(3), 129–151.

Baines, D. (2006b). "Staying with people who slap us around": Continuities of gender, home-work balance and violence in care work. Paper presented at the Changes. Challenges. Choices., Fremantle, Western Australia.

Baines, D. (2010a). "If we don't get back to where we were before": Working in the restructured non-profit social services. *British Journal of Social Work, 40*(3), 928.

Baines, D. (2010b). Neoliberal restructuring/activism, participation and social unionism in the nonprofit social services. *Nonprofit and Voluntary Sector Quarterly, 39*(1), 10–28.

Baines, D. (2011). An overview of anti-oppressive practice: Roots, theory, tensions. In D. Baines (Ed.), *Doing anti-oppressive practice: Building transformative, politicized social work*. (2nd ed., pp. 2–24). Halifax: Fernwood Books.

Bak, M. (2004). Can developmental social welfare change an unfair world? The South African experience. *International Social Work, 47*(1), 81–94.

Ballenger, B. (1997). Methods of memory: On Native American storytelling. *College English, 59*(7), 789–800.

Banham, M., Gibbs, J., Osofisan, F., & Plastow, J. (1999). *African theatre in development*. Bloomington: Indiana University Press.

Banks-Wallace, J. (2002). Talk that talk: Storytelling and analysis rooted in African American oral tradition. *Qualitative Health Research, 12*(3), 410–426.

Barnes, H. (1999). Inhlanzi Ishelwe Amanzi—As Fish Out of Water: Finding authentic voices in a multi-cultural student production. *Research in Drama Education, 4*(2), 1999, 161–180.

Barnes, H. (2000). Finding appropriate expression for multiculturalism in

a student production. *South African Theatre Journal, 14*(1), 28–54.

Barnes, H. (2011). Mapping ethics in applied drama and theatre. In D. Francis (Ed.), *Acting on HIV: Using Drama to create possibilities for change* (pp. 131–143). Rotterdam, the Netherlands: Sense Publishers.

Barnes, H. & Peters, D. (2002a). Translating trauma: Using arts therapies with survivors of violence. *South African Theatre Journal, 16*(1), 157–184.

Barnes H. & Peters, D. (2002b). Sticks and stones: Telling trauma, building hope. *IDEA Dialogues 2001*, eds., Bjorn Rasmussen and AnnaLena Ostern, 128–139.

Barton, S. S. (2004). Narrative inquiry: Locating Aboriginal epistemology in a relational methodology. *Journal of Advanced Nursing, 45*(5), 519–526.

Barton, S. S. (2008). Using narrative inquiry to elicit diabetes self-care experience in an aboriginal population. *Canadian Journal of Nursing Research, 40*(3), 16–36.

Baskin, C. (2005). Storytelling circles: Reflections of Aboriginal protocols in research. *Canadian Social Work Review/Revue canadienne de service social, 22*(2), 171–187.

Battiste, M. A., & Youngblood Henderson, J. (2000). *Protecting Indigenous knowledge and heritage: A global challenge*. Saskatoon, SK: Purich.

Baxter, V. (2013). Postcards on the aesthetics of hope (in Theatre). In H. Barnes (Ed.), *Arts Activism, Education, and Therapies: Transforming Communities Across Africa*. Amsterdam and New York: Rodopi.

Belfiore, E., & Bennett, O. (2007). Rethinking the social impacts of the arts. *International Journal of Cultural Policy, 13*(2), 135–151.

Bellak, L., Hurvich, M., & Gediman, H. K. (1973). *Ego functions in schizophrenics, neurotics, and normals: A systematic study of conceptual, diagnostic, and therapeutic aspects*. New York: Wiley.

Benard, B., & Marshall, K. (1997). A framework for practice: Tapping innate resilience. *Research/practice, 5*(1), 9–15.

Benard, B., & Truebridge, S. L. (2009). A shift in thinking: Influencing social workers' beliefs about individual and family resilience in an effort to enhance well-being and success for all. In D. Saleebey (Ed.), *The strengths perspective in social work practice* (5th ed.) (pp. 201–219). Boston: Pearson.

Benham, M. (2007). Mo' ōlelo: On culturally relevant story making from an indigenous perspective. In J. Clandinin (Ed.), *Handbook of narrative inquiry: Mapping a methodology* (pp. 512–533). Thousand Oaks, CA: Sage.

Berger, R. (2008). Fostering post-traumatic growth in adolescent immigrants. In L. Liebenberg & M. Ungar (Eds.), *Resilience in action*. Toronto: University of Toronto Press.

Bigby, C., & Frawley, P. (2010). Reflections on doing inclusive research in the "Making Life Good in the Community" study. *Journal of Intellectual and Developmental Disability, 35*(2), 53–61.

Biko, S. (1978). *I write what I like*. Johannesburg, South Africa: Heinemann.

Birns, B. (1999). Attachment theory revisited: Challenging conceptual and methodological sacred cows. *Feminism and Psychology, 9*(1), 10–21.

Blaeser, K. M. (1999). *Writing voices speaking: Native authors and an oral aesthetic*. Paper presented at Talking on the Page: Editing Aboriginal Oral Texts, Toronto, Ontario.

Blom, B. (2009). Knowing or un-knowing? That is the question in the era of evidence-based social work

practice. *Journal of Social Work, 9*(2), 158–177.

Bloom, R. (2000). *Personal effects.* Toronto: Pedlar Press.

Boal, A. (1979). *Theatre of the oppressed.* London: Pluto Press.

Boal, A. (1992). *Games for actors and non-actors.* London: Routledge.

Boal, A. (1995). *The rainbow of desire: The Boal method of theatre and therapy.* London: Routledge.

Boal, A. (1996). Politics, education and change. In J. O'Toole & K. Donelan (Eds.), *Drama, culture and empowerment: The IDEA dialogues.* Brisbane, Australia: IDEA.

Boler, M. (1997). The risks of empathy: Interrogating multiculturalism's gaze. *Cultural Studies, 11*(2), 253–273.

Bolton, G. M. (1984). *Drama as education: An argument for placing drama at the centre of the curriculum.* London: Longman.

Bond, P. (2006). *Talk Left Walk Right.* Durban: UKZN Press.

Borrows, J. (2010). *Drawing out law: A spirit's guide.* Toronto: University of Toronto Press.

Botcharova, O., & Johnston, D. M. (1998). Bosnia: Grassroots participation in conflict resolution. In J. L. Connor (Ed.), *Forgiveness in conflict resolution: Reality and utility.* Washington, DC: Woodstock Theological Center, Georgetown University.

Botes, J. J. (2003). Conflict transformation: A debate over semantics or a crucial shift in the theory and practice of peace and conflict studies? *International Journal of Peace Studies, 8*(2), 1–20.

Bottrell, D. (2009). Understanding "marginal" perspectives towards a social theory of resilience. *Qualitative Social Work, 8*(3), 321–339.

Bourgeault, R. G. (1983). The Indians, the Metis and the fur trade: Class, sexism and racism in the transition from "communism" to capitalism. *Studies in Political Economy, 12,* 45–80.

Bourriaud, N. (2002). *Relational aesthetics* (S. Pleasance & F. Woods, Trans.). Dijon Quetigny, France: Les Presses du Réel.

Bowell, P., & Heap, B. S. (2001). *Planning process drama.* London: David Fulton.

Bowlby, J. (1973). *Attachment and loss: Volume 2. Separation: Anxiety and anger.* New York: Basic Books.

Bowlby, J. (1977). The making and breaking of affectional bonds. II. Some principles of psychotherapy. The fiftieth Maudsley Lecture. *British Journal of Psychiatry, 130*(5), 421–431.

Brant Castellano, M. (2000). Updating Aboriginal traditions of knowledge. In B. L. Hall, G. S. Dei, & D. G. Rosenberg (Eds.), *Indigenous knowledges in global contexts: Multiple readings of our world.* Toronto: University of Toronto Press.

Brazier, D. (1993). Safe space. *Amida Trust Occasional Paper* Retrieved January 18, 2013, from http://www.amidatrust.com/article.html

Brecht, B. (1964). *Brecht on theatre: The development of an aesthetic* (J. Willett, Trans.). London: Methuen.

Bretherton, I. (1984). *Symbolic play: The development of social understanding.* Orlando, FL: Academic Press.

Brook, P. (1968). *The empty space.* London: MacGibbon & Kee.

Brown, W. (1995). *States of injury: Power and freedom in late modernity.* Princeton, NJ: Princeton University Press.

Bulhan, H. A. (1985). *Frantz Fanon and the psychology of oppression.* New York: Plenum Press.

Bullough, E. (1957). "Physical distance" as a factor in art and an aesthetic principle. In E. M. Wikinson (Ed.),

Edward Bullough: Aesthetics, lectures and essays. London: Bowes and Bowes.

Burstow, B. (1991). Freirian codifications and social work education. *Journal of Social Work Education, 27*(2), 196–207.

Burton, B. (2006). Enhanced Forum Theatre. *Drama NSW JESA Journal, 13*(1), 1–7.

Butler, J. (2001). Giving an account of oneself. *Diacritics, 31*(4), 22–40.

Butler, J. (2004). *Precarious life: The powers of mourning and violence.* London: Verso Books.

Cain, R., Jackson, R., Prentice, T., Mill, J., Collins, E., & Barlow, K. (2011). Depression among Aboriginal people living with HIV in Canada. *Canadian Journal of Community Mental Health (Revue canadienne de santé mentale communautaire), 30*(1), 105–120.

Cain, R., Jackson, R., Prentice, T., Collins, E., Mill, J., & Barlow, K. (2013). The experience of HIV diagnosis among Aboriginal people living with HIV/AIDS and depression. *Qualitative Health Research, 23*(6), 815–824.

Campbell, R. (2001). *Emotionally involved: The impact of researching rape.* New York: Routledge Press.

Canella, G., & Mauelito, K. (2008). Feminisms from unthought locations: Indigenous worldviews, marginalized feminisms, and revisioning an anticolonial social science. In N. K. Denzin, Y. S. Lincoln, & L. T. Smith (Eds.), *Handbook of critical and indigenous methodologies.* Thousand Oaks, CA: Sage.

Caputo, J. (2011). *Philosophy and theology.* Nashville: Abingdon Press.

Carlson, L. (2001). Cognitive ableism and disability studies: Feminist reflections on the history of mental retardation. *Hypatia, 16*(4), 124–146.

Carniol, B. (1987). *Case critical. The dilemma of social work in Canada.* Toronto: Between the Lines.

Carroll, J., & Minkler, M. (2000). Freire's message for social workers. *Journal of Community Practice, 8*(1), 21–36.

Casey, E. S. (2000). *Remembering: A phenomenological study.* Bloomington: Indiana University Press.

Chambers, R. (1995). Paradigm shifts and the practice of participatory research and development. In N. Nelson & S. Wright (Eds.), *Power and participatory development: Theory and practice.* London: Intermediate Technology (ITP).

Charon, R. (2001). Narrative medicine: A model for empathy, reflection. *Journal of the American Medical Association, 286*(15), 1897–1902.

Chase, S. (2008). Narrative inquiry: Multiple lenses, approaches, voices. In N. K. Denzin & Y. S. Lincoln (Eds.), *Collecting and interpreting qualitative materials* (3rd ed.). Thousand Oaks, CA: SAGE.

Chinyowa, K. C. (2009). Theatrical performance as technology: The case of drama in AIDS education (DramAidE) in South Africa. *Studies in Theatre and Performance, 29*(1), 33–52.

Chukwu-Okoronkwo, S. O. (2011). Art and societal dialectics in sub-Saharan Africa: A critique of Wa Thiong'o and Osofisan as dramatists. *Journal of African Studies and Development, 3*(4), 76–86.

Cixous, H. (2001). Savoir (G. Bennington, Trans.). In H. Cixous & J. Derrida (Eds.), *Veils.* Stanford, CA: Stanford University Press.

Clacherty, G. (2004). *The suitcase project: A psychosocial support project for refugee children.* Retrieved from huma1970a.blog.yorku.ca/files/2010/04/the_suitcase_project.pdf

Clacherty, G., & Welvering, D. (2006). *The Suitcase Stories: Refugee children reclaim their identities.* Cape Town: Double Storey.

Clare, E. (2001). Stolen bodies, reclaimed bodies: Disability and queerness. *Public Culture, 13*(3), 359–365.

Clare, E. (2009). *Gawking, gaping, staring: Living in marked bodies.* Audio. Access Living.

Clarke, J. (2004). Dissolving the public realm? The logics and limits of neo-liberalism. *Journal of Social Policy, 33*(1), 27–48.

Clarke, J. (2010). Public management or managing the public? *Public Policy and Administrantion, 25*(3), 1–18.

Clutterbuck, P., & Howarth, R. (2007). *Heads up Ontario! Current conditions and promising reforms to strengthen Ontario's nonprofit community services sector.* Toronto: Community Social Planning Council of Toronto in support of the Community Social Services Campaign.

Cochran, P., Marshall, C., Garcia-Downing, C., Kendall, E., Cook, D., McCubbin, L., et al. (2008). Indigenous ways of knowing: Implications for participatory research and community. *American Journal of Public Health, 98*(1), 22–27.

Cohen-Cruz, J. (2006). Redefining the private: From personal storytelling to political act. In J. Cohen-Cruz & M. Schutzman (Eds.), *A Boal companion: Dialogues on theatre and cultural politics.* London: Routledge.

Collins, P., & Barker, C. (2009). Psychological help-seeking in homeless adolescents. *International Journal of Social Psychiatry, 55*(4), 372–384.

Cologna, I., John, R., & Johnson, T. (2011). The road trip: A narrative art therapy group for sexual assault survivors. *International Journal of Narrative Therapy and Community Work, 1*, 32–44.

Cook-Lynn, E. (2008). History, myth and identity in the new Indian story. In N. K. Denzin, Y. S. Lincoln, & L. Smith (Eds.), *Handbook of critical and indigenous methodologies.* Thousand Oaks, CA: Sage.

Coulter, C. A. (2009). Finding the narrative in narrative research. *Educational Researcher, 38*(8), 608–611.

Cox, S. M., Kazubowski-Houston, M., & Nisker, J. (2009). Genetics on stage: Public engagement in health policy development on preimplantation genetic diagnosis. *Social Science & Medicine, 68*(8), 1472–1480.

Crofoot Graham, T. L. (2002). Using reasons for living to connect to American Indian healing traditions: Symposium on Native American wellness. *Journal of sociology and social welfare, 29*(1), 55–75.

Cruikshank, J. (1999). The social life of texts: Editing on the page and in performance. In L. Murray & K. Rice (Eds.), *Talking on the page: Editing Aboriginal oral texts* (pp. 97–119). Toronto: University of Toronto Press.

Cunningham, I. (2008). *Employment relationships in the voluntary sector.* London: Routledge.

Dalrymple, L. (2013). Applied art is still art, and by any other name would smell as sweet. In H. Barnes (Ed.), *Arts activism, education, and therapies: Transforming communities across Africa.* Amsterdam and New York: Rodopi.

DeCarlo, A., & Hockman, E. (2004). RAP therapy: A group work intervention method for urban adolescents. *Social Work with Groups, 26*(3), 45–59.

Dei, G. J. S. (2006). Introduction: Mapping the terrain—towards a new politics of resistance. In G. J. S. Dei & A. Kempf (Eds.), *Anti-colonialism and education: The politics of resistance* (pp. 1–23). Rotterdam: Sense Publishers.

Demaria, C. (2004). The performative body of Marina Abramovic. *European Journal of Women's Studies, 11*(3), 295–307.

Denzin, N. K., & Lincoln, Y. S. (2008). Preface. In N. K. Denzin, Y. S. Lincoln, & L. T. Smith (Eds.), *Handbook of critical and indigenous methodologies* (pp. ix–xv). Thousand Oaks, CA: Sage.

Department of Social Welfare. (1997). *The white paper for social welfare.* Pretoria, South Africa: Department of Social Welfare.

Derrida, J. (1998). *Right of inspection.* New York: Monacelli Press.

Derrida, J., & Stiegler, B. (2002). *Echographies of television: Filmed interviews.* (J. Bajorek, Trans.). Cambridge, England: Polity Press.

Deutsch, M., & Coleman, P. T. (2000). *The handbook of conflict resolution: Theory and practice.* San Francisco: Jossey-Bass.

DiSunno, R., Linton, K., & Bowes, E. (2011). World Trade Center tragedy concomitant healing in traumatic grief through art therapy with children. *Traumatology, 17*(3), 47–52.

Dlamini, J. (2009). *Native nostalgia.* Johannesburg, South Africa: Jacana Media.

Dominelli, L. (2002). *Feminist social work theory and practice.* Basingstoke, England: Palgrave.

Dominelli, L. (2004). *Social work: Theory and practice for a changing profession.* Cambridge, UK: Polity Press.

Dottridge, M. (2008). *Kids abroad: Ignore them, abuse them, or protect them.* The Hague: Terre des Hommes.

Duncan, N., Stevens, G., & Bowman, B. (2004). South African psychology and racism: Historical determinants and future prospects. In D. Hook (Ed.), *Critical psychology.* Landsdowne, South Africa: UCT Press.

Dunlop, R. (1999). *Boundary Bay: A novel as educational research.* Unpublished doctoral dissertation, University of British Columbia.

Durden, E. (2013). Researching the theatricality and aesthetics of applied theatre. In H. Barnes (Ed.), *Arts activism, education, and therapies: Transforming communities across Africa.* Amsterdam: Rodopi.

Emmons, K. (2010). *Black dogs and blue words: Depression and gender in the age of self-care.* Piscataway, NJ: Rutgers University Press.

Emmons, K. (2011). *Whose stories: Narrative medicine or rhetorical self-care?* Paper presented at the Society for Social Studies of Science Annual Meeting, Cleveland.

Ensink, K., Robertson, B., Zissis, C., & Leger, P. (1997). Post-traumatic stress disorder in children exposed to violence. *South African Medical Journal, 87*(11), 1526–1530.

Enweazer, O., & Basualdo, C. (2002). Documental 1. Ostfildern-Ruit, Germany: Hatje Cantz.

Eriksson, S. A. (2009). *Distancing at close range: Investigating the significance of distancing in drama education.* Bergen, Norway: Vasa Press.

Esping-Andersen, G. (1999). *Social foundations of postindustrial economies.* Oxford: Oxford University Press.

Eth, S., & Pynoos, R. S. (1985). Developmental perspectives on psychic trauma in childhood. In C. R. Figley (Ed.), *Trauma and its wake: The study and treatment of posttraumatic stress disorder.* New York: Brunner Mazel.

Evans, J. (1999). Feeble monsters: Making up disabled people. In J. Evans & S. Hall (Eds.), *Visual culture: The reader* (pp. 274–288). London: Sage.

Fanon, F. (1967). Black skin, white masks (C. L. Markmann, Trans.). New York: Grove Press.

Favret-Saada, J. (1980). *Deadly words: Witchcraft in the Bocage.* Cambridge, England: Cambridge University Press.

Ferguson, I. (2008). *Reclaiming social work.* London: Sage.

Figley, C. (1995). Compassion fatigue: Towards new understanding of the cost of caring. In R. Stamm & B. Hudnall (Eds.), *Secondary traumatic stress: Self-care issues for clinicians, researchers and educators.* Baltimore: Sidran Press.

Foot Newton, L. (2005). *Tshepang: The third testament.* Johannesburg, South Africa: Wits University Press.

Forced Migration Studies Programme. (2007). *The unaccompanied minor study.* Johannesburg, South Africa: University of the Witwatersrand Forced Migration Studies Programme.

Forché, C., & Gerard, P. (Eds.). (2001). *Writing creative nonfiction: Instruction and insights from the teachers of the Associated Writing Programs.* Cincinnati, OH: Story Press.

Foster, D. (2004). Liberation Psychology. In D. Hook, N. Mkhize, P. Kiguwa, & A. Collins (Eds.), *Critical psychology.* Landsdowne, South Africa: UTC Press.

Fox, J., & Dauber, H. (1999). *Gathering voices: Essays on playback theatre.* New York: Tusitala.

Fraser, N. (1998). From redistribution to recognition? Dilemmas of justice in a "post-socialist" age. In C. Willett (Ed.), *Theorizing multiculturalism: A guide to the current debate* (pp. 19–49). Malden, MA: Blackwell.

Freeman, B. (2011). Indigenous pathways to anti-oppressive practice. In D. Baines (Ed.), *Doing anti-oppressive practice. Building transformative, politicized social work.* (2nd ed., pp. 116–132). Halifax, NS: Fernwood Books.

Freire, P. (1970a). *Cultural action for freedom.* London: Penguin Books.

Freire, P. (1970b). *Pedagogy of the oppressed* (M. B. Ramos, Trans.). New York: Continuum.

Freire, P. (2006). *The Pedagogy of the oppressed.* 30th anniversary edition. New York: Continuum.

Frost, A., & Yarrow, R. (1989). *Improvisation in drama.* New York: St. Martin's Press.

Fudge Schormans, A. (2006). Hearing what cannot be spoken: Social work's responsibility towards non-speaking persons labelled disabled. In N. Hall (Ed.), *Social work: Making a world of difference, social work around the world IV in the Year of IFSW's 50th Jubilee* (pp. 225–242). Berne, Switzerland: International Federation of Social Workers and Fafo.

Fudge Schormans, A. (2010). Epilogues and prefaces: Research and social work and people with intellectual disabilities. *Australian Social Work, 63*(1), 51–66.

Fudge Schormans, A. (2011). *The Right or responsibility of inspection: Social work, photography, and people with intellectual disabilities.* University of Toronto.

Furman, R., Coyne, A., & Negi, N. J. (2008). An international experience for social work students: Self-reflection through poetry and journal writing exercises. *Journal of Teaching in Social Work, 28*(1–2), 71–85.

Galabuzi, G. E. (2006). *Canada's economic apartheid: The social exclusion of racialized groups in the new century.* Toronto: Canadian Scholars' Press.

Galabuzi, G. E. (2010). *Colonialism and racism in Canada: Historical traces and contemporary issues* (with Maria A Wallis and Lina Sunseri). Toronto: Nelson.

Gardner, H. (2007). *Five minds for the future.* Boston: Harvard Business Press.

Garland Thomson, R. (2001). *Seeing the disabled: Visual rhetorics of disability in popular photography. The new disability history: American perspectives,* 335–374.

Garland Thomson, R. (2009). *Staring: How we look.* New York: Oxford University Press.

Garroutee, E. M., & Westcott, K. D. (2013). The Story is a living being: Companionship with stories in Anishinaabeg Studies. In J. Doerfler, N. J. Sinclair & H. K. Stark (Eds.), *Centering Anishinaabeg Studies: Understanding the world through stories* (pp. 61–80). East Lansing: Michigan State University Press.

Gersie, A. (1992). *Storymaking in bereavement*. London: Jessica Kingsley.

Gersie, A., & King, N. (1990). *Storymaking in education and therapy*. London: Jessica Kingsley.

Gilbert, T. (2004). Involving people with learning disabilities in research: Issues and possibilities. *Health & social care in the community, 12*(4), 298–308.

Gilbert, T. (2006). Written orality in Thomas King's short fiction. *Journal of the Short Story in Fiction, 47,* 97–109.

Gilson, S. F., & DePoy, E. (2002). Theoretical approaches to disability content in social work education. *Journal of Social Work Education, 38*(1), 153–165.

Giroux, H. A. (1992). Paulo Freire and the politics of postcolonialism. *Journal of Advanced Composition, 12*(1), 15–26.

Giroux, H. A. (2012). *Twilight of the social: Resurgent publics in the age of disposability*. New York: Paradigm.

Glasl, F. (1999). *Confronting conflict: A first-aid kit for handling conflict*. Pennsylvania: Hawthorn.

Global Movement for Children. (n.d.) 10 'Must-Dos' to better protect children's rights. Retrieved from http:// www.gmfc.org/en/action-within -the-movement/gmc-actions/ actions-by-imperatives

Gobodo-Madikizela, P. (2003). *A human being died that night: A South African story of forgiveness*. Boston: Houghton Mifflin Harcourt.

Goffman, E. (1971). *The presentation of self in everyday life*. London: Penguin.

Goffman, E. (1974). *Frame analysis: An essay on the organization of experience*. Boston: Northeastern University Press.

Goldstein, H. (1992). If social work hasn't made progress as a science, might it be an art? *Families in Society, 73*(1), 48–55.

Goldstein, H. (1998). Education for ethical dilemmas in social work practice. *Families in Society, 79,* 241–253.

Goodley, D., & Moore, M. (2000). Doing disability research: Activist lives and the academy. *Disability & Society, 15*(6), 861–882.

Government of South Africa. (2010). *Millennium development goals country report 2010*.

Grainger, R. (1990). *Drama and healing: The roots of drama therapy*. London: Jessica Kingsley.

Grant, J. S., & Cadell, S. (2009). Power, pathological worldviews, and the strengths perspective in social work. *Social Work Faculty Publications, Paper 7*. Retrieved from http:// scholars.wlu.ca/scwk_faculty/7

Gray, M. (2006). The progress of social development in South Africa. *International Journal of Social Welfare, 15*(s1), S53–S64.

Gray, R. (2003). *Prostate tales: Men's experiences with prostate cancer*. Harriman, TN: Men's Studies Press.

Gray, R., & Sinding, C. (2002). *Standing ovation: Performing social science research about cancer*. Walnut Creek, CA: AltaMira Press.

Graybeal, C. T. (2007). Evidence for the art of social work. *Families in Society, 88*(4), 513.

Gross, G. D. (1999). The drama of prejudice. *Journal of Teaching in Social Work, 19*(1–2), 139–149.

Grotowski, J. (1975). *Towards a poor theatre* (2nd ed.). London: Methuen.

Gruber, H. (2000). Creativity and conflict resolution: The role of point of view. In P. Coleman & M. Deutsch (Eds.), *The Handbook of Conflict Resolution*. San Francisco: Jossey-Bass.

Gutkind, L. (1997). *The art of creative nonfiction: Writing and selling the literature of reality*. New York: John Wiley & Sons.

Hammond, S. A. (1998). *The thin book of appreciative inquiry*. Plano, TX: Thin Book.

Hardt, M., & Negri, A. (2009). *Commonwealth*. Cambridge, MA: Belknap Press of Harvard University Press.

Harvey, D. (2005). *A brief history of neoliberalism*. Oxford: Oxford University Press.

Hatcher, A., & Bartlett, C. (2010, May). Two-eyed seeing: Building cultural bridges for Aboriginal students. *Canadian Teacher Magazine, 6*, 14–17.

Hauptfleisch, T. (2010). Tipping points in the history of academic theatre and performance studies in South Africa. *Theatre Research International, 35*(3), 275–287.

Heath, S., Brooks, R., Cleaver, E., & Ireland, E. (2009). *Researching young people's lives*. Los Angeles: Sage.

Heathcote, D. (1984). *Collected writings on drama and education*. London: Hutchinson.

Herman, J. (1992). *Trauma and recovery*. New York: Basic Books.

Herman, J. (1995). *Trauma and recovery: The aftermath of violence from domestic abuse to political terror*. New York: Basic Books. (Original work published 1992)

Hevey, D. (1997). The enfreakment of photography. *The Disability Studies Reader* (pp. 332–347). New York: Routledge.

Hick, S. (2002). *Social work in Canada*. Toronto: Thompson Educational.

Hillier, L. (2007). *Children on the move: Protecting unaccompanied migrant children in South Africa and the region*. London: Save the Children UK.

Hinz, L. D. (2009). *Expressive therapies continuum: A framework for using art in therapy*. New York: Routledge.

Homann, G. (2009). Landscape and body. *South African Theatre Journal, 23*(1), 149–176.

Homann, G. (2011). *Character and dramatic conflict*. Johannesburg, South Africa: University of the Witwatersrand.

hooks, b. (1994). *Teaching to transgress: Education as the practice of freedom*. New York: Routledge.

hooks, b. (2008). *Belonging: A culture of place*. New York: Routledge.

Huizinga, J. (1949). *Homo ludens: A study of the play element in culture*, Vol. 3. London: Taylor & Francis.

Hulko, W. (2011). Intersectionality in the context of later life experiences of dementia. In O. Hankivsky (Ed.), *Health inequities in Canada: Intersectional frameworks and practices*. Vancouver: UBC Press.

Ignani, E., & Church, K. (2008). Disability studies and the ties and tensions with arts-informed inquiry: One more reason to look away? In J. G. Knowles & A. Cole (Eds.), *Handbook of the arts in qualitative research: Perspectives, methodologies, examples and issues* (pp. 625–638). Thousand Oaks, CA: Sage.

International Association of Schools of Social Work. (2001). *Global definition of the social work profession*. PDF.

International Committee of the Red Cross (ICRC). (June 8, 1977). *Protocol Additional to the Geneva Conventions of 12 August 1949, and relating to the Protection of Victims*

of International Armed Conflicts (Protocol I).

International Organization for Migration. (2011). *Unaccompanied children on the move*. Geneva: International Organization for Migration.

Irwin, R. L., & de Cosson, A. (2004). *a/r/tography. Rendering self through arts-based living inquiry*. Vancouver, BC: Pacific Educational Press.

Irwin, R. L., & Springgay, S. (2008). A/r/tography as practice-based research. In M. Cahnmann-Taylor & R. Siegesmund (Eds.), *Arts-based research in education: Foundations for practice* (pp. 103–124). New York: Routledge.

Iwama, M., Marshall, M., Marshall, A., & Bartlett, C. (2009). Two-eyed seeing and the language of healing in community-based research. *Canadian Journal of Native Education, 32*(2), 3–23.

Jackson, A. (2008). *Theatre, education and the making of meanings: Art or instrument?* Manchester: Manchester University Press.

Jackson, R., Cain, R., Prentice, T., Collins, E., Mill, J., & Barlow. (2008). *Depression among Aboriginal people living with HIV/AIDS: Research report*. Ottawa: Canadian Aboriginal AIDS Network.

Jennings, S. (Ed.). (1987). *Dramatherapy: Theory and practice 1*. London: Routledge Chapman & Hall.

Jennings, S. (Ed.). (1992). *Dramatherapy: Theory and practice 2*. London: Tavistock/Routledge.

Jennings, S. (Ed.).(1997). *Dramatherapy: Theory and Practice 3*. London: Routledge, Chapman & Hall.

Johnson, D. R. (2009). Commentary: Examining underlying paradigms in the creative arts therapies of trauma. *The Arts in Psychotherapy, 36*(2), 114–120.

Johnston, B. (2007). Foreword. In S. McKegney (Ed.), *Magic weapons: Aboriginal writers remaking community after residential school* (pp. vii–xv). Winnipeg: University of Manitoba Press.

Jones, P. (1996). *Drama as therapy: Theatre as living*. London: Routledge.

Jordan, J. (2008). Valuing vulnerability: New definitions of courage. *Women & Therapy, 31,* 209–233.

Kagin, S. L., & Lusebrink, V. B. (1978). The expressive therapies continuum. *Art Psychotherapy, 5*(4), 171–179.

Kaminer, D., & Eagle, G. (2010). *Traumatic stress in South Africa*. Johannesburg, South Africa: Wits University Press.

Karp, M., Homes, P., & Tauvon, K. B. (1998). *The handbook of psychodrama*. London: Routlege.

Kaseke, E. (2005). Social security and older people: An African perspective. *International Social Work, 48*(1), 89.

Kaseke, E. (2010). The role of social security in South Africa. *International Social Work, 53*(2), 159–168.

Kemmis, S. (1993). Action research and social movement. *Education Policy Analysis Archives, 1*(1).

Kincheloe, J. L., & Steinberg, S. R. (2008). Indigenous knowledges in education: Complexities, dangers, and profound benefits. In N. Denzin, Y. Lincoln, & L. Smith (Eds.), *Handbook of critical and indigenous methodologies* (pp. 135–156). Thousand Oaks, CA: Sage.

King, T. (2003). *The truth about stories: A native narrative*. Toronto: House of Anansi Press.

Kirmayer, L. J., Brass, G. M., & Valaskakis, G. G. (2009). Conclusion: Healing / Invention / Tradition. In L. J. Kirmayer & G. G. Valaskakis

(Eds.), *Healing traditions: The mental health of Aboriginal peoples in Canada* (pp. 440–472). Vancouver: UBC Press.

Kistner, J. (2007). HIV/AIDS, trauma and "landscapes of suffering." Unpublished address given on World Trauma Day. Centre for the Study of Violence and Reconciliation in Johannesburg, South Africa.

Knox, M., Mok, M., & Parmenter, T. R. (2000). Working with the experts: Collaborative research with people with an intellectual disability. *Disability & Society, 15*(1), 49–61.

Kovach, M. (2009). *Indigenous methodologies: Characteristics, conversations, and contexts.* Toronto: University of Toronto Press.

Kratz, C. (2002). *The ones that are wanted: Communication and the politics of representation in a photographic exhibition.* Berkeley and Los Angeles: University of California Press.

Kris, E. (1952). *Psychoanalytic explorations in art.* Oxford: International Universities Press.

Kulchyski, P. K., Angmarlik, P., McCaskill, D. N., & Newhouse, D. (1999). *In the words of elders: Aboriginal cultures in transition.* Toronto: University of Toronto Press.

Kumar, R. (2005). *Research methodology: A step-by-step guide for beginners.* London: Sage.

Landy, R. (1994). *Drama therapy: Concepts, theories and practices.* Springfield, IL: Charles C. Thomas.

Landy, R., & Bolton, G. (1996). *Essays in drama therapy: The double life.* London: Jessica Kingsley.

Larlham, P. (1985). *Blacktheater, dance and ritual in South Africa.* Ann Arbor, MI: UMI Research.

Lavell-Harvard, D., Memee, D., & Corbiere-Lavell, J. (2006). Until Our Hearts Are on the Ground. *Aboriginal Mothering, Oppression,*

Resistance and Rebirth. Toronto: Demeter Press.

Lavellée, L. (2009). Practical application of an indigenous research framework and two qualitative indigenous research methods: Sharing circles and anishnaabe symbol-based reflection. *International Journal of Qualitative Methods, 8*(1), 21–40.

Lederach, J. P. (1995). Conflict transfromation in protracted internal conflicts: The case for a comprehensive network. In K. Rupesinghe (Ed.), *Conflict transformation.* New York: St. Martin's Press.

Ledwith, M. (2001). Community work as critical pedagogy: Re-envisioning Freire and Gramsci. Community *Development Journal, 36*(3), 171–182.

Lee, J. A. B. (2001). *The empowerment approach to social work practice: Building the beloved community.* New York: Columbia University Press.

Levinas, E. (2001). Being for the Other (J. Robbins, Trans.). In J. Robbins (Ed.), *Is it righteous to be? Interviews with Emmanuel Levinas* (pp. 105–113). Stanford, CA: Stanford University Press.

Lightman, E. S. (2003). *Social policy in Canada.* Toronto: Oxford University Press.

Loumeau-May, L. V. (2012). Art therapy with traumatically bereaved children. In S. Ringel & J. R. Brandell (Eds.), *Trauma: Contemporary directions in theory, practice, and research* (pp. 98–129). Thousand Oaks, CA: Sage.

Luce-Kapler, R. (2007). *Proceedings of the 2007 Complexity Science and Educational Research Conference.*

Lundy, C. (2004). *Social work and social justice: A structural approach to practice.* Peterborough, ON: Broadview Press.

Lüsebrink, V. B. (2004). Art therapy and the brain: An attempt to understand the underlying processes of art expression in therapy. *Art Therapy, 21*(3), 125–135.

Madison, D. S. (2010). *Acts of activism: Human rights as radical performance.* Cambridge: Cambridge University Press.

Main, M., Goldwyn, R., & Hesse, E. (2002). Adult attachment scoring and classification system. Unpublished manuscript.

Main, M., & Solomon, J. (1990). Procedures for identifying infants as disorganized/disoriented during strange situation. In M. T. Greenberg, D. Cicchetti, & E. M. Cummings (Eds.), *Attachment in the preschool years: Theory, research, and intervention.* Chicago: University of Chicago Press.

Malpas, J. (2012). Suffering, compassion, and the possibility of a humane politics. In J. Malpas & N. Lickiss (Eds.), *Perspectives on human suffering* (pp. 9–21). Netherlands: Springer.

Martin, R., & Spence, J. (2003). Photo-therapy: Psychic realism as a healing art? In L. Wells (Ed.), *The photography reader* (pp. 402–409). London: Routledge.

Marvin, R., Cooper, G., Hoffman, K., & Powell, B. (2002). The circle of security project: Attachment-based intervention with caregiver-preschool child dyads. *Attachment & Human Development, 4*(1), 107–124.

May, J., & Meth, C. (2007). Dualism or underdevelopment in South Africa: What does a quantitative assessment of poverty, inequality and employment reveal? *Development Southern Africa, 24*(2), 271–287.

Mazel, A. (2010, 20 March). The Seven-Day War: Capturing conflict on film. *Weekend Witness.* Retrieved from http://www.pmbhistory .co.za/portal/witnesshistory/ custom_modules/Supplement_ PDFs/The_Seven_Day_War_ capturing_ conflict_on_film.pdf

McDonald, C. (2006). Challenging social work: *The institutional context of practice.* Basingstoke, England: Palgrave Macmillan.

McFerran-Skewes, K. (2005). Using songs with groups of teenagers: How does it work? *Social Work with Groups, 27*(2–3), 143–157.

McGillicuddy, P., Johnson, T., Jensen, P. M., Fitch, M. I., & Jacobs, M. A. (2011). Speaking, hearing and understanding the stories we hold as health care providers. *Canadian Social Work/Travail Social Canadien, 13*(1).

McLaren, P. (1992). *Paulo Freire: A critical encounter.* London: Routledge.

McLaren, P. (1998). *Critical pedagogy and predatory culture: Oppositional politics in a postmodern era.* London and New York: Routledge.

McLaughlin, H. (2009). What's in a name: "Client," "patient," "customer," "consumer," "expert by experience," "service user"—what's next? *British Journal of Social Work, 39*(6), 1101–1117.

McLeod, N. (2007). *Cree narrative memory: From treaties to contemporary time.* Saskatoon, SK: Purich.

Merrett, C. (2010, 20 March). March 20–March 31, 1990: "The number of unanswered questions is as great as the evidence." *Weekend Witness.* Retrieved from http://www.pmb history.co.za/portal/witness history/ custom_modules/Supplement_ PDFs/The_Seven_Day_War_ capturing_conflict_on_film.pdf

Mezaros, I. (2010). *Social structure and forms of consciousness.* New York: Monthly Review Press.

Midgley, J. (1995). *Social development: The developmental perspective in social welfare.* London: Sage.

Miller, P. (2006). *REwind: A cantata for voice, tape and testimony.* Cape

Town: Baxter Theatre recording of live performance on DVD.

Mitchell, C. (2002). Beyond resolution: What does conflict transformation actually transform? *Peace and Conflict Studies, 9*(1), 1–23.

Moore, C. W. (1996). *The mediation process: Practical strategies for resolving conflict.* San Francisco: Jossey-Bass.

Moore, J. B. (2011). *Superheroes: Healthcare workers walking the talk.* Big Tancook Island, NS: Backalong Books.

Moreno, J. L. (1947). *The theatre of spontaneity.* New York: Beacon House.

Moreno, J. L. (1953). *Who shall survive?* New York: Beacon House.

Morgan, A. (2000). *What is narrative therapy? An easy-read introduction.* Adelaide, South Australia: Dulwich Centre.

Morgan, J. (2004). Memory work: Preparation for death? Legacies for orphans? Fighting for life? One size fits all, or time for product differentiation. *AIDS Analysis Africa, 13*(2), 36–40.

Mueller, K. (2005). Journeys of freedoms: Responding to effects of domestic violence. *International Journal of Narrative Therapy and Community Work, 3/4,* 106–117.

Mullaly, B. (2002). *Challenging Oppression: A critical social work approach.* Toronto: Oxford University Press.

Mullaly, B. (2007). *The new structural social work.* (3rd ed.). Toronto: Oxford University Press.

Murray, M. (2002). Connecting narrative and social representation theory in health research. *Social Science Information, 41*(4), 653–673.

Navarro, V. (2006). The worldwide class struggle. *Monthly Review, 58*(4), 18.

Nebe, W. (2011). A workshop given to masters of dramatic art students of the Drama for Life programme. University of the Witwatersrand, Johannesburg.

Needles, D. J. (1980). Dramatic play in early childhood. In W. Paul (Ed.), *In celebration of play* (pp. 181–189). London: Croom Helm.

Nerburn, K. (2009). *The wolf at twilight: An Indian elder's journey through a land of ghosts and shadows.* Navato, CA: New World Library.

Newbury, D. (1996). Reconstructing the self: Photography, education and disability. *Disability & Society, 11*(3), 349–360.

Nicholas, L. (2010). The history of South African social work. In J. R. L. Nicholas & M. Maistry (Ed.), *Introduction to social work* (pp. 40–47). Capetown, South Africa: Juta.

Nikoloski, Z. (2011). Impact of financial crises on poverty in the developing world: An empirical approach. *Journal of Development Studies, 47*(11), 1757–1779.

Nisker, J. (2010). Theatre and research in the reproductive sciences. *Journal of Medical Humanities, 31*(1), 81–90.

Noori, M. (2013). Beshaabiiag G'gikenmaaigowag: Comets of knowledge. In J. Doerfler, N. Sinclair & H. Stark (Eds.), *Centering Anishinaabeg Studies: Understanding the world through stories* (pp. 35–58). East Lansing, MI: Michigan State University Press.

Norman, E. (2002). Introduction: The strengths perspective and resiliency enhancement—a natural partnership. In E. Norman (Ed.), *Resiliency enhancement: Putting strengths perspective into social work practice* (pp. 1–16). New York: Columbia University Press.

Nwagbara, U. (2011). Arresting historical violence: Revolutionary aesthetics and Alex La Guma's fiction. *Journal of Pan African Studies, 4*(3), 114–130.

O'Connor, P. (2003). *Reflection and refraction: The dimpled mirrow of process drama: How process drama assists people to reflect on their*

attitudes and behaviours associated with mental illness. Unpublished doctoral dissertation, Griffith University, Brisbane.

O'Toole, J. (1976). Theatre in education: New objectives for theatre, new techniques in education. London: Hodder and Stoughton.

O'Toole, J. (1992). The process of drama: Negotiating art and meaning. London: Routledge.

O'Toole, J., Burton, B., & Plunkett, A. (2005). Cooling conflict: A new approach to managing bullying and conflict in schools. Frenchs Forest, NSW: Pearson Longman.

Odhiambo, C. (2008). Theatre for development in Kenya: In search of an effective procedure and methodology (Vol. 86). Bayreuth, Germany: Thielmann & Breitinger.

Oida, Y., & Marshall, L. (1997). The invisible actor. London: Methuen.

Okri, B. (1997). A way of being free. London: Phoenix House.

Oliver, M., & Sapey, B. (2006). Social work with disabled people (3rd ed.). Basingstoke, England: Palgrave Macmillan.

Olivier, M. (2004). South Africa. In M. P. Olivier & E. R. Kalula (Eds.), Social protection in SADC: Developing an integrated and inclusive framework (pp. 116–177). Johannesburg, South Africa: Rand Afrikaans University and University of Cape Town.

Ong, W. (1982). Orality and literacy. London: Routledge.

Onwueghuzie, A., Dickinson, W., Leech, N., & Zoran, A. (2009). A qualitative framework for collecting and analyzing data in focus group research. International Journal of Qualitative Methods, 8(3), 1–21.

Palmary, I. (2009). For better implementation of migrant children's rights in South Africa. Report for UNICEF, Forced Migration Studies Programme, Johannesburg, 11.

Patel, L. (2005). Social welfare and social development in South Africa. Cape Town, South Africa: Oxford University Press.

Patterson, F. M. (2004). Motivating students to work with Elders. Journal of Teaching in Social Work, 24(3–4), 165–181.

Payne, M. (2005). Modern social work theory (3rd ed.). London: Lyceum Books.

Peacock, T. (2013). Teaching as story. In J. Doerfler, N. Sinclair, & H. Stark (Eds.), Centering Anishinaabeg Studies: Understanding the world through stories (pp. 103–102). East Lansing: Michigan State University Press.

Pearlman, L. A., & Saakvitne, K. W. (1995). Trauma and the therapist: Countertransference and vicarious traumatization in psychotherapy with incest survivors. New York: Norton.

Pease, B. (2007). Critical social work theory meets evidence-based practice in Australia: Towards critical knowledge-informed practice in social work. In K. Yokota (Ed.), Emancipatory social work (pp. 103–138). Kyoto: Sekai Shisou-sya.

Peltier, D., Jackson, R., & Nowgesic, E. (2012). N'ginaajiiwimi: An Indigenous framework for resisting the language of HIV in research from a place of strength. Paper presented at the OHTN 2012 Research Conference: Research with Real-Life Impact, Toronto, Ontario.

Peltzer, K. (1999). Posttraumatic stress symptoms in a population of rural children in South Africa. Psychological Reports, 85(2), 646–650.

Phillips, C. (2001). Re-imagining the (dis)abled body. Journal of Medical Humanities, 22(3), 195–208.

Phillips, C. (2007a). Pain(ful) subjects. *Qualitative Social Work, 6*(2), 197–212.

Phillips, C. (2007b). Untitled moments: Theorizing incorporeal knowledge in social work practice. *Qualitative Social Work, 6*(4), 447–464.

Phillips, C., & Bellinger, A. (2010). Feeling the cut: Exploring the use of photography in social work education. *Qualitative Social Work, 10*(1), 86–105.

Pinkola Estés, C. (1992). *Women who run with the wolves: Myths and stories of the wild woman archetype.* New York: Ballantine.

Poff, D. C. (2006). The importance of story-telling: Research protocols in Aboriginal communities. *Journal of Empirical Research on Human Research Ethics, 1*(3), 27–28.

Polack, R., & Chadha, J. (2004). An emerging approach to teaching global social justice issues. *Critical Social Work, 5*(1).

Polkinghome, J. (2001). Novel practices: Reading groups and narrative ideas. *Gecko: Dulwich Centre Newsletter, 3,* 34–50.

Polzer, T. (2010). *Population movements in and to South Africa.* Johannesburg, South Africa: Forced Migration Studies Programme, University of the Witwatersrand.

Porr, C. J., Mayan, M., Graffigna, G., Wall, S., & Vieira, E. R. (2011). The evocative power of projective techniques for the elicitation of meaning. *International Journal of Qualitative Methods, 10*(1), 30–41.

Postle, K. (2002). Working "between the idea and the reality": Ambiguities and tensions in care managers' work. *British Journal of Social Work, 32*(3), 335–351.

Potgieter, M. C. (1998). *The social work process: Development to empower people.* South Africa: Prentice Hall.

Price, L. (2007). Narrative mediation: A transformative approach to conflict resolution. Retrieved from http://www.mediate.com/articles/price11.cfm

Prilleltensky, I. (2008). The role of power in wellness, oppression, and liberation: The promise of psychopolitical validity. *Journal of Community Psychology, 36*(2), 116–136.

Radley, A. (2009). *Works of illness: Narrative, picturing and the social response to serious disease.* Ashby-de-la-Zouch. England: InkerMen.

Rankopo, M. J., & Osei-Hwedie, K. (2011). Globalization and culturally relevant social work: African perspectives on indigenization. *International Social Work, 54*(1), 137.

Rautenbach, J. V., & Chiba, J. (2010). Introduction. In L. J. Nicholas, J. Rautenbach & M. Maistry (Eds.), *Introduction to social work* (pp. 3–39). Cape Town, South Africa: Juta.

Reader, J. (1999). *Africa: A biography of the continent.* London: Penguin.

Reiter, B. (2009). Fighting exclusion with culture and art. Examples from Brazil. *International Social Work, 52*(2), 146–157.

Reynolds, B. (1946). *Rethinking social casework.* San Diego, CA: Social Service Digest.

Reynolds, B. (1963). *An uncharted journey.* New York: Citadel Press.

Richmond, T., & Shields, J. (2004). NGO restructuring: Constraints and consequences. *Canadian Review of Social Policy/Revue canadienne de politique sociale, 53,* 53–67.

Riessman, C. K. (1993). *Narrative analysis: Qualitative research methods. Series 30.* Newbury Park, CA: Sage.

Ringel, S. (2011). Attachment theory, infant research and neurobiology. In S. Ringel & J. R. Brandell (Eds.), *Trauma: Contemporary directions*

in theory, practice, and research. Los Angeles, CA: Sage.

Ross, M. (2011). Social work activism amidst neoliberalism: A big, broad tent of activism. In D. Baines (Ed.), *Doing anti-oppressive practice: Social justice social work* (pp. 251–264). Halifax, NS: Fernwood.

Rothe, J., Ozegovic, D., & Carroll, L. J. (2009). Innovation in qualitative interviews:"Sharing circles" in a First Nations community. *Injury Prevention, 15*(5), 334–340.

Saakvitne, K., & Pearlman, L. (1996). *A workbook on vicarious trauma.* New York: Norton Professional Books.

Sakamoto, I., Chin, M., & Young, M. (2010). "Canadian experience," employment challenges, and skilled immigrants: A close look through "tacit knowledge." *Canadian Social Work Journal, 10*(1), 145–151.

Saleebey, D. (2009). Introduction: Power in the people. In D. Saleebey (Ed.), *The strengths perspective in social work practice* (5th ed., pp. 1–23). New York: Pearson Education.

Salhi, K. (1998). *African theatre for development: Art for self-determination.* Bristol, England: Intellect.

Samba, E. N. (2013). Appreciative inquiry—an alternative approach to applied theatre. In H. Barnes (Ed.), *Applied drama and theatre as an interdisciplinary field in the context of HIV/AIDS in Africa.* Amsterdam: Rodopi.

Samuels, A. (1993). *The political psyche.* London: Routledge.

Saunders, R. (2004). *Human resource issues in Canada's non-profit sector—A synthesis paper.* Ottawa: Canadian Centre for Policy Alternatives.

Save the Children UK. (2009). *Regional seminar on children who cross borders in southern Africa.* Report. Convened by Save the Children UK in collaboration with the University of the Witwatersrand, Forced Migration Studies Programme. London: Save the Children UK.

Schirch, L. (2005). *Ritual and symbol in peacebuilding.* Bloomfield, CT: Kumarian Press.

Schorcht, B. (2003). *Storied voices in Native American texts: Harry Robinson, Thomas King, James Welch, and Leslie Marmon Silko.* New York: Routledge.

Schutzman, M., & Cohen-Cruz, J. (1994). *Playing Boal: Theatre, therapy, activism.* New York: Taylor & Francis.

Schwartzman, H. (1978). *Transformations: The anthropology of children's play.* New York: Plenum Press.

Seedat, S., Nyamai, C., Njenga, F., Vythilingum, B., & Stein, D. (2004). Trauma exposure and post-traumatic stress symptoms in urban African schools: Survey in Cape-Town and Nairobi. *British Journal of Psychiatry, 184*(2), 169–175.

Sewpaul, V., & Hölscher, D. (2004). *Social work in times of neoliberalism: A postmodern discourse.* Pretoria, South Africa: Van Schaik.

Shahjahan, R. A. (2010). Towards a spiritual praxis: The role of spirituality among faculty of color teaching for social justice. *Review of Higher Education, 33*(4), 473–512.

Shank, M., & Schirch, L. (2008). Strategic arts-based peacebuilding. *Peace & Change, 33*(2), 217–242.

Shields, N., Nadasen, K., & Pierce, L. (2008). The effects of community violence on children in Cape Town, South Africa. *Child Abuse & Neglect, 32*(5), 589–601.

Silko, L. M. (2006). *Ceremony.* New York: Penguin Books.

Simmons, H. G. (1982). *From asylum to welfare.* Downsview, ON: National Institute on Mental Retardation.

Simon, R. I. (2003). Innocence without naivete, uprightness without

stupidity: The pedagogical Kavannah of Emmanuel Levinas. *Studies in Philosophy and Education, 22,* 45–49.

Simpson, L. (2011). *Dancing on our turtle's back: Stories of Nishnaabeg re-creation, resurgence and a new emergence.* Winnipeg, MB: Arbeiter Ring.

Sinclair, M., Bala, N., Lilles, H., & Blackstock, C. (2004). Aboriginal child welfare. In N. Bala, M. K. Zapf, R. J. Williams, R. Vogl, & J. P. Hornick (Eds.), *Canadian Child Welfare Law: Children, Families and the State* (2nd ed.). Toronto: Thompson Educational.

Sinding, C., Gray, R., & Nisker, J. (2008). Ethical issues and issues of ethics. In J. G. Knowles & A. L. Cole (Eds.), *Handbook of the arts in qualitative research* (pp. 459–468). Thousand Oaks, CA: Sage.

Sinding, C., Paton, C., & Warren, R. (2012). Social work and the arts: Images at the intersection. *Qualitative Social Work.*

Sitas, A. (1986). Culture and production: The contraindictions of working class theatre in South Africa. *African Perspective, 1*(1&2), 84–110.

Slade, A. (2008). Mentalization as a frame for working with parents in psychotherapy. In E. Jurist, A. Slade & S. Berger (Eds.), *Mind to mind: Infant research, neuroscience, and psychoanalysis* (pp. 307–334). New York: Other Press.

Slade, P. (1954). *Child drama.* London: Hodder and Stoughton.

Slade, P. (1955). *Child drama.* Michigan: Philosophical Library.

Smith, C. (2006). *Persona dolls: Making a difference. Training Manual.* Western Cape, South Africa: Persona Doll Training South Africa.

Smith, L. (2008). South African social work education: Critical imperatives for social change in the post-apartheid and post-colonial context. *International Social Work, 51*(3), 371–383.

Smith, L., & Nathane-Taulela, M. (2011). *Social work education: Art toward student conscientization in the post-apartheid and post-colonial context.* Paper presented at the Social Work Beyond Borders, Social Work Artfully workshop.

Solomon, L. (1989). *Khula Udweba: A handbook about teaching art to children.* Soweto, South Africa: African Institue of Art.

Solomon, L. (2005). *Creative beginnings: A hands-on innovative approach to artmaking for adults and children.* Johannesburg: STE.

Solórzano, D. G., & Yosso, T. J. (2002). Critical race methodology: Counter-storytelling as an analytic framework for education research. *Qualitative Inquiry, 8*(1), 23–44.

Somers, J. W. (2008). Interactive theatre: Drama as social intervention. *Music and Arts in Action, 1*(1), 61–86.

Sontag, S. (2003). *Regarding the pain of others.* New York: Farrar, Straus and Giroux.

Spolin, V. (1999). *Improvisation for the theatre* (3rd ed.). Evanston, IL: Northwestern University Press.

Springgay, S., Irwin, R. L., Leggo, C., & Gouzouasis, P. (2007). *Being with A/R/Tography.* Rotterdam: Sense.

Steele, W., & Raider, M. (2001). *Structured sensory intervention for taumatized children, adolescents and parents.* Lewiston, NY: Edwin Mellen Press.

Stephenson, M. (2002). *Social work in Canada.* Ottawa: Human Resource Development Corporation.

Strauss, A., & Glazer, C. (1990). *Basics of qualitative research: Grounded Theory procedures and techniques.* Newbury Park, CA: Sage.

Sutton-Smith, B. (1997). *The ambiguity of play.* Cambridge, MA: Harvard University Press.

Tafoya, T. (2000). Unmasking Dash-kayah: Storytelling and HIV prevention. *American Indian and Alaska Native Mental Health Research, 9*(2), 53–65.

Tafoya, T. (2009). Circles and cedar: Native Americans and family therapy. *Journal of Psychotherapy and the Family, 6*(1), 71–98.

Tedlock, B. (2011). Braiding narrative enthnography with memoir and creative nonfiction. In N. K. Denzin & Y. S. Lincoln (Eds.), *The Sage handbook of qualitative research* (4th ed., pp. 331–339). Thousand Oaks, CA: Sage.

Teeple, G. (2000). *Globalization and the decline of social reform* (2nd ed.). Toronto: Garamond Press.

Terreblanche, S. (2002). *A History of inequality in South Africa 1652–2002.* Pietermaritzburg, South Africa: University of Natal Press.

Tolfree, D. (1996). *Restoring playfulness: Different approaches to assisting children who are psychologically affected by war or displacement.* Stockholm: Rädda Barnen.

Trent, J. W. J. (1994). *Inventing the feeble mind: A history of mental retardation in the United States.* Los Angeles: University of California Press.

Ungar, M. (2011). The social worker—a novel: The advantages of fictional re-presentations of life narratives. *Cultural Studies—Critical Methodologies, 11*(3), 290–302.

Van der Kolk, B. (1984). *Post-traumatic stress disorder: Psychological and biological sequelae.* Washington, DC: American Psychiatric Press.

Van der Kolk, B. (2002). In terror's grip: Healing the ravages of trauma. *Cerebrum, 4*(1), 34–50.

van der Walt, C. (2001). *Trauma and the gaze: A Lacanian analysis of perpetrator testimony in the Truth and Reconciliation Commission.* Unpublished master's thesis, University of

the Witwatersrand, Johannesburg, South Africa.

Van Graan, M. (2006). From protest theatre to the theatre of conformity? *South African Theatre Journal, 20*(1), 276–288.

Vygotsky, L. S. (1976). Play and its role in the mental development of the child. In J. S. Bruner, A. Jolly & K. Sylva (Eds.), *Play: Its role in development and evolution.* Harmondsworth, England: Penguin.

Wagner, B. J. (1988). *Dorothy Heathcote: Drama as a learning medium.* London: Hutchinson.

Walker, P. O. (2004). Decolonizing conflict resolution: Addressing the ontological violence of Westernization. *American Indian Quarterly, 28*(3), 527–549.

Walker, R. (2005). Social cohension? A critical review of the Urban Aboriginal Strategy and its application to address homelessness in Winnipeg. *Canadian Journal of Native Studies, 2*, 395–416.

Walkup, J., & Crystal, S. (2010). Mental health and the changing context of HIV. In T. Scheid & T. Brown (Eds.), *A handbook for the study of mental health* (pp. 548–570). New York: Cambridge University Press.

Waller, D. (2006). Art therapy for children: How it leads to change. *Clinical Child Psychology and Psychiatry, 11*(2), 271–282.

Walsh, F. (1998). *Strengthening family resilience.* New York: Guilford Press.

Ward, C. L., Flisher, A. J., Zissis, C., Muller, M., & Lombard, C. (2001). Exposure to violence and its relationship to psychopathology in adolescents. *Injury Prevention, 7*(4), 297–301.

Ward, C. L., Martin, E., Theron, C., & Distiller, G. B. (2007). Factors affecting resilience in children exposed to violence. *South African Journal of Psychology, 37*(1), 165–187.

Watters, C. (2008). *Refugee children: Towards the next horizon*. London; New York: Routledge.

Way, B. (1967). *Development through drama*. London: University of London Press.

Weininger, O. (1980). Play and early childhood. In P. Wilkinson (Ed.), *In Celebration of play: An integrated approach to play and child development*. London: Croom Helm.

Welvering, D. (2006). A reflection on the art-making process. In G. Clacherty & D. Welvering (Eds.), *The suitcase stories: Refugee children reclaim their identities* (pp. 154–165). Cape Town, South Africa: Double Storey.

Wenocur, S., & Reisch, M. (2001). *From charity to enterprise: The development of American social work in a market economy*. Evanston: University of Illinois Press.

Wertz, M. S., Nosek, M., McNiesh, S., & Marlow, E. (2011). The composite first person narrative: Texture, structure, and meaning in writing phenomenological descriptions. *International Journal of Qualitative Studies on Health and Well-being, 6*(2), 5882–5898.

White, M. (2005). Children, trauma and subordinate storyline development. *International Journal of Narrative Therapy & Community Work, 2005*(3/4), 10–20.

White, M. (2007). *Maps of narrative practice*. New York: W.W. Norton.

White, M., & Epston, D. (1990). *Narrative means to therapeutic ends*. New York: Norton.

Wilson, S. (2008). *Research is ceremony: Indigenous research methods*. Winnipeg, MB: Fernwood.

Winnicott, D. W. (1975). Transitional objects and transitional phenomena. In D. W. Winnicott (Ed.), *Collected papers: Through pediatrics to psycho-analysis* (pp. 229–42). New York: Basic Books.

Winnicott, D. W. (1971). *Playing and reality*. New York: Routledge.

Winslade, J., & Monk, G. (2000). *Narrative mediation: A new approach to conflict resolution*. San Francisco: Jossey-Bass.

Withorn, A. (1984). *Serving the people: Social services and social change*. New York: Columbia University Press.

Worden, J. W. (2002). *Grief counseling and grief therapy: A handbook for the mental health practitioner*. New York: Springer.

Wulff, D., George, S. S., Faul, A. C., Frey, A., & Frey, S. (2010). Drama in the academy. *Qualitative Social Work, 9*(1), 111–127.

Yalom, I. D. (1970). *The theory and practice of group psychotherapy*. New York: Basic Books.

Zwicky, J. (2008). *Songs for relinquishing the earth*. London, ON: Brick Books.

Contributors

Donna Baines teaches labour studies and social work at McMaster University, Canada. Her research focuses on international comparisons of paid and unpaid care work, managerialism, social welfare, and anti-oppressive social work theory and practice. She has published recently in *Critical Social Policy, Journal of Social Work, Journal of Industrial Relations*, and in 2011 published the second edition of *Doing Anti-Oppressive Practice: Social Justice Social Work* (Fernwood).

Hazel Barnes is a retired Head of Drama and Performance Studies at the University of KwaZulu-Natal, South Africa, where she is a Senior Research Associate. She is a member of the Management Committee and Chair of the Research Committee of Drama for Life, School of Arts, University of the Witwatersrand. Her research interests lie in the field of applied drama and theatre, in which she has published papers and edited books. She has also published on South African playwrights, in particular Greig Coetzee and Mandla Mbothwe.

Kennedy C. Chinyowa is former Head of the Division of Dramatic Arts at the University of Witwatersrand and currently Research Professor the Faculty of Arts at Tshwane University of Technology in Pretoria, South Africa. He was a visiting scholar in the Centre for Applied Theatre Research at Griffith University (2001–2005), where he obtained his Ph.D. in Theatre for Development. He has presented papers and workshops at international conferences, and published in journals such as *Research in Drama Education, Studies in Theatre and Performance, Drama Research, Nadie Journal*, and the *South African Theatre Journal*.

Nadine Cross is Research Associate with the York University–UHN Academy, University Health Network, in Toronto, Canada, where she offers opportunities to explore research methods for understanding the experiences of nurses, healthcare teams, and patients in different healthcare contexts. Complexity thinking and arts-based methodologies guide Nadine's educational practices.

nancy viva davis halifax, Associate Professor in the M.A. and Ph.D. Program in Critical Disability Studies, York University, originally trained as a conceptual artist; her research interests and practices are grounded in this history. Her writing and teaching is oriented by body/bodies, illness, disability, and difference, and her ethnographic commitment to the articulation of what flickers at the threshold. She lives in a world wherein she embodies disability and illness. She imagines and is curious about life that is not lived as whole, separate, and invulnerable but rather is lived through deep connections and ways of knowing that are off-centred, multiple, sensuous.

Corena Debassige is Nishnawbe from M'Chigeeng First Nation on Manitoulin Island (Ontario), is a mother of two, and takes great pride in having a spirit name, spirit helpers, and traditional colours. Corena is currently the Client Care Coordinator with the 2-Spirited People of the 1st Nation (Toronto, Ontario), holds a Bachelor of Science from Trent University, and is a passionate advocate of end-of-life care planning.

Ann Fudge Schormans is an Associate Professor in the School of Social Work at McMaster University, Canada. She brings almost twenty years of social work practice and ongoing activist work with disabled people to her research and teaching activities. Current research projects explore the use of city space by people with intellectual disabilities; parenting with an intellectual disability; the intersection between intellectual disability, homelessness, education, and employment; and friendships for youth with intellectual disabilities. Her research also explores how inclusive research is facilitated by arts-informed methods. She is the parent of two daughters with intellectual disabilities.

Khayelihle Dominique Gumede completed his B.A. (Dramatic Arts) at the University of the Witwatersrand, South Africa, in 2011, specializing in performance, directing, and writing, and has since worked professionally in all three of these areas. He is currently on a writing residency with the Royal Court of London and developing a new South African play as part of the appointment. He teaches on a sessional basis at the South African School of Motion Picture Medium and Live Performance in Johannesburg and directs the third-year final live performance graduating project.

Randy Jackson is a Ph.D. candidate in the School of Social Work at McMaster University, Canada. He is cross-appointed as lecturer in the Department of Health, Aging and Society. Randy is Anishinaabe from Kettle and Stony Point First Nation (Ontario), Bear Clan, and is involved in a number of Aboriginal community-based HIV/AIDS research projects. He works to actively engage community members in ways that incorporate Aboriginal knowledges, values, and perspectives into the research process.

Edwell Kaseke is Professor of Social Work at the University of the Witwatersrand in Johannesburg, South Africa. He teaches social policy and social development at both undergraduate and postgraduate levels. Prior to joining the University of the Witwatersrand, Edwell Kaseke was the Director of the School of Social Work at the University of Zimbabwe. His research interests include social policy, social development, social protection, and social security.

Liebe Kellen is the clinical social work supervisor at Sophiatown Community Psychological Services in South Africa. She is currently registered as a Social Work Ph.D. candidate at the University of Witwatersrand, South Africa. Her proposed research focuses on unaccompanied migrant girls.

Renée Masching is a First Nation woman from Southern Ontario and presently the Director of Research and Policy with the Canadian Aboriginal AIDS Network. She has dedicated her professional energies to Aboriginal health and earned her Master of Social Work degree in 2003. She has contributed to Aboriginal HIV/AIDS work with dedication and determination from 1995. Renée's research interests focus on community-based research frameworks, Indigenous knowledge, and community health with an emphasis on HIV and AIDS.

Patti McGillicuddy is a Director of Professional Practice in Collaborative Academic Practice, University Health Network, Toronto, Canada, and a Social Worker and Adjunct Lecturer with the Faculty of Social Work at the University of Toronto. Patti works with health professionals, patients, and organization leaders to build partnerships in care pathways, trauma-sensitive practices, arts and humanities integration, and voice in complex health systems.

Gail Mitchell is a Professor in the Faculty of Health at York University and the former Director/Chair for Person-Centred Care at the York–UHN Academy in Toronto, Canada. She has taught and conducted research on person-centred care for more than thirty years. Gail has worked with teams to complete powerful research dramas about living with dementia and about patient safety to help healthcare persons imagine different ways of relating to the persons with whom they interact in healthcare and community settings.

Tlale Nathane-Taulela is a lecturer in the department of Social Work at the University of the Witwatersrand, South Africa. She has years of experience and a special interest in the field of child protection in South Africa. As a social worker she developed community-based education intervention on child protection in informal settlements in the province of Gauteng, South Africa. Her teaching involves child protection with a focus on national and international issues affecting unaccompanied refugee minors and foreign child migrants. She is a full candidate in the School of Human and Community Development.

Cathy Paton is an artist and a Ph.D. Candidate in Social Work at McMaster University, Canada. Based in Toronto, Cathy facilitates workshops within academic and social community contexts. Her workshops and current research focus on bringing the art of improvisational theatre into the realm of relational reflection—paying attention to how we relate to one another. Cathy also works with children and youth as a social arts practitioner.

Carolyn Plummer is Senior Manager of Innovation for Collaborative Academic Practice at University Health Network in Toronto, and Adjunct Lecturer at the Lawrence S. Bloomberg Faculty of Nursing at the University of Toronto, Canada. She leads an innovation strategy to advance collaborative academic practice, research, education, and leadership within a framework

of partners in care. Carolyn has held clinical, leadership, and management positions in various healthcare and consulting organizations across multiple healthcare sectors.

Edmarié Pretorius is a senior lecturer in the Department of Social Work at the University of the Witwatersrand, South Africa. Her Ph.D. focused on the professional identity of social worker, specifically the process of "advisory helping" between social workers. She teaches macro practice, management in social work, and research methodology as well as healthcare at the undergraduate level. She is the coordinator of the M.A. in Social Development course and responsible for teaching the social development module. Her research interests include social and community development, management and supervision, healthcare, and school social work.

Christina Sinding is Associate Professor at McMaster University in Hamilton, Canada. Her research focuses on cancer and social marginalization, critical analyses of service user involvement in care practice, and arts-informed social science. On the latter theme, she explores how social work educators, researchers, and practitioners draw on the arts for insight, new forms of engagement, and social justice goals. She is the author, with Ross Gray, of *Standing Ovation: Performing Social Science Research about Cancer.*

Linda Harms Smith is a senior lecturer at the University of the Witwatersrand, South Africa. Her interests include social justice and social change, critical and radical social work, community work, Freirian approaches to education and change, social movements, human rights, transformation, and post-apartheid/post-colonial studies. Before joining social work education, she practised as a community worker and social worker in the area of social development and child and family welfare. She is a member of the Social Work Action Network and member of the editorial boards of the *Critical and Radical Social Work Journal* and the *International Social Work Journal.*

Wanda Whitebird is currently a Traditional Counsellor with the Ontario Aboriginal HIV/AIDS Strategy, which provides culturally respectful and sensitive programs and strategies for Indigenous people facing HIV/AIDS. Wanda has been an integral part of Toronto's First Nations community since 1976. She is a member of the Mic'maq First Nations, Bear Clan, from Afton, Nova Scotia. She is a leader who works to incorporate ceremony in her work as part of the healing process.

Index

Photographs indicated by page numbers in italics